History as Art, Art as I

MW01133820

History as Art, Art as History pioneers methods for using contemporary works of art in the social studies and art classroom to enhance an understanding of visual culture and history. The fully illustrated interdisciplinary teaching toolkit provides an invaluable pedagogical resource—complete with theoretical background and practical suggestions for teaching U.S. history topics through close readings of both primary sources and provocative works of contemporary art.

Features include:

- A thought-provoking series of framing essays and interviews with contemporary artists address the pivotal questions that arise when one attempts to think about history and contemporary visual art together.
- An 8-page, full color insert of contemporary art, plus over 50 black and white illustrations throughout.
- A Teaching Toolkit covering major themes in U.S. history provides an archive of suggested primary documents, plus discussion suggestions and activities for putting theory into practice.
- Teaching activities keyed to the social studies and art curricula and teaching standards.
- Resources include annotated bibliographies for further study and lists of arts and media organizations.

This sophisticated yet accessible textbook is a must-read resource for any teacher looking to draw upon visual and historical texts in their teaching and to develop innovative curriculum and meaningful student engagement.

Dipti Desai is Associate Professor and Director of the Graduate Art Education Program, Department of Art and Art Professions, at New York University.

Rachel Mattson is a historian, a teacher educator, and an Assistant Professor, Department of Secondary Education, at SUNY New Paltz.

Jessica Hamlin is the Director of Education and Public Programs for the non-profit organization Art21, Inc.

The Teaching/Learning Social Justice Series
Edited by Lee Anne Bell
Barnard College, Columbia University

History as Art, Art as History

Contemporary Art and Social Studies Education

Dipti Desai, Jessica Hamlin, and Rachel Mattson

Routledge
Taylor & Francis Group

NEW YORK AND LONDON

First published 2010
by Routledge
711 Third Avenue, New York, NY 10017, USA

Simultaneously published in the UK
by Routledge
2 Park Square, Milton Park, Abingdon, Oxon OX14 4RN

Routledge is an imprint of the Taylor & Francis Group, an informa business

© 2010 Routledge, Taylor and Francis

Typeset in Bembo and Helvetica Neue by Prepress Projects Ltd, Perth, UK

Library of Congress Cataloging in Publication Data

British Library Cataloguing in Publication Data
A catalogue record for this book is available from the British Library

ISBN 10: 0–415–99375–X (hbk)
ISBN 10: 0–415–99376–8 (pbk)
ISBN 10: 0–203–87030–1 (ebk)

ISBN 13: 978–0–415–99375–3 (hbk)
ISBN 13: 978–0–415–99376–0 (pbk)
ISBN 13: 978–0–203–87030–3 (ebk)

To Sumita and Maggie, the next generation of creative minds,
and
to Ulrich, a real patron saint.

Contents

List of Illustrations

PLATES (between pages 80 and 81)

FIGURES

Series Editor Introduction

The Teaching/Learning Social Justice Series explores issues of social justice—diversity, equality, democracy, and fairness—in classrooms and communities. "Teaching/learning" connotes the essential connections between theory and practice that books in this series seek to illuminate. Central are the stories and lived experiences of people who strive both to critically analyze and challenge oppressive relationships and institutions, and to imagine and create more just and inclusive alternatives. My hope is that the series will balance critical analysis with images of hope and possibility in ways that are accessible and inspiring to a broad range of educators and activists who believe in the potential for social change through education and who seek stories and examples of practice, as well as honest discussion of the ever-present obstacles to dismantling oppressive ideas and institutions.

History as Art, Art as History is an inspired collaboration between two art educators and a historian who creatively interweave the analytic methods of historians with those used by contemporary artists to produce a methodology for using visual texts in both history and art classrooms. The juxtaposition of interpretive methods from these two fields suggests inventive ways to teach history through visual texts as well as to think critically about visual texts through historical methods. The result is a sophisticated yet accessible framework that teachers of history and the arts, as well as teachers in other areas who draw upon visual and historical texts in their teaching, can use to develop innovative curriculum and generate critical engagement with meaningful, open-ended questions about memory, history, representation, and democracy.

The theoretical and methodological framework is illustrated in practice through a fascinating interview with an artist/educator who describes her work with young people in public high school classrooms. The methodological framework is elaborated further through conversations with two contemporary artists who discuss how they consciously create through their art public spaces where thoughtful reflection about historical ideas and questions can be provoked and engaged. These essays, interspersed with illustrative visual images, enable the reader to vicariously experience the power of the critical pedagogical approaches advocated in the first part of the book.

The second part of the book provides a set of interdisciplinary resources and practical suggestions for teaching U.S. history topics in both art and social studies classrooms through combining primary documents with provocative works of art. Sample lessons and materials are provided for teaching about the Constitution, Japanese Incarceration, Slavery and Abolition, Immigration, Westward Expansion, and the U.S. war in Vietnam. This part outlines a set of principles, or "critical visual strategies," teachers can use to

promote dialogue about historical and visual documents. These principles and the lessons that illustrate how they may be used in practice provide a valuable toolkit for teachers to adapt and build on in their own classrooms. A wealth of material is provided in ways that respect the capacities of teachers to engage with ideas and methods and shape them to their own students, subject, context, and pedagogical goals.

The distinguished educational philosopher Maxine Greene, a lifelong advocate of the power of art to engage critical awareness, has argued eloquently that the arts should be central to any construction of curriculum today, especially one that seeks to address vital issues of justice and democracy (1995). In a similar vein, the historian Robin D. G. Kelley, viewing the arts as compelling and relevant aspects of historical analysis, writes "our imagination may be the most revolutionary tool available to us, and yet we have failed to understand its political importance and recognize it as a powerful social force" (2002). In an increasingly impoverished, test-driven curriculum where both art and history are often pushed to the margins, this book is worthy of the transformative imaginative possibilities of which Kelley and Greene write, capable of inspiring curriculum practices that keep alive sensual engagement with questions worth asking, toward a future worth living.

Lee Anne Bell
Barnard University

REFERENCES

Greene, Maxine. (1995). *Releasing the imagination: Essays on education, the arts and social change*. San Francisco: Jossey Bass.
Kelley, Robin D. G. (2002). *Freedom dreams: The black radical imagination*. Boston: Beacon Press.

Acknowledgements

We undertook this collaborative journey a few years ago in the spirit of crossing disciplinary borders. We could not have done this alone. It is truly a collective effort and we would like to thank all the people who supported us in various ways along this journey: Dennis Lacey, John Landewe, Lee Ann Bell, Michelle Kloehn, Jennie Aleshire, Rachel Meyers, Phoebe Zinman, Terri Ruyter, Eileen Clancy, Jenny Romaine, Diana and Bob Mattson, Gail Cooper, Karen-Michelle Mirko, Jania Witherspoon, Nina Callaway, Mickey Lambert, Sarita Khuana, Joey Mogul, Leah Gilliam, Daniel Lang/Levitsky, Ariel Federow, the Department of Secondary Education at SUNY New Paltz, Diana Turk, Robert Cohen, Anna Jacobs, Gretchen Hildebran, the Steinhardt School of Culture, Education and Human Development which gave us a Professional Development Grant, laurie prendergast of moonmark design/editing/indexing, the generosity of all the artists and galleries represented in this book, the reviewers for their helpful comments, and our editors at Routledge, Catherine Bernard and Heather Jarrow.

Reframing History and Art

CHAPTER I

Introduction

Dipti Desai, Jessica Hamlin, Rachel Mattson

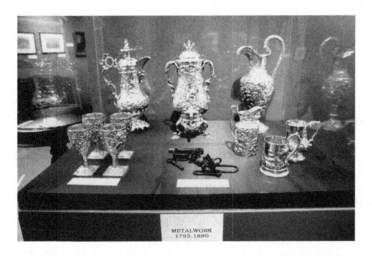

Figure 1.1 Fred Wilson, "Metalwork 1793–1880," *Mining the Museum*, 1992.

In 1992, at the Maryland Historical Society in Baltimore, the artist Fred Wilson mounted an exhibit that would become something of a legend. Wilson's installation, the aptly titled *Mining the Museum,* was a radical departure from conventional exhibition standards at historical museums. Bringing nothing new into the museum, Wilson's exhibit featured items from the society's collection—old tea sets, paintings, furniture—the typical relics of a bygone era, but presented in an unprecedented way. Wilson repositioned select objects from the archives of the Maryland Historical Society to provoke difficult questions about the histories that these objects embody, and the purpose of the institutions that preserve them. Acting as curator, historian, and artist, Wilson sought to reveal untold stories embedded in these objects, by creating surprising juxtapositions, and playing with the placement of objects within the physical space of the gallery. A case labeled "Metalwork 1793–1880" contained highly polished Repousse-style silver table settings produced for the elite of Baltimore society surrounding a pair of grim iron slave shackles produced in the same period (Figure 1.1). In other parts of the exhibit Wilson positioned

otherwise pristine museum "artifacts" so that they faced the wall, rather than the viewer. These strategic interventions, presented in the context of the historical museum, set up competing and often contradictory narratives that provoked audiences to question not only how history is represented, but how it is obscured. In short, Wilson assumed the role of critical historian under the auspices of art and in the role of an artist; he transformed the possibilities for historical discourse and presented new ways to consider the role of the arts in relation to history.

In this book we ask: can the work of contemporary artists help us re-imagine the ways that we teach about history and imagine the past? Wilson's *Mining the Museum* exhibit suggests that they can. And Wilson is not the only artist whose work provokes an enthusiastic response to this question. There are a great number of other contemporary artists, working in a range of media, and with a diversity of intellectual commitments, whose work suggests new ways to make sense of, and teach about, the past. Here we provide a range of contexts through which to explore how to rethink history, art, and pedagogy.

We began this project saying that this book, *History as Art, Art as History: Contemporary Art and Social Studies Education*, is a tiny flare of hope. In a moment when the debate about K–12 education narrows—each year, seemingly, more and more—around a rigid and unimaginative set of tests, classroom scripts, political debates, and bureaucratic mandates, this book insists on an alternate set of educational priorities—priorities that promote, above all, creative and critical thinking in history and art classrooms. We have created an experientially grounded, practically minded pedagogical investigation and toolkit meant to push teachers and students to teach, learn, and think critically and visually without sacrificing their ability to succeed in this difficult educational climate. The book brings together both cutting-edge scholarly thinking and best practices for teaching two subjects that are rarely considered coincidentally: history and contemporary art. Building on theoretical and methodological insights from both fields—and especially from contemporary artists and historians who are engaged with public and civic questions— we wrote this book in an effort to open new ways of thinking about teaching.

The book itself is the result of a several-year collaboration between three educators separated by great disciplinary divides. A textile artist turned art educator, Dipti works primarily at the university level as the Director of the Art Education program at New York University (NYU). Jessica works daily to bridge the worlds of contemporary art and public education as the Director of Education and Public Programs for Art21, Inc. a non-profit art organization. Rachel is a professionally trained historian who has worked for many years with history and social studies teachers in New York City, teaching them to think historically and teach creatively; she now works as an assistant professor at the State University of New York (SUNY) New Paltz.

All three of us have worked for years with teachers and students in the beleaguered New York City and New York State public school system, and, in doing that work, have grown frustrated with the ways in which disciplinary boundaries and state and national standards infringe upon the promise of compulsory public education in a democracy and undermine the creative and critical educations of the students in our city's and our nation's schools. We saw in this book an opportunity to model critical and investigatory education that empowers students to think beyond subject area boundaries. Dedicated to the radical promise of public education, we believe that interdisciplinary education has great, unrealized potential. It contradicts the notion that knowledge is specialized

and isolated, and allows students to make connections between skills and concepts across subject areas and disciplines, and ideas more generally.

We three wrote this book over the course of four years, in an out-of-the way classroom building on the campus of NYU. Throughout this process, we have labored very hard to communicate effectively across the disciplinary and educational divides that stretch between us. This work has not been easy. Not only do we come to this work from at least two, if not more, distinct disciplinary locations, we also address ourselves herein to at least two separate groups of audiences: art teachers and history teachers. To fail to acknowledge these divisions—or at the very least, to note that they marked our collaboration, and that they mark this book—would be to misrepresent our work. The process that produced this book was not seamless. The ride was bumpy. We did not always understand each other. We did not always agree. And although we developed, as we had set out to do, a site where our ideas, and our disciplines, could meet up, this volume itself is also not seamless. Indeed, we believe there is something useful about showing the seams along which we have stitched together our ideas.

We show these "seams" in several ways within this volume. As you will notice, some chapters were co-written; others were authored individually. Some sections feature essays written in the first person; others take the form, strictly, of the traditional third person. Additionally, Chapters 2 and 4—which we have grown used to calling, informally, our "methodologies" chapters (and which we introduce in more detail below)—take on similar questions from distinct vantage points. In Chapter 2, Rachel tackles the challenge that contemporary art and "the visual" pose to history—and history pedagogical—methodologies. In Chapter 4, Dipti and Jessica deal with the challenge that "history" poses to artists and arts educators. These essays lay bare the distinct lenses through which we view this work, and the contrasting possibilities we find there. They provide two very different doorways into this work. You may enter through either or both of them.

We realize this is unconventional. But this is difficult work, and we have had to invent our methods for working, and our strategies for communicating our ideas, along the way. We believe that showing, instead of hiding, the seams where we have grafted together the divergent critical approaches that we bring to this work serves the purpose of making visual the distinctly interdisciplinary nature of this collaboration.

WHY THIS BOOK

We live in a visual culture. We no longer represent ideas, feelings, thoughts, and experiences primarily through oral and written means. Rather, multi-modal ways of representing human experience are now commonplace. Nicholas Mirzoeff (1999) reminds us "[h]uman experience is now more visual and visualized than ever before from satellite pictures to medical images of the interior of the human body" (p. 1). Our students not only are extremely familiar with visual symbols and communication, but are often the target of this messaging. Visual imagery saturates their daily existence, and they are perhaps more likely to learn about history from television, film, video games, and photographs than from reading. And while students are learning how to negotiate every aspect of contemporary existence in this increasingly visual culture, educators cannot ignore the visual nature of students' lives, no matter what subject they teach. As Henry

Giroux (1994) suggests, we have to pay attention to the sites where students are learning, however far from our idea of the "ideal" learning environment that may be, and help them to understand "how conflicts over meaning, language, and representation" relate to "larger struggle[s] over cultural authority, the role of intellectuals and artists, and the meaning of democratic public life" (p. 8). The stakes of this endeavor are high. Movies, television, videogames and other visual and entertainment-based media offer young people a steady diet of something that they might learn to call "history"—no matter how hard we protest that it is not so.

Meanwhile, research about arts-based education suggests that it holds enormous possibilities for K–12 education. Not only is arts education proven to develop the critical and creative thinking capacities of young people, reports demonstrate that students who consistently participate in arts education are more engaged and successful, and have better communication skills than other students. A Carnegie Foundation report recently found that students who "consistently participate in comprehensive, sequential, and rigorous arts programs" are four times more likely to be recognized for academic achievement and to participate in math and science fairs, and three times more likely to be elected to leadership positions within their schools or to win awards for school attendance (Heath, Stanford University, & Carnegie Foundation, 1998). Other studies have found that arts-based educational strategies improve the core skills of reading and writing and that integrating visual assessments in addition to written assessments improves student understanding of historical knowledge. One study reported "that students reveal more history knowledge when their knowledge is assessed through a combination of writing plus drawing than when it is assessed through writing alone" (DeJarnette, 1997, p. 141).

This book proposes that not only do the arts support core academic skills, they support the development of core historical literacy skills such as the ability to articulate an idea; to take a position and defend it; to critically navigate the landscapes students move through every day; to become critical investigators of both images and objects in the world; to understand the world, in both contemporary and historical context; to generate new questions about what they see; and to produce and represent historical knowledge in dynamic ways. The arts also provide students with a new language and a new set of visual tools and methods to process and articulate their ideas. Works of historically engaged art suggest that how we understand the past might be as much a visual question as it is a textual one—that is, that text is not the only medium through which to analyze and represent the past. Most significantly, teaching with works of art provides an opportunity to involve students in critically open-ended conversations: to engage in inquiry that recognizes that every student possesses, and has the right to possess, their own interpretations of the images and events that they observe around them. This idea, and the dynamic pedagogical space it creates, can teach students to develop their own analyses and opinions about the meaning of the past and present, and support their ability to communicate, believe in, and defend their ideas.

As an interdisciplinary project, this book supports a related set of skills that encourage students to integrate or synthesize disciplinary knowledge and modes of thinking. For the purposes of this book, we define "contemporary art" as artwork made by living artists. We chose to focus our attentions specifically around the work of contemporary, living artists because, on the whole, artists working today model the kind of cross-disciplinary, collaborative work that an integrated curriculum aspires to. Unconstrained by a particular media or method, many artists utilize the practices and resources of historians,

social scientists, anthropologists, urban planners, architects, graphic designers, scientists, engineers, and many others in the production of their work. These artists present interdisciplinary models that can inspire students to ask critical questions and debate the meanings of history, as well as envision new ways of understanding and representing the past, present, and future. Teachers can and should involve students in this same kind of participatory and collaborative learning about current issues and historic themes.

By placing the work of contemporary artists next to the sources and methods of professional historians, we find new epistemological and pedagogical possibilities. That is to say: thinking about history and contemporary art together suggests new ways to teach and to think. Contemporary art, we believe, can in fact serve as a pedagogical site itself, one that that suggests alternative ways of thinking about the past, present, and future. Thinking about history through an investigation of visual art does not simply provide students with yet another set of texts to understand. It provides students with a new landscape within which to make sense of their world and develop their opinions.

Divided into two distinct parts, this book introduces a spectrum of issues and ideas related to contemporary art and history, as well as a set of practical tools meant to help educators bring these ideas into the classroom. The first part of the book, "Reframing History and Art," presents the central themes of the book through a series of reflective interviews and methodological essays. The second part, "Investigating History and Art: A Teaching Toolkit," provides a sampling of methods for implementing critical visual and historical strategies in the classroom.

REFRAMING HISTORY, EMBODIED KNOWLEDGE, AND PUBLIC ART AS PUBLIC HISTORY

Three key ideas emerge when we place the work of contemporary artists in conversation with primary historical documents and the methods of professional historians. First among the central arguments and ideas that frame the work of this book is that there are a great many contemporary artists who are critical interpreters of the past in their own right. These artists (many of whom we feature in the second part of this book) make art only after conducting rigorous historical research, deploying critical analytical methods, and engaging with a range of scholarly debates. Using visual evidence and strategies, they tell critical historical stories and interrogate the ways in which we remember the past. Artists working today labor, like some of the most critical historians, to expose the

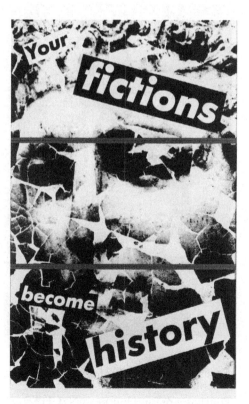

Figure 1.2 Barbara Kruger, *Untitled (Your Fictions Become History)*, 1983.

tensions and contradictions of traditional, closed historical narratives. The provocative statement by Barbara Kruger, *Your Fictions Become History* (1983; Figure 1.2) provokes the viewer to consider and perhaps rethink how history is constructed and for whom. Is history simply a form of storytelling? Artists offer new frames within which to consider standard historical narratives, and offer new methods for investigating the past and for making meaning out of it. *Your Fictions Become History* proposes that history not only is deeply personal, but is constructed by individuals who are able to tell their stories and are acknowledged in the historical record. We are all implicated in history.

Using a wide range of tools, materials, and sources of inspiration, contemporary artists explore, critique, debate, and comment on pertinent issues of our times that often require the creation of a new visual language. By utilizing their unique position as borrowers, remixers, rearrangers, and critical thinkers, artists "upset the assumptions of the present" (G. Sholette, personal communication, April 26, 2007) and (Figure 1.3) produce new forms of knowledge that have the potential to unframe and reframe historic themes, events, and issues. This reframing of history illustrates what Hayden White (2002) suggests is required of critical historians. He writes: "critical historians must proceed on the basis of the realization that they have to invent a language adequate to the representation of historical reality for their own time and place of work" (p. xiii).

The truth is that historians are not the only ones who should—or do, in fact—have license to interpret the past. Historical stories are told, written down, danced, photographed, sung, painted, sculpted, and performed on stages or on streets by a range of individuals, many of whom care just as much about the past as professional historians. In doing so, artists borrow from and critique traditional historical methods; they investigate the locations where we have come to expect to get told sanctioned historical stories; and they offer up new historical ideas.

Although this idea of artists reframing historical discourse is woven into each part of this volume, we explore its implications most explicitly in the first part of this book, "Reframing History and Art." This part presents the central themes of the book through a series of interviews and methodological essays. Chapter 2, "Using Visual Historical Methods in the K–12 Classroom: Tactical Heuristics," examines this idea in greater detail, and explores the possibility of putting questions about visual knowledge at the center of historical inquiry and history education.

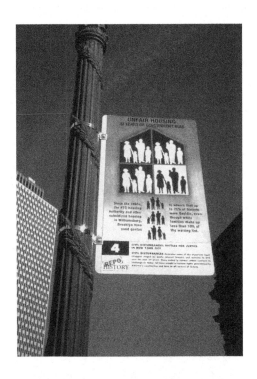

Figure 1.3 REPOhistory, "Ending Discrimination in Public Housing: Williamsburg Fair Housing v. NYCHA," *Civil Disturbances: Battles for Justice in New York City*, 1998–1999.

Drawing on the work of a number of cultural historians, visual theorists, and researchers of teaching and learning, this chapter presents a new set of methodological rubrics that help us critically read contemporary art as historical interpretation. This chapter also offers suggestions for provoking young people to inquire deeply into visual narratives and sources. Paired with the interview with artist and educator Thi Bui in Chapter 3, "Curriculum as a Creative Process," this first part of the book introduces different ways that artists and educators can shift the discourse around historic themes and events, to create new ways of imagining and interpreting the past, while grounded in the present.

The second key idea we explore throughout this book is the embodied nature of historical inquiry. Art educators commonly tell their students that viewing a work of art is not just an intellectual or academic exercise, but also a physical and emotional process. That is to say that the experience of looking at and interpreting visual imagery does not occur only in the thinking brain. When we look at images or works of art, we often intuitively recall a range of related memories, ideas, events—even other images from different aspects of our lives, conscious and subconscious associations with other media. For all the sophistication in their analyses, historians and history educators rarely discuss this aspect of the intellectual process, and they almost never highlight the emotional or embodied quality of historical storytelling. But any honest discussion of history, or of the effect that historical stories have on us as humans—as members of specific tribes, nations, or affiliations—has to acknowledge that we can never fully separate our understandings of, or our relationships to the past, from our emotions or our bodies. We might be able to repress our knowledge of its presence, but we should not. This is especially true for those of us who are interested in teaching and learning for social

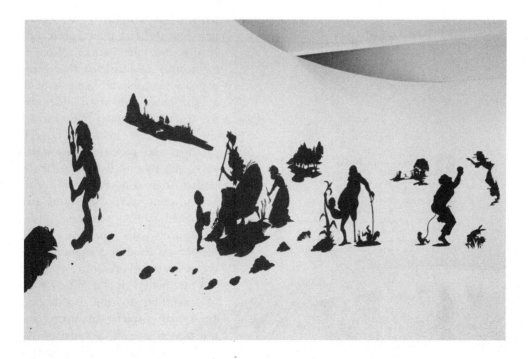

Figure 1.4 Kara Walker
The End of Uncle Tom and the Grand Allegorical Tableau of Eva in Heaven, 1995.

justice.

Looking at, and critically reading historically engaged artwork, such as Kara Walker's silhouettes (Figure 1.4), which reference and comment so precisely on the interplay of race, violence, and sexuality in U.S. history and life, remind us that history is full of emotional charge. Walker explains that she has:

> no interest in making work that doesn't elicit a feeling—not just a mood, a real visceral "oh-you-mean-me?" . . . I know there's a great need for things to be clear in the end but I actually think that kind of jittery feeling of uncertainty and just a lack of clarity about who you are and how you define yourself and how you define yourself against the person next to you in the room watching the same thing with you is vital.

> (2007, paragraphs 6 and 9)

Our sense of our selves in relationship to the world is at once deeply historical and deeply embodied. It is time to bring this insight into our classrooms, our research practices, and our efforts to teach young people to think critically about both the past and the world they live in. "What might become possible and thinkable if we were to take pedagogy to be sensational" (Ellsworth, 2005, p. 24)? Talking about historical ideas through the lens of visual art can provide students with an avenue through which to address the emotional connections they have to the past, to develop an intellectual response to these connections, and to reimagine the idea of history as a personal journey. In his print series, *Runaway Slaves*, the artist Glenn Ligon (featured in Chapter 8) appropriates the visual format of eighteenth-century wanted posters for runaway slaves to describe himself as a twenty-first-century black man (Figure 1.5). In this and other works related to eighteenth- and nineteenth-century primary documents, Ligon extends a particular historical narrative to a contemporary experience, suggesting that history is deeply personal and inevitably connected to events in our lived experience. Rather than conceiving of history as a distant series of events that happened to someone else, unconnected to our lives today, history is a lived understanding that merges past and present.

Our belief in the importance of attending to the bodily and emotional character of history and the importance of considering the sensory experiences of historical events through the work of contemporary artists is articulated

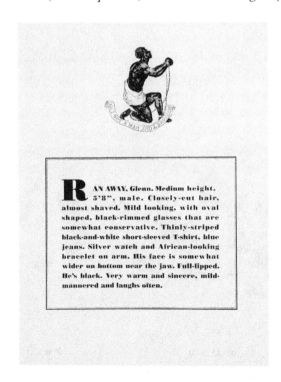

Figure 1.5 Glenn Ligon, *Runaways (Ran away, Glenn. Medium height, 5'8", male. . .),* 1993.

across many different artistic practices in Chapter 4, "Artists in the Realm of Historical Methods: The Sound, Smell, and Taste of History." This essay explores different ways that artists are engaged in historical methods and describes their efforts to involve viewers in the sensations and emotions of historical knowledge.

The third major idea in this volume posits select works of public art as public history, and advocates for the importance of staging conversations about history in public places. Art, we believe, has the power to reframe public debate about the past and to help us transform popular memories and histories. And many contemporary artists involve the public self-consciously as contributors and participants in their work. These artists envision new ways of generating dialogue and encouraging people to imagine "new forms of civic engagement constituted with, in, and through the body" (Springgay, 2008, p. 22), creating temporary installations or performances on street corners, on the sides of buildings, in store fronts. *The Freedom of Expression National Monument* (see Plates 1 and 2, in Insert, and Figures 7.1 and 7.2), for instance, invited passersby to literally "Step up and speak up!" into a giant megaphone, mounted across from the federal courthouse in downtown Manhattan. Krzysztof Wodiczko encouraged immigrants to use his interactive sculptures—*Alien Staff* and *Mouthpiece* (see Plates 9 and 10, in Insert, and Figures 8.9–8.11)—as a platform for telling stories about what it means to live as a migrant in the United States. Peggy Diggs set up a storefront on a commercial street in North Adams, Massachusetts, and invited local residents to visit and record the history of their personal relationship with local public spaces. She then created a work of art that told a story about the community's collective experiences (Figure 1.6). Because Diggs's contributors did not always agree about either the history or the significance of specific sites, this collaborative narrative told a history of North Adams that was marked with

Figure 1.6 Peggy Diggs, *Here & Then*, 2006.

enormous, and enormously revealing, tensions and contradictions.

By inviting public audiences to contribute to and activate their work, artists such as Diggs, Wodiczko, and the creators of the Freedom of Expression National Monument have begun to highlight the power of collective, public storytelling about history. Quite unlike either a traditional war monument or a gallery exhibition, their public artworks provoke dialogue about the meanings of the stories we tell (and don't tell), utilize diverse sites of public memory, and reimagine the possibilities for historically framed civic dialogue.

Of course public art is certainly not a new concept, nor is the use of dialogue and civic engagement. But the ways in which these artists aspire to involve the public directly often disrupt audience expectations, and suggest new models for teaching, and thinking about, both history and art with young people. The cultural theorist Irit Rogoff (2005) reminds us that today "works of art no longer simply present existing knowledge"; they also offer open-ended narratives and invite further research. By addressing the complexities of the past and its relation to the present, contemporary works of art prompt us to critically examine assumptions often made about the past, and to consider new ways of thinking about our relationship to historical events and ideas.

We examine questions about public art and public histories in Chapter 5 "Committing History in Public: Lessons from Artists Working in the Public Realm." We borrowed the phrase "committing history in public" from the historian Edward T. Linenthal (1994) not only to describe these artists' connections to public history, but to suggest the ways that artists offer counter-narratives, unsanctioned testimonies that are often unrecognized as valid sources. In this chapter we present excerpts from two conversations with artists: Greg Sholette and Krzysztof Wodiczko. In their work, both exemplify and make visible the idea that contemporary art can be, and has often been, a site of critical pedagogy and civic engagement, and a place where individuals can come together to reflect upon our collective memories and the meaning of the past. These artists are deeply engaged in historical debates, questions, writing, methods, and ideas. Their work, and the work of many of the artists discussed in this book, affirms that history is taught and learned in many different sites: classrooms, public squares, galleries, city streets, and perhaps even the experience of the works of art themselves.

We used each of these three ideas in our efforts to construct the book's second part, "Investigating History and Art: A Teaching Toolkit." Here, we offer an interdisciplinary set of resources, complete with practical suggestions for teaching select U.S history topics (the Constitution, Japanese incarceration, Slavery and Abolition, Immigration, Westward Expansion, and the U.S. war in Vietnam), meant to help both history teachers and art teachers use them in their pedagogical and classroom practice.

Opportunities for students to critically read and analyze these topics are based on select primary documents paired with provocative works of contemporary art. In Chapter 6, "Introduction to the Teaching Toolkits: Visual Approaches to Teaching about History," we foreground the use of these "mini-archives" with an overview of how the Teaching Toolkits materials featured in Chapters 7, 8, and 9 are organized, strategies for engaging students in broad-based discussion about works of art, and an introduction to a series of postmodern principles that artists employ in creating their work. We offer these principles as productive interpretive strategies for approaching the historic topics at hand. Visual methods such as juxtaposition, layering, borrowing, and integrating text

and image (Gude, 2004) open new avenues for teaching both history education and art education in schools. This introductory chapter anticipates the suggestions for actively engaging students in historically contextualized seeing, debating the meanings of the past, and producing written and visual responses to historical questions that inform the Teaching Connections materials included for each historical topic we present.

In addition to selecting the work of only living artists, we deliberately chose two-dimensional works (painting, prints, photography) and some three-dimensional works (sculptures, installation, and interactive, site-specific public works) that could effectively be used in a classroom context. Likewise, we intentionally chose not to include temporal media such as videos or performances because of the difficulties of effectively representing them in book form, and because introducing this kind of work in a classroom setting introduces a broad range of additional questions to which we could not adequately attend in a book of this sort. We did, however, include several site-specific performance and projection works that we felt that educators could productively bring into the classroom through still images. Most significantly, we chose work made by artists who are committed to inviting the unsuspecting passerby and other members of the public into a conversation about the meaning of history in contemporary life. Deeply connected to the ideals and practices of the best public historians, this work also opened up important critical spaces for the sort of social justice oriented education that this book is dedicated to inspiring in classrooms.

This book was never intended as a comprehensive collection of artworks related to history, or as a comprehensive approach to the U.S. history curriculum. Instead it is a focused effort to establish meaningful relationships between these two disciplines. Our research centered on artists who were engaged in debating the meaning of historical events and ideas, and who are producing works of art today that offer new ways of thinking about key topics and themes in United States history.

Because we believe that the best teaching and learning has to be flexible and based on the experiences students bring to the classroom, we do not provide prescriptive resources or an exhaustive set of models for teaching with history and contemporary art. Rather, the Teaching Toolkit section encourages teachers to design creative and provocative art and history lessons that suit their students, classrooms, and communities. All of the curricular ideas we pose invite students and teachers to consider and debate questions that unhinge historical issues and express their ideas visually and in writing as a way of forging new knowledge and new critical literacies. In this way, we have tried to emulate the work of those scholars, such as Herbert Kohl, who write about complicated but urgent ideas in ways that are useful to working teachers. We have, to quote Kohl (2005), "deliberately stuffed as much material into this guide" as we could, "with the confidence that teachers can pick and choose what is useful in their own programs, and will feel free to adjust, add, subtract, shape, and recreate what is provided here" (p. 80).

We have tried, in this book, to develop new methods for far-reaching interdisciplinary thinking and practice, both in the collaboration that grew up around the writing of the book itself and in the resources we include and draw from herein. This work, we know all too well, is very difficult. Not only do art educators and history educators speak profoundly different languages, and take divergent ideas, vocabularies, and assumptions for granted, they also labor under quite different pressures. In writing this book, we have encountered and wrestled with many of these differences. Despite the difficulties, we

are resolute in our belief in the importance of this sort of cross-disciplinary work, and in our desire to address more than one audience: to speak to both history and art teachers; to educators working at both the secondary and college levels; and to historians, artists, and scholars interested in new approaches to the relationship between visuality and history. Each of these audiences will come to this book with a different set of questions, practices, and desires. Our goal is to promote connections to themes, subjects, and teaching strategies beyond individual disciplines. We hope that for the most part, we speak in a language that members of each group can understand, and address questions relevant to their concerns and labors. We hope readers find suggestions that make immediate sense; we also hope that they encounter new ideas and conventions, and that they find a way to open their own practice and minds to these new visions.

How might you use this book? Read it straight through, or cherry pick. Read it for inspiration or for specific methodological ideas. Always adapt it to your needs and contexts. If you are a history teacher teaching in a school in which experimentation is discouraged, find those suggestions that look, at least outwardly, to be the least threatening to the standard practice of the history classroom. If you teach art and feel unprepared to confront all of the historical ideas presented here, focus on one chapter and build your confidence and knowledge in that area. Or do something else entirely. We hope you will come up with new ways to use our suggestions in the practical context of your classroom and your investigations.

REFERENCES

DeJarnette, K. G. (1997). The arts, language, and knowing: An experimental study of the potential of the visual arts for assessing academic learning by language minority students. Unpublished doctoral dissertation, University of California, Los Angeles.

Ellsworth, E. (2005). *Places of learning: Media, architecture, pedagogy.* New York: Routledge.

Giroux, H. (1994). Borderline artists, cultural workers, and the crisis of democracy. In C. Becker & A. Wiens (Eds.), *The artist in society: Rights, roles, and responsibilities* (pp. 4–14). Chicago: New Art Examiner Press.

Gude, O. (2004). Postmodern principles, in search of a 21st century art education. *Art Education, 57*(1), 6–14.

Heath, S. B., Stanford University, and Carnegie Foundation for the Advancement of Teaching. (1998). *Living the Arts through Language + Learning: A Report on Community-based Youth Organizations.* Americans for the Arts Monograph.

Kohl, H. (2005). *She would not be moved: How we tell the story of Rosa Parks and the Montgomery bus boycott.* New York: New Press.

Linenthal, E. T. (1994). Committing history in public. *Journal of American History, 81,* 986–991.

Mirzoeff, N. (1999). *Introduction to visual culture.* London: Routledge.

Rogoff, I. (2005). *Engendering terror.* Retrieved November 7, 2006, from http://mediageographies. blogspot.com/2005/08/irit-rogoff-engendering-terror.html

Springgay, S. (2008). Corporeal pedagogy and contemporary video art. *Art Education, 61*(2), 18–24

Walker, K. (interviewee), Combs, M. (interviewer). (2007). Artist forces racism out of the shadows. Retrieved February 4, 2009, from National Public Radio audio file from April 4, 2007, http://www. npr.org/templates/story/story.php?storyId=7898752

White, H. (2002). Foreword. In R. Koselleck, *The practice of conceptual history: Timing history, spacing concepts* (pp. ix–xiv). Palo Alto: Sanford University Press.

Using Visual Historical Methods in K–12 Classroom

Tactical Heuristics

Rachel Mattson

> Heuristic. (Adjective.) "Enabling a person to discover or learn something for themselves."
>
> Tactic. (Noun.) "A plan, procedure, or expedient for promoting a desired end or result."
>
> (*Random House Unabridged Dictionary*, 2009)

I have, spread out before me, a stack of Xeroxed photographs, and notes (neatly arranged by topic and date, in file folders), and also several—many—books. The books come in three main types. First, there are the historical accounts—books written by historians, on the subject of particular, already long gone, moments: the age of imperialism, the American Civil War, the 1920s. Second, there are the photograph collections: one book, for instance, collects photographs taken by Charles Moore, during the Civil Rights movement; another depicts an array of women, from many different regions of the world, all wearing the veil; still another attempts to present, in chronological order, exemplary photographs from each decade of the twentieth century. Finally, there are books about education: essays on pedagogy and teaching strategies, first-person reflective-practitioner accounts, explorations of diverse teaching methodologies. Collectively, these texts are meant to help me arrange my thoughts about the sorts of interpretive methods that historians employ, and the ways in which they can and should be put to use, in visual ways, in middle and secondary history classrooms. They are meant to provide the raw material for my attempts to explore questions about visual knowledge and historical inquiry. But they appear to be having something of the opposite effect. The primary documents—rich with their depictions of individual and collective humanity at work and at rest—distract me, inviting me to drift off into memory and wonder; the scholarship, offering up various methodologies and diverse suggestions, overwhelms and disperses my focus.

More to the point, as I look at these texts and consider my notes, I can feel the wheels of my brain grinding with difficulty, as I try to align three different disciplines (that is, the fields of history, visual knowledge, and teacher education) that barely share a common vocabulary, or speed—much less a common purpose. Oddly, I realize, these are not disciplines that often get considered in the same breath; they're not disciplines that are entirely comfortable, despite their obvious connections, speaking to each other. And so, as I attempt to bring my understanding of these various endeavors into conversation with each other, I find myself with few models to draw from. Indeed, this is one of the reasons why I undertook to collaborate on this book: to address the very absence of texts that consider visual knowledge, historical thinking, and pedagogy all at once. One of the central purposes of this book, in my mind, is to create models for thinking about how to bridge and combine these distinct disciplines, and to make visible the logical ways that they can do so. By borrowing from and combining elements of each, we, the authors of this book, hope to find new ways to bring together the radical possibilities that lurk within both history and art education; to consider the civic possibilities contained within visual, pedagogical, and historical languages; and to propose a model for integrating complicated historical pedagogies with visual art making and interpretation. The unrest that I feel as I look at the books arrayed around my desk is, I have come to realize, suggestive of the deep divisions that mark both the theory and the practice of teaching history and art at both the K–12 and the university levels.

As a university-trained historian who has spent much of the past six years working with New York City and New York State public school teachers (and administrators) to improve history instruction at the elementary, middle, and secondary levels, I have encountered these divides at close range. On one hand, you could say that they originate at the university level, where, although the past several decades have seen a blossoming of interdisciplinary collaborations, real separations still remain between the arts and the humanities. On the other hand, you could say that these gaps have also been maintained by the contemporary political climate that has surrounded K–12 public education for the past several decades. The combined power of federal and local instructional standards, popular theories of human development, and the particular model that dominates teacher training programs in this country has, in many cases, created a model for K–12 history education that leans predominantly toward getting students to master a certain (ostensibly limited, fixed, and predetermined) number of facts.

This will not come as news to anyone who teaches, or studies the teaching of, history at the "precollegiate" level. A wide range of scholars have extensively documented this problem; and growing numbers of teachers and teacher educators have developed methods for teaching against this pedagogical model, creating methods that more closely parallel those of professional historians, who place a premium on *knowledge organization* and *critical thinking*. Among these are such scholars as Peter Stearns, Peter Seixas, Bruce Van Sledright, and Herbert Kohl, each of whom has deepened our ability to understand and counteract the myth-and-fact-based educational model; the individuals behind the American Social History Project and the Center for History and New Media, who provide an indispensable—and ever-growing—set of digital resources for critical historical inquiry; Douglas Selwyn and Jan Maher, David Kobrin, and Myra Zarnowski, who have developed practical resources for doing this work under the constraints of the secondary classroom; and Joel Kahne and Joel Westheimer, who have written powerfully about the possibility of civically oriented social justice history education.

Perhaps most emblematic and far-reaching of the scholarship that inquires into the teaching and learning of history is the work of the educational psychologist Samuel Wineburg. In addition to developing a language and a set of strategies for translating the methods of professional historians for use in K–12 classrooms, Wineburg has also considered the costs of our reliance of fact-oriented precollegiate history instruction. Focusing on fact memorization at the K–12 level, he argues, not only serves *not* to prepare students for success at the college level, but also short-changes them of some of the fundamental literacies that they will need as they develop into adult citizens and democratic participants. This model of education fails to instruct students especially in the important skill of thinking and reading critically: of questioning what they read, of wondering about the author or "source" of a text, of asking questions about the agendas and subjectivity of creators of primary documents. In this respect, Wineburg's and his colleagues' work aligns quite nicely with the work of conventional professional historians. Historians almost universally understand historical inquiry to be an art—a philosophical endeavor addressed to big questions about humanity's political, economic, cultural, and social struggles—and not a science or an exercise in fact memorization.

Moreover, Wineburg suggests that this focus, on facts rather than sourcing or historical thinking, means that we are failing to prepare our nation's youth to actively participate in the mechanisms of democracy. Knowing a collection of facts in isolation prepares students, at best, for answering a few multiple choice questions, Wineburg writes. But "knowing how to read and think" serves as "a survival kit for democratic life," enabling students "to confront the written world as an empowered agent, not a passive consumer" (Wineburg, 2005, p. 662). Other scholars concur with this idea, and build outward from it. "Democracy won't run on autopilot," Joseph Kahne and Joel Westheimer (2003) write, "and making democracy work requires that schools . . . educate and nurture engaged and informed democratic citizens" (p. 66).

This work, and the work of the other teachers and scholars who have labored to make the history classroom a place for asking questions and developing arguments about meaning, is critically important. But there is a glaring absence in this literature. It almost uniformly leaves aside questions of creative thinking, visual knowledge, and art. Although it does not appear to be malicious or deliberate, this absence is hardly benign. Current trends in educational policy have deliberately placed art education, and instruction in creative thinking, on the sidelines. And yet, problems requiring creative solutions pile up around us; research documenting the import of arts-based education for both personal and societal development mounts; and the world in which we—and our students—live grows increasingly visual all the time (Arts Education Partnership, 2002, 2006; Eisner, 2002; Jensen, 2001).

Historians and teachers committed to prioritizing the teaching of historical thinking skills should be especially concerned about these absences, since our efforts to teach critical historical thinking skills rely on our being able to teach our students to use their imaginations to envision new worlds. If we do not learn how to integrate visual languages and meanings into the complicated practice of the historical method, then we also lose important opportunities to connect with our students, and to help them translate their ideas about the very visual world they live in into textual language and thought.

But how to do this? How to integrate concern with visual knowledge into our efforts to teach young people to think historically? These questions lie at the center of this essay. Considering the work of a range of cultural historians, visual theorists, and scholars

of teaching and learning, I explore the possibility of putting questions about visual knowledge at the center of historical inquiry and history education. What methods, I ask, to be specific, might help us develop a way to critically read the historical arguments and interventions that contemporary artists are making today?

THE CONVENTIONAL HISTORICAL METHOD

Before I get anywhere near questions about visual knowledge, however, let me set out the standard principles that guide historical inquiry, and inquiry-based history education. At their best, history and social studies classrooms function as laboratories: sites where teachers can help their students develop analytical skills, and teach them to read text and image with a critical eye; to ask smart questions; and to wonder about the meaning and uses of the past. The task of a history teacher, after all, is not simply to teach skills and facts or to prepare students for standardized tests, but also to help students develop intellectual habits of mind that will enable them to reflect upon their lives and their world in which they live, as well as to face down the big challenges that they will encounter as adult residents of a democracy. In order to do this, students need to learn to think historically.

Generally speaking, according to conventional wisdom and scholarship, teaching young people to think historically is a three-part process. First, students must learn to frame historical questions; second, they must learn to find and critically read primary source documents; and third, they must begin to engage broader debates about the meaning of the past and form opinions of their own about these histories (Bain, 2005; Holt, 1990; VanSledright, 2002).

Framing and Identifying Exciting Historical Questions

Why is there no socialism in the United States? How did Jews become white? Did slavery cause racism or did racism cause slavery? Historical questions are like hooks, meant to define a subject, raise the stakes of investigation, pique interest, and organize information into viewable chunks. For history teachers, the frame of a provocative question offers enormous advantages. Not only does teaching about the past through questions encourage students to think of history as a set of debates instead of a list of facts, it also has the power to highlight the contemporary relevance of history. Good provocative historical questions can generate debate, inspire curiosity and investigation, and tap into controversies that young people are likely to care about. But framing a good question does not mean that you will get a clear answer to it. Indeed, getting students to frame and seek answers to provocative questions—about the meaning of historical events or primary documents, about how humans or Americans or others remember and misremember the past—accomplishes a great deal in and of itself, even in the absence of a firm answer. It trains students to think and read critically; it teaches them to see history as a set of debates about the nature of the world; and perhaps most important, it helps them practice the arts of *consideration* and *taking a stand*; arts that, you might say, are at the foundation of democratic citizenship and personal development.

Critically Reading Primary Source Documents

Of course, asking a solid historical question can get you only so far in the absence of source material. Thus, after framing a good question, one must confront the task of seeking out and interpreting primary source documents: "actual records that have survived from the past" (Library of Congress, 2002); the items that people living in the past placed their hands on—the writings they created, the snapshots that captured their image, presidential addresses, protest poems, personal diaries, local and national laws, newspaper articles, reports from public meetings, clothing, and so on. Using primary sources in the history classroom, and giving students the chance to look at the writings and possessions of those people whose lives they are studying, opens up provocative avenues for transformative education, for the development of critical reading skills, and (even) for student engagement with many of the specific facts that will appear on standardized tests. Meanwhile, looking at and working with original documents enables students to see events from multiple perspectives—that is, from the perspective of national leaders as well as ordinary people, slave holders and enslaved people, women and men, children and adults—and teaches students to read critically. It teaches students, then, to become accustomed to *not believing* everything they see in print and to develop their own opinions about ideas and events, and hopefully, to participate: in the mechanisms of U.S. democracy, in their communities, and the shaping of their own futures. Using a diversity of primary sources about one event, era, or historical topic also has the power to raise questions about who can legitimately tell stories about, and interpret the meanings of, U.S. pasts.

Still, the simple act of putting primary sources into students' hands does not guarantee the development of good critical and historical thinking skills. Using primary sources to promote critical reading and thinking skills, in the words of the educational scholar Robert Bain (2005):

> involves more than just finding information in sources; it requires that students pay attention to features within and outside of the text, such as who wrote the source, in what circumstances and context, with what language, and for what reasons.
>
> (p. 202)

Samuel Wineburg (2005) calls this interpretive strategy the "sourcing heuristic"—that is, "the practice of reading the source of the document before reading the actual text" (p. 76). Teachers who want to teach young people to think historically should additionally teach them to continue to deploy the sourcing heuristic throughout their encounter with any given primary document. Although most historians do not use the term "sourcing heuristic," they consistently deploy this method in their work. It is an integral part of learning to read and think historically. The chart that we are calling Figure 2.1 provides one model that historians and history educators have productively deployed in their efforts to structure this sort of close reading of primary sources.

Step one: DESCRIPTION

Describe the document.
What kind of document is it? What do you observe about it?

Does the document contain any clues that indicate when it was
created?

Does the document contain any clues that indicate where it was
created?

Can you tell who created the document?
And what do you know about that person/those people (based
either on your prior knowledge, or on information contained in
the document itself)?

For what purpose did this person create the document? (If you
don't know for sure, make an educated guess.)

Who was the intended audience of the document? (If you don't
know for sure, make an educated guess.)

Step Two: ANALYSIS

What opinion do you think the author of the document is trying
to convey?

What information does the document leave out? What are you
still curious about?

Figure 2.1 This chart offers one model for analyzing primary documents.

Making an Argument and Engaging in Debate

Finally, in order for any of this information to have deeper meaning beyond the specific
and local, teachers need to push students to see history not as a set of facts to be ingested,
but rather as a series of debates about the meaning of the past. Certainly students of
history and social studies should leave their classrooms knowing some facts, but they
should also leave the history classroom knowing how to take a position and defend it.
Debating the *meaning* that a collection of primary documents creates gives the enterprise
of historical inquiry coherence, and a significance beyond the page. Doing this also gives
students the tools to be critical, independent thinkers, able to interpret the world around
them.

These, then, are the primary elements of the conventional historical method. What
happens when we add questions about visual knowledge into this mix?

HISTORY'S "ANTI-OCULAR" BIAS AND THE PRO-OCULAR RESISTANCE

I am not the first to recognize, or lament, the apprehensiveness with which historians and history educators have approached questions of visual knowledge. While the world erupts around us in ways that are seemingly more visual every year, many historians barrel along apparently undisturbed, clinging fiercely to a belief in the primacy of the written word. The U.S. historian Joshua Brown calls this history's "anti-ocular" bias (Brown, 2003, 2004). Historians, Brown observes, have demonstrated a far-reaching "uneasiness in the presence of visual evidence," and an "innate bias in favor of the word (especially the written word)." As a result, they tend to treat visual sources "as a rubber stamp for their findings in text," or as "arresting but incomplete indications of something significant that they hope is documented in [the] more reliable medium" of written text (Brown, 2003, p. 5).

But it would be inaccurate to say that historians have entirely ignored visual sources or questions about visual meanings. Over the past several decades, a small, and growing, corpus of historians have begun to take visual questions seriously, wondering, on the one hand, if perhaps we might learn new things about the past through visual sources, and, on the other hand, if perhaps there might be some value in telling historical stories through visual means. Brown himself is one among many historians and history educators who have advocated, and begun to develop methods for, confronting and interpreting visual texts. Indeed, in addition to publishing traditional, text-based analyses of visual historical evidence, Brown, who holds the rare distinction of being both a university-trained historian and a professional artist, has also *illustrated* (that is, drawn images of) his ideas about history and visual ideas.

In one of these illustrations—a cartoon entitled "Great Moments in Labor History II: The Completion of the Transcontinental Railroad" (Figure 2.2)—Brown does a good job of introducing some of the central themes that have preoccupied those historians who are interested in thinking critically about the visual historical record, specifically photographs. A collage of imagery and historical critique, the cartoon features a reproduction of a well-known photograph taken the day the transcontinental railroad was officially "completed" in 1869. Brown has redrawn the scene of this famous photograph, and then superimposed over it another drawing of two additional figures who do not appear in the original image: the photographer who snapped the image of laborers gathered, that day, around the newly-laid railroad ties, and a historian from the twenty-first century. As we encounter them, these two figures are engaged in a fantastical conversation—or, more accurately, they are in the midst of a quarrel. "But if you don't point the camera in that direction," the twenty-first-century historian says, gesturing to the left side of the page, "you'll leave out the Chinese workers!" The photographer, hunched under the cloth apparatus of his camera, appears unperturbed. "Exactly!" he replies to the historian.

This cartoon introduces, in a visual way, several of the ideas that historians interested in photographs as historical sources have had over the years. As visual texts that were created in the past, scholars observe, photographs have enormous potential to fill in details about otherwise unreconstructable events, ideas, places, and lives from another era. But they are not transparent representations of the truth. They were created by human beings who made choices about what to photograph, and how to do so. Indeed,

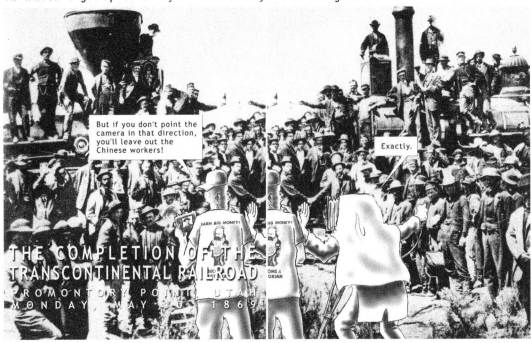

Figure 2.2 Joshua Brown
"Great Moments in Labor History II: The Completion of the Transcontinental Railroad." 2004.

even if we could travel back in time and speak directly to the recorders of historical events (as Brown's "twenty-first-century historian" figure does in "The Completion of the Transcontinental Railroad") we would not be able to extract from them an unbiased, neutral account. This goes against the popular idea that photographs can literally transport us back into the past. As Alan Trachtenberg (1995)—a historian who has studied, especially, the role of photography in creating national memories of the Civil War—has written, "The idea of the camera has so implanted itself that our very imagination of the past takes the snapshot as its notion of adequacy, the equivalent of *having been there*." Indeed, he continues, photographs seem to describe, in an unaffected way, "nothing less than reality itself" (p. 12). But photographs are as much statements of opinions about social reality as is any textual document. They provide critically important evidence about what happened long ago, but they deliver this information in ways that are ideological. Just like written primary source documents, they bear the mark of the ideas, beliefs, and desires of their creators, and they are full of silences and omissions. These silences in the visual and textual record, Brown reminds us, account for (among other things) the fact that most Americans have little idea that the labor of Chinese immigrants and Chinese Americans helped build the infrastructure of the modern U.S.

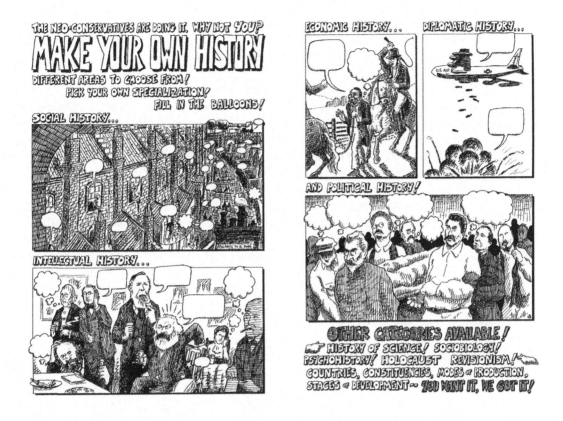

Figure 2.3 Joshua Brown
"Make Your Own History." Originally published in the *Radical History Review* 1981, 25 (1).

Brown's cartoon also introduces the idea that interpreting and teaching with visual documents requires careful consideration of interpretive method. On the one hand, interpreting visual evidence requires that we follow processes akin to the techniques that historians have long used to interpret textual documents (see, again, Figure 2.1, above). We must foreground, in our dealings with visual sources, the visual equivalent of Wineburg's "sourcing heuristic"—that is, questions about the person who created it, the audience to whom it was directed, and the context in which it was produced.

But reading photographs also requires additional interpretive mechanisms— mechanisms that will help us appreciate and take advantage of the *visualness* of visual sources (Burke 2001; Rosenstone, 1995; Szarkowski, 1966/2007; Wexler 2000). "To be able to use photographs as documents," the cultural theorists Marsha Peters and Bernard Mergen (1977) explain, "we must ask new questions" (p. 284). Perhaps most critically, these scholars recommend that we divide our interpretive strategies, here, into two broad categories: (a) those that address information contained "within the frame" of the photograph (What can we learn about the people, events, or objects represented in the image from what is contained within the photograph itself?) and (b) those that address information contained "outside the frame" of the photograph (In what context did this

image appear? What do we know about who took the image, and for what purpose? Toward what precise ends?). This idea has proven critically important to historians interested in learning about the past through historical images of various sorts, from documentary photographs to paintings.

To illustrate how this inside-the-frame/outside-the-frame analytical strategy works, let us look at it in practice. Among the historians who have deployed this interpretive rubric in their work is Laura Wexler, who drew heavily upon it in her history of gender, race, and photography in the nineteenth century, *Tender Violence: Domestic Visions in an Age of U.S. Imperialism* (2000). It is easy to see the effect of this kind of close reading in one section, for instance, where she endeavors to read a pair of photographs created by officials at a Native American boarding school in the late nineteenth century, the Hampton Normal and Agricultural School in Hampton, Virginia. The photographs are "Before" and "After" photographs of three young Native American girls. In her attempts to make sense of these photographs and their possible meanings, Wexler makes creative use of information she ascertains both "inside" and "outside" the frame of these two photographs.

She begins her inquiry with some simple description. First, she reads information contained "outside the frame" of the image, starting with the captions. Photograph number one, she observes, has been titled "On arrival at Hampton Va.: Carrie Anderson—12 yrs., Annie Dawson 10 yrs, and Sarah Walker—13 yrs." Photograph number two, "Fourteen months after." She then begins to look more closely at the first image. Combining the text of these captions with what she knows about the broader history of Native American boarding schools, Wexler (2000) can now say that the three girls have "just arrived at Hampton from out west for a term of education that, given the then current thinking of the Bureau of Indian Affairs, was likely to last for several years without respite or visits home." "At this point," she continues, again drawing on information she has gathered from information that lies outside of the photographic frame, "the three girls probably did not know how long they were likely to be separated from their families and the customs with which they were familiar . . . [and] it is quite possible that they were not able to understand a single word of English" (p. 109–110).

Then, although she reproduces the image for her readers to inspect themselves, Wexler states what she observes "inside the frame" of these photographs. "In the first image," she writes, "three little girls huddle close together. They sit on a bare tile floor and lean against a wall, keeping their plaid blankets gathered closely about them." They look "glum and fairly suspicious, if not exactly frightened of their new environment." Although "the smile had not yet" become standard in photographic portraits, "the deep, downward turn of the three small mouths is quite pronounced even in comparison to the stoic expressions commonly elicited in contemporary portraits of members of all races." The second image, Wexler notes, displays an image in which "much has changed and much has remained the same." Now, fourteen months after the initial image was shot, the three girls sit not on the floor, but rather "on chairs, around a table that holds a game of checkers" wearing new clothes: "tightly fitting Victorian dresses with lace collars [and] leather boots instead of their old soft moccasins." "It is obvious that all three have been carefully posed," she notes, and then, comparing this image to one from the original edition of *Alice in Wonderland*, she notes: "they replicate the exact ideal image of Victorian girlhood" (Wexler, 2000, p. 111).

It is only after completing this initial observation that Wexler begins making

suppositions about the meaning of these photos. The images were probably created to be used, in large part, as a promotional tool, she notes, and, as such, endeavor to demonstrate that even "savage" little girls can be educated to be "civilized' beings." But what do Carrie Anderson, Annie Dawson, and Sarah Walker think about their "transformation"? As Wexler reads the photograph, the three girls, "simultaneously collaborate with . . . and resist" both the official Hampton narrative about their transformation, and their U.S. government-sponsored education. In the second photograph, she explains, "their hands go where they are told, but the shoulders, heads, and eyes refuse the pantomime" (Wexler, 2000, p. 110–111). Wexler reads the girls' stances and expressions in this final photograph against the background of information from "outside the frame," including one particular fact that Wexler discovered through her archival research: that each of these girls had, nominally, at least, actually chosen to come to Hampton. She concludes that each girl was deeply ambivalent about her position. Having made the painful decision to come to this school, all three were nonetheless confused about how to make their way in the new world they lived in—a world that was now dominated by the ideologies of white supremacy and the political power of the U.S. government.

It is a testament to the power of Wexler's interpretive strategies, and especially her creative and thoughtful use of the inside-the-frame/outside-the-frame analytical rubric, that she manages to wring so much meaning out of these photos. And, finding evidence of three girls' feelings and thoughts, she also proposes new ways to understand the complex history of the resistance and suffering of Native people in the nineteenth century.

This work, and these ideas, bring us closer to understanding how we might teach young people to confront contemporary visual art as historical narrative. But all of the interpretive models discussed so far have approached the question of visual knowledge as a question about visual primary sources *from* the past, and have left aside questions about how to interpret *contemporary* visual narratives *about* the past. Can we translate these ideas for use with contemporary visual narratives? And how might we begin to read contemporary visual narratives for historical argument? How, moreover, might we use these ideas to develop methods for teaching students to think historically through contemporary art?

Although far fewer historians have taken up these questions, there are two historians who have quite exceptionally endeavored to confront the work of contemporary visual artists on visual terms, and to think about how to make sense of the visual contemporary historical narratives that surround us: Robert Rosenstone and Christopher Capozzola. Both historians suggest that we ought to see visual artists as capable of producing historical interpretations as complex and worthy of study as the textual interpretations produced by academic historians. Both also insist that if we are to derive meaning from visual historical narratives, we must not simply consider them as illustrations of written ideas.

Robert Rosenstone's (1995) work offers an important set of suggestions for the task of reading art for historical narrative and argument. A historian with a longstanding interest in understanding just exactly how historical films "challenge . . . our idea of history," Rosenstone has endeavored to create mechanisms for critically reading historical film as a visual form capable of making historical arguments in ways that historians are largely unfamiliar—and uncomfortable—with: that is, visually. In this work, Rosenstone asks not "[how does film] measure up to written history?" but rather, "what exactly happens

28.1942.7 Digital Image © 2003 MoMA, New York

Figure 2.4 Jacob Lawrence (1917–2000)
"*The Migration of the Negro*, Panel No. 14:
Among the social conditions that existed
which was partly the cause of the migration
was the injustice done to the Negroes in the
court," 1941.

to history when words are translated into images?" And "If it is true that the word
can do many things that images cannot, what about the reverse—don't images carry
ideas and information that cannot be handled by the word?" (Rosenstone, 1995, p. 4).
Rosenstone's analyses of these questions are remarkably creative, and offer a broad array
of ideas about what non-scholarly narratives offer to those of us interested in researching
and teaching history. Among the most important of these ideas is his insistence that, in
order to understand the historical ideas that visual narratives offer, we must consider
the "codes" and "conventions" of that visual media itself (Rosenstone, 1995, pp. 64–
70). These visual codes and conventions often "violate the norms of written history,"
Rosenstone observes. But "it is the historian's task," he continues, "to learn how to 'read'
this [visual] historical vocabulary" on its own terms.

Capozzola's work, especially his provocative writing about the work of the esteemed
African American painter Jacob Lawrence, complements Rosenstone's. Lawrence,
Capozzola argues, was not only a painter of historical themes but also an interpreter of
historical meanings. Indeed, we would do well to consider Lawrence a historian in his
own right. To illustrate this point, Capozzola focuses on Lawrence's famous series "The
Migration of the Negro" (1941; Figure 2.4 is a reproduction of one of the panels in this

series). In the first place, Capozzola notes, Lawrence did an extraordinary amount of research before making these paintings. Specifically, he "studied primary and secondary accounts of early twentieth-century African American migration, and interacted with the emerging Negro History movement that centered on Harlem's Schomburg Collection." Then he presented, in the paintings themselves, a set of historical arguments that actively challenged the historical interpretations of the history of black migration to the North that prevailed in his day. Stressing "the individual agency of African American migrants" and "the forbidding social, economic, and ideological structures that shaped" both the world they left behind and the new one they encountered up north, Lawrence challenged the idea, current in 1941, that the World War I era migration of African Americans to the North (traditionally called "The Great Migration") was uniformly "great" in any sense of the word. Reading intertextually between the imagery of the paintings and their captions, Capozzola argues that the series deftly "interweave[s] image and text" and, in the process, challenges our understanding of the past, and "makes us rethink what history is, who can tell its stories, and how they can be told" (2006, p. 294).

MOVING FROM "FREESTANDING LOOKING" TOWARD "HISTORICALLY CONTEXTUALIZED SEEING": IMPLICATIONS FOR TEACHING

> We hear it all the time: we're living in a visual culture. Nearly every day we're warned about the bad effects on children of much of what they see. Little or no thought, though, is directed to the benefits of positive visual stimulation . . . [of teaching students to] learn to look closely at visual images and think more consciously about what they see.
>
> (Ewald, 2002, pp. 7, 17)

The collective work of these cultural historians and visual theorists offers a great deal to those of us who wish to teach history through visual sources, and to those of us who want to use historical instruction to teach students to think critically about visual narratives. But, as anyone who has ever tried to teach history to seventeen-year-olds knows, it is one thing to use exciting strategies in one's own historical research. It is quite another matter to translate them into material that will work in the secondary classroom. Although young people might be, as the historian David Jaffee (2006) recently observed, "eager to look" at images, and able to offer deeply "suggestive readings" of them, they tend to have "difficulty integrating their insightful visual readings with contextual historical understanding" (p. 1378). So how can we translate the rubrics described above into methods that might guide our classroom practice? Jaffee himself offers one very good strategy: create structures that enable your students to read "intertextually"—that is, that enable your students to "move between historical, literary, and visual materials" as they attempt to interpret visual sources. And Jaffee's classroom experiments offer some critical observations and suggestions for any teacher who wishes to bring these complex but critically important ideas into the history classroom.

Specifically, Jaffee developed an instructional scaffold meant to help his students grow accustomed to doing so: a targeted, image-specific archive of additional text and images. In conjunction with assignments in which he asked students to pick a historical image— such as a painting of industrial workers from the early twentieth century—and interpret

it as historical evidence, Jaffee created a "mini-archive" of related material, and then placed it online where students could access it easily. "I wanted to push students away from *freestanding looking* and toward *historically contextualized seeing* of the visual evidence," he explains (Jaffee, 2006, p. 1378; my emphasis). (In fact, these sorts of "archives" need not be online; they could exist anywhere.) The point, Jaffee explains, is to provide students with the incentive to read images always in relationship to written text.

The work we have considered thus far suggests the contours of a provisional method—a method that we might productively put to use in teaching students to read contemporary art in a historical framework. Specifically, they offer at least five "tactical heuristics"—that is, interpretive devices—that can be deployed to help students and scholars alike read contemporary visual art for historical arguments. I borrow the term "heuristic" from Samuel Wineburg, who suggests that teaching students to think historically requires teaching them to use several different "heuristics," including the "sourcing heuristic" that I discussed at the outset of this essay. Although heuristic is neither a word that comes easily off the lips nor one that educators encounter too often, I have found it useful for describing a set of processes in which most educators already engage on a daily basis, and for organizing the methods that I want to propose for this work.

Indeed, Wineburg's own "sourcing heuristic" is first among the "tactical heuristics" that we might use in our efforts to read the historical arguments put forth in works of contemporary visual art. Whereas historians apply the "sourcing heuristic" chiefly in their work with primary documents, we might also use it, to critical effect, in our efforts to think about the historical arguments that visual artists make. When encountering a work of art, we should push our students to ask: Who created this work of art? Why? What ideas did they hope to convey? If they cannot answer these questions immediately, ask them to research and develop some answers to these questions before attempting to interpret the artwork.

Second is the inside-the-frame/outside-the-frame heuristic that Wexler deploys so capably in her reading of documentary photographs from the nineteenth century. Indeed, we might use Wexler's approach as a model for our investigations into history-engaged contemporary art. That is, we might start by simply describing what we can immediately see outside the frame: What is the title of the artwork? What other information accompanies the piece? And then move on to describing what we see inside the frame. What objects, setting, and personages are portrayed here? What sorts of materials did the artist choose to use in creating their work? What historical events does the image appear to depict or comment on? This is an effective way to slow down the viewing process, and get students to think about what they see inside the frame and what's happening, and what has happened, outside the frame.

The third heuristic draws from David Jaffee's (2006) observations about the importance of teaching students to read texts and images together. Students especially need to be provoked to read "intertexually"—that is, to read written sources that relate to the material contained within and outside the frame of the image. This can easily be accomplished with the aid of specially developed archives containing primary and secondary sources that relate to the subject of the work of art, the artist who created it, and the historical figures and events to which the work makes reference. Just as Jaffee's students' analysis of visual primary sources was deepened by reading images in relationship to texts, so will our readings of contemporary art be strengthened by cross-

referencing visual meanings with written texts. Teach students to cross-pollinate their observations of an image with information from other sources: historical documents, historical interpretations, other images they've seen on similar subjects.

The fourth heuristic orbits around the interpretive strategies that reside at the center of traditional historical inquiry, especially framing exciting historical questions, and making an argument and engaging in debate. That is to say, we must view the ideas put forth in contemporary artwork within the context of driving historical questions and debates. Consider, for instance, the series of paintings that Roger Shimomura based on the diary that his grandmother kept while she was a detainee at a U.S. "internment" camp for Japanese Americans. Shimomura titled this work *An American Diary*, and used in it visual quotations from popular mid-century American comics such as Dick Tracy (see Plate 4, in Insert). The paintings connect, quite clearly, to the deeply historical question "What is an American?"—a question that was also sharply at issue in the 1940s, when the U.S. government forcibly detained American citizens of Japanese heritage. Framing an inquiry into the meaning of Shimomura's series around the question "What is an American?" has the power to focus students observations and interpretations and gives a clear frame to (and raises the stakes of) their inquiry.

The fifth and final heuristic builds on Rosenstone and Capozzola's insights; it is the "visual codes and conventions" heuristic. As we inquire into contemporary visual art, historians and history educators need to step outside our comfortable humanities framework, and begin to consider visual creativity. What kinds of creative methods, ideas, and notions does the artist deploy? Why might they use, for instance, juxtaposition as a narrative method in their work? How do artists use this, and other methods, to shape an historical argument? Asking these sorts of questions will not only help structure critical readings of historically engaged artwork; it also will begin to provide space for students to develop their own creative minds. And creativity is surely the mark of a good historian, just as it is the mark of a good artist.

In the Teaching Toolkits that appear in the second half of this book, we have attempted to begin to offer some models for applying these heuristics. You will see that we do not suggest that you use each and every heuristic in every encounter with a work of contemporary art. Rather, we mix and match these strategies depending on our pedagogical goals.

CONTEMPORARY VISUAL ARTISTS AS HISTORIANS

[Few academic historians] seem willing to consider the possibility that [artists] may have as much right to think about the past as do historians . . . [But] language itself is only a convention for doing history—one that privileges certain elements: fact, analysis, linearity . . . History [could also] be a mode of thinking that utilizes elements other than the written word: . . . vision, feeling, montage.

(Rosenstone, 1995, 6–11)

For me, as a U.S. historian trained to think critically about the kinds of narratives that get told in both official and non-official spaces, putting on the lenses I had to adopt as a writer of this book was extremely revealing. Although I had already seen a great deal of the contemporary art that we include in this book before I began working on this project,

in books, newspapers, and posters, in galleries and museums, and on the street—and although I recognized that some of these artists were offering thoughtful arguments about the meaning of historical events—I never understood it as historical interpretation that could speak, in any workable way, to written history. In truth, I was, as Rosenstone observes (above) about historians generally, unable to see them as interventions into the scholarly debates that they were, in fact, so clearly speaking to. Like other professional historians, I had been trained to think of historical argument as something that comes in the container of journal articles or book-length monographs—not as paper cut-outs or oil paintings or found-object sculptures; not hanging on the wall of a museum or an art gallery. But I have come to believe that many of these contemporary artists contribute enormously to our understanding of the past. Historians—and history educators—sacrifice a great deal by letting our formal biases limit our willingness to think critically about the historical interpretations that contemporary visual artists offer us.

To put it simply, there are a great number of contemporary artists who—much as Jacob Lawrence did in 1941—grapple with important historical questions in their work, and produce extremely astute, analytically provocative, well-researched visual analyses of the past and its meaning. We have been able to include only a small sampling of these works in this book—truly, there are piles and piles of other work, work we painfully had to exclude, collected in our files and on our flash drives. These artists, and the work they produce, offer fresh kinds of critical historical analysis about many of the same subjects with which professional historians are grappling—including the historical foundations of contemporary U.S. identities, the history of racial categories, popular U.S. memory of slavery, and the history and development of U.S. nationalisms, exceptionalisms, and empire. Certainly, the "language" contemporary visual artists use is distinct from the language that historians deploy; and the "codes" and "conventions" of which they make use indeed pose "a challenge to our idea of history."

Among other things, we propose in this volume that many of these contemporary artists should be considered historians in their own right. They conduct rigorous historical research, deploy critical analytical methods, engage with a range of scholarly debates, and present nuanced arguments about historical questions. Using found objects, pigment, and visual and embodied narrative strategies, they interrogate the ways in which we remember and make sense of the past. This growing corpus of contemporary artists who create history-engaged work address pressing historical questions and debates, and offer innovative interpretations of those questions and those debates; they challenge us to wrestle with visual narratives and languages; and they often present fresh approaches to well-worn methodological, narrative, and pedagogical problems.

Take, for instance, the work of the artist Fred Wilson. Wilson is best known for the 1992 exhibit called *Mining the Museum* that we mention in the introduction to this book, in which he repurposed objects from the permanent collection of the Maryland Historical Society to make a series of arguments about popular representations of African American and Native American histories. But in the years since he first mounted the *Mining the Museum* exhibit, Wilson has produced a wide range of other sculptural artworks that also tackle historical questions. Among my favorites is a found-image sculpture entitled "Mine/Yours." (Although we were not able to reproduce "Mine/Yours" in this volume, you can find a photograph of it online, at http://www.artsjournal.com/artopia/images/ yourssmall.jpg). Consisting of a framed photograph, a collection of kitsch dolls, and

stencils of the words "mine" and "yours," the sculpture inquires into contemporary popular memory of slavery and enslaved families. Under the heading of "Mine" Wilson presents a sepia-toned reproduction of a well-known photograph a family of enslaved Africans—mother, father, grandmother, grandfather, and four children—sitting and standing in front of their quarters. Next to this image, under the heading "Yours," Wilson presents an assemblage of kitsch porcelain statues, arranged in a way that mimics the familiar arrangement of the initial photograph. These statues are easily recognizable as what is sometimes called "racist kitsch": cookie jars and salt and pepper shakers in the shape of Aunt Jemima and Uncle Mose.

It is a striking image, and one that, using the heuristics suggested above, is not terribly difficult to read. First, using the sourcing heuristic, we learn that Wilson is a black man who was born in the Bronx, in 1954, and that this piece was made for a gallery show in New York City in the mid-1990s. Second, even though this work is three-dimensional—as opposed to two—and thus lacks a traditional "picture frame," we can still read the images contained inside something that acts like a "frame." This, indeed, is what I did in the previous paragraph. Then, looking outside the frame, we might learn that images of Mammy/Aunt Jemima, Uncle Mose, and the like proliferated in the years following the end of slavery, and continue to proliferate into the present day. We might also learn that porcelain statues of these images—the sort that Wilson uses in this sculpture—have become highly valued collectibles, fetching large sums of money on the antiques and vintage market. Wilson's Mine/Yours juxtaposition, additionally, seems to address a range of traditional historical questions and debates about memory that we might use to frame, or deepen, our inquiry here. How, he seems to be asking, does racial identity shape the way Americans make sense of the past? This is not only a provocative question that might compel young people into engagement and debate, it is also a question that has long gripped the interest of professional historians. Thus, it would be easy to find a great number of written texts that you might adapt and organize into an archive, to enable your students to read "intertextually," and to enable them to engage in "historically contextualized seeing."

What, then, do these interpretive devices help us to see? On one hand, Wilson seems to be suggesting that contemporary American pop culture has relied on, and reproduced, a clichéd and nostalgic, sanitized image of U.S. slavery. Whereas he ("Mine") remembers slave families as brutalized but dignified, other Americans ("Yours") have had their memories shaped by the image of, for instance, kitsch objects that make visible old stereotypes about African Americans and the happy slave. The piece also invites its viewers to wonder more generally about several of the central themes in U.S. history: memory; multiple perspectives; the historical and contemporary meanings of race in the U.S.; the uses and abuses of material culture, kitsch, and historical photographs; and the relationship between history, popular memory, and identity.

Although it is deeply linked to debates and questions into which professional historians and history educators have long inquired, "Mine/Yours" does not simply illustrate a set of arguments that historians have *already* made. Instead, it offers entirely new interpretations about the meaning that objects have in our life. Perhaps, it suggests, those objects transport into our lives ideologies that we like to think are long dead. It also offers new ideas about the attention we ought to pay to historical photographs. *Do we really understand what we see there?* And it suggests new ways to understand just how ideas

about the U.S. past might live, and get reproduced, in the lives and consciousnesses of diverse Americans.

Like "Mine/Yours," many of the pieces we feature in this volume open up unusual doorways for thinking about historical interpretation and ask a fresh set of deeply historical questions that, I believe, have the power to provoke new historical insights, and new methods for teaching historical inquiry to young people. Kara Walker's work, for instance, asks, among other things, "Why do we remember the antebellum South as a genteel place?" An-My Lê asks, "Why do people reenact traumatic historical events, such as war?" Jenny Holzer asks, "What is the difference between a painting and a historical document?" and "How can we fight against the official abuse of constitutional power?" Jaune Quick-to-See Smith asks "Who gets to determine what's valuable?" and "How has U.S. popular culture erased the complexity of Native histories?" Glenn Ligon asks, "How do nineteenth-century ideas about race linger in contemporary U.S. life?" The *Freedom of Expression National Monument* asks, "How loud do you have to speak to be heard by the government in this country?" These works of art also ask us, the viewer, to do things that written inquiry cannot—for instance, to engage our physical bodies in historical inquiry. Some also point out the ways that even a knickknack can make a historical argument. Others prompt us to wonder in new ways about how historical memory shapes contemporary politics.

Historians and history educators can only benefit from examining the historical arguments that artists are making and the historical stories they are telling. Moreover, if we can teach students to read the historical arguments that contemporary visual artists are making, then we stand a chance of opening up, for them, the idea of what a historical narrative, or a historical argument, might be. We stand a chance, also of helping them find new pathways into engagement with historical questions, new avenues of explorations, and new relevance for otherwise difficult-to-engage historical ideas. And because this work is visual—often arrestingly so—it holds out the possibility of making complicated historical ideas accessible even to those students who are still struggling to read. And it also suggests a range of new methods and ideas that history educators might deploy in an effort to provoke debate about the meaning of the past—among ourselves and with our students.

Visually oriented history methods will not, of course, offer an easy, quick-fix, magic bullet for the troubles plaguing the nation's public school curricula. Even though the ideas we present herein are easy to align with state and federal history and art standards, they can be effective tools in our efforts to teach toward justice only if practiced in the context of radical school reform, student-centered learning methods, and critical teacher reflection. The work of teaching young people to think historically and visually is difficult work that requires above all, I think, teachers who maintain an interest in their students' lives, in constantly learning new things, and who have supportive and collaborative networks that help them through when the going gets tough (as it inevitably does), in addition to reflective, supportive administrators and access to resources. But visual approaches to history education do open up new opportunities for engaging students, and there is a great deal at stake here: learning to think historically, and critically, about visual narratives has the power to prepare young people to be critical and engaged adult citizens and reflective human beings in a world that is increasingly shaped and lived through visual media.

REFERENCES

Arts Education Partnership. (2002). *Critical links: Learning in the arts and student academic and social development*. Retrieved December 12, 2008, from http://www.aep-arts.org/publications

Arts Education Partnership. (2006). *Critical evidence: How the arts benefit student achievement*. Retrieved February 12, 2009, from http://www.aep-arts.org/publications

Bain, R. (2005). 'They thought the world was flat?': Applying the principles of *How People Learn* in teaching high school history. In John Bransford and Suzanne Donovan (Eds.), *How students learn history, mathematics, and science in the classroom* (pp. 179–215). Washington, DC: National Academies Press.

Brown, B. (2003). Toward a meeting of the minds: Historians and art historians. *American Art, 17*(2), 4–9.

Brown, J. (2004). History and the Web, from the illustrated newspaper to cyberspace: Visual technologies and interaction in the nineteenth and twenty-first centuries. *Rethinking History, 8*(2), 253–275.

Burke, P. (2001). *Eyewitnessing: The uses of images as historical evidence*. Ithaca, NY: Cornell University Press.

Capozzola, C. (2006). Jacob Lawrence: Historian. *Rethinking History, 10*(2), 291–295.

Eisner, E. (2002). *The arts and the creation of mind*. New Haven, CT: Yale University Press.

Ewald, W. (2002). *I wanna take me a picture: Teaching photography and writing to children*. Boston: Beacon Press.

Holt, T. C. (1990). *Thinking historically: Narrative, imagination, and understanding*. New York: College Board.

Jaffee, D. (2006). Thinking visually as historians: Incorporating visual methods. *Journal of American History, 92*(4), 1378–1382.

Jensen, E. (2001). *Arts with the brain in mind*. Alexandria, VA: Association for Supervision and Curriculum Development.

Kahne, J., & Westheimer, J. (2003). Teaching democracy: What schools need to do. *Phi Delta Kappan, 85*(1), 34–66.

Library of Congress. (2002). *American Memory* website. Retrieved July 31, 2009, from http://memory.loc.gov/learn/lessons/psources/source.html.

Peters, M., & Mergen, B. (1977). 'Doing the rest': The uses of photographs in American studies. *American Quarterly, 29*(3), 280–303.

Random House. (2006). *Unabridged Dictionary*. New York: Random House.

Rosenstone, R. (1995). *Visions of the past: The challenge of film to our idea of history*. Boston: Harvard University Press.

Szarkowski, J. (1966/2007). *The photographer's eye*. New York: Museum of Modern Art.

Trachtenberg, A. (1989). *Reading American photographs: Images as history, Matthew Brady to Walker Evans*. New York: Hill and Wang.

Van Sledright, B. (2002). *In search of America's past: Learning to read history in elementary school*. New York: Teachers College Press.

Wexler, L. (2000). *Tender violence: Domestic visions in an age of U.S. imperialism*. Chapel Hill: University of North Carolina Press.

Wineburg, S. (2005). What does NCATE have to say to future history teachers? *Not much. Phi Delta Kappan, 86*(9), 658–665.

CHAPTER 3

Curriculum as a Creative Process
Interview with Artist-Educator Thi Bui

Dipti Desai

Designing a history or art curriculum is a creative process that requires teachers to use their imagination to connect and relate ideas to the lives of their students. Enacting their curriculum, as all teachers know, requires not only good interpretative strategies, but also creative pedagogical strategies that support critical thinking and the visualization of new ideas. What would such a lesson or unit look like?

We were drawn to the classroom practice of Thi Bui, a teacher who regularly combines both history and art in her classroom. She feels her interdisciplinary approach allows for embodied understanding of both historical and artistic concepts. By continuously weaving connections between the past and present through popular culture, she helps her students empathize with the people they study from the past.

Bui provides lessons from the field that speak to one of the central arguments we make in this book: historical arguments can be made through art, and artistic explorations can be made through history. I began an email conversation in April 2004 with Thi Bui about her teaching practice, which combines social studies and art, and how that has influenced her own art making.

Thi Bui is an artist and social studies/history teacher whose work in the classroom draws on both areas of study. She began her teaching career in New York City at the High School of Telecommunication Arts and Technology and currently works as a teacher of history, art, and reading in a new public school for recent immigrants called Oakland International High School in California. Thi has exhibited her artwork widely and is currently working on a graphic novel about her family history in relation to the war in Vietnam.

Thi, could you tell us about your teaching? How do you bring together history and art in your classroom?

I started teaching full-time in 2003 at a public high school in Bay Ridge, Brooklyn. I was hired as a social studies teacher and given art classes, so I had to try very hard to cover content in both subjects. I had to pay more attention to how I covered social studies, of

course, because in New York, ninth and tenth graders are supposed to learn the history of humankind from the hominids to today, in chronological order . . . which is a crazy thing. The nerd in me couldn't live with doing the easy thing, which would have been to make up "fun" art projects that imitated the style of the culture and time period being studied. Like Egyptian papyrus, or Japanese fans, or any number of essentialist projects that art teachers have been known to do. I didn't like that my students were studying ancient history from Africa, Asia, and South America for a year and a half before they had any decent exposure to current events or twentieth-century world history. I thought it reinforced the notion that only people in America and other Western countries are modern, and that everyone else is stuck in the far-off past. So I did hardly any art history linked to countries, unless it was related to a theme I was working with. There was so much I wanted to bring together in my classes. I would stare at my bookshelf and images I'd collected and try to find the connecting theme that made me love them all. Then, I would write a curriculum around Jungian archetypes and tie it to Paleolithic hunter-gatherers shifting into new roles in civilization, or the state of being on the move, and we would learn about nomadic peoples, build model yurts and invent new mobile homes, discuss the downsides of tourism or the exhilaration of travel and the problems with romanticizing lifestyles that are not our own.

The ninth grade Global History class began with Neanderthals and Cro-Magnons, so in my Global Art class, I showed an old movie called *Quest for Fire*. It's about a band of Cro-Magnons who, in a raid by some hostile Neanderthals, lose their fire and have to send two of their men to go look for another. It's great about showing how early humans might have lived – not just what they ate or wore but what their motivations, fears, and worldviews might have been. And it shows them as individuals who play unique roles in their communities. There's also an establishing shot or scene at the beginning that is sexualized. It's my first year teaching and I have 35 ninth graders screaming and giggling at this, when in the door walks four suits: my principal, assistant principal, and two visiting principals. I thought I would get in very deep first-year teacher trouble, but to my surprise, my assistant principal, on his way out, leaned over and whispered, "I love this movie! I show it to my class every year."

Anyway, I followed the movie with images and lessons about various cave paintings. I bought several jars of earth pigments, and with help from Art Guerra, who has a paint store in the Lower East Side of Manhattan, taught the kids how to mix their own paint and understand the properties of pigments, solutions, binders, and additives in paint. I pointed out, because one always has to point out the obvious, that there were no paint stores twenty thousand years ago, and that people would have had to figure out very good mixtures to make paintings that lasted till today. The kids painted studies of cave painting details that I printed out and put in sheet protectors, and learned about writing captions with the information about the location and date of each painting. I gave them a homework assignment to do another cave painting study using whatever non-art materials they could find at home, and many of these were the most creative and beautiful drawings they produced! Mom's make-up, ketchup, spices, dirt . . . they would pull these homeworks out of their backpacks and pieces of dark stuff would be crumbling off and getting everywhere, and they would complain about how they got in trouble for using their mom's favorite lipstick. It was a lot of fun for me. I think in my second year doing this curriculum, I demonstrated how underground caves are formed,

using baking soda and vinegar. Then I showed how deep in these tunnels some of the paintings are made, and asked students to hypothesize why they were made in places that were both hard for the artists to get to, and out of the way for other people to see.

Every lesson was meant to reinforce the students' ability to empathize with primitive people, which is actually not very hard for young people. All I had to do was get them to come up with all the different roles that would have existed in a tribe of hunter-gatherers. There would have been a leader, a hunter, a warrior, a gatherer, a caretaker, possibly a spiritual leader or an artist, a teacher . . . each bringing an important and specific contribution to the tribe.

This is when I introduced Carl Jung. I gave the students readings from *Introducing Jung*, which is a very accessible graphic novel from the Introducing series published in the UK. Jung's idea that we each carry within us an archetype, or unconscious, pre-existent disposition to be the way we are, enabled the students to take their empathy with early humans to another, more personal level. They could identify themselves as a leader, a hunter, a warrior, a gatherer, a caretaker, a spiritual leader or an artist, a teacher . . . each bringing an important and specific contribution to the world.

I gave them each a 9 12 inch canvas and had them paint self-portraits, giving them a prompt to imagine a dream in which they meet their archetype in three different time periods. To help them, I showed them an episode of the TV show *Buffy the Vampire Slayer*, which is a personal favorite of mine. The show is full of archetypal images, as well as teenagers, rock music and demons. This particular episode has Buffy meeting her archetype, the First Slayer, in a surreal dream that bends space and time.

As they went on to study the rise of civilizations in history class and forgot all about the cave people, I asked them how they thought their archetype would have fared in a changing environment. The hunter, once a hero in the tribe, became less important as people learned to grow food and trade for their necessities. The skill sets and character strengths of the nomadic hunter-gatherer were not needed, and may not have even been appropriate in the new civilization. I'm not sure if I got through to them, but this reflection was meant to affirm my rowdy, academically challenged students. Many of them would have made great mammoth hunters, but in today's school environment, one does well by sitting politely at one's desk, listening to the teacher, working with abstract ideas – none of the things a hunter does well.

Spring semester came and my usual restlessness kicked in, thinking of the summer and where I might go. I put together a curriculum called "On the Move: a comparative study of nomads, tourists, travelers and wanderers." I started the unit by showing *Winged Migration*, a visually amazing documentary that follows migratory birds on their yearly journeys to reproduce and survive. The vistas were really appealing to city kids who saw concrete and buildings most of the time. We spent a long time studying Genghis Khan and the Mongols, because they had been covered in the history class and because, well . . . I loved learning about them. I experimented with different ways of representing what was remarkable about the Mongols. To demonstrate how Genghis Khan fought to unite the different tribes of the steppe into one Mongol identity, I divided the class into different tribes of Brooklyn. We played a make-believe game for two days. I said it was a post-apocalyptic Brooklyn fifty years in the future, and each tribe had to stay alive in a hostile environment where tribes competed for limited resources. The kids really got into it and were so inventive; I didn't have to do much besides be a sort of Dungeon

Master, serving as a storyteller and referee. Whenever someone came up with a detail that resembled something in Genghis Khan's life, I would use it as a teaching moment to tell them about him.

Sometimes I made tenuous connections, which made sense to some and not to others. I gave a reading that described in detail how a Mongol migration was organized, and then I showed them Mondrian's painting *Broadway Boogie Woogie* and pointed out how one could imagine the grid of New York city and the flashing lights and yellow cabs of Broadway in his very abstract system of yellow, blue, red and white shapes and lines. Then I asked them to visually represent a Mongol migration using such an abstract system, where a red rectangle might be an ox cart and a blue square might be a horse, etc.

A more successful parallel that I drew was between a Mongolian ger, or yurt [house], and a mobile home. I had kids redesign an old Volkswagen mobile home into the home of their dreams. They added modern conveniences like satellite dishes and TVs. I showed them modern-day Mongolian yurt that had stoves, radios, TVs, and a motorcycle parked outside. I gave them illustrated instructions to make a miniature ger and taught them to lash bamboo skewers together with string to build the frame of a ger. We used embroidery hoops for the roof, and sewed felt on for the cover. I brought in my camping tent, because I didn't have a real ger for us to try assembling, and had the kids time themselves to see who could pitch the tent the fastest. This was pretty funny with these city kids, most of whom had never been camping.

To teach about nomadism as an economically necessary way of life, though, required contrasting it with other states of being on the move, some of which are temporary and voluntary, even luxurious. I showed them a nineteenth-century woodprint by Hiroshige called *Travelers on a Mountain Pass at Night*. We talked about the people in the picture and how they might have felt. The students observed that the person who got to sit in the carriage was feeling a lot better than the two people who had to carry him or her. We also talked about the speed of traveling by foot, and what that might allow one to experience along the way. The students did ink and brush studies of how Hiroshige depicted the landscape.

Then I showed them Duane Hanson's sculpture *Tourists*. I asked them for visual cues as to why these people were tourists. I also asked the students what they liked to do when they visited new places. Almost all of them said they liked to collect souvenirs. So I asked them to do a modified version of Hiroshige's *Travelers*, and change them into tourists. I got some really great drawings with camera-toting, garbage-throwing tourists, some walking, but most riding a bus, on their way to a tourist attraction lit up with bright signs.

The last movie I showed was *Crouching Tiger, Hidden Dragon*, an epic kung fu love story in which one of the central characters is a spoiled young woman who leaves her family to lead the life of a traveling warrior. I asked them questions about her motivations, what she was trying to escape from, what she thought she was escaping to, and how the reality of it was different from what she expected. The students who were able to follow the story through the subtitles did great; the others had difficulty understanding the word *romanticize*. They got it confused with romance. When I asked if they had ever romanticized someone they really liked, and then found out they didn't really know the person for who they really were, this helped a little. But I wouldn't be surprised if some of my former students think that romanticizing someone is the same as romancing them.

Can you talk about one of your most successful moments/ projects/attempts to bring history education and art together in the classroom?

In terms of getting kids to really understand the significance of history, I think my Comics as Oral History class was one of my most successful attempts. Because they came up with their own ideas for their final project, which was a short graphic novel based on oral history research, they came at the history from a personal place. I had shown them some of my work and had them read *Maus* by Art Spiegelman, and *Persepolis* by Marjane Satrapi, so they were somewhat primed for it, but still I was surprised at how many of them chose to do projects rooted in historical events. One boy interviewed his father about the Cultural Revolution in China; another interviewed his grandmother about the Japanese invasion of Nanking. There were many stories of immigration, from Germany, the Dominican Republic, Trinidad . . . and stories of the

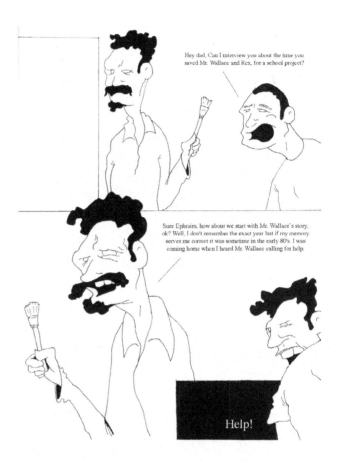

Figure 3.1 Comics as Oral History Project. Student artwork, by Ephraim Hafftka.

difficulties of life here—issues of violence, death, abuse, and also stories of everyday heroism, or stories that were just funny. I liked that the history trickled in through the making of the art. The students were so worried about whether they could draw and how many panels they would need and how to ink and so forth that they were less resistant to learning history.

The options are wide open when it comes to teaching how to draw comics, which is exciting and gives students with all kinds of different drawing styles a chance to shine. I said it was okay to draw stick figures, as long as you created a whole universe that was consistent with them, and two students really took this idea and ran. They each developed a very minimal, personal language that expressed the full range of human emotions. Others came with a preference for manga and some could draw really well. My job was to point out what they were doing that worked, and to help them develop a drawing style that was all their own.

This said, it was my first time teaching the class, and there are many things I would do differently if I were to teach it again.

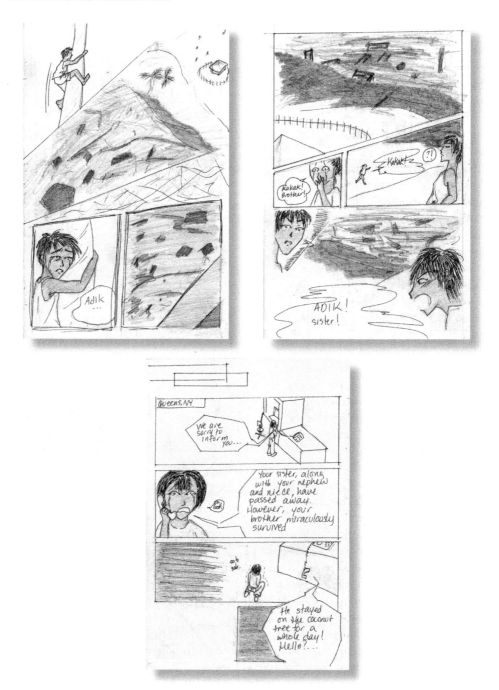

Figure 3.2–3.4 Comics as Oral History Project. Student artwork, by Sarah Rooney.

When a semester-long class ends with a final project as huge as an illustrated story based on oral history research, every week needs to feed into the skills and perceptive abilities of the students so that they have everything they need to do the job.

I think the categories I was more or less consciously working on were: drawing

style, character development, conflict, transitions, and speech. I assigned homework that required the students to work within given constraints to push their creativity. For example, the first lesson was a slide show of my research trip to Vietnam and the drawings I produced about them. The first homework was to draw a one-panel comic about me, based on something they had learned that day. I got back very observant comics about the things I love, which taught me about how I speak, and also some very funny ones about the difficulties of traveling while pregnant. (This is the class that watched my belly grow, and the one I missed for three weeks while on maternity leave.)

Another successful homework was one where I randomly assigned each student two constraints that they picked out of two bags. One constraint had to do with content, and the other was about form. So a student had to go home and think about what he could create, for example, with "a mysterious fire" and no dialogue. Or "a girl fight" and all the text in speech balloons.

I gave a few projects that they worked on in class. The first was to take an image and create it three different ways, using unlikely materials, as a way of loosening up and surprising oneself. I modeled the project by showing three drawings I did of a little boy, my friend's son, whom I had been looking at a lot trying to imagine what my baby would look like. The kids did great. The leaps of imagination that happened between versions were just beautiful to see. Version 1 would be a drawing of Mickey Mouse in pen on computer paper, and by Version 3, it was made of little shimmering staples on a canvas of dark blue denim. The first comic with all panels and ink was about a conflict. Another was about using collage. We looked at a lot of examples and constantly referred to Scott McCloud's book, *Understanding Comics*. The days spent working on these comics were about developing an idea from a rough draft to a finished project, practicing skills such as line variety and how to use a dip pen, and most importantly, showing one's work to others for critique. The kids really liked looking at each other's work, and I created a formal time and process for reading work and writing comments. I used a rubric so that it was clear what we were looking for, and averaged students' marks with my own when grading a project.

I wish I had been this specific with my requirements for the final project. Thinking too much like an artist, I wanted to leave the parameters wide open so that I wouldn't limit anyone's creativity. I had also never done this before with high school students and didn't know what to expect. But the fact is that the project itself was huge and possibly daunting without specific guidelines to help a student picture what their end product needed to look like. Looking back, I don't think it would have hurt to have had a page requirement. The project had to have margins and be inked, but I also could have required the use of several more techniques learned in class, such as a title box; a conflict; captions; lettering that expresses the speaker's emotions and diction; one part in color for impact; and three different kinds of transitions.

Having just come out of a master's final project based on oral history, I spent a lot of class time having my students go through an abbreviated version of the same formal process. They did a miniature literature review in the school library, where the librarian had ordered many of the graphic novels I suggested. They practiced listening and taking notes by attempting to write down all the lyrics of a rap song I played in class (*Butterfly* by The Digable Planets – a song about a girl who gets an abortion). They turned those notes into a comic, and we looked at all the different ways they had represented the same subject. They read *Maus* and *Persepolis* and answered reflection questions about

the content, the storytelling and the form. I thought these kids, for being teenagers who had never before thought about the ethics or significance of oral history, were very thoughtful in their conceptual understanding of the project. The project proposals they wrote me were full of wonderful ideas. I asked them to write a page describing three ideas, and I gave these back with detailed comments about which I thought would work best, or how to shape the project so that it encompassed all three ideas, and what to do next.

Perhaps if I had been there (and not away having a baby) while they worked on this project in class, I would have seen the pitfalls and been able to intervene successfully. But in terms of designing a good project, I would definitely go back and more clearly define the parameters of the project. I would also build in a midway deadline so that the students could workshop a draft in class before finishing it. They were very critical of each other, and having others read their work made them work harder at making their own ideas more clear.

How have you used popular media and contemporary sources in the history classroom?

The trouble with popular culture is that it moves so quickly, you can't use the same thing more than once or twice. If a movie is more than three years old, you can't talk about it with teenagers because they were only children when it came out. The upside is that if you happen to know something that just came out, just the very fact that you do is enough to get the class's attention. The moral is that, on top of being well-read intellectuals, teachers should keep entertainment magazines in the bathroom and surf the web for trashy gossip!

In my ninth grade Global Art classes, I used the Matrix movies for a few different purposes. The first was about creative license. Thirteen- and fourteen-year-olds tend to have very specific ideas about how things are supposed to look, and if by that age they haven't figured out how to draw realistically or just like the cartoons on TV, they don't want to draw at all. They'll censor each other, saying things like "Trees are brown and green, not purple, stupid." I wanted them to see that the piece of paper they were drawing on was just an illusory space, and that they could do whatever they wanted with it if they made up their own rules. I guess in retrospect I could have just said so, but I thought it was great fun to give a lecture on Baudrillard's *Simulacra and Simulation* instead. I likened Baudrillard's conception of the world to the idea of the Matrix being a complex set of illusions that machines, in the future, have created in order to keep humans sedated while they exploit us. The main character, Neo, comes to understand that the Matrix is not real, that the world he perceives is all in his mind, and just the knowledge of this gives him the power to change the illusion. Suddenly he is able to dodge bullets and jump through people, save humankind and get the girl. So, to my students from then on, trees can be purple, and what you put in a drawing can be what you want it to be as long as it is consistent in the mini-universe you have made.

I used *The Matrix* again to get my students in the library to research mythology and history. I gave them a list of characters and names from the Matrix movies—almost all of which have a historical or religious reference—and then had them find out the significance of the names. The librarian pulled encyclopedias and reference books for

us. Persephone, for example, is a female character in the movie who is married to a shady character named the Merovingian. We found out the story of Persephone from the Greek myth, and why it makes sense that the movie has the couple own a nightclub called Hades. For the Merovingian they had to look at Europe and early Christianity, and found references to a line of Frankish kings with mythical powers linked to their long hair.

I also showed "Kid's Story," one of the short animations on *The Animatrix*, which is a collection of peripheral stories that don't get told in the Matrix movies. This was a big hit with the kids. The class was working on an animation project about an ancient myth, and I needed them to make key frames for their storyboards. So I showed it twice. The first time was to get the story. The second time was to break down the story into plot points, and to identify each plot point with a key frame—the image that best described that part of the story. During the second viewing I paused the DVD whenever the kids identified a key frame, and forwarded or rewound it to compare frames, and I drew on the board thumbnail sketches of the key frames they all agreed on, so that we ended up with a ten-panel storyboard of the movie.

What the story was, was not so important. It could have been any movie that the kids were excited to watch. The great thing about using popular culture is that some kids are just so happy to get to watch something current in class, they'll go along with you on any crazy intellectual ride you want. For me, this was actually just a way to teach them a technical skill, because I wanted them to storyboard an animation of a myth that they had studied in English and history.

From the storyboard, they created dozens of frames that we took pictures of on my digital camera. They imported them into PowerPoint on a laptop that I borrowed from the principal, and then took turns working on the computer to make it look like animation. This took a long time! Many of them stayed long hours after school to finish, which showed how serious they were about the project.

I also had them choose songs for the myth animations. I asked them to bring CD players, music and headphones to class, which was against school rules and thus a major incentive for them to do it. I gave them time in class to listen to lyrics of songs they thought could work for their myth, and then change the lyrics to match the myth in small groups of three or four. With the help of two teachers who figured out how to use the old recording room in the school, some of the groups were able to sing their new lyrics on top of the existing music. Other groups that ran out of time just chose a really good song that had some connections to the myth, and used those. Because the animations were actually just really long PowerPoint slideshows, after the kids had their music ready, they were able to use the Rehearse function in PowerPoint to set the timing of the slideshow to the beat of the music. When we presented, I projected the slideshows and played the music from a boom box that I snuck out of my assistant principal's office.

What connections do you see between your work as a teacher and your work as an artist?

Teaching in a classroom is like having the pressure of a critique or workshop constantly over your head. It's thrilling and exhausting, but you get the constant interaction with young people that really forces you to be clear and passionate about what it is you're

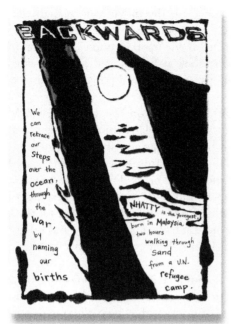
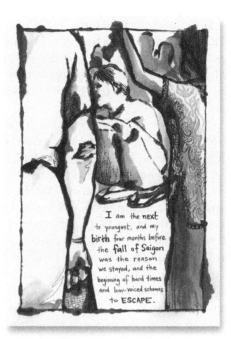
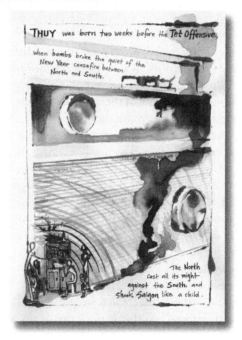

Figure 3.5–3.7 Thi Bui, *Backwards*, 2008. Pages of graphic novel.

saying. Coming up with curriculum is a very creative process—pulling from various sources and making unlikely connections, taking your audience through a series of steps that leads them to a discovery or a deeper understanding of something, making mistakes, constantly fine-tuning.

But the balance between teacher and artist is a hard one to maintain! Both are so time-consuming. And because I love the students and I love the art, both can be all-consuming and compete for my energy and time.

Teaching has made me more aware of audience in my work. I don't mean that now I will make all my work for young people. But there's a love and a sense of duty to communicate clearly in teaching that I would like to retain in my art. When I begin work on a new page for the graphic novel, I let the ideas run free. But when I go back and edit, everything has to have a purpose, to move the story forward, to express a complex emotion or reveal a subtext that is important—or else it gets cut out. Nothing is there just to be beautiful or decorative. The text and the visuals do different jobs, and if I feel like my words have sufficed to bring an image to mind, I won't draw that image.

The graphic novel is about my family and Vietnam, the two histories – how the events that shaped the country also affected who we are, from our deepest fears to our highest hopes. The idea came about partly from the dinnertime stories I grew up with and partly as a reaction to the awful Vietnam War movies I also grew up with. I wanted to make something that didn't shortchange the Vietnamese people but that wasn't patriotic or dogmatic about Vietnam either. So I ended up with an approach that is part autobiographical, part fiction, part historical research, part oral history, with a lot of creative license.

What's the role of research, and specifically historical research, in your artistic work and this graphic novel in particular?

Research satisfies the part of my brain that is verbal, analytical, and uptight about getting things right. I do a lot of historical research as a way, sometimes, of putting off getting to the work of creating something. It's most productive when I save it for the editing process, and then it can help make connections or unearth details that ground the work.

The graphic novel actually started as an oral history research project for my Masters in Art Education. The question that I posed in my Masters final project was: how can one compete with the dominance of American-centric perspectives in representations of the Vietnam War? The stance I am taking in writing what is becoming a very personal novel is that history *is* very personal. I want Vietnamese people to be protagonists and not just faceless victims who die. I want to show them as complete human beings who eat, sleep, go to the bathroom, have sex, love, fear, betray—so that if they die, or get hurt, you mourn them as if you loved them, and not just as an abstract symbol of tragedy. One of the connecting threads in the stories I've collected is the legacy of loss as it plays out in family relationships and through generations—how war shapes the structure of families, how, for example, wartime poverty rips a boy away from his mother and creates a rift that affects how he treats his wife, connects to his children, and behaves in the world.

There are volumes written on the Vietnam War by American scholars, but since I am looking for Vietnamese perspectives, I have to sift through another level of bias in books written by Vietnamese authors. The ones printed by small Vietnamese presses here tend to have a lot of strong anti-Communist, patriotic, or nostalgic anger getting in the way of good scholarship, and the ones that get here from Vietnam tend to have a suspicious party line motif running through them—lots of rhetoric about liberation and the American imperialists and so forth. So I read what I can and end up with more

questions than answers, but this gives me more specific questions to go back and ask my family. Questions about politics, such as who they wanted to be president, and whether they protested the war, or how it was to be South Vietnamese after the North Vietnamese victory.

Then I pare the details down to what is really necessary to the story. I find it fascinating that the Indochinese Communist Party convened in Vietnam in 1945, just days after the bombing of Hiroshima and Nagasaki, as though they had known those were the last days of the Japanese occupation, breathlessly waiting for the other shoe to drop. Cheering at the destruction of one superpower by another, and ready to pounce on the opportunity to declare a new government. But I don't know yet if these details fit in the final edit of the story of my father's childhood in the north. They infuse my portrayal of the land, and the circumstances of his childhood, but in the end my loyalty is to the telling of a personal story. Why? I don't want the historical details to cloud the direct line I am drawing between events that shaped the family. The novel is about how war affected us, but it is not about war itself.

What are the challenges of telling a family story (and/or specifically your family story) visually?

Well, I hope they'll still love me when it's done and out for everyone to see! There are things about your loved ones you don't tell people on a social level because it's just not cool, but when you're writing a book or making art, you suddenly feel compelled to paint a more complete portrait of them, warts and all, so that they come across as the real people they are.

To me, a story feels more alive when I can imagine being in the shoes of the person who is speaking. It is tempting to draw maps, use photographs, and illustrate the person doing the things they are talking about, but in the end too much of that can distance the reader from the storyteller. I am trying to visually connect the reader to the physical body that experienced the story, so I use images from memory to evoke what the speaker might have been seeing, hearing, or otherwise sensing while the events took place.

There are issues of language in the graphic novel that I haven't resolved yet. The names of people and places can be difficult for a person who doesn't read Vietnamese, but as someone close to them I don't want to change them for the sake of a stranger's comfort reading. There is also the issue of writing in the language of the dominant culture, to which I have no ready answers. I am hoping that the visual language of the book will be a unifying thread, one that helps you appreciate the human experience the same way no matter what your first language is.

CHAPTER 4

Artists in the Realm of Historical Methods

The Sound, Smell, and Taste of History

Dipti Desai and Jessica Hamlin

Billboards are ubiquitous in New York City. The newest form of the billboard, one that reflects the screen culture of the twenty-first century, is the digital billboard: a constantly evolving series of images, graphics, and animations that pulse rhythmically with consumer possibility. On a summer afternoon in Times Square 2006, an interesting rupture disturbed the flow of typical images selling perfumes, deodorants, shoes, and other luxury goods. Sandwiched in between images of impossibly beautiful models and shimmering lip gloss, pedestrians were confronted with a video of a man talking about organizing migrant farm workers. Small groups of people gathered to watch and listen as a man standing in front of a set of microphones solemnly described the importance of personal responsibility and providing youth with an alternative to violence. Was this a speech happening in real time? Who was this person speaking such powerful, almost familiar words? In fact, this video was part of a series of reenactments of protest speeches from the 1960s and 1970s called *The Port Huron Project* conceived by the artist Mark Tribe. Since 2006 Tribe has staged a series of six reenactments presented in the same locations where the original speeches were given. Tribe selects individuals to deliver the speeches to an audience of invited guests and passersby as a form of civic engagement. Each of these reenactments is documented using video and photography, then rebroadcast online, on select public screens such as the one in Times Square, and in exhibition spaces.

Although Tribe's work is self-described as art, did passers-by consider it as *art*? Can historical reenactment be a form of *art*? Without the parameters of a gallery or museum, can public art serve as public history? What are the assumptions we make about what art looks like, sounds like, and feels like, and how are artists currently pushing those assumptions in new directions, toward new artistic methods and models that allow us to look at history in new ways?

In conversations we have about art with family and friends, there is a common misunderstanding that artists spend most of their time alone in a studio producing objects that will ultimately find their way into museums or galleries. Given that most

art education practices in K–12 schools still follow a traditional studio-based pedagogical model—students working independently with a specific media towards a predetermined object or image—the idea that the artistic process is often inspired by a moment of deep insight that propels an artist to work furiously and determinedly in isolation until the piece is finished, or more specifically ready for sale, is understandable. Artists have been popularly identified as people with a "gift" or talent, a specialized set of skills that allows them to make desirable images and objects.

Throughout art history, artists have continuously expanded the methods, tools, and subjects informing their work, including breaking down perceived distinctions between art and life, as well as the seemingly isolated role of the artist in society. These interests have taken shape as an emphasis on conceptual or idea-based work over purely aesthetic work, an interest in initiating dialogue and debate with viewers rather than just delivering content to them, crossing disciplinary boundaries that have pushed art and artists out into the fields of anthropology, biology, philosophy, engineering, architecture, and, most importantly for the purposes of this book, history. Artists are increasingly taking on new roles and skills as they participate in these fields and generating new ways of understanding what visual art can be and do. Performing the roles of curators, ethnographers, archeologists, researchers, educators, and archivists many artists working today are border crossers who use their interest in the world of ideas to enter and draw from a wide range of fields and practices. More specifically, artists have begun to borrow historical methods and sources to inform their work. Reenactments such as *The Port Huron Project* offer one example of an interdisciplinary event where the artist plays the role of producer, researcher, documentarian, and community activist in their own right.

The deep divide between how art is conceived in the middle and high school art classroom and the contemporary art world is similar to the divide between history education at the middle/high school and university level. K–12 instruction in the arts tends to be medium- and technique-based—that is, organized around teaching students how to use different kinds of materials, such as acrylic paint or clay. In contrast to this, contemporary artists work across disciplines, engaging with different topics and methods to explore contemporary themes, ideas, and questions, including relationships to history. For those artists specifically interested in historic themes and events, the methods that they use to investigate the past are often similar to those employed by professional historians: mining archives for primary and secondary documents, conducting oral histories, and asking critical questions as part of the process of opening dialogue about the past and its relationship to the present. Some artists also make use of methods that amateur historians and ordinary citizens use, such as historical reenactment and autobiography—methods often dismissed by experts as not rigorous enough to engage with the past thoughtfully. But these methods also contribute a great deal to efforts to make sense of the past, and offer important strategies that teachers can use in their classrooms to encourage students to engage with history in a thoughtful, critical manner. In this essay we focus on a range of historical methods and practices that artists have begun to appropriate and reframe under the auspices of art.

EMBODYING HISTORY, CRITIQUING OBJECTIVITY, INTEGRATING NEW VOICES

As we looked at the work of artists in relation to the strategic use of archives, historical reenactment, oral history, autobiography and memoir, and photography we identified three primary contributions to historical research and subsequently the teaching of history. The artist projects we spent time researching offered much more than an illustrated or literal record of history. Instead, artists were involved in creating experiential work designed to involve multiple senses or more often, a physical relationship to stories and ideas about the past. Central to the work of many artists, and rarely considered by historians and history educators, is the multi-modal and emotional quality of the historical record. Many artists working with historical narratives, as well as non-historical material, explore the ways that viewers can participate more viscerally, can perhaps even embody the feelings, emotions, and experiences of an idea or event, whether past or present. We argue that this embodied way of knowing is crucial to learning about both history and art. A Western reliance on logic and reason and the notion that methods of inquiry must be based on observable, empirical, and measurable evidence has strongly influenced the ways that not only science, but history, mathematics, and most other categories of knowledge have been framed. Since its formal introduction in the late nineteenth century, the scientific method has served as the most accepted means of pursuing and establishing knowledge, one that privileges a neutral process of observation, data collection, and analysis. This method de-emphasizes an emotional stake in the process of pursuing knowledge, which is considered to cloud or corrupt otherwise pure information. Offering a divergent perspective, the feminist theorists Alison Jaggar and Susan Bordo (1989) among others have long argued that emotions are a useful and necessary way that we construct knowledge about the world and its history. As Alison Jaggar and Susan Bordo suggest:

> Just as observation directs, shapes, and partially defines emotions, so too emotion directs, shapes, and even partially defines observations. Observation is not simply a passive process of absorbing impressions or recording stimuli; instead, it is an activity of selection and interpretation. What is selected and how it is interpreted are influenced by emotional attitudes.
>
> (p. 154)

It is difficult to remain emotionally distant when viewing the work of Kara Walker, Ben Sakoguchi, or Martha Rosler. The provocative images that these artists produce can often feel unsettling, inspiring a visceral, physical reaction that pushes beyond a purely intellectual response. The work of these artists highlights the emotional texture of history that is often captured in historical novels and movies, but is largely missing from the way we teach history in schools.

The second contribution made by contemporary artists whose work addresses the people, places, and events of the past is their ability to reframe our understanding of historical research and its methods. Artists can challenge linear narratives of the past and the idea of "objective" representations of history. In particular, we were interested in artists who question how we speak about the past in terms of truth, subjectivity, and

authenticity, artists who are engaged in the "subversive function of art 'not to be politely absorbed but rather to challenge and disrupt' " (Becker in Garoian, 1999, p. 137). Artists such as Glenn Ligon open new ways of thinking about how we engage our students in the complexity of history: its multiple layers, contradictions, and tensions. These artists also offer tangible evidence that history is a subjective field of study, reflecting the unique perspectives, biases, opinions, and fallible memories of its authors.

The third significant contribution that contemporary artists offer to the historic record is their interest in seeking out unique perspectives and previously unheard voices often in the form of unrecognized individuals or communities. Artists are establishing new primary sources and create works that could be considered primary documents in their own right as they collect the stories of marginalized, unconsidered sources. We argue that the work of these artists, and specifically living artists, should be considered as secondary sources, and in some cases, as primary sources in historical research—that is, an interpretation of the past that merits the attention of other historians. And this raises new questions, such as: If we consider works of contemporary art as historical analysis in its own right, how does this challenge the way we think about what constitutes a primary or secondary document? How do art objects, including photographic images, reframe what we can learn through historical research? In short, we believe that contemporary art provides a space to imagine alternative historical methods and arguments.

These contributions suggest not only ways that artists are involved in the creation of historical knowledge, but strategies that can be applied to a classroom context. Informing our own thinking about the pedagogical approaches we present for investigating history in Part II, these ideas inspired our thinking about opportunities to create art that move beyond technical skills and into the realm of content, concept, and process, into new ways of thinking about the past that can help us make sense of the present. They also suggested important questions about how history is constructed and understood. We do not attempt to answer these questions, but pose them in relation to each artist as a series of provocations to explore. In what follows, we explore four historical methods used by contemporary artists: archive, oral history, historical reenactments and autobiography/ memoirs. These methods suggest not only relevant classroom practices for use with students, but opportunities to help students construct an emotional, embodied relationship to the past; to consider the voices and perspectives that are, and are not, included in the historic record; and to embark on a critical, investigatory journey into the events of the past that uses questions and debate to reframe their own understandings about history.

THE ARCHIVE

Recently, the archive has become a locus of investigation by contemporary artists, and a topic for art exhibitions, art books, and symposiums: *Archive Fever: Uses of the Document in Contemporary Art*, an exhibition of photographs by contemporary artists who use archival images in their work, presented at the Institute of Contemporary Photography in New York (Enwezor, 2008); *Deep Storage: Collecting, Storage, and Archiving in Art*, an exhibition and catalogue that looked at storage and archiving as imagery, first presented in Munich and then at P.S. 1 in New York City (Schaffner, 2008); *The Archive (Documents of Contemporary Art)* (Mereweather, 2006), an edited book of essays on archiving as a

concept and art practice, to name a few. These artistic investigations interpret, contest, redefine, and reinvent our understanding of archives, both their structures and their materials. Like historians, artists understand the archive as a collection of documents, images, or objects that contain a wealth of information about the past, as well as a physical space that houses these documents in order to collect, preserve, and store them. The artists highlighted here explore the archive as it shapes the way we construct meanings about the past. In addition, their work often refers to the idea that the archive serves as a representation of our historical memory. These artists assert that this site of history should be examined not only cognitively, but also physically, emotionally, and viscerally. Not surprisingly, many of the artists who reference the archive in their work use photography as their artistic medium—one that is also most commonly collected as archival material.

The impulse to analyze and critique the archive runs strong in the work of many artists whose work is located in historical methods or events. What is an archive? Who determines what materials are archival? What particular histories do archives tell? Conceived as powerful institutions that warrant creative criticism, the archive itself can serve as a space for critical and visual inquiry. Jenny Holzer's series of *Redaction Paintings* (2006), featured in Chapter 7 (see Figures 7.3–7.5), speak to these searching questions. As the basis of this series of silkscreened paintings, Holzer utilized government documents released through the Freedom of Information Act and available from the National Security Archives, as well as the archives of the FBI and American Civil Liberties Union. Holzer first photographed these obscured redacted documents, and then silkscreened them onto large canvases (Figure 4.1). In addition to creating large printed versions of the documents, Holzer also projected the documents onto the facades of urban buildings. In both versions, Holzer re-presents previously undisclosed documents to new publics, in and out of the art world. Holzer does not alter the original documents in any way other than through the transfer processes she uses. Simply by placing them in a new visual format, making them larger, and exhibiting them in new 'public' spaces, Holzer shifts the way these politically charged, highly obfuscated documents can be read. Intentionally opening and placing its questionable holdings on display is a brash

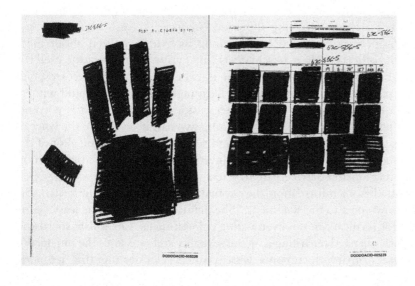

Figure 4.1 Jenny Holzer *Hand Yellow White* (detail, Panel 8 and Panel 9), 2006.

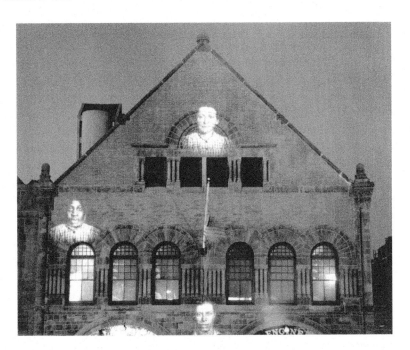

Figure 4.2 Shimon Attie, detail, *An Unusually Bad Lot*, 1999–2000.

act of protest. These documents could be considered primary historical sources, but the fact that most of the text is blacked out and illegible raises questions about the kind of history they actually represent. How do we read the history of this particular moment when the evidence has been erased?

The site-specific public work *An Unusually Bad Lot* by Shimon Attie (Figure 4.2) uses archival research to re-present the past from a contemporary vantage point, excavating hidden or forgotten histories in the process. Shimon Attie (1998) describes this form of excavation as "peeling back the wallpaper of today to reveal the histories buried underneath." *An Unusually Bad Lot* presents the history of a building: the former site of the Institute of Contemporary Art in Boston, which, before becoming a space dedicated to contemporary visual art in 1982, served as a police station and jail. Attie spent many months in the police archives studying thousands of pages of case files containing photographs of prisoners and other detainees along with texts written about these prisoners by arresting officers, judges, psychiatrists, and family members. Attie used the front facade of the building to present laser-written text choreographed to correspond with photographic portraits of former detainees. Each night, pedestrians could witness the former history of the site, as well as the different stories contained in the portraits and corresponding police descriptions. By juxtaposing two narratives—first, the voice of authority (the texts written about the prisoner) and second, the silent mug shot of the prisoner—*An Unusually Bad Lot* visualizes the archive in a new way. Attie's presentation asserts a particular relationship between archival text and image that suggests the often contrasting or contradictory information they contain. The image of a unremarkable young woman is shown next to the statement, "She did not seem to feel the least shame for being arrested for fornication, not even with a colored man." Obviously social and cultural attitudes have changed regarding issues of sexuality and race since the nineteenth century when these primary documents were created. Connecting this temporal

disjunction with the use of text and image suggests contradictory messages. Attie's work refocuses the viewer's attention on the kinds of histories that archives tell and the ways that different narratives shape our understanding of history. This juxtaposition creates a tension that has to be examined more closely in light of Amitava Kumar's (2000) insight that "to begin to see the contradictions is to become aware of history and therefore, of another relation that this history has with the present" (p. 26). If archives are the repositories of the official versions of history, whose stories get told through archives? Whose stories and what histories are missing from archives? How do we research the other narratives that are not recorded, that have no voice or advocate?

Not often considered by historians and scholars is the sensual experience of the archive. The sensual experience is what the collaborative team of Kate Ericson and Mel Ziegler focus on, specifically the most significant institution that preserves the official record of our national history: the National Archives. Ericson and Ziegler's work diverges from the idea that art is a purely visual experience and instead requires viewers to employ additional faculties; to experience other dimensions of history. In *The Smell and Taste of Things Remain*, exhibited in 1992, Ericson and Ziegler created an installation that literally invoked the smell of our nation's history. Upon walking into the exhibition space the viewer was greeted with the aroma of musty books and long-forgotten records—the antiquated scent of dust and age that we associate with history. At one end of the room an antique cabinet known as a "pie safe" stood open, revealing eighty amber-colored jars filled with a liquid that was crafted by the perfume designer Felix Buccellato to smell exactly like the National Archive in Washington, DC, that "imparts the collective heritage of the United States and its democratic ideals" (Weintraub, 1996, p. 214). By connecting an abstract concept such as history with a smell, Ericson and Ziegler suggest a collective way of locating our ideas about the past. They continue:

> This artwork encourages us to expand our understanding of history beyond the temporal, spatial, and physical to include all our senses as a way of knowing. How can we capture the taste of history—its sounds, its kinesthetic movements, its spatial configurations?
>
> (quoted in Weintraub, 1996, p. 214)

Artists use not only the archive for research, but also the collection of artifacts in an effort to question, debate, and reinvent our understanding of how archives can be defined and populated. For example, the Atlas Group is a project led by the artist Walid Raad, which produces semi-fictitious events and individuals in an effort to represent a contemporary history of Lebanon. Started in 1999, *The Atlas Group Project* is an online project (Raad, n.d.), as well as exhibitions that take place around the world. Physical documents including film, videotapes, photographs, and notebooks that have been created as part of the project are housed in New York and Beirut. The unorthodox methods of the Atlas Group disturb common notions of authenticity, veracity, neutrality and point of view in relation to the archive. Raad's creation of a fictional archive strategically challenges the idea that primary documents, specifically video and photography, exist as unbiased, authentic forms of history. By constructing fictional evidence and representing simulated events, *The Atlas Group Project* questions the presumed authority of the archive to represent the past in an impartial manner. What are the similarities and differences between photographs as primary documents in historical research and photographs as art? Can each form serve a different purpose in historical research? In light of these

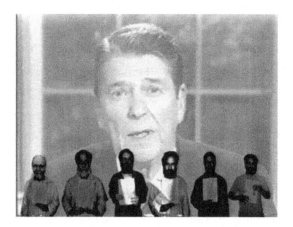

Figure 4.3 Walid Raad, *Hostage: The Bachar Tapes*, 2000, video still.

questions, can art be considered a primary document? If so, in what situations and how might that change the questions we use to investigate primary documents more broadly?

A particular project within the Atlas Group archive is titled *Hostage: The Bachar Tapes* (2000; Figure 4.3), a video that presents the testimony of a fictional person named Souheill Bachar in connection with the crisis of five American hostages held in Lebanon in the 1980s. This "captivity narrative" as Raad calls it, is the story of an imaginary sixth hostage who is Arab. The testimony addresses various aspects of the crisis, including the experience of captivity from an Arab perspective and the differences between Arab and Western notions of masculinity. Bachar's fictional story gives voice to another perspective typically missing from the international news: the Arab as hostage. By introducing a new perspective on the widely documented real crisis in Lebanon, this artwork suggests a different relationship between Arabs and the West. How does our understanding of the Middle East and Arab identity shift if we begin to consider the notion of Arabs as hostages of geopolitics and dominant Western ideologies rather than the constant image circulated by the media of Arabs as perpetrators, instigators, and terrorists?

Another artist intent on expanding the parameters of archival documentation is Melinda Hunt. Basing her work on existing archival research, Hunt uses a different strategy of presentation in the *Hart Island Project* (Figure 4.4).[1] Found archival documents are used as a framing device to present new contemporary narratives. Taking the form of an installation, a book, a film, and a work of public art, the *Hart Island Project* combines fragments of the island's history with contemporary photographs in an effort to simultaneously represent the past and the present of this poignant site. Hunt uses burial records, prison documents, logs, and newspaper clippings to contextualize and situate photographs of present-day burials at Hart Island by the photographer Joel Sternfeld. In addition to these official archival documents, Hunt includes written narratives provided by inmates who are ferried from Rikers Island prison to dig the graves for unclaimed bodies. Each photograph captures a moment in the burial process that is framed by a set of different documents. Hunt has mined the Department of Corrections archive[2] for contextual references, but has also expanded the archive by including new kinds of historical narratives: the statements of the prisoners. In this sense, Hunt both presents the archive and redefines it to include new, previously unrecognized voices.

HISTORICAL REENACTMENT

Historical reenactments such as *The Port Huron Project* are one method that contemporary artists frequently use to frame and reframe the past. Performing history is literally an embodied experience that opens other ways of knowing the past from the vantage point of the present. The dramatic staging of historical events brings to the foreground

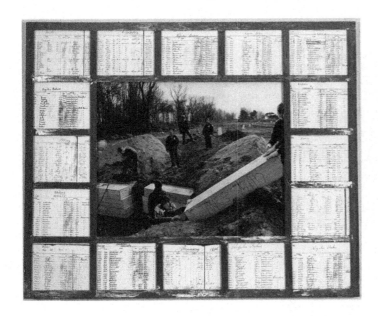

Figure 4.4 Melinda Hunt
*Adult Mass Burial with pages from
Hart Island Burial Record Books,*
1997.

questions regarding what and how we remember (and what we choose to forget).

Artists such as Greta Pratt use the photograph to capture a form of vernacular history, creating a collection of images that reflect a living history. In her exhibition catalogue *Using History*, Greta Pratt (2005) writes: "I decided to photograph how Americans remember the past, in order to understand what is revealed by the events we choose to celebrate as history" (p. 1). To create the series of photographs for *Using History*, Pratt visited pageants, county fairs, parades, and reenactments at various historical sites that she had learned about in elementary school: Plymouth Rock, Jamestown, Gettysburg, and Mount Vernon. The subsequent photographs tell us about how different communities and individuals commemorate and remember the past, today. As she says:

> I observed historic iconography everywhere and realized that its usage elicits a predictable response, valuable for selling merchandise, constructing identity, and invoking patriotism. I began to understand how the framing of the past evolves, reflecting the beliefs and ideals of the present.
>
> (Pratt, 2005, p. 1)

In her series of photographs, *Nineteen Lincolns* (2005; Figure 4.5), Pratt presents portraits of nineteen Abraham Lincoln impersonators as individuals with unique connections to this nationally mythologized president. In corresponding statements written by each impersonator, the viewer is able to read how individuals interpret this historic man's legacy. Pratt's photographs represent "a meta-level reflection on reenactments that have occurred in the culture" (Jay, 2006, p. 32) by ordinary people based on their own experiences of social class, race, gender, and sexuality. It is these differences that are highlighted in the photographs and accompanying texts as we read each impersonator in relation to the others. The resultant *Nineteen Lincolns* challenges notions of linear history and instead, as Martin Jay (2006) suggests, visualizes "history as repetition and difference" (p. 32).

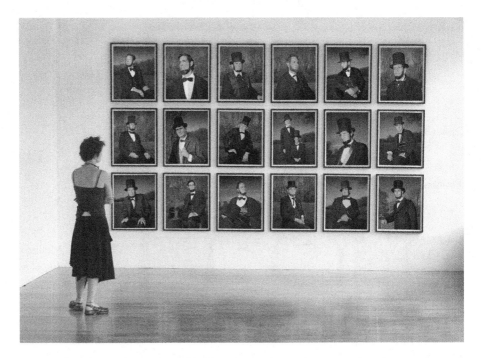

Figure 4.5 Greta Pratt, *Nineteen Lincolns*, 2005.

Also using photography as her medium, the artist An-My Lê (whose work is featured in Chapter 9, Figures 9.2–9.5) explores the idea of conflict and war through photographs that simulate the look of warfare, while remaining safely in the realm of fiction. Both real and imagined, Lê's photographs document staged, theatrical moments from training maneuvers enacted by U.S. Marines stationed on military bases in California who are preparing for combat in Afghanistan and Iraq, as well as Vietnam war reenactors in Virginia and North Carolina. The photographs from the *Small Wars* series (1999–2002) portray a group of dedicated Vietnam War reenactors as they recreate particular battles and confrontations. Required to participate as a reenactor in order to photograph the events, Lê is also included in several of the images as a Vietcong sniper and South Vietnamese translator. In the photographic series *29 Palms* (2003–2004; Figure 4.6) expansive vistas of the harsh southern California dessert overshadow miniscule tank formations. These images are paired with more intimate images of trainees involved in staged combat that takes place in replicas of Iraqi villages complete with fake anti-American graffiti. These trainees have not yet participated in real fighting, but the images suggest that war is taking place and being witnessed. Conflating real and imagined, these images reveal their theatricality only in their titles. The reenactments that Lê documents suggest what Nato Thompson (2006) calls "an embodied experience with many of the qualities of ritual" (p. 17). Lê presents a living history of war that is carried out by real people in real time, but is based in a perceived sense of what pivotal events such as war might feel like.

Some pertinent questions surface in light of this particular strategy to reimagine and document historical themes and events. The photographs of historical reenactments by Greta Pratt and An-My Lê convey particular stories about American-ness and American history. These stories are different from those told in more accepted forms of historical

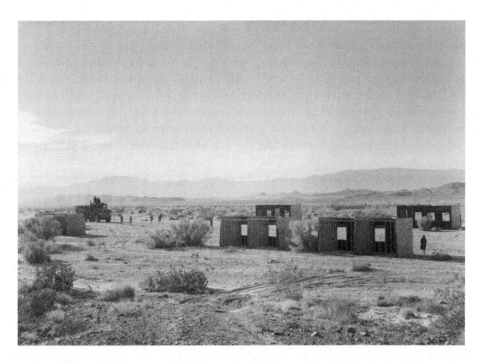

Figure 4.6 An-My Lê, *29 Palms: Combat Support Service Operations I,* 2003–2004.

record such as newspaper photographs and accompanying articles printed in 1971 about the unfolding events in Vietnam. How are these stories of American identity similar and/or different from the stories told through pageants, reenactments, and tableaux that were staged in the past? Do these reenactments distort history? Do they perpetuate stereotypes? What can one glean about history from these reenacted photographs?

ORAL HISTORY

The increased interest in using oral history as a method of investigation among artists opens new opportunities for debating notions of truth and subjectivity in relation to representing history, especially hidden or previously unrecognized historical narratives. Often artists deliberately choose oral history as a method to document the stories of people who are socially, culturally, economically, racially, or ethnically marginalized. Oral histories capture and record the narratives, experiences, and feelings of people through video and audio recordings in order to create a more vivid and nuanced picture of the past. A common method for historians conducting research, artists have begun to use oral history specifically for the interactive and dialogic nature of the process, but have interpreted different aspects of the process for their individual purposes and interests.

Looking at the work of a cross-section of artists who use oral history, one finds that depending on the ideas being explored, oral history interviews are often used in three different ways: one, as a general inspirational foundation as is exemplified in the work of Tomie Arai; two, as excerpts that are integrated directly into the work; and three, as a complete interview that is used to construct an experience or relationship to a

conversation, such as in the installation *made in usa: Angel Island Shhhh* (2000) by Flo Oy Wong (featured in Chapter 8, see Plate 7 and Plate 8, in Insert).

Tomie Arai is interested in working with people to make art and often uses the oral history method as inspiration. Although formally trained to conduct oral history interviews, Arai does not adhere to the common methodological procedures of verifying the stories she is told. Verification is the process by which the interviewer submits the collected narrative back to the person interviewed in order to have them approve, edit, or alter the material in an effort to make it truthful to the teller's vision. She explains:

> looking for some kind of truth was not the purpose of any of these interviews. And, so, in a sense a lot of the interviews themselves became for me like stories, or sort of narratives, which were very close in some respects to fiction. And, that opened up a lot for me in terms of what the art could look like or what possibilities could be.
> (personal communication, December 14, 1999).

Beginning the silkscreen series *Memory-in-Progress: A Mother–Daughter Oral History Project* (1988–1989) during her residency at the Chinatown History Project (NY), Arai drew on individual and collective memories to construct a living history of the different ethnic/racial groups of Asian communities living in Chinatown. Tape-recorded interviews served as the loose foundation for a series of prints including *Chinatown* (1989), *Laundry Woman's Daughter* (1988), *An Immigrant Story* (1989; Figure 4.7), *Kona* (1989), *The Family Cloth* (1989), *East Fifth Street* (1989), and *Sari Palace* (1989). Additional sources of inspiration for the prints included collected photographs, recipes, stories, and archival research. The oral history interviews that she conducted in order to complete the *Memory-in-Progress* series are housed in the Chinatown Museum and Arai considers them a separate element from the silkscreen prints. Arai also uses excerpts of oral history interviews in several of her other works. For example, in *Double Happiness* (1998; Figure

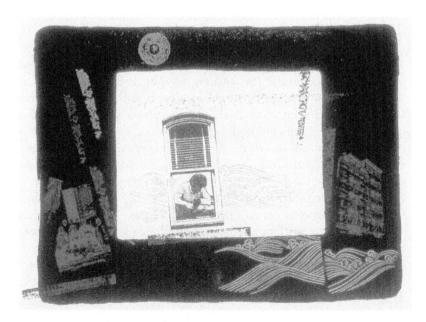

Figure 4.7 Tomie Arai *Memory-in-Progress: A Mother–Daughter Oral History Project. An Immigrant's Story*, 1989.

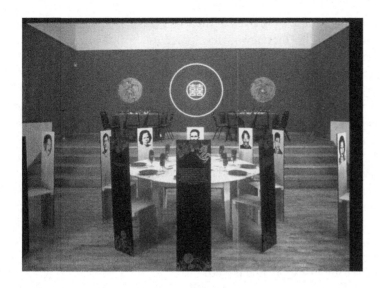

Figure 4.8 Tomie Arai
Double Happiness, 1998.

4.8), an installation that depicts a traditional Chinese wedding banquet, she etched excerpts from interviews she conducted with bicultural adults onto the back of featured chairs. Each chair stands for a person she interviewed and tells his/her story.

Jackie Brookner's installation *Of Earth and Cotton* (1994–1998; Figure 4.9) incorporates oral history methods and documentation more directly. Sculptural portraits of feet made of soil are viewed against a video backdrop documenting conversations between the artist and former cotton farmers. In addition, historical photographs made for the Resettlement Administration/Farm Security Administration that depict the working and living conditions of cotton pickers during the 1930s are projected alongside the video. From 1994 to 1996, Brookner followed the westward migration trail of workers in the Cotton Belt, interviewing men and women in six different areas who had picked cotton by hand in the 1930s and 1940s. As the men and women spoke about their experiences

Figure 4.9 Jackie Brookner
Of Earth and Cotton,
1994–1998.

and memories, Brookner hand sculpted portraits of their feet using local soil. The video conveys not only the dynamics of the interview—viewers see and hear the interview as it takes place—but also the dynamics of the artistic process as the artist sits on the ground in front of the person being interviewed to sculpt their feet.

The historical photographs commissioned by the federal government convey proud, heroic workers whereas the video and interview present the geriatric bodies and difficult stories of a life spent picking cotton by hand. The juxtaposition of the sculpted feet, video, and commissioned historical photographs, many taken by Works Progress Administration artists, creates a web of complex and intricate relationships between historic and artistic knowledge, racial stereotypes, embodied history, and different ways of knowing about the past. These intimate perspectives confront the contradictory stories told about this historical period, the noble laborer dedicated to the land. How do we narrate the multiple and often contradictory stories that are part of history? Would Brookner have solicited a different series of narratives had she been sitting on a chair with a tape-recorder rather than sitting at the feet of the interviewees? Does the way an interview is conducted alter the history that gets told?

AUTOBIOGRAPHY/MEMOIRS

How is the use of autobiography or memoir in art different from art based on oral history? An obvious difference is that the autobiography, whether visual or written, is based on the artist's personal memories of experiences and events, whereas the oral history narrative is based on the stories told by other people and re-presented by the artist in a written, auditory, or visual form. An autobiographical work is framed by personal recollections representing a particular moment or period such as childhood, a specific memory, or a significant experience, whereas an oral history interview is guided by the expectations for a collective conversation and the types of questions asked. In both autobiography and oral history, fact and fiction cannot always be clearly delineated

Figure 4.10 Roger Shimomura *American Diary: December 12, 1941*, 1997.

because memory is subjective and often fallible. However, autobiographers and oral historians assert that their methods are an attempt to tell the truth as best as they can. The desire to tell the truth and the lines that separate fact from fiction are often a source of interest and exploration for artists, who can more dynamically skirt the borders between subjectivity and objectivity. Looking at the work of contemporary artists reminds us that "Autobiography is the product of various factors—real experiences, together with things heard, seen, read, narrated and invented. Fact and fiction are inextricably woven together" (Steiner & Wang, 2004, p. 27).

Drawing on his own experiences as a Japanese-American citizen and those of his family, Roger Shimomora's autobiographical paintings chronicle events in U.S. history that were of particular significance to his family. In the *American Diary* series (featured in Chapter 7, see Plate 3 and Plate 4, in Insert, and Figure 4.10), Shimomora created a visual image to accompany each entry from his grandmother Toku Shimomora's diary recording her daily experiences in the internment camp where she was forced to live from 1941 to 1943. Toku's diary entries address a particularly controversial moment in U.S. history: the forced incarceration of Japanese-Americans during World War II. The artworks do not simply reproduce the diary entry in a visual manner, as an illustration of the text, but rather comment on aspects of American popular culture through the iconic use of bicultural signs and symbols. As it shares much in common with literary autobiographical works that are considered primary historical sources, we suggest that Shimomura's visual biography should also be considered a primary document in the context of written diaries from that time.

In her larger than life installations, Kara Walker presents a full theater of imagined characters rendered in black cut-out silhouettes: young southern belles, pickaninny children, uncle toms and uppity Southern gents. These characters are rendered as exaggerated stereotypes and caricatures that exist as fantastical versions of historical stories and mythologies about the American antebellum south. Walker produces extended titles that not only place the work in the controversial site of the plantation, but identify her as the Negress: the work's author and narrator. Not limited to titles, Walker writes extensively in connection with her silhouette installations and animations. These writings are conceived in the first-person voice and place Walker both in the historical context of the scenes she renders, but also as the self-conscious contemporary producer.

> The Negress, as a term that I apply to myself, is a real and artificial construct. Everything I'm doing is trying to skirt the line between fiction and reality. And for the most part I've titled exhibitions and a book or two as though they were the creations of a "Negress of Noteworthy Talent," or a "Negress of Some Notoriety." I guess it comes from a feeling of being a black woman, an African American artist—that in itself is a title with a certain set of expectations that come with it from living in a culture that's maybe not accustomed to a great majority of African American women artists.
>
> (Art21, n.d., para 15)

Walker refers to her work as "two parts research and one part paranoid hysteria" (Art21, n.d.). As a historical, autobiographical and fictional construct, how does Walker's work relate to traditional ideas about the antebellum south? To what degree is authenticity and truth possible in historical research and interpretation? Walker exaggerates the fictional qualities of historical representation and presents an autobiographical narrative related to

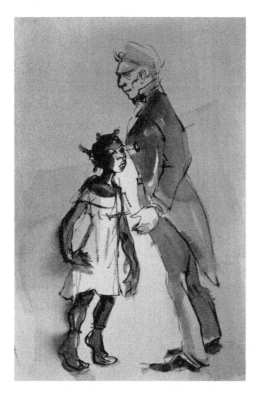

Figure 4.11 Kara Walker
Negress Notes (Brown Follies), 1996–1997.

a fabricated history. Given that all autobiographies are constructed, containing incomplete and partial truths, we can reconsider how we might read and use autobiography and memoirs in reconstructing historical narratives. How do we navigate the cacophony of voices that make up American history and bring these voices into a multi-layered dialogue when representing history, textually and visually? As researchers we not only have to question how we speak and for whom, but from what place in time and space.

THE LOCATION OF PHOTOGRAPHY IN HISTORY AND CONTEMPORARY ART

In writing and thinking about the methodologies and strategies used by contemporary artists in relation to history we were struck by the ubiquitous use of photography. Some artists create original imagery whereas others reference found photographs from archives or more contemporary sources. Many artists integrate photography as a component of larger installations or multi-media presentations, others utilize the camera as their primary medium. This recognition that photography can serve as both a functional tool for documentation, as well as an artistic strategy, positions it at a very interesting place between history and art. What are the relationships between the ways that artists use photography and the ways that historians use photography? What can photography contribute to a visual approach to history and how can we critically investigate the layers of information embedded in the frame of a photograph, whether historic or contemporary, art or artifact?

A photograph is a single frame of history, a moment in time. Taking a photograph captures light from an instant and transfers it to paper for posterity. The Latin roots of the word *photograph* mean "writing with light." When looking at a photograph we are connected to a moment of history as spectators and sometimes as witnesses. As a visually recorded moment, "photography is critical to the practice and authority of the archive, in so far as it folds together history as representation and representation as history" (Merewether, 2006, p. 160). Each photograph transfers the historical event to image, producing "a certain archival effect" (Merewether, 2006, p.160). Photographs document a moment in history but they also provide a window through which to understand the present, the moment in which the viewer is looking at them. Like all works of art or pieces of historical evidence, photographs are participatory. They require the viewer or reader to react and interpret their content from an individual perspective: to bring a unique biographical, cultural, political, social view to the information contained within them. The subjective nature of images corresponds to the idea that history is in and of itself subjective, that is, it is constructed and interpreted according to individual points of view. While the viewer shapes their own interpretations or reactions to a photograph, photographic images in turn shape individual understandings about history, they tell stories and suggest meanings used to interpret history.

Photography in the work of contemporary artists covers a broad range of concerns, intentions, and visual strategies. Significantly different from the genre of "art photography" that is grounded in the idea of the autonomous role of art or art for arts sake, many contemporary artists use photography to address the social and cultural world animated by a critical or deconstructive stance. Artists such as An-My Lê and Jenny Holzer use photography to challenge common assumptions that mechanical images capture reality and can be read as truth. In this way artists "destabilize [photography's] authority as a technology of remembrance" (Merewether, 2006, p.160) and assert that the meanings of a photograph are not singular but multiple: they reference many different things at once, including other images from art, mass media, and visual culture. Other artists working today, including Shimon Attie and Walid Raad, use the appropriation of existing photographic imagery as an alternative way of producing art in an already saturated visual environment. Still other artists, including Melinda Hunt and Jackie Brookner, employ a combination of both methods, using photography as a critical lens as well as a way of referencing or borrowing existing historical imagery. All photographs are mediated by the social, cultural, political, and economic experiences of both the photographer and the viewer. In the words of John Berger, photographs construct a "radical system" that can be "seen in terms which are simultaneously personal, political, economic, dramatic, everyday and historic" (quoted in Kumar, 2000, p. 47). Moreover, photographic images presented in the context of contemporary art can serve as a form that moves beyond simply embracing "plural histories, multiple narrative lines, where each such line continues to move from a limited collective past, through a fleeting (but determined) present and into an unknown (but largely determined) future" (Grossberg, 2000, p. 158). Contemporary photography has the potential to "question how and what it is that photography remembers and forgets, for whom and for what purposes" (Merewether, 2006, p.162). This idea of images as providing selective knowledge based on what we remember and what we forget is important to bring into the history and art classrooms. It allows students to question the fact-based rendering of history and opens discussion on the subjective aspect of historical knowledge.

CLOSING THOUGHTS

The strategies and methods employed by artists presented in this essay reconceive historical knowledge with "new ways of imagining our relations to the multiple temporalities of objects, people and events, and of the worlds that they and we inhabit" (Grossberg 2000, p. 158). An-My Lê's photographs from the series *Small Wars*, Melinda Hunt's *Hart Island Project*, and Walid Raad's archival project *The Atlas Group*, each provoke us to imagine history not as a linear narrative of facts or a temporal progression of events coherently leading to the present moment, but as a dynamic, uneven, often surprising collection of memories, ideas, commentaries, opinions, and assertions that simultaneously move in multiple directions across time and space. This space is created not through static images and objects left to be interpreted passively by a viewer, but through performative, embodied experiences that suggest new interpretive possibilities for understanding and debating the meanings of history. Engaging with information in many different forms, these multi-modal perspectives can provoke students to encounter history as a lived and living experience. Presenting students with works of art that tell historical narratives through multiple senses provides an opportunity to embody historical knowledge beyond cognitive recognition, memorization, and regurgitation. Instead, history is an empathetic and felt space of ideas.

Artists also use historical methods in their work to foreground the notion that history is a subjective field. Historical reenactment, oral history, the archive, and photography as documentation serve as tools for constructing a critical vantage on traditional or accepted historical narratives. This critique of objective, authentic, or neutral concepts of history is an important notion for both the history and art classroom. Using the constructed narratives presented in the artistic projects featured in this essay, history and art can be presented as a series of entry points and gateways with numerous perspectives and voices to be analyzed and debated. These voices contradict the singular, authoritative stance of factual evidence so often presented in textbooks, singular artifacts, or primary documents. As an antidote to the mind-numbing culture of testing and correct answers, students can explore works of contemporary art as models for enacting their own critical approaches to historical information and navigating the messy and difficult matter of the past.

Equally important is the idea that the historical record is never complete. In their pursuit of new voices and vantage points, some contemporary artists, such as Melinda Hunt, Jackie Brookner, and Tomie Arai, place a significant emphasis on bridging the official record with new contributions from unconsidered sources. Utilizing their position as border crossers, artists model an important approach to historical research that reinforces the idea that history is an infinitely unfolding process of collecting ideas and perspectives about the past. These artists draw attention to the incredible range of voices that belong in the historic record. The individuals and communities that these artists engage in their work suggest new opportunities for students to investigate and solicit new vantage points to inform their own historical understanding, including ones from within their own communities.

Rather than the neatly factual, cohesive, and primarily textual narratives we encounter in textbooks, can we envision history and art as interconnected spaces for inquiry? What is possible pedagogically if we begin to think about researching, writing, and teaching

history as art and art as a location that coheres the future, the present, and the past? The work of many contemporary artists suggests that our commonsense understanding of history as merely about the past is shortsighted. The writer James Baldwin (1965) reminds us:

> [t]he great force of history comes from the fact that we carry it within us, are unconsciously controlled by it in many ways, and history is literally present in all that we do. It could scarcely be otherwise, since it is to history that we owe our frames of reference, our identities and our aspirations.
>
> (p. 26)

By posing critical questions about the past and drawing connections to the present, contemporary artists can inspire educators to rethink the ways history is taught, understood, enacted, and embodied.

NOTES

1 New York is one of the few major cities that have a public burial ground. Dating back to the British colonial period, Hart Island was formerly a potter's field that now serves as the largest cemetery in New York City, where all unclaimed bodies and the bodies of those who cannot afford a private funeral are laid to rest. Melinda Hunt began visiting the island in 1991 and has become a major advocate for releasing the records of the over 750,000 people buried there.
2 The Department of Corrections currently manages Hart Island and maintains all record keeping for the site.

REFERENCES

Art21. (n.d.). The melodrama of *Gone with the Wind*. Interview with Kara Walker. Retrieved February 15, 2009, from http://www. pbs.org/art21/artists/walker/clip2.html

Attie, S. (1998). Between dreams. Retrieved January 12, 2009, from http://www.creativetime.org/programs/archive/1998/BetweenDreams/between/

Baldwin, J. (1965). White man's guilt. *Ebony Magazine*, August.

Enwezor, O. (2008). *Archive fever: Uses of the document in contemporary art*. London and New York: Stedil Publishing and International Center for Photography.

Garoian, C. (1999). *Performing pedagogy: Toward an art of politics*. Albany: State University of New York Press.

Grossberg, L. (2000). History, imagination and the politics of belonging: Between the death and fear of history. In P. Gilroy, L. Grossberg, & A. McRobbie (Eds.), *Without guarantees: In honour of Stuart Hall* (pp. 148–164). London: Verso.

Jagger, A., & Bordo, S. R. (1989). *Gender/body/knowledge*. Edited by Alison Jagger and Susan R. Bordo. New Jersey: Rutgers University Press.

Jay, M. (2006). Aesthetic experience and historical experience. In N. Thompson (Ed.), *Ahistoric occasion: Artist making history* (pp. 26–35). North Adams, MA: Massachusetts Museum of Contemporary Art.

Kumar, A. (2000). *Passport photos*. Berkeley: University of California Press.

Merewether, C. (Ed.). (2006). *The Archive (Documents of Contemporary Art)*. Boston: MIT Press.

Pratt, G. (2005). *Using history*. Germany: Steidl.

Raad, W. (n.d.) *The Atlas Group Archive*. Retrieved January 31, 2009, from http://www.theatlasgroup.org

Schaffner, I., & Winzen, M. (Eds.) (1998) *Deep storage: Collecting, storage, and archiving in art*. Munich: Prestel-Verlag.

Steiner, B., & Yang, J. (2004). *Autobiography*. New York: Thames and Hudson.

Thompson. N. (2006). Ahistoric essay. In N. Thompson (Ed.), *Ahistoric occasion: Artist making history* (pp. 12–25). North Adams, MA: Massachusetts Museum of Contemporary Art.

Weintraub, L. (1996). *Art on the edge and over*. Litchfield, CT: Art Insights.

CHAPTER 5

"Committing History in Public"

Lessons from Artists Working in the Public Realm

Jessica Hamlin and Dipti Desai

Progressive educators assert that classrooms should model the democratic ideals of civic space, where freedom of speech, fair representation, and freedom from unfair persecution are embraced and enacted. As artists enter civic spaces to present public art that directly address citizens, their rights, and their experiences—both past and present—educators have an opportunity to learn from their practices and their attempts to engage audiences in meaningful debate and dialogue. The public work created by the artists Krzysztof Wodiczko and the artist collective *REPOhistory*, co-founded by Greg Sholette, model pedagogical methods that could be considered "best practices" for teaching history. Deliberately involved in "the process of communicating knowledge about the past," these artists treat the subject of history in very different ways (Stearns, Seixas & Wineburg, 2000). Not simply an aesthetic gesture, the process of artistic communication can be considered an "epistemological and cultural act" (ibid.). Sholette and Wodiczko are both interested in civic engagement, but their artistic practices offer unique connections to historical knowledge and methods. As educators interested in finding dynamic approaches for teaching students critical historical and visual literacy skills, as well as for encouraging them to become engaged in civic issues, we are interested in exploring these artists' methods in order to connect them with classroom practice. Educators have much to learn from artists, not just by looking at the images and objects they produce, but through a critical examination of their creative process, their motivations, and their sources of inspiration.

Both Wodiczko and *REPOhistory* make use of historical events and symbols as "critical tools for addressing contemporary issues of social justice" (Sholette, personal communication, April 26, 2007). Wodiczko's work empowers marginalized groups with the power of public speech using memorials, monuments, and architecture. Wodiczko believes that public monuments play an important role in civil, and specifically democratic societies, and can serve as significant sites for discussion and debate about current events and history. By reanimating public monuments and offering opportunities for public debate, he does something that the best history educators also do: he disrupts the notion that there are singular truths about the past. Sholette's work with *REPOhistory* likewise

attempted to disrupt the narrowness of "official" histories by using public signage as a means of excavating and re-presenting the hidden histories of particular locations and events, and to tell stories of marginalized groups, in public.

We asked each of these artists to talk with us about how their work intersected with historical methods, tropes, and themes. Our conversations with Sholette and Wodiczko reflected different ways that these artists articulate and realize the connections between creating visual art and involving the public in historical knowledge. Sholette and Wodiczko both assert that artists have an important role to play in democratic society, and in appropriating public space to explore issues relevant to the past and the present. By borrowing and reinterpreting the official histories memorialized in public on monuments, memorials, plaques, and street signs each artist heeds the critic Walter Benjamin's (1955) call to supplant the "history of the victor" with the "tradition of the vanquished." Each artist refers to this seminal text in describing the motivations and theoretical perspectives that animate their work, and yet Sholette and Wodiczko use different visual strategies to interpret this idea and to insert challenging stories of marginalized groups into public discourse. For Sholette and the members of *REPOhistory*, visual imagery provided a useful "hook" to engage public audiences in controversial material. Artists have a unique position and function in this in-between space of history, public space, and design. For Wodiczko, artists are essential to public discourse and to democracy—to maintaining the dynamism of public discourse as instigators, assistants and provocateurs. His visual practice uses technology to draw connections between past and present, between invisible members of society and highly visible public monuments.

Our interviews also reinforced an essential claim of this book, that we learn about history not only through cognitive reasoning in formal learning environments, but through emotional responses and bodily/sensory experiences in many different contexts, including public and private space. In a sense, the work of both these artists is a form of public history that requires the physical presence and participation of the viewer to be realized. Sholette and Wodiczko contribute to the idea that history is always in the public sphere. Their work can be considered as contributions to a continually reimagined and evolving historic discourse.

We were inspired by our conversations with Sholette and Wodiczko to imagine a classroom as a new kind of public space that has the potential to creatively disrupt monumental histories. Their work, and their ideas about art and the public sphere, informed our ideas about how educators might teach with works of contemporary art, both public and not. Their ideas also affected the pedagogical strategies we offer in the second part of this book. The classroom should be a site for significant discussion and debate about the meanings of the past. It is in this exceptional space that we can critically consider what stories we tell as a society, how they are told, and the uses to which we put those stories.

Both Wodiczko and Sholette also suggest compelling lessons and best practices for engaging students with visual and historical knowledge: the importance of soliciting multiple viewpoints and perspectives, the potential of collaborative strategies, the value of locating and exploring hidden/forgotten histories, the significance of appropriating and reframing accepted/taken for granted public symbols and knowledge, and the power and reach of using diverse public spaces for research, exhibition, and information sharing. In designing the "Teaching Connections" section of our toolkit, we drew

heavily from Sholette and Wodiczko's ideas about the importance of art that uses public space, performance, research, and the tools of new media. We developed a sampling of activities that combine critical analysis, personal opinion, and research; opportunities for conducting interviews and oral histories; and working collaboratively with other students and "specialists" outside the classroom. These activities include doing community-based and archival research, creating public interventions using classrooms, school buildings, and neighborhood spaces, and producing and disseminating zines, trading cards, and mail art. These are not the only activities that can inspire students to think critically, to collaborate, to express their ideas visually, or to engage in public dialogue about issues of civic importance. Instead, they are meant to serve as provocations and illustrations; suggestions geared toward illustrating our belief that critical, primary document-based historical inquiry can be productively paired with inquiry-based instruction that builds students' visual literacies. We present them in the Teaching Toolkit section of this book in hopes that they will inspire additional ideas about how you might structure pedagogical experiences that will encourage students to move beyond a classroom context and consider the publicness of historical understanding and interpretation that are directly inspired by artistic practice and methods.

KRZYSZTOF WODICZKO: ANIMATING MONUMENTS, PUBLIC DIALOGUE, AND DEMOCRACY

Krzysztof Wodiczko's work uses a diverse range of media, sites, and materials. Grounded in the idea that art has a social function, Wodiczko has created therapeutic and communicative "devices"—including what he refers to as "storytelling equipment" for new immigrants that combines video technology in a traditional walking stick form (see Plate 9 and Plate 10, in Insert); he has also used digital projections on the facades of public monuments and buildings to invite marginalized communities to speak publicly about issues of violence, trauma, and forgotten histories. In this interview, Wodiczko talks about his use of historical monuments as a symbolic vehicle, a public site where he can explore contemporary issues and historical assumptions, and engage the public in dialogue and critical reflection about the meaning of these issues. Wodiczko uses the idea of "projection" as both a technological device and a metaphorical idea, suggesting that as citizens, we can reclaim and reconsider history in the contemporary moment.

JESSICA HAMLIN: Can you talk a bit about why and how you became an artist who makes work for public spaces?

KRZYSZTOF WODICZKO: It has something to do with my upbringing and the history of my displacement. I don't necessarily like to describe my work in biographic terms, but this displacement is important because it informs the way I work. I lived in Poland until I was 35. After I left I did not return because of the political circumstances. I was in a country where the ideals of public space and democracy were very central and significant, precisely because we did not have the right to pursue them. There was no democratic process possible and the term "public space" was a contradiction in itself as such a space was exclusively controlled by the authorities.

Figure 5.1
Krzysztof Wodiczko,
*Soldiers and Sailors,
Brooklyn Projection*, 1985.
Public slide projection
at Soldiers and Sailors
Memorial Arch, Grand
Army Plaza, Brooklyn,
NY.

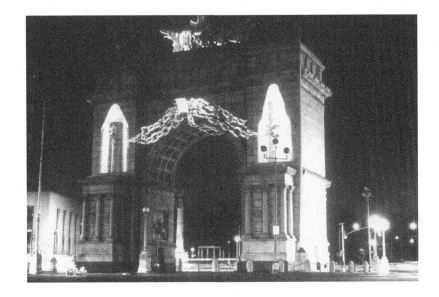

As soon as I ended up in Canada, and later in the United States and other countries, I embarked on a journey in search for democracy, public space, and the opportunity to play an active role as an artist in the democratic process. I learned quickly that democracy as such does not exist. It was a utopia, or a phantom. The more I tried to find it, the harder it was to locate—like something that is always on the horizon, but never can be reached. So I realized that is what democracy is. It is the pursuit of an ideal that is unattainable and never guaranteed.

It was interesting to discover that in the United States, every time I insert something into public discourse, something usually relegated to private domain, that it becomes a very small gesture towards democracy in public space. I do this as an artist, who combines artistic work with social research—and to some degree psychological work. There is a process I go through of discovering something that is happening of which the public ought to be emotionally informed. This process hopefully enlarges or articulates more clearly some of the experiences and conditions of life in this world—often conditions and experiences that people would rather not hear about. This process can also give a voice to people who are silent and marginalized, bringing up "personal" or "private" stories, testimonies, and concerns and turning them into historical moments in the life of public domain.

The effectiveness of such democratic effort depends on the level of dynamism of its public discourse: its political passion, free expression, disagreement, dis-sensus, protest, disruption, and intervention. Public artists are integral—inspiring, provoking and assisting this process.

JH: What inspired your original interest in working with monuments?

KW: The fact that they are being taken for granted as merely urban decoration and sentimental ornaments, a conservative embellishment of the city real estate developments.

The fact that nobody recognizes them as the valuable critical witnesses from whom we may learn something about the present and the future.

Monumentum in Latin, after all, derives from the verb *Moneo* "to warn," and thus means "something that serves to warn or remind with regard to the conduct of future events." The word *Memorial* refers to *Memento*, that is, a thing—or more precisely, a command—to mind and remind.

This present and future bound concern—a critical mission of the monument and memorial—is being repressed through its continuing relegation to the past . . . continuing to serve uncritical decorative, commemorative, and celebratory functions and duties. In response to this, I decided to bring the monuments back to critical and meaningful democratic life. I decided that my task should be to animate them, so they could respond to the events and circumstances of today, connect with us—with the experiences of the living—and become useful to us as our critical companions.

Walter Benjamin would say that public space is reserved for the memory and history of the Victors, that through monuments and grand civic edifices, we remember and celebrate those who have succeeded, while conveniently forgetting those who have not—the Nameless and Vanquished, the forgotten witnesses and survivors of yesterday and of today.

Speaking like Walter Benjamin I decided that my role was to help these monuments to the "Victors" be animated, or rather reanimated, by the voices and gestures of the "Nameless" and the "Vanquished"—the survivors, residents of our cities.

There is a complicated process of animating or establishing a dialogue with these monuments. They are witnesses to the past and also to the present. For one of my projection projects I was working in Boston, in Charlestown—a neighborhood that has been plagued by terrible street violence. I talked to many residents of Charlestown, especially to a group of women who had organized themselves into the group, Charleston After Murder Project. These women had lost their children to local violence, to the contemporary battles around the Bunker Hill Monument. I asked them, "What if the monument could speak?" These women were absolutely aware that the Bunker Hill Monument overlooks the contemporary crime and injustice that is a mockery to the pursuit of life, liberty, and happiness,

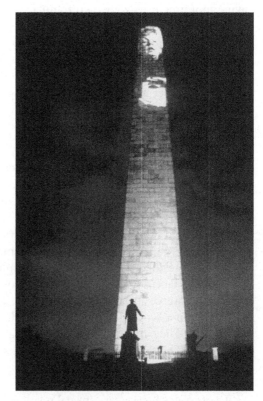

Figure 5.2 Krzysztof Wodiczko
Bunker Hill Monument Projection, 1998. Public video projection at Bunker Hill Monument, Boston, Massachusetts.

in the name of which it was built. The revolutionary war hero General Gilbert du Motier de Lafayette placed the cornerstone of this monument. This gesture embodies all of the values and hopes behind the American Revolution. [Figure 5.2.]

But in Charlestown, the battle continues for life, liberty, and the pursuit of happiness. Mostly by these mothers who have nothing more to lose since they lost their children. They are facing death threats to keep silent but they don't care. They want people to start speaking, to break the code of silence that is self-imposed by this so-called community. Let's talk about who murdered whom, and give this information to the justice system, in the name of the First Amendment. After all, we live in a democracy. This is American democracy. America has the only constitution in the world that includes the rights of communication as its first position. It is the first modern constitution. So why not speak out?

I asked the mothers, "Why don't you become this monument, fifty times taller, a hundred times taller, and say all the things that the monument knows and saw from its height? Point as if you were the monument and tell what you remember happening and where. Then people will start to identify with the monument and see what is happening around them in the name of all of those qualities and hopes and visions of America. Perhaps you will finally be making use of this monument. You will create a living monument to your own trauma. You will see that the monument also needs to speak. You need to speak and the monument is also a monument to its own trauma—trauma at not being able to respond to what it has seen happening around it. When you talk to journalists you are breaking the code of silence, so you are healing yourself. Why don't you heal the monument as well? In order to heal the monument, you have to heal yourself. In order to heal yourself, you may use the monument as a vehicle. And in fact heal the entire crowd underneath. All those people who are scared to death—and this is not a metaphor—to speak and open up."

JH: Are you looking for symbolic connections between the significance of particular monuments and the issues that exist between the historical moment and the contemporary moment?

KW: Yes, monuments are works of art, but they are also works of architecture. So even if a monument was created with a certain intention, it actually becomes transformed based on different readings and discourses that animate it with new meaning. We project our own circumstances—our loneliness, our stories of survival—onto that facade. Every war memorial observes new wars; people place flowers on them, new names of the dead are inscribed. First World War memorials in the United States became Second World War memorials. They also became Vietnam War memorials, Korean and even Spanish war memorials. The same words are there—sacrifice, patience—these are sacred words. So even officially there is a projection going on from one meaning to the next, one war to the next.

We of course have a very special relationship to those monuments. Monuments have become part of parks and part of recreational space. These are the places we go with our families on Saturdays, Sundays, and holidays; where we go for a walk; where tourists photograph each other; where we photograph each other; where our children climb. They become part of our lives. Yet no one wants to know what they mean.

There are some occasions when monuments are able to speak again. One day, there will be a demonstration and suddenly the seemingly subdued and aestheticized statue, previously used for entertainment, will speak again. Take for instance the monument of General Washington on horseback in Union Square Park in New York City. Union Square was the site of many massacres in the past. It was one of the most political, if not violent, parts of New York City. Now, almost every week there is a political event that takes place around the statue of Washington. This public sculpture is the oldest in New York City so it is a witness to many things. It was installed over 150 years ago so it must remember a lot. The various groups who stage demonstrations around this monument know that.

According to the original sculptor Washington is pointing in the direction of the evacuation of the British troops. But now, this finger and this gesture means something else. This gesture is against the war in Afghanistan, against the war in Iraq. The sculpture of Washington has been transformed into a very complex anti-war monument. In fact, this monument is not a war monument. It is a peace monument.

JH: It is an interesting stance to say that it is not just we who create monuments in recognition of history, but that history is also witnessing us. We are being observed by history.

KW: Exactly. The issue is to be both judged by history and to judge it.

JH: Can monuments represent history?

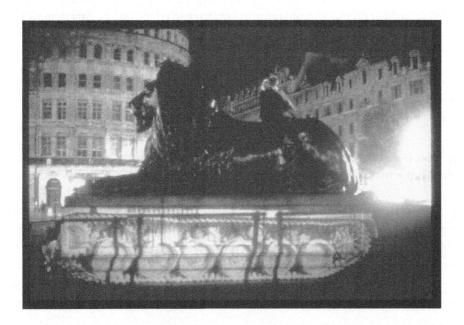

Figure 5.3 Krzysztof Wodiczko, *Nelson's Column Projection* (detail), 1985. Public slide projection at Nelson's Column, Trafalgar Square, London, England.

KW: Yes, they can recognize what Nietzsche called "monumental history." That is, monuments can help us to create a monumental history—the history that suggests, "great things have happened." But Nietzsche would give us an immediate warning, because circumstances are never the same, therefore there is very little possibility that just because some great and good things happened in the past that they will happen again. A monumental history is something to be skeptical of. Our sites of celebration or commemoration may be perpetuating grand illusions. They often function as historical megalomania.

JH: There is a political sense of who gets to claim ownership, of who gets to say how these monuments speak, to whom, and to what purpose.

KW: The meaning of a monument is never fixed. Of course there is an original intention for creating the memorial, such as war memorials. For instance, the memorials to the First World War are some of the most powerful symbolic structures in this country. They have attempted to confront the great difficulty of explaining to people that that war resulted in something good, that is to say that the number of people killed in the First World War resulted in something good. When war monuments are more elaborate—when they combine reliefs, sculptures, and texts—they provide a narrative to help people to live with hope for better future and peace, including those who lost their sons and daughters or people who came home with injuries. These monuments can help people to move on. They also can speak to future generations.

So when you ask what is the meaning of a memorial it is a combination of things. I would not say that memorials and monuments have fixed meanings. Any demonstration can change the meaning of a memorial. Simultaneously, monuments hold on to themselves as a protected, eternal, untouchable and sacred ground.

Is what I do political? It is difficult to say. There can be no more political art than those monuments as they exist already. Monuments are already speaking to each other. There is a history of political art—art that questions previous politics. Part of the strategy of the monument [and of art] is to draw people in through aesthetics.

JH: That is a very specific function that an artist can provide, very different from what a historian or a sociologist can provide.

KW: Permanent monuments are always changing, creating an opportunity for someone to insert their voice, and maybe even to question the monuments' own intentions. The problem is that once we build it, the monument often becomes a monolith. Rather than embodying a process of opening up the opportunity for various people to engage in the work, to maintain discourse, the monument is protected against all that brings new life to it. Authorities only want to do minimal maintenance: change the bulb, dust, or

clean. What a loss of an opportunity for the next generation (who perhaps don't even remember the original event) to become involved in discussion!

The proposals for the World Trade Center Memorial have exactly this problem. They turn that space into sacred ground, where the monument itself doesn't have the opportunity to open up discussion, or attempt to bring about more thinking to the process, a critical recollection of the past. The proposals for the World Trade Center Memorial bring the danger of premature closure, one that interrupts the process of critical rethinking, remembering, and recollection of our potentially unaware, albeit naïve, blind, and careless mistakes of the past. I am thinking of a monument that is a working memorial, a place and an institution for critical discussion of our notoriously misguided relations to the developing world, all that may have given ideological ammunition and popular support to the murderous and blind "avengers of blood" who have attacked us. In fact the memorials should be the places of both study and engagement toward practical work and transformative actions in the world, rather than a melancholic place for a premature closure that replaces "thinking-through" and paves the ground for "acting-out" and contributes to a danger of the repetition of the tragic event.

The Declaration of Independence, the heart of our Constitution, is both a memorial and a critical projection. It is a recollection of our historical trauma and the murderous acts against us. It recalls, like in post-traumatic testimony, tragic events and declares our right and will to change, while projecting a radically new course of events, so that an unjust past will not happen again.

GREG SHOLETTE: COLLABORATION, HISTORY, AND THE URBAN LANDSCAPE IN THE WORK OF *REPOHISTORY*

Greg Sholette's work as artist, writer, activist, and organizer has continually explored the intersections between history, current events, and visual art. As a cultural producer whose work is grounded in history, his visual practice is part of a tradition of artists, cultural theorists, historians, and philosophers who understand art as a mode of production that is deeply connected to the lived conditions of people in society. He is one of the founding members of two artist collectives: Political Art Documentation/Distribution (PADD) (1980–1988) and *REPOhistory* (1989–2000). Interested in collaborative practices that open up dialogue about contemporary political issues, Sholette's work is mainly designed for the public sphere and is disseminated in a variety of ways: on street signs, posters, flyers, and postcards, as well as in the context of performances, public installations, educational activities.

REPOhistory, the artist and writers collective that Sholette helped found in 1989, attempted to "repossess history" by exploring new ways of representing the past as a multi-layered, living narrative. Interested in addressing questions such as "Who owns history? Who makes history? Can history be owned? What does it mean to reclaim one's past?" *REPOhistory* created a series of public projects in New York City and Atlanta, Georgia, intended to raise questions about the hidden histories of neighborhoods, marginalized communities, and controversial events.

Dipti Desai: What was *REPOhistory*?

Greg Sholette: *REPOhistory* was a New York City based collective of visual artists, educators, academics, performers, and media activists. Our common ground was an interest in the intersection of public space, unknown, often radical histories, and using culture to support political activism. Over a hundred women and men of diverse backgrounds, as well as several high school classes, collaborated with *REPOhistory* between 1989 and 2000. Some individuals participated in a single project while others remained active over a longer period of time.

REPOhistory—whose name refers to the 1984 indie film *Repo Man*—sought to retrieve, or "repossess," lost, forgotten, or repressed historical knowledge by publicly re-representing and remapping these unheralded narratives at specific locations linked with each overlooked subject. For example, our first project in 1992 was called the *Lower Manhattan Sign Project* (LMSP), and it featured street signs that marked a variety of locations around New York City that had been the site of important, but little-discussed, events: the original "pre-Columbian" coastline of Lower Manhattan on Pearl Street when the island was inhabited by the Lenape people; the temporary overthrow of British rule in 1689 by Jacob Leisler, almost a century before the American Revolution [Figure 5.4];

the site of an alleged slave rebellion near Wall Street in 1741; and the location where Madame Restell, AKA Ann Trow, operated a prosperous abortion clinic next to the World Trade Center. Altogether, LMSP consisted of thirty-nine aluminum signs that measured eighteen by twenty-four inches. A four-color map designed by *REPOhistory* was printed in a ten thousand edition and made available free around the city so anyone could in theory do their own self-guided "walking-tour" of the entire project.

It took us three years to plan, research, obtain permits, produce, and install this first project. When LMSP did finally open on June 27, 1992, it was one part of an event called ¿*the Americas?*, a series of counter-Columbus programs situated in all five boroughs and intended to challenge the prevailing view that Europeans had "discovered" the *New World* in 1492. Following that first project, we did several other street sign-based projects— the *Queer Spaces* project (1994), the *Civil Disturbances: Battles for Justice in New York City* project (NYC: 1998–1999), *Entering Buttermilk Bottom* and *Voices of Renewal* project (Atlanta, Georgia: 1995 and 1997). All of these street sign installations followed a similar formula:

Figure 5.4 REPOhistory, "Leisler's Rebellion," Lower Manhattan Sign Project (LMSP), NYC, 1992

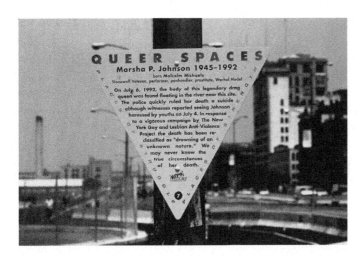

Figure 5.5 REPOhistory, "Marshia P. Jonson," Queer Spaces: nine street signs commemorating gay and lesbian activism in NYC, 1994.

we used individually designed graphics and researched texts mounted on rectangular metal blanks. Except in *Queer Spaces*, which was produced in collaboration with the Storefront for Art and Architecture to memorialize the 1969 Stonewall uprising, and consisted of nine uniform signs using text that was screened onto a pink triangle made of chipboard. [Figure 5.5.]

All in all, *REPOhistory* carried out a decade's worth of varied, public-art activity as both local and geopolitical realities underwent dramatic shifts.

DD: Why focus on history?

GS: I think everybody in the collective would have a different answer for you and that is characteristic of how the group operated: more through collective differences than any compulsory accord. When we first began to meet, some people were already involved in discussions about countering the upcoming Columbus Quincentenary celebrations (and that ultimately did frame our first project as I mentioned before). My own interest was focused on the ways in which history is represented by the "victorious," as Walter Benjamin points out, and how to develop a counter-history from "below."

But there is also a more matter-of-fact answer to your question "why history?" By the late 1980s many formal artistic issues once so dominant in the post-war era were, for a complex set of reasons, less and less tenable. Suddenly it seemed possible to reinvestigate oppositional art and culture and locate marginal histories within New York City—the very center of artistic power, which made me at least feel truly subversive, at least for a while.

One important inspiration for *REPOhistory* was *Points of Reference 38/88*, an exhibition organized by Werner Fenz for the city of Graz, Austria. In 1988 Fenz invited a group of international artists and had them install temporary memorials around the city marking its notorious Nazi past (thus the reference: 1938/1988). Artists such as Dennis Adams and my former professor Hans Haacke were included in the project. Notably, neo-Nazis firebombed Haacke's public work sometime after its completion. It seemed that some historical points of reference remain alive, like nerve-ends, just beneath the surface. Fenz's Austrian-based project also seemed like such an interesting format for New York

City. No, we don't have a Nazi past, but we certainly have layers and layers of interesting history.

All of which is to say there is nothing terribly original about the idea of *REPOhistory*: its structure is simple and can be applied elsewhere. It's really a DIY [Do It Yourself] approach to public art and to historical research, and perhaps that is what most links our work to a certain kind of street art, the Situationist International, and the often antagonistic stance of punk culture, as opposed to formalist notions of detached high art.

DD: What were the goals of *REPOhistory*?

GS: Our aim was to "retrieve and relocate absent historical narratives at specific locations in the New York City area through counter-monuments, actions and events." We asked: why is it that some histories are invisible, while others are all too visible? We (semi-naïvely) asked why are George Washington and Ben Franklin memorialized in public sculpture, while an admired radical politician of the 1930s such as Vito Marcantoni goes unmarked and virtually forgotten? Our early research also revealed for instance that the stock exchange was established in 1792 not far from the location of the city's slave and meal [grain] market. While a bronze marker indicating where the stock traders first met has been installed near an old Buttonwood tree at 68 Wall Street, the site of the nearby slave exchange was, and remains, invisible to passersby. That is except for one year in the summer of 1992 when *REPOhistory* marked the site. A significant part of what we wanted to accomplish therefore involved challenging the rules, hidden or merely tacit, that allow some things, some events, some people to be visible, and others to be consigned to the shadows.

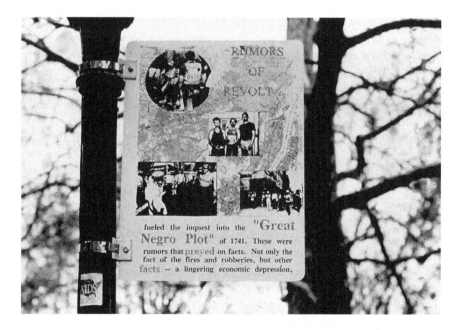

Figure 5.6 REPOhistory, "The Great Negro Plot of 1741 New Amsterdam," LMSP, 1992.

DD: Can you speak about some of the projects *REPOhistory* undertook, in particular your process of working? Given that most of the projects were conceived for public spaces, how did you think about your audience?

GS: The working process for most of these projects followed a similar pattern. The core working group would develop the historical profile of a proposed project's subject matter by combing through both official as well as alternative historical resources. After that we would put out the word to collaborators, asking them to join us in exploring the particular thematic concept of a new project. When someone showed interest, we provided the prospective collaborator with a packet of documentation, but we also encouraged each artist to do their own research and submit these ideas to us. No one was excluded, no proposals rejected. Which is to say that *REPOhistory* projects were not "curated," but developed out of a group effort. There were, however certain technical specifications for each project such as the shape and dimension of each sign, as well as the size and style of the typeface artists were to use. The group wanted some visual cohesion to the entire project of course, but some of these specifications were simply practical.

Whenever possible, we also took advantage of friendly experts interested in our work. During the production of the *Lower Manhattan Sign Project* for instance, we ran the texts of the signs by a team of social historians associated with the Municipal Art Society just to be sure our work was as accurate as possible. That said, and I think this is very important to note, *REPOhistory* was really about a process of taking responsibility for uncovering, writing, and visually representing history essentially from a multi-faceted, subaltern perspective.

DD: Why did you choose to take history into the public sphere?

GS: Well, history is already in the public sphere. Our self-appointed job was simply to illuminate that fact. But the idea of exposing invisible histories was, for most of us, not intended to be about producing a novelty experience, you know, like, "isn't it amusing that this fill in the blank: colorful immigrant neighborhood, quaint sailors' hangout, lascivious red light district, was once located at this very spot?" Instead, for most of us in *REPOhistory* I believe, the idea of exploring the past was about upsetting the assumptions of the present. History was merely a critical tool for addressing contemporary issues of social justice. That is why we focused on the historical roots of racism, sexism, gentrification, colonialism, economic inequality, and personal and sexual liberation among other issues.

DD: What is the importance of aesthetics in telling histories?

GS: Aesthetics is of course a tricky term under any circumstances, and more so when dealing with the artistic production of a group, rather than an individual. *REPOhistory*'s street-sign projects directly called out to the passersby.

A particular kind of aesthetic pleasure was generated by the way *REPOhistory* mimicked the authority of urban signage such as traffic signs. This act of impersonation also had a practical side. One reason we met with so few bureaucratic "speed bumps" in 1992 was

because our work didn't fit the patterns and molds city officials were familiar with. Was *REPOhistory* an art project? (negative connotations); a commercial venture? (not likely); or was it an educational project? (positive connotations). In truth, *REPOhistory* slid back and forth between different frameworks of knowledge and expectation. No doubt, people who walked down the street and encountered a *REPOhistory* sign probably never thought of it as an art project at all. This sort of mimicry—reproducing the appearance of things including the labor of other workers as well as social institutions—is the principal freedom artists are permitted by the State, although it is a liberty given reluctantly, often as a means of gaining control over the symbolic order. Recall that Plato initially banished artists from the Republic because artists have the capacity to deceive innocent citizens with their work!

I like to think some of the work of *REPOhistory* also belongs to a socially engaged artistic tradition, which is another kind of aesthetic experience. Socially engaged artistic practice is pedagogical in that the artists deliberately address the public in order to transform people's understanding of their world and particular historical events.

DD: Clearly, education is a major component of *REPOhistory*'s mission, and I know that a lot of the *REPOhistory* projects involved working directly with middle and high school students in both public and private schools. What was the impetus for getting middle/high school students involved in the projects and why was the school component important to *REPOhistory*?

GS: I would say every project had at least one if not a couple of high school oriented projects involved, and they were often interdisciplinary so we would get involved with a history teacher and an art teacher, let's say, and try to bring those together because that's kind of what we were doing. Many of the people that were involved in this project were already educators to begin with. We also saw the whole concept of *REPOhistory* as a basic way for anyone to get involved in history, citizens and non-citizens included, but certainly students as well. Working with students to reclaim some aspect of their public space and confront something they didn't know about seemed like a perfect way to teach history. We saw artwork as a kind of pedagogy oriented to the person in the street, but also to the city. I think the idea of getting all kinds of people engaged with rereading the spaces that they thought they knew, which is a kind of pedagogy of the everyday, was vital to the project.

REFERENCES

Benjamin, W. (1955). *Illuminations: Walter Benjamin essays and reflections*. London: Verso.
Stearns, P. N., Seixas, P., & Wineburg, S. (2000). Introduction. In P. N. Stearns, P. Seixas, & S. Wineburg (Eds.), *Knowing, teaching, and learning history: National and international perspectives* (pp. 1–14). New York: New York University Press.

Investigating History and Art

A Teaching Toolkit

Introducing the Teaching Toolkits
Visual Approaches to Teaching about History

In the second part of *History as Art, Art as History*, we move from theory to practice, offering a set of pedagogical tools for teaching standards-aligned historical content in a way that is meant to draw upon and deepen students' visual literacies and critical thinking skills. These strategies are the product of several years of research and experimentation, and they are intended to provide—even for history teachers who have little experience teaching with visual art, or art teachers who have limited historical knowledge—a set of structures for teaching visual and historical thinking skills in secondary classrooms. We do not believe that introducing students to either visual or historical literacies requires teachers to learn entirely new pedagogical skills; rather, we have designed instructional suggestions that are meant to build upon the critical strategies that many teachers already employ.

Drawing upon the ideas we explored in the previous part of this book—public art as public history, artists engaged with historical methods, teachers crossing disciplinary boundaries in the classroom, and heuristics for engaging art in the history classroom—we offer a sampling of methods for using critical visual strategies with students. We call these samplings "Teaching Toolkits." Because we know that each teacher comes to this work with particular pedagogical goals and interests, and faces distinct pressures, we have not attempted to provide a complete guide to teaching the entire U.S. history curriculum. Instead, we have developed a series of resources, provocations, suggestions, and invitational activities meant to offer a set of visual and historical lenses through which to integrate works of visual art and primary historical documents in the classroom. Our hope is that these resources and suggestions can serve as an additional set of tools that any history or art teacher might add to the pedagogical toolbox they have already developed.

HOW IS THIS PART ORGANIZED? WHAT IS IN THE TOOLKITS?

The resources in this part are presented in three thematically organized chapters. Each chapter addresses a broad theme related to the study of U.S. history: Foundations of

Citizenship, Constructing Race, and The United States and the World. For each theme, we address two related topics that provide different ways to consider the theme through a particular historical moment or issue. For each of these topics we have developed a "Teaching Toolkit" that consists of three overarching elements.

First, we present a short historical essay (the Historical Introduction), meant to introduce some of the important debates that have animated historians' interest in this topic.

Second, we offer a "mini-archive" akin to the online archives that David Jaffee (2006) developed for his students. (These archives, and Jaffee's work, are discussed in greater detail in Chapter 2.) The mini-archives contain a collection of primary historical documents, and reproductions of artwork by two contemporary artists, all of which speak directly, in some way, to the historical theme that organizes each section. For instance, the first section of Chapter 9 examines the history of "Westward Expansion" in the nineteenth-century U.S. For this section, we have developed a mini-archive that features works of art by Jaune Quick-to-See Smith and David Avalos (each with an accompanying "About the Art" explanation), as well as four primary source documents related to the history of Indian removal.

Third (and finally), we supply a "Teaching Connections" section, which offers suggestions for teaching with the entirety of this assembled material.

THE HISTORICAL CONTENT

In developing this pedagogical toolkit, we had to make difficult choices about which themes and topics from the U.S. history curriculum to focus on. The topics we present were chosen to ensure an alignment both with state and federal history and art standards, as well as with the creative and practical needs of teachers. Thus, each one of these thematic sections corresponds to the federal and state history and art standards, especially those set down by the National Council for the Social Studies and the National Art Education Association. We append, at the conclusion of each Teaching Toolkit, a short, but specific, accounting of these connections.

Just as we labored to align these curricular resources with the practical demands that make themselves painfully felt in this era of high-stakes testing, we also labored against a pedagogical model that all-too-frequently plagues secondary-level history education and teaching across subject areas—that is, what Grant Wiggins and Jay McTighe (2005), the developers of the *Understanding by Design* method of lesson planning, call the "twin sins" of "coverage" and "activity-based planning" (p. 16). In other words, we attempted to avoid offering up lesson ideas that sounded exciting but in fact had no connection to a set of overarching instructional goals; and we focused on developing topical depth rather than curricular breadth. With these issues in mind, we placed our investigations of these standard U.S. history topics within broader thematic and debate-driven contexts, building outward from both historical debates and arts integration methods that utilize big ideas and essential questions. Thus, we discuss the history of both the U.S. Constitution and Japanese incarceration in the context of historical debates about the meaning of citizenship in the United States; we explore the histories of slavery, abolition, and immigration in the context of debates about U.S. American ideas about race; and we introduce the history of "Westward Expansion" and the U.S. war in Vietnam

in relationship to larger historical arguments about the history of U.S. encounters with the wider world over the course of the past two hundred years. Although this adds an extra layer of content to the Teaching Toolkits, we believe it also adds a crucial level of sophistication to this pedagogical work.

SELECTED PRIMARY DOCUMENTS AND ARTWORK

Our selection of primary documents and works of art was guided by an intentional effort to initiate a dialogue between art and history. By juxtaposing these two kinds of sources, we encountered new epistemological possibilities for teaching about history and considering works of art. Cross-pollinating these disciplines allowed us to break out of the confines of each of our subject areas to find connections and meanings beyond our initial understandings of the particular works of art and the historical events and questions discussed in this book. Issues of citizenship and democratic participation, for instance, take on a new hue when specific language from the Freedom of Information Act and the Bill of Rights is placed alongside paintings based on redacted government documents and photographs of a contemporary monument dedicated to the Freedom of Expression. Likewise, placing the remembrances of the former Secretary of State Robert McNamara and the former U.S. Army Specialist Larry Colburn (who witnessed, and tried to intervene in, the massacre at My Lai) alongside photographs and collages made by artists with a personal stake in the history of Vietnam, suggests new answers to the long-debated question, what are the "lessons" of the U.S. war in Vietnam?

We made a conscious effort to select works of art that had something unusual or incisive to say about the historical topic at hand. We then read these works of art in relationship to related historical writing. What kinds of historical questions does this work of art ask? What kinds of historical arguments does it put forth? How does that build upon, challenge, or add something new to the historical debates that animate historians writing about this topic? Using our answers to these questions as a guide, we then created a collection of visual and historical primary source documents that allowed us to present a unique approach to supporting student investigation into related topics and themes. By placing primary documents in dialogue with contemporary artworks, we suggest new ways of constructing visual knowledge around history. We encourage art educators, history educators, artists and historians to use the intertextual heuristic outlined in Chapter 2 ("Using Visual Historical Methods in K–12 Classroom") to help students begin to see art in a historically contextualized way, and to read primary documents with strategies borrowed from contemporary visual art. This, we hope, will enable educators to consider deploying, in their classroom, new methods and sources, to jump disciplinary boundaries, and to open up disciplinary discussions to make room for a broader community of visual and historical ideas.

TEACHING CONNECTIONS

The final element of each Toolkit is a "Teaching Connections" section. Intended to bring the visual and historical documents that we have collected in our "mini-archives" together with the ideas we introduce in each section's Historical Introduction, the

Teaching Connections sections are grounded in four core goals. First, we want to provide resources that will help teachers educate students to be critical readers of texts and images. We believe that if we are to help young people become adept and engaged citizens in the twenty-first century, we need to find ways to consistently encourage them to develop their abilities to thoughtfully and thoroughly analyze text and images in relation to their own beliefs, related information, and contradictory perspectives. That is to say, we believe that students need to be taught to question the truth and authority of what they see and read. Thus, our instructional suggestions in the Teaching Strategies section orbit around activities meant to help students learn to recognize and investigate the perspective, authorship and intentions of all visual and textual documents. Second, we believe that history is not a set of discrete facts that students should be required to ingest but, rather, a debate about the meaning of the past in the present. Similarly, the study of art history or individual works of art cannot be confined to memorized facts. We are convinced that students can more productively learn all the factual information they will need to pass end-of-the-year standardized exams if they are taught to debate critical questions and concepts instead of simply regurgitating dates, places, and authors. Teaching students to engage with history as a debate also helps them develop an understanding of their beliefs, and deepen their writing and speaking skills. Third, we believe that in order to teach students the skills of critical historical thinking and visual literacy we need to teach them to frame productive questions. In this way, they can begin to organize their curiosity into rich discussions about the meaning of the past, and the relationship between the past and the present. Fourth, we want students to be able to analyze and construct visual arguments that reflect understandings about key historical events and themes.

Each Teaching Connections section consists of three subsections: a Prologue, a statement of Teaching Goals, and a collection of suggested Teaching Strategies.

Teaching Connections: The Prologue

The Teaching Connections Prologue introduces the central visual principle that we use as an interpretive and pedagogical lens in the Teaching Strategies subsection. The visual principles that we introduce in this Prologue (and that we integrate throughout the teaching strategies) are based on six postmodern principles that many of the artists we have included deploy. Our initial inspiration for offering a set of visual principles as an overarching structure for the instructional activities came from an article written by the artist-educator Olivia Gude (2004). Entitled "Postmodern Principles: In Search of a 21st Century Art Education," the article offered a challenge to seven principles— balance, focal point, gradation, movement, proportion, rhythm, and variety—that have informed art education since the turn of the century. These original principles frame the appreciation and understanding of works of art in purely aesthetic terms, devoid of any consideration of content or meaning. Because visual art now includes a much broader range of practices and products—performance, installation, new media, interactive, and public works—these terms are inadequate for helping students learn to appreciate and analyze works of art in the twenty-first century. In her article, Gude proposed eight alternate principles—appropriation, juxtaposition, recontextualization, layering, interaction of text and image, hybridity, gaze, and representing—that, in her view, make

more sense as heuristics to help observers and educators make meaning out of the visual art that artists are making today. These principles, she argued, are more responsive to and descriptive of the work that contemporary artists are making; they are more appropriate to the task of understanding art in our "postmodern" era.

Gude's principles stimulated our own thinking about how strategies for looking at contemporary art could be pedagogically connected to strategies for analyzing history. But because Gude's work does not directly address the kinds of historical questions we were interested in, we modified her original "postmodern principles" and developed six new operative principles. Some, including "juxtaposition," came directly from Gude's original text. Others were modifications or wholesale reinventions. In one case, we took one of Gude's original principles, "appropriation," and altered it slightly to articulate a related principle we call "borrowing." We see these principles as metaphorical hinges: moving pieces that bridge the divide between historical and visual ideas and languages. We believe that they offer yet another interpretive lens useful for structuring classroom dialogue and for encouraging students to ask critical questions about the relevance of the past in their daily lives through the strategies employed by contemporary artists.

The first of these principles is *Borrowing*. In the context of visual art, to borrow means to take elements from an existing image, document, or object and to add, change, or emphasize some aspect of it in order to reimagine the original—and in the process, to create new images and meanings. Artists have always borrowed ideas from other artists, even copying master works as part of their formal training. But during the twentieth century, artists such as Pablo Picasso, Robert Rauschenberg, and Andy Warhol began to more deliberately and pointedly appropriate images from popular culture and other non-art sources to create new, evocative works of art. These days, artists borrow from a dizzying array of sources: from television, advertisements, or newspapers; from archives, primary documents, or memorabilia; from industrial packaging, street signs, office supplies or bureaucratic protocols. Borrowing images and ideas in art has become a way to challenge the very idea of originality, to comment upon the present day, and to reimagine the past.

The second principle is *Juxtaposition*. Juxtaposition is "the act or an instance of placing two or more things side by side" (Merriam-Webster Online Dictionary, 2009, http://www.merriam-webster.com/dictionary/juxtaposition). Artists use the method of juxtaposing images, ideas, and objects as a way to communicate new ideas and suggest unexpected relationships between disparate things. The close proximity of two seemingly unrelated images or objects might encourage a viewer to read them and the space they occupy as a collective or connected event. This act often creates unusual and unanticipated connections that draw attention to, stimulate curiosity and critical thinking about, and raise questions regarding a specific issue or topic. Artists use juxtaposition to establish intentional disruptions; they deliberately create contradictory relationships between images to create new meanings.

Principle number three is *Recontextualization*. Sometimes, just placing a familiar object in an unfamiliar setting can change its meaning. What if you took an ordinary men's urinal and without altering it in any meaningful way, placed it in a gallery exhibition and called it "art"? In 1917, Marcel Duchamp—an artist whose name would come to be closely associated with the art movement known as Dada—famously did just that. He acquired a standard-issue porcelain urinal and submitted it for exhibition at the

Society of Independent Artists in New York City. The work, which he called *Fountain*, created an enormous international sensation—and irreparably changed the way many Westerners defined and made sense of the idea of art. But what, really, had Duchamp created? Through the act of inserting a commonplace object into an uncommon space a new kind of art object was created. The seemingly simple act of recontextualization allowed Duchamp to make a set of complex assertions about the meaning of art, and its relationship to everyday life.

The fourth principle addresses the *Interaction of Text and Image*. Many artists work with text in addition to visual imagery. Most often the text is not inserted to literally explain the image; nor is the image meant to simply illustrate the text. Rather, artists have developed unique ways to deliberately place text together with visual imagery as a challenge, to invite the viewer to explore the possible connections between the two. By bringing together images and words that typically are not associated with one another, artists can encourage us to contemplate, question, make new associations, and explore the contradictions or disruptions between previously unrelated ideas.

The fifth principle is *Mash-up*. This principle borrows from the overlapping worlds of digital experimentation, youth culture, and music. The term "mash-ups" originally referred to the process of digitally combining music from one song with vocal material from another. Collaged together, these disparate tracks become one, integrated track—and also, a new musical form. (Hip-hop music uses similar methods to combine beats, melodies, and lyrics from two or more songs.) Contemporary visual artists—many working in the arena of installation, video, and performance—have adopted the concept of mash-ups to combine and remix diverse sources in the interest of creating unified relationships, new forms, and new ideas. Distinct from the processes of either juxtaposition or layering, mash-ups emphasize the creation of connections among sources rather then highlighting the differences between them.

The sixth and final principle is *Layering*. The word "layering" suggests multiple levels, a combination of materials, an amalgamation of things, bits and pieces sandwiched together, a collection of surfaces that is built one upon the next. This is similar to an idea that lies at the center of critical historical pedagogies: in order to understand the complexity of the past, many scholars argue, students of history must examine the various and multiple layers of historical narratives, and a diversity of perspectives from which all past events were viewed. The medium of collage has a very literal connection to the idea of layering. Collage as a visual technique is defined by the act of bringing together various visual elements and forms to create a new image. The word collage is derived from the French word *coller*, to glue. In this process images stack up on one another, overlap, accumulate. Digitally, one can create multiple layers of imagery with varying levels of transparency using graphic software. In painting, artists literally add layers of pigment to create particular visual or emotional effects.

Each of the postmodern principles we include in this subsection proposes different ways to construct and deconstruct historical and cultural knowledge. These principles offer tangible ways to connect the seemingly discrete fields of history and visual art. Artists may use one or more of these strategies simultaneously in their work and by employing these principles in the service of historical research we suggest that classroom strategies may require one or more principles to guide meaningful investigation.

Teaching Goals

The second subsection included in Teaching Connections is Teaching Goals. Here we identify the Essential Questions, Key Ideas, and Instructional Goals that frame our approach to the topic. Featured questions and ideas are intended to connect the historical introduction to the topic and the Prologue with specific learning strategies included in the final subsection, Teaching Strategies. These are the big ideas that we identify as compelling avenues for inquiry and debate using the mini-archives as source material.

Teaching Strategies

The final subsection of the Teaching Connections section, Teaching Strategies, is subdivided further into "Observe, React, and Respond" (ORR) and "Constructing Visual Knowledge" (CVK). In "Observe, React, and Respond," we present a set of discussion prompts meant to take students from close readings of contemporary artworks and primary documents into broader critical analysis. ORR questions always begin the same way: with a modified example of the "sourcing heuristic" discussed in Chapter 2. That is, they prompt students to consider who the author is, who the audience is, what argument is being put forth, and what the purpose or occasion on which the visual or historical document was created. These questions are followed by more detailed questions that ask students to analyze and discuss the documents in relation to specific essential questions and key understandings. The additional discussion questions are not presented as a sequential set of conversation prompts but can be selected according to particular interests and classroom goals.

After engaging in close reading and discussion of featured documents, "Constructing Visual Knowledge" offers methods for asking students to use the ideas they generated by "Observ(ing), React(ing), and Respond(ing)" to represent their ideas about history through visual means. Here, rather than providing complete lesson plans with explicit procedures and instructions, we describe the suggested activities in general terms, leaving room for individual interpretation and customization within the specific context of different kinds of classrooms. Activities can be grouped to form a unit of potential lessons or can be selected individually to follow up with a particular discussion. These activities were inspired by the working methods and ideas articulated by artists featured throughout the book but we avoided creating activities that mimicked a particular artist's style or product. These activities reflect a process of articulating how the critical methods and investigatory processes of artists can be interpreted to teaching practice. Moving beyond discussion, this subsection also offers strategies for provoking students to make their own visual arguments about the meaning of the past.

SOME NOTES ON TEACHING WITH REPRODUCTIONS OF VISUAL ART

When looking at different types of art we must take into account that experiencing a work firsthand can be a very different experience than viewing a reproduction in a book, especially when the work is three-dimensional, site-specific, or temporal. These differences stem from the fact that being in the same room as a work of art allows you

to define your own view of it: the most compelling angles from which to see it, the closeness or distance that provides the best views and perspectives. When you see a work of art as a reproduction you are forced to use someone else's lens and you are allowed only one view. If the work has many sides you are unable to see all of them. If the work is very large or very small you will be unable to know what it feels like to have it tower over your head or be dwarfed at your feet. These experiences can provide very personal connections to works of art and potentially different interpretations.

Looking at reproductions of artwork in the pages of a book (or on Xeroxes) narrows the range of experiences that a viewer can have with that work. We thought hard about this limitation when selecting the artwork that we include here. Generally speaking, we chose to focus on two-dimensional works (including painting, prints, and photography) as well as some three-dimensional works (such as sculpture, installation, and interactive public works). We intentionally chose not to include temporal media such as videos or performances because of the difficulties of effectively representing and discussing them in the classroom.

Discussing Works of Art

Because most young people are unfamiliar with contemporary art, and most likely new to many of the historical ideas we present, we recommend beginning to teach with the works of art included in the toolkits, and other works you find, with a broad-based descriptive discussion, even before introducing the discussion prompts or activities that we lay out here. This initial discussion should begin to get students thinking as expansively as possible about what they are seeing, in order to anticipate more focused discussions suggested in the Teaching Connections subsection. This preliminary discussion should model the tactical heuristics outlined in Chapter 2: ask students to analyze the work according to what they can see "within the frame" (the people, events, or objects included in the work itself) as well as what they can deduce or research based on information contained "outside the frame" (including how the work was originally exhibited, and who the artist is: biographical information, sources of inspiration, and related work). An initial conversation about a particular work of art will yield a rich body of ideas that can be followed up in discussions incorporating related primary historical documents. You can deploy, in this initial conversation, any number of questions pertaining to what can be seen or understood from looking directly at the work of art itself, including the following:

Looking Inside the Frame

- What do you see? What imagery or symbols do you recognize? What does the imagery remind you of?
- What colors, tones, or textures are included? What do these colors, tones, or textures remind you of or suggest?
- What is the work made out of? Where else have you seen these materials used?
- If there are figures, who might they be? What are they doing and why?
- What places or locations are suggested or depicted in the work?

- How big or small is the work? Why do you think the artist created the work at this scale?
- What smells or sounds would you associate with this work?

Throughout the process of discussing the work, ask students to make educated guesses and to describe why they have certain ideas or opinions: to articulate what visual evidence supports their thinking. Encourage students to draw connections to personal experience, opinions, and prior knowledge and to ask questions of their own. After exhausting what can be seen and understood from looking directly at the work, you might ask students to speculate about what additional information can be understood by considering related contextual questions:

Looking Outside the Frame

- How do you think the work was created or constructed? By whom? Do you think the artist worked alone or there were others involved in the conception and construction of the work? Why? Who?
- Is collaboration an important element of the work? Is audience participation important?
- Where might this work be exhibited? How does where it would be exhibited affect who might see it and what they might think about it?

Some of the works we include in this book are participatory, site-specific, or public. In the case of these kinds of art, we encourage teachers to facilitate a process of imagining what it might be like to interact with these works in person.

- What would it be like to stumble upon this work while going about your daily routines?
- How would seeing the work in a public space be different from seeing it in a museum or gallery?
- What would it be like to walk around the work and experience it from different angles?

Indeed, because you will be using reproductions of all the works of art we feature, two-dimensional as well as three-dimensional, there is a similar need to consider the difference between seeing a work in person and seeing it as a copy. As you look at these reproductions, consider asking these additional questions:

- What would you see, smell, hear, and feel if you were in front of this work, or maybe behind it?
- How do you think the work would look from closer up, from further away?

Finally, encourage students to pose their own questions. Suggest ways to research and add outside knowledge or expertise to the discussion that might further inform or direct their thinking.

Although artists may have specific ideas and intentions when creating works of art, investigating the end results is a very personal and individual process. Many artists consider their work unfinished until it is 'completed' by the audience. In this way, we as viewers create the many meanings that a work can have. These meanings can co-exist with the intentions of the artist, as well as different interpretations made by other viewers. These interpretations are layers of meaning that enrich a work of art. The process of discussing and analyzing a work of art can be connected to the idea of interpreting history as a series of layers or unique perspectives. Multiple stories can be told about any work of art or any moment in time. It is this process of gathering and interpreting different narratives, perspectives, and opinions that allows history to be a dynamic space of ideas rather then a static collection of facts.

The teaching suggestions we offer here are meant, only, to suggest possibilities. There are an infinite number of other journeys one might take. We encourage you to modify, rephrase, reorder or create additional discussion prompts and lesson ideas, and to follow the questions students raise to construct a learning experience tailored to your classroom community and goals. Each classroom discussion will generate a unique collective body of ideas and possibilities for understanding works of art and the histories they are related to. There are no wrong answers. As one experienced art educator has observed, "A group of people brings a breadth of information and experience to the process, even if it is not experience with art," and "the synergy of people adding to each other's observations and bouncing ideas off one another enables a 'group mind' to find possible meanings in unfamiliar images much more productively than any individual alone could do" (Yenawine, 2003, p. 12).

CONSTRUCTING VISUAL KNOWLEDGE IN THE CLASSROOM

Why do we think it is important for teachers to design lessons that allow their students to construct visual knowledge? Since the time of John Dewey the arts have been considered a powerful way of knowing and experiencing the world. Educators such as Maxine Greene (2000) have long argued for the inclusion of arts-based learning in teacher education. Recently, there has been a renaissance among educators and curriculum theorists who argue that the arts offer new ways of thinking about pedagogy because they break through conventional ways of seeing and being, and in fact transform the way we learn and embody knowledge (Crichlow, 2003; Dimitriadis & McCarthy, 2001; Ellsworth, 2005). Although many educators are looking to art as a way of rethinking teaching practices, most content-area teachers—whether "in-service" or "preservice"—rarely think to include art in their lessons. Few pedagogical models exist that help history teachers, for instance, use the visual arts for teaching critical historical literacies based on close investigation of primary source documents. Likewise, the art classroom is still a space where teachers use modernist notions of art that emphasize skills that address formal aesthetic ideas such as line, color, space, and balance rather than including contemporary art practices that use ideas and principles that reflect contemporary, postmodern approaches to making and experiencing art.

At the core of this book is our interest in affecting classroom practice. Although looking at images in a book has its limitations, a book is also a dynamic space that can

bring together images with interpretive text and historical documents. It is this "mash-up" of materials and resources that allow us as authors to suggest what we hope are dynamic and inspiring connections between works of contemporary art, historical themes, and pedagogical practice.

REFERENCES

Crichlow, W. (2003). Stan Douglas and the aesthetic critique of urban decline. In G. Dimitriadis & D. Carlson (Eds.), *Promises to keep: Cultural studies, democratic education, and public life* (pp. 155–156). New York: Routledge Falmer.

Dimitriadis, G., & McCarthy, C. (2001). *Reading and teaching the postcolonial: From Baldwin to Basquiat and beyond*. New York: Teachers College Press.

Ellsworth, E. (2005). *Places of learning: Media, architecture, pedagogy*. New York: Routledge.

Gude, O. (2004). Postmodern principles, in search of a 21st century art education. *Art Education, 57*(1), 6–14.

Greene, M. (2000). *Releasing the imagination: Essays on education, the arts and social change*. New York: Jossey-Bass.

Jaffee, D. (2006). Thinking visually as historians: Incorporating visual methods. *Journal of American History, 92*(4), 1378–1382.

Wiggins, G., & McTighe, J. (2005). *Understanding by design* (2nd ed.). Alexandria, VA: Association for Supervision and Curriculum Development.

Yenawine, P. (2003). Jump starting visual literacy. *Art Education, 56*(1), 6–12.

Foundations of Citizenship

CHAPTER OVERVIEW

Middle and secondary social studies educators, school administrators, politicians, and other observers often argue that one of the primary purposes of K–12 history and social studies education is the creation of strong citizens. Look, for instance, at the National Council for the Social Studies (NCSS)'s formal statement on social studies education: "Social studies is the integrated study of the social sciences and humanities to promote civic competence," the statement reads. "The primary purpose of social studies is to help young people develop the ability to make informed and reasoned decisions for the public good as citizens of a culturally diverse, democratic society in an interdependent world" (NCSS, 1994, p. vii). But it is not just the NCSS that connects history and social studies education to the development of democratic citizenship. Especially in the past several years, a great number of organizations and individuals have debated the question of whether and how to develop history and social studies curricula that also have the power to instruct young people in the arts of "civic competence," "citizenship," "democracy," and "patriotism." (See, for instance, Ayers, n.d.; Bender, Katz, & Palmer, 2004; Brown & Patrick, 2004; Organization of American Historians, 2004; Albert Shanker Institute, 2003.)

In this chapter, we approach the ideas of "citizenship" and "democracy" through a slightly different lens. Instead of asking how we might develop history curricula that will create good citizens, we inquire into the meaning—and engage a set of debates about the history—of citizenship and civic rights in the U.S. What exactly has "citizenship" meant in the U.S. over the past two hundred years?, we ask. In doing so, we hope to provoke, among our readers, a related set of conversations about the idea of history education and civics instruction. What does it mean to teach young people to be strong citizens, exactly? Does it mean we ought to teach students to be good future jurors, military draftees, drivers who pause at yellow traffic lights? To be thoughtful, critical voters? Is the job of an engaged citizen perhaps bigger than simply knowing and observing the law? If so, what might that encompass? And, finally, if history education is about creating engaged

citizens, what about the students in our classes who aren't, and may never become, U.S. citizens? In short, the broad concepts of "Americanness" and "citizenship" are deployed, in the social studies and history content areas, very frequently, and with great gravity. But what, really, do these terms mean? Do they have a history? What controversies surround them?

These are thorny questions, of course, with no established answers. But simply discussing these issues with young people is an act of great importance—each year, even more so.

We have organized this chapter around the broad theme of citizenship in an effort to name and offer up for examination one of the central meta-narratives underlying contemporary social studies education; that is, the discrete story of the U.S. as a nation. By so doing, we mean to call into question two of the fundamental presumptions that attach to the idea of U.S. citizenship and nationality in the context of K–12 social studies/ history education: (1) that U.S. citizenship has always been a unitary category, and (2) that it was experienced equally by all individuals who could claim it. We also hope that this chapter will provoke you—whether you teach art or history—to think about the various ways that you can introduce critical questions about citizenship throughout your curriculum; to consider both the hidden meanings that lurk in the unexamined national framework that structures K–12 history education; and to explore, with your students, the actual contours of democracy as it has developed in the United States.

REFERENCES

Albert Shanker Institute. (2004). *Education for democracy*. Retrieved March 1, 2009, from http://www.ashankerinst.org/Downloads/EfD%20final.pdf

Ayers, E. (n.d.). The next generation of history teachers: A challenge to departments of history at American colleges and universities. Retrieved December 12, 2007, from http://www.historians.org/pubs/free/historyteaching

Bender, T., Katz, P.M., & Palmer, C. (2004). *The education of historians for the twenty-first century*. Urbana: University of Illinois Press.

Brown, S. D., & Patrick, J. J. (2004). History education in the United States: A survey of teacher certification and state-based standards and assessments for teachers and students. Retrieved December 12, 2007, from http://www.historians.org/pubs

NCSS (National Council for the Social Studies). (1994). *Expectations of excellence: Curriculum standards for social studies*. Silver Spring, MD: National Council for the Social Studies.

Organization of American Historians. (2004). History, democracy, and citizenship: The debate over history's role in teaching citizenship and patriotism. Retrieved February 22, 2009, from http://www.oah.org/reports/tradhist.html#_ednref98

SECTION 1: THE CONSTITUTION AND U.S. GOVERNMENT

I: Historical Introduction

The subjects of the Constitution and the American Revolution are, in a sense, ground zero for public debates about the teaching of U.S. history. How we teach about the founding documents of the nation that is controversially the world's only superpower matters to a great many people. Perhaps for this reason, the history of the Founding of the U.S. is one of the most overresourced and most discussed topics in K–12 U.S. history. It is also one of the most poorly conceptualized of these topics. All too often instruction in the Founding of the U.S. becomes an occasion to repeat one-dimensional myths about the nation's heritage. But just like every other topic of U.S. history, the era of the American Revolution and the historical foundations of the U.S. Constitution should be taught, even at the K–12 levels, through the lens of critical questions and multiple perspectives. It should be subject to debate and dialogue.

This topic is a tender, complex, and politically charged one, and it has a long history of its own. Perhaps most memorably, the acrimonious "history wars" of the 1990s turned on debates about the history and meaning of the Founding (and the Founding Fathers) of the United States (Nash et al., 1997, p. 3). The current, heavily standardized educational climate meanwhile features efforts to ensure that the nation's students learn "traditional American history" and stories that affirm the righteousness of the American way of life.[1] And although these debates pose a challenge to teachers' efforts to build their students' critical thinking skills, there is, hiding in this cloud of difficulty, some very good news: federal and state history standards actually leave room for complicated investigations into the foundations of U.S. government and citizenship. (See p. 119 for a list of related NCSS standards.) Armed with good questions and a critical approach, K–12 teachers can easily use these openings in the standards as tools to help them frame critical investigation into the structures of U.S. democracy.

In this section we provide a set of resources that frame a series of investigations into several of those rights that Americans often consider to be among the "most basic" of rights under a democracy, including Freedom of Speech, Freedom of Information, and Freedom of Assembly. The "mini-archive" that we have assembled as the basis for these investigations contains primary documents and photographs of public, street-side installations, each of which raises a set of questions about the history and contemporary state of Americans' Constitutional rights, especially the rights claimed under the First Amendment.

First, we include, here, the text of the Bill of Rights. Many of the rights that American claim as their "constitutional" rights are contained in this "document" (the Bill of Rights is not, actually, a document, but rather, the first ten amendments to the U.S. Constitution): freedom of speech, assembly, and religion; freedom from unreasonable search and seizure; the right to a speedy trial; and the right to a trial by jury, among others. Although these rights are familiar and easy to repeat, they are, in fact, quite difficult to define, and have been the source of a great number of debates over the centuries. What, for instance, is "speech"? What constitutes an "unreasonable" search? Is the federal government ever permitted to suspend or limit U.S. citizens' access to these rights? The U.S. past is filled with moments when these questions, among others, were fiercely debated—up to the highest levels of government.

Questions about the meaning of the rights contained in the Bill of Rights nearly ripped the nation apart as early as 1798. In the 1790s, the U.S. was edging toward the brink of war with France, and it was in this context that President John Adams and Congress passed a set of laws meant to limit the rights of individuals living in the U.S. (both citizens and non-citizens), called the Alien and Sedition Acts. These Acts, for one thing, placed express limits on freedom of speech, making it illegal to "write, print, utter or publish . . . any false, scandalous, and malicious writing or writings against the government of the United States" (Stone, 2005, p. 37). It also made it legal for the President to "seize, detain, and deport" any non-citizen that "he deemed dangerous to the United States," whether they were subjects of an enemy nation or not. Wildly controversial, these Acts raised, for the first time in the nation's history, debate over the meaning of the U.S.'s constitutional rights; about liberty, repression, and dissent in a democracy, especially in wartime; and about whether the rights laid out in the Constitution apply to non-citizens. "Although the context change[d] from 1798 to 1861 to 1917 to 2004," the Constitutional historian Geoffrey Stone has written, these same questions have recurred in nearly every generation (Stone, 2005, p. 17).

These debates have gained new meaning in the past several years, as the U.S. engaged in a global "War on Terror," and passed a set of laws—most notably, the USA PATRIOT ACT (in 2001 and 2006)—that, once again, place strict limits on the rights of both citizens and non-citizen immigrants. And once again, these questions have sparked a passionate debate. Supporters of the USA PATRIOT ACT have argued that national security during wartime necessitates limitations on domestic civil liberties. Meanwhile, the law's critics argue that dissent is a critical element in a democracy, even in wartime, and that, in great measure, the purpose of the Constitution is to protect democracy, especially in times of crisis.

Jenny Holzer's recent investigations into freedom of speech and freedom of information in wartime offer very visual—but also very historically specific—doorways into the meaning of this debate in contemporary U.S. political life. Her work, which features giant public projections of heavily censored government documents that she obtained using the Freedom of Information Act, asks a range of questions about civil rights, public outrage, and public action. By projecting images of official documents that have been released for public viewing only after heavy censorship, Holzer seems to be asking street audiences to wonder about the state of our Constitutional rights. If the government will not show us the documents that detail exactly how and why it is suppressing dissent, how will we know if this suppression is justified?

The primary source documents we present offer, we hope, some context for debating Holzer's piece, the USA PATRIOT ACT, the Freedom of Information Act, and related matters. In addition to the Bill of Rights, we also offer here excerpts from the Freedom of Information Act, which was passed in 1966 and amended several times, including in 2002. This Act gives all U.S. citizens the right to petition agencies of the federal government. "The Freedom of Information Act is one of the glories of American democracy," notes Tom Blanton, executive director of a non-profit historical group called the National Security Archive. And yet, he explains, just "like democracy," "making the law actually work requires real effort both inside and outside of government" (Blanton, 2008, p. 5). Among other things, as you will notice in the text of the document itself, the Act includes a great number of exemptions. Federal agencies can refuse to release

information about their activities on any number of vaguely delineated grounds, including if releasing information threatens "national defense or foreign policy," "could reasonably be expected to interfere with enforcement proceedings," or discloses "trade secrets." Holzer's public projects demonstrates just how partial our right to government information often is. And it raises questions about what our duty, as citizens, might be in the face of this fact.

Next, we feature two documents that introduce the two sides of the debate over the Patriot Act. On the one hand, we present a flyer that was produced and distributed by the American Civil Liberties Union in the immediate aftermath of the Patriot Act's passage. This flyer details what lawyers for that group considered to be the multiple ways that the Patriot Act "violates the rights extended to all persons, citizens and non-citizens, by the Bill of Rights"—freedom of speech, and freedom from unreasonable search and seizure, among others. The flyer also suggests that citizenship in a democracy requires active engagement on the part of citizens themselves. It urges those "organizations and individuals concerned with protecting our civil rights and civil liberties" to "join . . . [the] effort to regain our hard-won freedoms." "Support a resolution in your city rejecting the USA PATRIOT Act." "Contact your elected representatives . . . , send letters to local newspapers . . . , organize discussions in your schools, organizations and religious institutions."

On the other hand, we offer a document that introduces the perspective of supporters of the Patriot Act, especially those Americans who felt that if the Patriot Act placed limits on civil rights, it did so for good reason. This document is a press release, issued by George W. Bush's administration, announcing the signing of the reauthorization of the Patriot Act in 2006. "This law," the administration argued, "allows our intelligence and law enforcement officials to continue to share information, and . . . will improve our nation's security." These two documents mark the passionate debate that grew up in the aftermath of the Patriot Act's passage, and offer a contemporary frame for questions that Americans have asked since the Founding of the U.S., including:

> Are those who dissent in times of war "disloyal"? Do the demands of war justify the suppression of dissent? How do we distinguish the "real" necessities of war from the partisan exploitation of a crisis? Can we rely upon judges and jurors to preserve civil liberties in the highly charged atmosphere of wartime?
>
> (Stone, 2005, p. 17)

What is the legitimate or proper role of an engaged citizen in a democracy? What rights, exactly, does the Bill of Rights guarantee? These are questions without clear-cut answers. Democratic citizenship certainly requires curiosity, inquiry, and investigation into complicated questions about the meaning of justice. Moreover, as the Constitutional scholar Sanford Levinson has argued, the promise of democracy requires critical examination; it is, he writes, "vitally important to engage in a national conversation about" the Constitution (Levinson, 2006, p. 5). In this section, we offer a selection of resources meant to get you started in the task of provoking your students (or your students' students) to engage in these most democratic of inquiries, and to explore several perspectives on citizenship, civil rights in wartime, freedom of information, and the uses and limitations on freedom of speech.

II: Mini-Archive

Freedom of Expression National Monument by Erika Rothenberg, Laurie Hawkinson, John Malpede

Erika Rothenberg, John Malpede, Laurie Hawkinson,
Freedom of Expression National Monument,
August 17–November 13, 2004.
Foley Square, New York, NY.

SEE Plate 1 and Plate 2, in Insert

Freedom of Expression National Monument captures people's imaginations and invites them to think about freedom of speech, as well as the power and powerlessness of ordinary people.

(Erika Rothenberg, 2008)

In anticipation of the 2004 presidential election a collective of artists, including an architect, a performance artist, and a visual artist, placed a curious object in front of the federal courthouses in New York City. For the four months leading up to the now infamous presidential race between the Democrat John Kerry and the Republican George W. Bush and during the Republican Convention that took place in New York City that year, the *Freedom of Expression National Monument* invited citizens and tourists to express themselves publicly (Figure 7.1). The giant red megaphone mounted on top of an elevated platform solicited everything from screams to speeches, political diatribes to personal secrets. Encouraged by the accompanying plaque to "step up and speak up" (Figure 7.2), art appreciators, residents, foreign visitors, and citizens from many countries were suddenly given an opportunity to be public speakers, to utilize a work of public art as a means of public expression, and to animate the work with their own voices.

First installed in 1984 on an undeveloped plot of land in lower Manhattan and presented as part of the *Art on the Beach* series sponsored by the organization Creative Time and the Lower Manhattan Cultural Council, the *Freedom of Expression National Monument* took on new significance when placed in the locus of federal and state judicial power in the fall of 2004. Offering no script or prescribed expectations for its use, anyone and everyone was encouraged to utilize the Monument in any way they saw fit. A symbolic representation of our First Amendment right to the freedom of speech, this work refocuses our attention on how individuals participate in democratic institutions and how we are able to assert the rights and responsibilities guaranteed to us by the Constitution and the Bill of Rights.

The title of this work suggests a national movement and an enduring monument worthy of monumental status, but there are some contradictions at work. The *Freedom of Expression National Monument* was conceived as a temporary exhibition, sited in a single location, on view for a limited time. In this way *Freedom of Expression* challenges many of the characteristics of traditional monuments that we are more familiar with, such as the monolithic plinth with a long-suffering, heroic, and ultimately victorious figure at its helm. The monuments that exist in our collective memory and understanding are usually permanent fixtures in parks and urban spaces, inert and seemingly lifeless tributes to a long-dead past. The monuments that we are more familiar with, the ones that stand aloof in public parks or motionless in the center of rotaries or other urban non-spaces, are often severed from the very act of public debate and contemporary street life. By situating the *Freedom of Expression National Monument* in the middle of a busy civic space, the traditional monument has

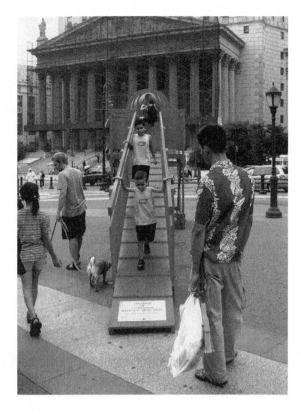

Figure 7.1 Erika Rothenberg, John Malpede, Laurie Hawkinson, *Freedom of Expression National Monument*, August 17–November 13, 2004.

been reconceptualized as an important element of civic dialogue and participation. Simply placing the monument in the middle of judicial power during an election year suggests very specific ways for this monument to be conceived and used. The *Freedom of Expression National Monument* practically pleads not only for broad public participation, but specifically for political involvement.

The power of the *Freedom of Expression National Monument* is in its capacity to help us reimagine the monument as a participatory object that can and should reflect not only the histories it represents, but the perspectives of those who are remembering and thinking about the world in the present tense. The *Freedom of Expression National Monument* offers such a platform. One of the artists, Erika Rothenberg, describes a particular episode during the 2004 installation in Foley Square: "Some very not fun things were happening—the war in Iraq for example—and we had many people yelling about that. I remember one woman in particular who screamed, 'Bring my brother home!'" (E. Rothenberg, personal communication, August 11, 2008).

Unfortunately, a large red megaphone installed in a public space does not guarantee that the people who use it will be heard, or that change will happen. In a climate in which individual citizens have few occasions to extend their voices and opinions in

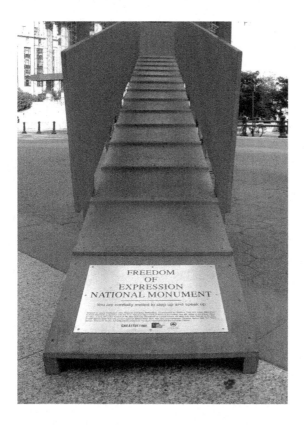

Figure 7.2 Erika Rothenberg, John Malpede, Laurie Hawkinson, *Freedom of Expression National Monument*, August 17–November 13, 2004.

public, the *Freedom of Expression National Monument* symbolically exposes and attempts to bridge the real divide that many people feel from the systems of power and decision making in the United States. The artists describe how the monument inspires feelings of being "both powerful and powerless at the same time" (Rothenberg, 2003). The *Freedom of Expression National Monument* provides an opportunity to express oneself, but also exposes the difficulties of being heard. This is especially poignant as a work of art installed during the Republican National Convention and even more potent given the controversial results of that election year when significant numbers of votes were misplaced, lost, and miscounted. By installing this monument in a political space, during a presidential election, the artists have made a subtle connection between the first amendment right to freedom of speech—or using the broader term *expression*—with the process of voting. As one of the manifestations of asserting the right to speech, voting is one of the primary methods by which individual citizens can make themselves heard by those who represent them.

The *Freedom Monument* exposes some of the contradictions between the utopian ideals of the U.S. Constitution, regarding the freedoms it purports to guarantee, and the realities of representative democracy. Citizens still depend on the structures of government to create and enforce laws and policies, and ideally to have those laws and policies reflect their interests. As citizens stepped up to yell their thoughts and opinions into this cartoon-like megaphone, they were asserting a fundamental right of U.S. citizenship, one protected by the Constitution, but they were not guaranteed any kind of reaction or response, just as many during that election year felt that their votes had disappeared and remained unaccounted for.

The *Freedom Monument* offers an opportunity to ask, what does freedom mean according to the U.S. Constitution and how is it realized by citizens today? The artists who created the Freedom Monument have invited us not only to step up and speak up, but to perform our rights as citizens and to consider how Constitutional rights are enacted in real space and time.

Redaction Paintings by Jenny Holzer

ABOUT THE ART

Figure 7.3 Jenny Holzer, *Wish List Black* (detail, panel 10), 2006.

We wanted some paintings to be pretty enough that you would want to walk up to them and see the terrible things that have transpired in Guantanamo or Afghanistan. Others we wanted to be black and white so they seem credible—as real as the documents unfortunately are.

(Jenny Holzer on the *Redaction Paintings* series,
quoted in Sollins, 2007, p. 2)

Jenny Holzer has always been interested in words. Originally an abstract painter, Holzer started working with text in the 1970s. Presenting "visual poetics" (Holzer in Sollins, 2007, p. 2) in different public and private settings, Holzer is a researcher and writer as much as a visual artist. When Holzer was first whitewashing her text-based posters along New York City streets, artists had already begun to move outside traditional exhibition venues such as museums and galleries. Many artists were interested in reaching a wider public and changing the expectations of that public regarding how art could be seen and defined. Toward those ends, some artists began to work outdoors, in locations where art had never been seen before, utilizing billboards, sidewalks, parking garages, and city bus advertisements. Presenting text in public spaces, Holzer imagined a new paradigm of art that didn't rely on visual imagery alone and highlighted the power of words by recontextualizing them for public audiences.

Inspired by personal and political sources, Holzer works with texts written from her own ideas and experiences as well as those of others involved in world events such as the AIDS crisis, the Gulf War, and the Bosnian/Serbian conflict. Original texts have included terse single sentences and longer essays that range in tone from declarative to instructive, emotional to practical. Her first series of writings, *Truisms* (1979–1983), presented simple statements in black font on multi-colored backgrounds. Hung anonymously, these texts asserted statements such as "Abuse of power comes as no surprise," "All things are delicately interconnected," and "An elite is inevitable." Intended to convey ideas and opinions on a vast range of topics from all possible perspectives, this epic project was also exhibited on T-shirts, outdoor benches, billboards, and even the Spectacolor electronic sign in Times Square, New York. As an extension of these initial public works, Holzer began experimenting with public projections that would allow words to move and dissolve over architectural and natural surfaces including public buildings and bodies of water. Holzer has continued to work with projections and LED signs in public projects such as *Xenon for Berlin* (2001), which projected text from her text series *Laments* and *Erlauf*, as well as *Xenon for Rio de Janeiro* (1999), which presented text from *Truisms* (1977–79), *Survival* (1983–85), and *Arno* (1996).

Redaction Paintings and *For the City* Projection

Most recently, Holzer has collaborated with writers and poets and used language from other sources, specifically declassified documents released by the government under the Freedom of Information Act pertaining to the Gulf War, Abu Ghraib, and U.S. involvement in the Middle East. In the *Redaction Paintings* series—which includes *Wish List Black*, 2006—Holzer presents individual pages of declassified documents culled from publicly available sources including from the National Security Archives, the FBI, and the ACLU. Each page of a selected document is photographed, blown up, and silkscreened onto large canvases. Addressing themes such as torture and military protocol, many of the documents have significant amounts of text blacked out, or redacted. Available words leap out as you try to figure out whether you are looking at an abstract painting or a legible text. There is very little color used in the silkscreen process but the titles of the images often refer to colors. These titles could suggest more conceptual connections to the emotional and symbolic quality of colors and offer another level of interpretive possibilities. Because most of the images are represented in black

and white and reflect the graininess and poor quality of repeated reproduction, they suggest a long history of official bureaucratic protocols—successive efforts to photocopy or mimeograph a single, original document. While you understand that you are looking at a silkscreen print of a copy of a copy, these details also remind you of the authenticity of the documentation you are looking at, and the veracity of the often disturbing information it contains, or that you must assume it contains (Figure 7.4).

In addition to the redacted documents presented on canvas, Holzer has also projected images of the redacted documents onto the facades of buildings. In the public installation *For the City*, 2005 (Light Projections of Declassified Documents, NYU Bobst Library October 3–5), Holzer projected a series of sixty declassified documents onto the exterior walls of Bobst Library at New York University in New York City (Figure 7.5). These projections were joined by other projections of texts from a number of different poets and writers including Wislawa Szymborska, Yehuda Amichai, Henri Cole, and Mahmoud Darwish. Unsuspecting audiences viewed larger-than-life memos, letters, email correspondence, and bureaucratic paperwork periodically marred by ominous swathes of black. These works explore "the need to achieve a just and workable balance between secrecy and transparency" (Creative Time, 2005, para 3). As an artist, Holzer has recontextualized the documents from a political and bureaucratic context in which national security can serve as a justification for concealment, to a public context in which a citizen's right to know trumps the cause of secrecy but is still tempered by eliminated information.

The process of redaction allows the government to withhold details of documents that have been placed in the public record according to the Freedom of Information Act passed by Congress in 1966. Holzer's use of these documents is a very self-conscious act of further publicizing and disseminating information that has been requested by citizens

Figure 7.4 Jenny Holzer, *Colin Powell Green White* (detail, Panel 3 and Panel 4), 2006.

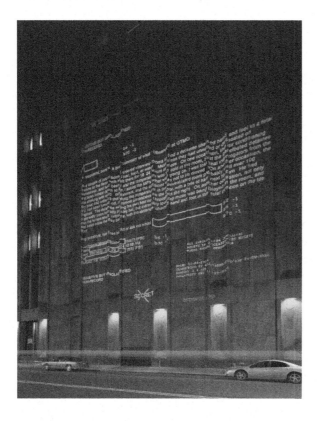

Figure 7.5 Jenny Holzer
For the City, 2005. Light
projections of poetry and
declassified documents.

and independent groups, often against the desires of the government. As an artist, Holzer has asserted a right that all citizens have, and reimagined these documents in a truly public way. Holzer has not changed the content of the documents themselves, but has recontextualized the way we are able to see them: as art objects, as public information, as dark truths about our country and our actions abroad. She has also shed light on a particular quality of citizenship, our right to free speech and our right to know as guaranteed by the U.S. Constitution.

The Freedom of Information Act, as Amended in 2002

(a) Each agency shall make [records] available to the public . . .

(b) This . . . does not apply to matters that are—

(1) (A) specifically authorized under criteria established by an Executive order to be kept secret in the interest of national defense or foreign policy and (B) are in fact properly classified pursuant to such Executive order;

(2) related solely to the internal personnel rules and practices of an agency;

(3) specifically exempted from disclosure by statute (other than section 552b of this title), provided that such statute (A) requires that the matters be withheld from the public in such a manner as to leave no discretion on the issue, or (B) establishes particular criteria for withholding or refers to particular types of matters to be withheld;

(4) trade secrets and commercial or financial information obtained from a person and privileged or confidential;

(5) inter-agency or intra-agency memorandums or letters which would not be available by law to a party other than an agency in litigation with the agency;

(6) personnel and medical files and similar files the disclosure of which would constitute a clearly unwarranted invasion of personal privacy;

(7) records or information compiled for law enforcement purposes, but only to the extent that the production of such law enforcement records or information (A) could reasonably be expected to interfere with enforcement proceedings, (B) would deprive a person of a right to a fair trial or an impartial adjudication, (C) could reasonably be expected to constitute an unwarranted invasion of personal privacy, (D) could reasonably be expected to disclose the identity of a confidential source, including a State, local, or foreign agency or authority or any private institution which furnished information on a confidential basis, and, in the case of a record or information compiled by a criminal law enforcement authority in the course of a criminal investigation or by an agency conducting a lawful national security intelligence investigation, information furnished by a confidential source, (E) would disclose techniques and procedures for law enforcement investigations or prosecutions, or would disclose guidelines for law enforcement investigations or prosecutions if such disclosure could reasonably be expected to risk circumvention of the law, or (F) could reasonably be expected to endanger the life or physical safety of any individual;

PRIMARY DOCUMENT

(8) contained in or related to examination, operating, or condition reports prepared by, on behalf of, or for the use of an agency responsible for the regulation or supervision of financial institutions; or

(9) geological and geophysical information and data, including maps, concerning wells.

Any reasonably segregable portion of a record shall be provided to any person requesting such record after deletion of the portions which are exempt under this subsection. The amount of information deleted shall be indicated on the released portion of the record, unless including that indication would harm an interest protected by the exemption in this subsection under which the deletion is made. If technically feasible, the amount of the information deleted shall be indicated at the place in the record where such deletion is made.

. . .

(f) For purposes of this section, the term—

(1) "agency" . . . includes any executive department, military department, Government corporation, Government controlled corporation, or other establishment in the executive branch of the Government (including the Executive Office of the President), or any independent regulatory agency; and

(2) "record" and any other term used in this section in reference to information includes any information that would be an agency record subject to the requirements of this section when maintained by an agency in any format, including an electronic format.

(g) The head of each agency shall prepare and make publicly available upon request, reference material or a guide for requesting records or information from the agency.

(5 U.S.C. 552. Available at
http://www.usdoj.gov/oip/foiastat.htm)

The U.S. Bill of Rights

Amendment I

Congress shall make no law respecting an establishment of religion, or prohibiting the free exercise thereof; or abridging the freedom of speech, or of the press; or the

right of the people peaceably to assemble, and to petition the Government for a redress of grievances.

Amendment II

A well regulated Militia, being necessary to the security of a free State, the right of the people to keep and bear Arms, shall not be infringed.

Amendment III

No Soldier shall, in time of peace be quartered in any house, without the consent of the Owner, nor in time of war, but in a manner to be prescribed by law.

Amendment IV

The right of the people to be secure in their persons, houses, papers, and effects, against unreasonable searches and seizures, shall not be violated, and no Warrants shall issue, but upon probable cause, supported by Oath or affirmation, and particularly describing the place to be searched, and the persons or things to be seized.

Amendment V

No person shall be held to answer for a capital, or otherwise infamous crime, unless on a presentment or indictment of a Grand Jury, except in cases arising in the land or naval forces, or in the Militia, when in actual service in time of War or public danger; nor shall any person be subject for the same offence to be twice put in jeopardy of life or limb; nor shall be compelled in any criminal case to be a witness against himself, nor be deprived of life, liberty, or property, without due process of law; nor shall private property be taken for public use, without just compensation.

Amendment VI

In all criminal prosecutions, the accused shall enjoy the right to a speedy and public trial, by an impartial jury of the State and district wherein the crime shall have been committed, which district shall have been previously ascertained by law, and to be informed of the nature and cause of the accusation; to be confronted with the witnesses against him; to have compulsory process for obtaining witnesses in his favor, and to have the Assistance of Counsel for his defence.

PRIMARY DOCUMENT

Amendment VII

In Suits at common law, where the value in controversy shall exceed twenty dollars, the right of trial by jury shall be preserved, and no fact tried by a jury, shall be otherwise re-examined in any Court of the United States, than according to the rules of the common law.

Amendment VIII

Excessive bail shall not be required, nor excessive fines imposed, nor cruel and unusual punishments inflicted.

Amendment IX

The enumeration in the Constitution, of certain rights, shall not be construed to deny or disparage others retained by the people.

Amendment X

The powers not delegated to the United States by the Constitution, nor prohibited by it to the States, are reserved to the States respectively, or to the people.

((1791) Available at http://www.ourdocuments.gov/doc. php?doc=13&page=transcript)

White House Press Release: President Signs USA PATRIOT Improvement and Reauthorization Act, March 9, 2006

"The law allows our intelligence and law enforcement officials to continue to share information. It allows them to continue to use tools against terrorists that they used against—that they use against drug dealers and other criminals. It will improve our nation's security while we safeguard the civil liberties of our people. The legislation strengthens the Justice Department so it can better detect and disrupt terrorist threats. And the bill gives law enforcement new tools to combat threats to our citizens from international terrorists to local drug dealers."

—President George W. Bush
March 9, 2006

Safeguarding America:
President Bush Signs Patriot Act Reauthorization

On March 9, 2006, President Bush Signed The USA PATRIOT Improvement And Reauthorization Act Of 2005. Since its enactment in October 2001, the Patriot Act has been vital to winning the War on Terror and protecting the American people. The legislation signed today allows intelligence and law enforcement officials to continue sharing information and using the same tools against terrorists already employed against drug dealers and other criminals. While safeguarding Americans' civil liberties, this legislation also strengthens the U.S. Department of Justice (DOJ) so that it can better detect and disrupt terrorist threats, and it also gives law enforcement new tools to combat threats. America still faces dangerous enemies, and no priority is more important to the President than protecting the American people without delay.

The Patriot Act Closes Dangerous Law Enforcement And Intelligence Gaps.

*The Patriot Act Has Accomplished Exactly What It Was Designed To Do –
It Has Helped Us Detect Terrorist Cells, Disrupt Terrorist Plots, And Save
American Lives.*

- ✧ The Patriot Act has helped law enforcement break up terror cells in Ohio, New York, Oregon, and Virginia.
- ✧ The Patriot Act has helped in the prosecution of terrorist operatives and supporters in California, Texas, New Jersey, Illinois Washington, and North Carolina.

The Patriot Act Authorizes Vital Information Sharing To Help Law Enforcement And Intelligence Officials Connect The Dots Before Terrorists Strike. The Patriot Act enables necessary cooperation and information sharing by helping to break down legal and bureaucratic walls separating criminal investigators from intelligence officers.

The Patriot Act Eliminates Double Standards By Allowing Agents To Pursue Terrorists With The Same Tools They Use Against Other Criminals. Before the Patriot Act, it was easier to track a drug dealer's phone contacts than a terrorist's phone contacts, and it was easier to obtain a tax cheat's credit card receipts than to

PRIMARY DOCUMENT

trace the financial support of an al-Qaida fundraiser. The Patriot Act corrected these double standards – and America is safer as a result.

The Patriot Act Adapts The Law To Modern Technology. The Patriot Act allows Internet service providers to disclose customer records voluntarily to the government in emergencies involving an immediate risk of death or serious physical injury and permits victims of hacking crimes to request law enforcement assistance in monitoring trespassers on their computers.

The Patriot Act Preserves Our Freedoms And Upholds The Rule Of Law. The legislation signed today adds over 30 new significant civil liberties provisions.

The Patriot Act Reauthorization Safeguards Our Nation.

The Patriot Act Reauthorization Creates A New Assistant Attorney General for National Security. By creating a new Assistant Attorney General for National Security, this legislation fulfills a critical recommendation of the WMD Commission. This will allow the Justice Department to bring its national security, counterterrorism, counterintelligence, and foreign intelligence surveillance operations under a single authority.

The Patriot Act Reauthorization Tackles Terrorism Financing. This bill enhances penalties for terrorism financing and closes a loophole concerning terrorist financing through "hawalas" (informal money transfer networks) rather than traditional financial institutions.

The Patriot Act Reauthorization Protects Mass Transportation. This bill provides clear standards and tough penalties for attacks on our land- and water-based mass transportation systems, as well as commercial aviation.

The Patriot Act Reauthorization Combats Methamphetamine Abuse.

The Patriot Act Reauthorization Includes The Combat Methamphetamine Epidemic Act Of 2005. This bill introduces commonsense safeguards that will make many ingredients used in methamphetamine manufacturing more difficult to obtain in bulk and easier for law enforcement to track. For example, the bill places limits on large-scale purchases of over-the-counter drugs that are used to manufacture methamphetamines – and requires stores to keep these ingredients behind the counter or in locked display cases. It increases penalties for smuggling and selling methamphetamines.

(U.S. White House, 2006. Accessed January 19, 2009, from http://www. whitehouse.gov/infocus/patriotact/)

ACLU Patriot Act flyer, 2001–2002

The USA PATRIOT ACT and Government Actions that Threaten Our Civil Liberties

New legislation and government actions take away our freedom

With great haste and secrecy and in the name of the "war on terrorism," Congress passed legislation that gives the Executive Branch sweeping new powers that undermine the Bill of Rights and are unnecessary to keep us safe. This 342-page USA PATRIOT Act was passed on October 26, 2001, with little debate by Members of Congress, most of whom did not even read the bill. The Administration then initiated a flurry of executive orders, regulations, and policies and practices that also threatened our rights.

The USA PATRIOT Act:

Expands terrorism laws to include "domestic terrorism" which could subject political organizations to surveillance, wiretapping, harassment, and criminal action for political advocacy.

Expands the ability of law enforcement to conduct secret searches, gives them wide powers of phone and Internet surveillance, and access to highly personal medical, financial, mental health, and student records with minimal judicial oversight.

Allows FBI Agents to investigate American citizens for criminal matters without probable cause of crime if they say it is for "intelligence purposes."

Permits non-citizens to be jailed based on mere suspicion and to be denied re-admission to the US for engaging in free speech. Suspects convicted of no crime may be detained indefinitely in six month increments without meaningful judicial review.

What rights are being threatened?

First Amendment - Freedom of religion, speech, assembly, and the press.

Fourth Amendment - Freedom from unreasonable searches and seizures.

Fifth Amendment - No person to be deprived of life, liberty or property without due process of law.

Sixth Amendment - Right to a speedy public trial by an impartial jury, right to be informed of the facts of the accusation, right to confront witnesses and have the assistance of counsel.

Eighth Amendment - No excessive bail or cruel and unusual punishment shall be imposed.

Fourteenth Amendment - All persons (citizens and non-citizens) within the US are entitled to due process and the equal protection of the laws.

New Federal Executive Branch Actions

- 8,000 Arab and South Asian immigrants have been interrogated because of their religion or ethnic background, not because of actual wrongdoing.
- Thousands of men, mostly of Arab and South Asian origin, have been held in secretive federal custody for weeks and months, sometimes without any charges filed against them. The government has refused to publish their names and whereabouts, even when ordered to do so by the courts.
- The press and the public have been barred from immigration court hearings of those detained after September 11th and the courts are ordered to keep secret even that the hearings are taking place.

- The government is allowed to monitor communications between federal detainees and their lawyers, destroying the attorney-client privilege and threatening the right to counsel.
- New Attorney General Guidelines allow FBI spying on religious and political organizations and individuals without having evidence of wrongdoing.
- President Bush has ordered military commissions to be set up to try suspected terrorists who are not citizens. They can convict based on hearsay and secret evidence by only two-thirds vote.
- American citizens suspected of terrorism are being held indefinitely in military custody without being charged and without access to lawyers.

What can be done?

This lack of due process and accountability violates the rights extended to all persons, citizens and non-citizens, by the Bill of Rights. It resurrects the illegal COINTELPRO-type programs of the '50's, '60's, and '70's, where the FBI sought to disrupt and discredit thousands of individuals and groups engaged in legitimate political activity.

The American Civil Liberties Union, along with thousands of organizations and individuals concerned with protecting our civil rights and civil liberties, is campaigning to ensure that our rights are not a casualty of the war on terrorism.

Join us in this effort to regain our hard-won freedoms.
- Support a resolution in your city rejecting the USA PATRIOT Act, joining your city with others across the country in upholding the Bill of Rights.
- Contact your elected representatives and the President to express your opposition to the USA PATRIOT Act.
- Send letters to local newspapers. Organize discussions in your schools, organizations and religious institutions.

ACLU
AMERICAN CIVIL LIBERTIES UNION

Become a member of the ACLU. Because freedom can't protect itself. For more information, go to www.aclu.org/safeandfree

Figure 7.6 "The USA PATRIOT ACT and Government Actions that Threaten Our Civil Liberties." Flyer created by the American Civil Liberties Union, 2001–2002, available at www.aclu.org.

III: Teaching Connections

Prologue: Recontextualization as a Visual Framework

The simple act of changing the context typically associated with an object, image, event, or even a primary document can allow us to rethink our presumptions or expectations. Consider how the passage of time changes individual and social ideas. Retrieving something from a previous historical era and placing it in a contemporary context can shed new light on both the historical event itself, as well as our current relationship to a related idea. Another way to recontextualize an object, event, or document is in terms of form or location. By taking a primary document or work of art and literally changing its context—transforming a bureaucratic memo into a painting or placing a sculpture into a public space—we can start new conversations about the definitions and expectations of primary documents and art. More specifically, we can look at how artists have used the strategy of recontexualization to examine the rights guaranteed by the U.S. Constitution and other legislative acts, as well as the enactment of those rights by its citizens.

Although the U.S. Constitution is often considered a historical document, drafted and completed two hundred years ago, it was originally conceived as a living document, designed to respond to the changing times and populations it served. Artists and historians have researched and referenced aspects of the Constitution in the interest of reanimating and questioning our present-day interpretations and understandings of the Constitution. Reading the Constitution today raises questions regarding its adequacy: for guaranteeing the rights of citizens, for protecting those rights, and for setting the expectations a society has about itself and its ideals.

The following subsection provides suggestions for a range of discussions and hands-on activities focused on a critical reading of the U.S. Constitution and corresponding notions of citizenship. These discussions and activities are premised on a thorough reading of all the primary documents and works of art included in the subsection. Suggestions for how to facilitate a discussion about these works of art can be found in Chapter 6. Once you've had a chance to familiarize yourself with all the documents included in the subsection, you're ready to get started with the Teaching Toolkit. Before using the suggestions in the following toolkit, we encourage you to start with a broad-based discussion about the individual works of art in order to help students develop their own observational skills and connections to personal experience and opinion. The Essential Questions, Key Ideas, and Instructional Goals in the toolkits do not represent a set of definitive facts, ideas, or questions, but in and of themselves should be carefully analyzed and considered. This questioning should lead to additional questions, ideas, and pedagogical strategies. The "Observe, React, and Respond" discussion questions and "Constructing Visual Knowledge" activities have been compiled as a set of strategies to be adapted and interpreted for different classroom needs. Again, these prompts are not exhaustive and do not offer a complete guide or lesson plan for teaching about the U.S. Constitution, but instead provide a series of provocations to be combined with many other possible resources, strategies, questions, and outcomes.

Teaching Goals

Essential Questions

✧ What rights does the First Amendment of the Constitution protect? Should there be limits on the right to freedom of speech?

✧ What does the word *citizenship* mean? What does it mean to be an engaged citizen?

✧ What is the role of art in a democratic society? Can art contribute to public discourse about the nature of democracy? Does art have democratic responsibilities?

Key Ideas

Students will understand that:

✧ Artists have used the strategy of recontextualizing images, objects, events, and documents in an effort to provoke debate about the meanings of freedom, citizenship, the Constitution, and the Bill of Rights.

✧ "Public art" refers to art that is specifically designed for, or placed in areas physically accessible to the general public, such as parks and pedestrian plazas or on sidewalks and billboards. Public art often sparks public debate about civic issues or local concerns.

✧ Although the First Amendment grants U.S. citizens the right to freedom of speech, it does not give citizens the right to say whatever they want at all times. There are limits on what kinds of speech are protected and allowed under the First Amendment.

✧ U.S. citizens have different opinions about how much freedom the Constitution actually guarantees to its citizens. Some think that the government places too many limits on citizens' rights to freedom of speech and information, and that we must fight to expand our rights to speak in public and to find out information about activities that our government engages in.

✧ The Freedom of Information Act gives citizens the rights to petition the government for access to its records.

Instructional Goals

Students will:

✧ Critically read and interpret a variety of visual and text-based sources including primary historical documents and works of contemporary art related to the U.S. Constitution and the rights and responsibilities of citizens.

✧ Frame effective questions about how individual rights are guaranteed, protected, and enacted in the United States.

✧ Engage in debate about the freedoms and responsibilities of being an engaged citizen and the role of art in a democracy.

✧ Construct visual arguments that reflect personal/individual understandings about the meanings of citizenship and constitutional rights based on historical knowledge and primary documents.

Teaching Strategies

Use the following prompts, either individually or together, to explore the essential questions and key ideas.

I. OBSERVE, REACT, AND RESPOND

a. Ask students to look at all of the documents and works of art contained in this section. In order to help students explore the ideas contained in these texts and images, ask them to consider the following:

✧ Who is the author of each document or work of art?

✧ What is the argument or idea each author puts forth?

✧ Who might the intended audience be for each of the documents and artworks? That is, to whom, specifically, was each piece initially addressed?

✧ What was the purpose for which, or "occasion" upon which, the documents or artworks were created?

✧ What do each of these pieces suggest about the meaning of freedom and citizenship in the U.S.?

Choose one or more of the following prompts to extend the initial discussion based on a close reading of particular primary documents and artworks.

b. What rights can U.S. citizens claim? What mechanisms—the courts, the press, the electoral process, etc.—guarantee and protect these rights? Based on the works of art presented here, do you think that art and public dialogue about art might play a role in guaranteeing the rights of citizens in

a democracy? How is art a different kind of protective mechanism than, say, the courts?

c. Examine the *Redaction Paintings* (2006) and the public projection *For the City* (2005) made by the artist Jenny Holzer. Contextualize your discussion using the "About the Art" that corresponds to this work. Does Holzer's presentation of heavily censored official documents in new locations (galleries and public buildings) and in new forms (as paintings and projections) change the meaning and significance of the original documents? What do you think she might be trying to say by presenting these documents in public? What do you think the artists who created the *Freedom of Expression National Monument* might have intended by placing their monument to Freedom of Expression in a public space, specifically a public space located in front of a federal courthouse? Does this "monument" make you think about freedom of speech in any new ways?

d. Do Holzer's *Redaction Paintings* (2006) or the *Freedom of Expression National Monument* offer new interpretations or proposals for the ways citizens can participate in society? What do you think these artists are trying to say about, for instance, the rights protected in the Bill of Rights? The Freedom of Information Act? The USA PATRIOT Act? Which work of art do you think is most effective at conveying an argument or idea about the rights of citizens? Why?

a. Ask students to brainstorm their associations with the words *freedom, the Constitution, citizen* and *government*. What other words, examples, images, or symbols do they associate with these concepts? Create a visual chart or web that reflects where the connections and contradictions exist between student associations with these words. Based on this brainstorming, ask the class to collectively create a new declaration of human rights that states not only what guaranteed rights citizens should have, but also what responsibilities citizens have to participate and contribute to a democracy. Have students refer not only to the U.S. Bill of Rights but also to the Universal Declaration of Human Rights and the disciplinary code for your school or school district. Encourage students to work in pairs to independently draft their ideas and then vote on them as a class to compile a collective document. If students choose to use any of the original rights or responsibilities from other sources, have them personalize or update the language to reflect their own understanding and context.

II. CONSTRUCTING VISUAL KNOWLEDGE

Create a final version of the declaration in the form of a zine that combines text and images for each element of the declaration. Xerox and distribute your zine to the school community, to local government representatives, or broader audiences to engage others in debate and discussion.

b. Ask students to look at images of the *Freedom of Expression National Monument* and the text of the Bill of Rights. What Amendment(s) do they think this monument addresses? How? What messages or meanings does this work convey to them? Do students think that this monument successfully engaged the public? Ask them to choose one Amendment from the Bill of Rights either that affects them personally or that they think is endangered. Ask them to write a paragraph about why they believe the rights that their Amendment protects are important. Then ask students to design a "national monument" that addresses this Amendment. What would their monument look like? Where would it be presented, and why? How would their design comment on the Amendment they wanted to monumentalize? How do they want the public to utilize it? What would they name it? You might also look at examples of other public monuments, including local and national monuments like the Vietnam Veterans Memorial in Washington, DC, the Bunker Hill Monument in Charlestown, Massachusetts, and the Jefferson National Expansion Monument (The St. Louis Arch). Or examine other kinds of monuments by contemporary artists such as Krzysztof Wodiczko (see, for instance, his *Bunker Hill Monument Projection, 1998*; Chapter 5, Figure 5.2), *REPOhistory* (see for instance the Lower Manhattan Sign Project; Chapter 5, Figure 5.4), and Do-Ho Suh (see, for instance, *Public Figures*, 1998–1999). As students design their monument or work of "public art," ask them to address the following questions:

✧ Who is your intended audience? (Are they street passersby? Other students in your school? Teachers? Government officials? Someone else?)
✧ What do you want to provoke your audience to think about?
✧ What kinds of visual objects or imagery can you use to help you convey your ideas to your audience?

The monument can be designed on paper or computer, or students can build a small-scale model of their monument out of cardboard or modeling clay. Display the designs in a public location at the school or a local library with an accompanying description and explanation.

Standards

National Council for the Social Studies Thematic Standards

Standard IV. Individual Development and Identity

The learner will…
h) work independently and cooperatively in groups and institutions to accomplish goals;

Standard VI. Power, Authority, and Governance

The learner will…
b) explain the purpose of government and analyze how its powers are acquired, used, and justified;
c) analyze and explain governmental mechanisms to meet needs and wants of citizens, regulate territory, manage conflict, establish order and security, and balance competing conceptions of a just society;

Standard IX. Global Connections

The learner will…
f) analyze or formulate policy statements demonstrating an understanding of concerns, standards, issues and conflicts related to universal human rights.

Standard X. Civic Ideals and Practices

The learner will…
c) locate, access, analyze, organize, synthesize and apply information about selected public issues—identifying, describing, and evaluating multiple points of view;
d) practice forms of civic discussion and participation consistent with the ideals of citizens in a democratic republic;
h) evaluate the degree to which public policies and citizen behaviors reflect or foster the stated ideals of a democratic form of government.

National Visual Arts Standards

Content Standard: 1: Understanding and applying media, techniques and processes
Content Standard: 3: Choosing and evaluating a range of subject matter, symbols, and ideas
Content Standard: 4: Understanding the visual arts in relation to history and culture
Content Standard: 5: Reflecting upon and assessing the characteristics and merits of their work and the work of others
Content Standard: 6: Making connections between visual arts and other disciplines

NOTES

1 See, for instance, the U.S. Department of Education's Teaching American History Grant program, which funds projects that "promote the teaching of traditional American history" (U.S. Department of Education, 2009).

REFERENCES

Art21 (n.d) "For 7 World Trade" & Redactions. Interview with Jenny Holzer. Retrieved June 19, 2009, from Art21 website: http://www.pbs.org/art21/artists/holzer/clip1.html

Blanton, T. (2008). *Effective FOIA requesting for everyone: A National Security Archive guide*. Washington, DC: National Security Archive.

Creative Time (2005). Jenny Holzer *For the City* September 29–October 9, 2005. Press release. Retrieved January 28, 2009, from *Creative Time*, August 29, http://www.creativetime.org/programs/archive/2005/holzer/press.html

Levinson, S. (2006). *Our undemocratic Constitution: Where the Constitution goes wrong (and how we the people can correct it)*. New York: Oxford University Press.

Nash, G., Crabtree, C., & Dunn, R. (1997). *History on trial: Culture wars and the teaching of the past*. New York: Knopf.

Rothenberg, E., in Muschamp, H. (2003). With a dubious idea of freedom. *New York Times*. Retrieved June 18, 2008, from http://query.nytimes.com/gst/fullpage.html?res=9D07EEDE1039F932A0575BC0A9659C8B63&sec=&spon

Sollins, S. (2007) *Art21: Art in the Twenty-First Century 4*. New York: Harry N. Abrams.

Stone, G. R. (2005). *Perilous times: Free speech in wartime from the Sedition Act of 1798 to the War on Terrorism*. New York: Norton.

U.S. Department of Education. (2009). Teaching American History . Retrieved March 1, 2009, from http://www.ed.gov/programs/teachinghistory/index.html

SECTION 2 – JAPANESE INCARCERATION

I: Historical Introduction

The case study we offer up for examination in this section is the event that most of us learned to call "the Japanese internment"; that is, the federally mandated relocation, during World War II, of all persons of Japanese ancestry from the West Coast of the U.S. to land-locked detention centers in the interior. A radical breach of the fundamental principles of a participatory democracy (and more specifically of the U.S. Constitution), the history of Japanese detention telescopes and highlights the uneven history of citizenship in the U.S.; during these years, the U.S. government rounded up and relocated not only non-citizen immigrants, but also large numbers of U.S. citizens. Indeed, of the 120,000 Japanese Americans incarcerated in camps during the war, the vast majority—a full two thirds—were citizens (Ngai, 2004). In the process, these individuals lost almost all of the rights and responsibilities that define "citizenship." Rounded up indiscriminately, they were denied the right to due process. Although they suffered from the general presumption that they were potential Japanese spies loyal to Japan and not to the U.S., none of the interned was accused of a specific crime. They also lost the rights to a trial by their peers, to face their accuser, to the presumption of innocence until proven guilty, to vote, and to the protection of their property that are so clearly laid out in the Constitution. (Forced to abandon or sell their property, their material possessions, and their jobs, many found themselves destitute after the war.) In short, they were denied all the fundamental protections and rights that constitute meaningful citizenship.

The Japanese incarceration—and incarceration is a more accurate term for these events than "internment"—wasn't, of course, the only moment in the American past when some U.S. citizens were prevented from accessing the full protections of their supposed membership in the U.S. nation. Access to the rights and responsibilities of U.S. citizenship has been, from the day the republic was founded, unevenly granted, and has been shaped by debates about race and gender—or, to be more accurate, by white supremacy and misogyny. White, native-born women have always had the right to claim membership in the American nation, but until 1920, they lacked the national right to participate in one of the fundamental features democratic citizenship: the right to vote. Likewise, although African Americans did legally have the right to vote throughout the twentieth century, in many cases, they were not capable of exercising that right. In many states, between the end of Reconstruction (in 1877) and the passage of the Voting Rights Act (in 1965), any black citizen attempting to vote in many states faced penalties ranging from humiliation (in the form of intentionally impossible-to-pass "voter tests") to death (at the hands of white vigilantes).

And yet, although the one-person-one-vote idea stands at the core of the democratic promise, democratic citizenship is more than the right to vote. Classical political theorists argue that democratic citizenship consists of three central elements: the civil, the political, and the social. "Civil" rights encompass the rights to free speech and equal justice; "political" rights include voting and other sorts of political participation; and "social" rights entitle us to economic benefits: social security, Medicaid, and the right to "live the life of a civilized being according to the standards prevailing in the society"

(Marshall, 1973, p. 72). In short, under the rules of U.S. democracy, citizens are entitled to protections that non-citizens cannot claim. Not only can they participate in elections and serve on juries, but they also receive financial support from the government, are entitled to due process and other protective legal rights, have the right to speak freely without penalty, and are protected by the U.S. government when traveling abroad.

More recently, other scholars have suggested that we might add a fourth subcategory to this list: "cultural" citizenship. Cultural citizenship, in short, refers to the idea of national belonging, to the ways that "Americanness" gets expressed outside the formal legal and political structures of a democracy. Although the law is "the discourse that most literally governs citizenship" (to quote the scholar Lisa Lowe, 1996, p. 2), citizenship and belonging also get determined through interactions between individuals in the streets, in the pages of the national news media, on TV, and through popular representations of "America" and "Americanness." That is to say, to quote Lowe again, that "U.S. national culture—the collectively forged images, histories and narratives that place, displace, and replace individuals in relation to the national polity—[also] powerfully shapes who the citizenry is." Asian American history (along with the histories of many other immigrant groups) provides a great number of examples of the ways that cultural citizenship functions to disenfranchise a range of individuals even if they are, formally and legally, U.S. citizens. As Sunaina Maira (2004) recently put it: "Cultural citizenship becomes an important construct to examine because legal citizenship is clearly no longer enough to guarantee protection under the law" (p. 222).

Some observers have protested, in response to this list of rights violations and the disturbing conditions of Japanese incarceration, that the U.S. government was still justified in taking wartime precautions. Didn't Japanese-Americans living on the west coast pose a threat to national security? And doesn't that potential threat override the protections of citizenship? In the years since World War II, historians have proven that at no time did the Japanese immigrant and Japanese-American community pose any sort of threat to the security of the nation. As the historian Roger Daniels has observed, even "a 1981 report by the Presidential Commission on the Wartime Relocation and Internment of Civilians" concluded that the Japanese incarceration "was not justified by military necessity" and that, on the contrary, the decision to relocate these individuals was motivated by "race prejudice, war hysteria, and failure of political leadership" (Presidential Commission, 1981, quoted in Daniels, 1993, p. 3). The U.S. government simply presumed "all Japanese in America to be racially inclined to disloyalty," in the words of Mae Ngai. "Today," she continues, "we call this racial profiling. In 1942 it was said, 'a Jap is a Jap'" (Ngai, 2004, p. 175).

Most historians also recognize that it wasn't simply overzealous wartime hysteria that created the conditions that made the detention of an entire group of Americans possible. On the contrary, this was an event that had its roots in political and cultural dynamics going back to the nineteenth century, if not longer. "The wartime abuse of Japanese Americans," to quote Roger Daniels (1993) again, "was merely a link in a chain of racism that stretched back to the earliest contacts between Asians and whites on American soil"—and especially on the soils of the coastal states of California, Washington, and Oregon (p. 3). From the moment that Asians first began landing in California in large numbers during the mid-nineteenth century, they faced enormous opposition to their full participation in community or national life. Even while they were clearly and

fundamentally helping to build the nation and the communities they lived in—working to construct the transcontinental railroad, growing crops on their farms that would feed other Americans, owning businesses, and doing manual labor of all sorts—they were treated as foreigners. Even as they established large communities and after an entire generation of U.S.-born Japanese- and Chinese-Americans arose in the United States, Asians were still looked upon as foreigners. (For more on this history, see Chapter 8.) The American Anglo elite—both in the state capitals on the West Coast and in Washington, DC—passed a long roster of laws, especially in the late nineteenth and early twentieth centuries, aimed specifically at disenfranchising Asians. Asian immigrants during the Gold Rush, for instance, had to pay a special "miners' tax" (1850); in 1913, the California state legislature made it illegal for non-citizen Asian immigrants to own property (through an act dubbed the "Alien Land Law"); and in 1922, the Supreme Court decided that Japanese immigrants could not become U.S. citizens (*Ozawa* v. *the U.S.*). Meantime, Asians faced violence in the form of mass riots and individual hate crimes up and down the coast. There were a hundred stories of heartbreak and suffering that resulted from each one of these provisions and phenomena.

It was not just non-citizens who suffered from this anti-Asian climate and the legal decisions that hardened within its freezing temperatures. These laws and sentiments had the widespread effect of separating Asian Americans from other Americans. Disenfranchised, forced to pay special taxes, prevented from working in many industries, and subject to brutal violence, Asians found themselves pushed to the margins, regardless of their language skills, their national status, or their educational accomplishments. And in turn, white Americans continued to clump Asians together (without much regard for the diversity within this large category) and to cast them as "foreigners," "immigrants," and "aliens." The result was that even later generations of U.S.-born Japanese- and Chinese-Americans found that they were not considered real "Americans." Dramatic as it was, the Japanese incarceration during World War II was not the first time that Asian-American citizens had their full access to the rights of citizenship interrupted.

So what, exactly, can we learn from this event, and the events surrounding it, about the meaning and histories of "citizenship" in the U.S.? Certainly, there are legal requirements to citizenship, and citizenship does include the rights and responsibilities of voting, serving on a jury, the right to due process, and, sometimes, required military service. But citizenship is far more than this. It is about relating to the people around you, it is about how participation and belonging are imagined in public and private, it is about how the idea of America is imagined and upheld. Indeed, even a citizen's legal rights can, and have been, officially negated and denied, not only during the World War II era incarceration of Japanese-Americans, but at other points in time.

If, as educators, we are trying to teach our students to think critically about the world around them—if we are trying to create, in the words of the educational scholar Samuel Wineburg, "empowered agents"—then teaching about the ways in which the U.S. state has not always upheld democratic principles is a critical piece of K–12 history education. The idea behind this sort of education strategy is not, as some critics might decry, to bash the U.S. It is instead to teach students to think historically about power and rights, and to teach them to be critically engaged participants as they become adults (Wineburg, 2005).

In the pedagogical toolkit that follows, we give you some provocative resources that we think might help you teach the history of the Japanese incarceration through critical questions about the meaning of citizenship in the U.S.

II: Mini-Archive

American Diary by Roger Shimomura

Roger Shimomura, *American Diary: February 3, 1942*, 1997.

Roger Shimomura, *American Diary: April 21, 1942*, 1997.

SEE Plate 3 and Plate 4, in Insert

Most of my artistic career has been fueled by an ever-growing awareness of the unique contributions that the Japanese Americans have made to the social and historic fabric of this country. At the core of that awareness has been my artistic interaction with my immigrant grandmother's diaries, which she began in 1912.
(Roger Shimomura, 2008)

Roger Shimomura is a third-generation Japanese-American artist whose paintings, drawings, mixed media works, prints, installations, and performances explore historic and contemporary experiences of Japanese-Americans. His elaborate visual narratives often juxtapose images from American popular culture with stereotypes of traditional Japanese characters, settings, and motifs. Drawing on his own bicultural experience, Shimomura's artwork often explores the complexity of bicultural identity that requires living with often contradictory ideas about the self and society. The complexity of this existence is captured by Shimomura's compositional method of layering images related to Japanese cultural identity, iconic American symbols and characters, personal history, art history, popular culture, and current events in a single image.

When he was a child, Shimomura and his family were forced into internment camps; first in the Puyallup State Fairgrounds near Seattle, Washington (before the permanent camps were built by the U.S. government), and later at Camp Minidoka in southern Idaho, where he spent two years. After World War II ended, the Shimomura family was permitted to return to Seattle, where Shimomura began his career as an artist. One of the major influences on his artistic practice was the discovery of his grandmother's diaries.

While interned in the camps, and throughout her life, Shimomura's grandmother, Toku Shimomura, kept an extensive personal diary documenting her daily life. Highly regarded as a form of literature in Japan, diaries provide an important source of information documenting the experiences of Americans of Japanese decent during this time. From 1939 to 1945 Toku Shimomura's diary describes her removal from a comfortable middle-class life in Seattle, first to the temporary assembly center, then to a relocation center, before ending up at Camp Minidoka. Toku describes the monotony of

daily domestic routines, the dreary landscape, the extreme weather conditions, and the increasingly stringent rules and regulations that shaped her life at Minidoka, including executive orders for fingerprinting and money allowances.

American Diary Series

Based on these diaries, Roger Shimomura created a series of thirty small paintings and ten prints titled *American Diary*. Each of the paintings in the series is connected to an entry from the diary chronicling events following the bombing of Pearl Harbor in 1941. Shimomura borrows frequently from the strong graphic styles of traditional Japanese Ukiyo-e woodcuts, comic books, and Pop Art, including liberal use of kitsch and irony.

In the work *February 3, 1942* (Plate 3) from the same series, Dick Tracy—the famous comic book detective—examines a shadow of a woman entering a doorway. A dramatic effect is created through the use of bright yellow against which the black figure is outlined. Looking for clues in the same way that Dick Tracy might, we try to determine who the shadowy figure in the doorframe is. Obviously she has something to hide and there is something suspicious about her activities given her shrouded appearance. Including Dick Tracy in the image suggests a powerful figure of authority, one who is recognized as a hero, an arbiter of truth, and a force of good over evil. Toku's diary entry for this day provides more specific context for what these images might refer to:

> When I finally decided to do my fingerprint registration since it had been hanging heavily on my mind. I went to the Post Office with Mrs. Sasaki. We finished the strict registration at 11:00 a.m. I feel that a heavy load has been taken off my mind.

Roger Shimomura has connected the image of Dick Tracy to the government bureaucracy that has suddenly required his grandmother to register as an alien. In compliance with the Alien Registration Act of 1940, Roger's grandmother and all "aliens" over the age of fourteen were legally required to register and be fingerprinted by the government. The shadowy figure in the painting is his grandmother and the government has now passed judgment on her. The playful yet poignant juxtapositions in this artwork suggest questions about what rights we have as citizens in the face of such powerful figures of the state who invoke national security as the rationale for infringing on the rights of citizens.

In his painting for *April 21, 1942* (Plate 4) Shimomura juxtaposes a bucolic view of the snow-capped mountains in Seattle with an image of, taped to a brick wall, the executive order that required all persons of Japanese ancestry to be removed from their homes and sent to "Assembly Centers." His grandmother's diary entry for this date reads:

> At last the order for evacuation was given formally by General DeWitt. There were some limitations to the first move. Kazuao [Toku's son] along with some others will leave here on the 28th as an advanced party. In haste, we prepare for the leave.

By visually cutting the artwork into two distinct images, Shimomura reminds us of the stark difference between Toku's impending transition from freedom to imprisonment. The contrasting images bring into sharp focus the ways an individual's life and the lives

Figure 7.7 Roger Shimomura, *American Diary: April 28, 1942,* 1997.

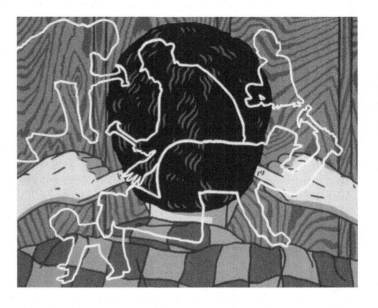

of families and whole cultures can be irrevocably changed through a federal act, simply, and literally, taped to a wall.

In many ways Roger Shimomura not only uses juxtaposition to create images that confront the discrepancies between personal and bureaucratic interests as well as Japanese and American identities, but also uses the idea of layering to construct images that reveal different levels of meaning. Pop Art graphics are layered over deeply personal and serious stories of daily life. Political and governmental references are layered on top of a childhood icon. This use of layering suggests a complex way of looking at the histories that inform Shimomura's paintings. Viewers must negotiate the contradictory yet often overlapping narratives and influences (family history, personal experience, popular culture, etc.) that construct the history of the Japanese who were incarcerated during World War II.

ABOUT THE ART

Postcards from Camp by Ben Sakoguchi

Ben Sakoguchi, "Rohwer, Arkansas" from the series *Postcards from Camp*, 1999–2001.

Ben Sakoguchi, "Heart Mountain, Wyoming" from the series *Postcards from Camp*, 1999–2001.

SEE Plate 5 and Plate 6, in Insert

I've been informed by the complex politics of race and cultural identity, the scope and reach of belief systems, the ways we disseminate, receive and interpret information, and the dynamics of fame and notoriety.

(Ben Sakoguchi, 2008)

Employing a brightly colored palette to his satirical acrylic paintings, Ben Sakoguchi comments on a range of injustices that frame American society including social and political issues and historic events. Drawing on images, texts, and objects from popular culture, Sakoguchi's images provoke the viewer to question conventional beliefs about modern warfare, citizenship, consumerism, and the media. More broadly, Sakoguchi's source material (*LIFE* magazine, movie stills, postcards, and newspapers) suggests that what we learn about events in the United States and around the world is inexorably linked to how we learn about it.

Sakoguchi's series *Postcards from Camp* (1999–2000) is a visual record of daily life in the internment camps that housed Japanese-Americans during World War II. Based on his own experience as a Japanese-American and his early childhood memory in the Poston internment camp in Arizona, each of the eighty picture postcards explores the tensions and contradictions between personal and public memory of this time, as well as the contradictions between propaganda and reality.

Sakoguchi began to work on this series in 1994 when he realized that his father was dying, and continued to work on it after his father's death in 1996. In discussing the project with his mother, he was taken aback when she declared that she had hated every moment of living in the camps, a time that he remembered her as accepting stoically, if not without issue. This disjunction between his memory of this time and her eventual revelations spurred Sakoguchi's interest in re-presenting the historical events of Japanese incarceration from a new vantage point. In this series Sakoguchi draws on primary source materials such as family photographs, documentary images of other internees, texts from media sources, and quotations from collections of Japanese-American internees and government agencies during that time period. The series is grouped into several sections: the prewar Japanese-American community, the evacuation, camp, the achievements of Nisei soldiers during WWII, postwar resettlement, and Asian-American victims of hate crimes in contemporary America.

In the work "Rohwer, Arkansas" (Plate 5), Sakoguchi portrays young Japanese-American boys playing marbles on a sunny day outside their barracks at the Rohwer Camp. It is a picture perfect moment that is often found on postcards in tourist stores. A postal stamp on the postcard indicates the time, place, and date this card was sent to us, the viewers, but also indicates that we are looking at a scene from that time. Below the image of the children is a quote from John J. McCloy, Assistant Secretary of War in 1942, that states: "If it is a question of the safety of the country (and) the constitution . . . why the constitution is just a scrap of paper to me." We are left to wonder where the connections are between this placid image and the distrustful, nervous quote below it. The statement by McCloy suggests that the country is not safe, and that in times of insecurity, drastic measures are required. McCloy refers to the Constitution as a scrap of paper – fragile, malleable, indefensible. His quote hints at the justifications for how the U.S. Constitution was reinterpreted and altered in the context of World War II in order to support the otherwise unconstitutional act of requiring all Japanese-Americans to live in internment camps. Sakoguchi's image suggests that the children who are playing peacefully not only were considered unsafe, but more significantly were seen by the government as the likely cause of the national threat during World War II.

Another postcard mailed from Heart Mountain Camp in Wyoming on April 9, 1945 (Plate 6), is reminiscent of a group photograph taken at a tourist site. The image shows

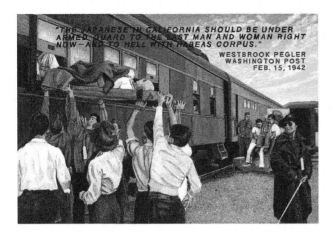

Figure 7.8 Ben Sakoguchi "To Hell with Habeas Corpus" from the series *Postcards from Camp*, 1999–2001.

Figure 7.9 Ben Sakoguchi "Shikata ganai" from the series *Postcards from Camp*, 1999–2001.

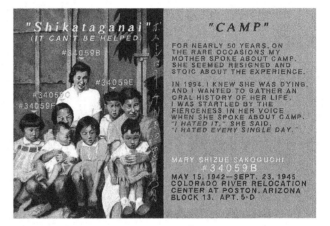

a group of Japanese-American men and women neatly dressed standing in front of a U.S.O. barrack. The terrain is rugged and isolated. Additional barracks in the same drab grey stretch in a single line as far as the eye can see in the distance. The figures in the image smile for what might be an unseen camera while groups of other Japanese-Americans walk on either side of them. Apart from the festive U.S.O. sign and the military style hats worn by several of the men, you might be tempted to think the image represents the activities at a summer camp or other recreational site. Beneath this snapshot moment is a quote from Henry L. Stimson, the U.S. Secretary of War in 1942, that states, "Their racial characteristics are such that we cannot understand or even trust the citizen Japanese-American." In this image Sakoguchi is integrating a more insidious and derogatory perspective on the sentiments that paved the way to Japanese incarceration. Stimson's quote reflects the ways that fear after Pearl Harbor day, after the direct attack on American soil by the Japanese military, encouraged government officials to incite prejudice as a means of justifying the *alteration* of the Constitution and the rights it guarantees citizens. The visual emphasis of the nationalistic U.S.O. sign suggests obvious contradictions between the American ideals of liberty, justice and equality and the period during World War II when those ideals were available for only certain kinds of citizens.

Sakoguchi deliberately uses the format of the picture postcard, a common symbol of travel and leisure, to shift our thinking about this period of time among multiple perspectives. In his particular wry manner, Sakoguchi forces the viewer to witness this national injustice and to confront the justifications and attitudes that led the United States to compromise the rights of its citizens in a time of war. By strategically layering fragments of texts from military officials and politicians holding senior-level positions in the government with images of daily life in the internment camps and his own visual use of the postcard format, Sakoguchi's images are ironic representations of American history—literally postcards of our past that are mailed to us today, challenging our understanding of this particular moment in U.S. history.

Executive Order No. 9066, Authorizing the Secretary of War to Prescribe Military Areas. Issued by President Franklin D. Roosevelt on February 19, 1942

Whereas the successful prosecution of the war requires every possible protection against espionage and against sabotage to national-defense material, national-defense premises, and national-defense utilities as defined in Section 4, Act of April 20, 1918, 40 Stat. 533, as amended by the Act of November 30, 1940, 54 Stat. 1220, and the Act of August 21, 1941, 55 Stat. 655 (U.S.C., Title 50, Sec. 104);

Now, therefore, by virtue of the authority vested in me as President of the United States, and Commander in Chief of the Army and Navy, I hereby authorize and direct the Secretary of War, and the Military Commanders whom he may from time to time designate, whenever he or any designated Commander deems such action necessary or desirable, to prescribe military areas in such places and of such extent as he or the appropriate Military Commander may determine, from which any or all persons may be excluded, and with respect to which, the right of any person to enter, remain in, or leave shall be subject to whatever restrictions the Secretary of War or the appropriate Military Commander may impose in his discretion. The Secretary of War is hereby authorized to provide for residents of any such area who are excluded therefrom, such transportation, food, shelter, and other accommodations as may be necessary, in the judgment of the Secretary of War or the said Military Commander, and until other arrangements are made, to accomplish the purpose of this order. The designation of military areas in any region or locality shall supersede designations of prohibited and restricted areas by the Attorney General under the Proclamations of December 7 and 8, 1941, and shall supersede the responsibility and authority of the Attorney General under the said Proclamations in respect of such prohibited and restricted areas.

PRIMARY DOCUMENT

I hereby further authorize and direct the Secretary of War and the said Military Commanders to take such other steps as he or the appropriate Military Commander may deem advisable to enforce compliance with the restrictions applicable to each Military area hereinabove authorized to be designated, including the use of Federal troops and other Federal Agencies, with authority to accept assistance of state and local agencies.

I hereby further authorize and direct all Executive Departments, independent establishments and other Federal Agencies, to assist the Secretary of War or the said Military Commanders in carrying out this Executive Order, including the furnishing of medical aid, hospitalization, food, clothing, transportation, use of land, shelter, and other supplies, equipment, utilities, facilities, and services.

This order shall not be construed as modifying or limiting in any way the authority heretofore granted under Executive Order No. 8972, dated December 12, 1941, nor shall it be construed as limiting or modifying the duty and responsibility of the Federal Bureau of Investigation, with respect to the investigation of alleged acts of sabotage or the duty and responsibility of the Attorney General and the Department of Justice under the Proclamations of December 7 and 8, 1941, prescribing regulations for the conduct and control of alien enemies, except as such duty and responsibility is superseded by the designation of military areas hereunder.

Franklin D. Roosevelt
The White House,
February 19, 1942

(Available at http://www.ourdocuments.gov/doc.php?flash=false&doc=74&page=transcript)

Instructions to all persons of Japanese ancestry, May 3, 1942

WESTERN DEFENSE COMMAND AND
FOURTH ARMY WARTIME CIVIL CONTROL ADMINISTRATION
Presidio of San Francisco, California
May 3, 1942

Instructions to all persons of Japanese Ancestry Living in the Following Area:

All of that portion of the City of Los Angeles, State of California, within that boundary beginning at the point at which North Figueron Street meets a line following the middle of the Los Angeles River; thence southerly and following the said line to East First Street; thence westerly on East First Street to Alameda Street; thence southerly

on Alameda Street to East Third Street; thence northwesterly on East Third Street to Main Street; thence northerly on Main Street to First Street; thence north- westerly on First Street to Figueron Street; thence northeasterly on Figueron Street to the point of beginning.

Pursuant to the provisions of Civilian Exclusion Order No. 33, this Headquarters, dated May 3, 1942, all persons of Japanese ancestry, both alien and non-alien, will be evacuated from the above area by 12 o'clock noon, P. W. T., Saturday, May 9, 1942.

No Japanese person living in the above area will be permitted to change residence after 12 o'clock noon, P. W. T., Sunday, May 3, 1942, without obtaining special permission from the representative of the Commanding General, Southern California Sector, at the Civil Control Station located at:

Japanese Union Church,

120 North San Pedro Street,

Los Angeles, California.

Such permits will only be granted for the purpose of uniting members of a family, or in cases of grave emergency. The Civil Control Station is equipped to assist the Japanese population affected by this evacuation in the following ways:

1. Give advice and instructions on the evacuation.
2. Provide services with respect to the management, leasing, sale, storage or other disposition of most kinds of property, such as real estate, business and professional equipment, household goods, boats, automobiles and livestock.
3. Provide temporary residence elsewhere for all Japanese in family groups.
4. Transport persons and a limited amount of clothing and equipment to their new residence.

The Following Instructions Must Be Observed:

1. A responsible member of each family, preferably the head of the family, or the person in whose name most of the property is held, and each individual living alone, will report to the Civil Control Station to receive further instructions. This must be done between 8:00 A. M. and 5:00 P. M. on Monday, May 4, 1942, or between 8:00 A. M. and 5:00 P. M. on Tuesday, May 5, 1942.
2. Evacuees must carry with them on departure for the Assembly Center, the following property:

 (a) Bedding and linens (no mattress) for each member of the family;
 (b) Toilet articles for each member of the family;

PRIMARY DOCUMENT

(c) Extra clothing for each member of the family;

(d) Sufficient knives, forks, spoons, plates, bowls and cups for each member of the family;

(e) Essential personal effects for each member of the family.

All items carried will be securely packaged, tied and plainly marked with the name of the owner and numbered in accordance with instructions obtained at the Civil Control Station. The size and number of packages is limited to that which can be carried by the individual or family group.

3. No pets of any kind will be permitted.
4. No personal items and no household goods will be shipped to the Assembly Center.
5. The United States Government through its agencies will provide for the storage, at the sole risk of the owner, of the more substantial household items, such as iceboxes, washing machines, pianos and other heavy furniture. Cooking utensils and other small items will be accepted for storage if crated, packed and plainly marked with the name and address of the owner. Only one name and address will be used by a given family.
6. Each family, and individual living alone will be furnished transportation to the Assembly Center or will be authorized to travel by private automobile in a supervised group. All instructions pertaining to the movement will be obtained at the Civil Control Station.

Go to the Civil Control Station between the hours of 8:00 A. M. and 5:00 P. M., Monday, May 4, 1942, or between the hours of 8:00 A. M. and 5:00 P. M., Tuesday, May 5, 1942, to receive further instructions.

J. L. DeWitt
Lieutenant General,
U. S. Army Commanding

(Western Defense Command and Fourth Army Wartime Civil Control Administration, 1942, available at http://www.geocities.com/ Athens/8420/poster.html)

Diary of Toku Shimomura, 1942

February 3, 1942

I finally decided to do my fingerprint registration since it had been hanging heavily on my mind. I went to the Post Office with Mrs. Sasaki. We finished the strict registration at 11:00 a.m. I feel that a heavy load has been taken off my mind.

Feb. 9

Rain at dawn. Clear during the day.

I energetically did the laundry . . .

In the afternoon I went to the [Japanese American] Citizen's League with Papa to go through the formalities of property registration. After all of these procedures were finished we were told that the Citizen's League would send us notifications later. We felt relieved and entrusted ourselves to them with a sense of security. We returned home.

I felt tormented by the news concerning the serious disaster in Singapore. Once again I felt restless over the debate about removing coastal Japanese 500 miles to the hinterlands. I can only leave everything to providence and be thankful for today.

Again, at night, we had a heavy rain . . .

Mar. 19

The newspaper reported that the evacuation of California Japanese Americans started. The first 1,000 will begin leaving.

Mar. 28

We reluctantly sold our Ford for $350. We deposited the money into Kazuo's bank account.

Apr. 4

Clear.

I went to the bank with Papa. We received permission to transfer our $3,500 account at Washington Mutual Bank to Kazuo's name.

We paid the balance of $845 left from the painting of the house.

This house now belongs completely to Kazuo.

During the afternoon I attended Mrs. Okumura's funeral.

PRIMARY DOCUMENT

Apr. 18

Today most of the Japanese stores in the traditional shopping areas marked the end and closed down. In this fashion our brethren, residents of America for 40 years, experienced a profound end. I have high blood pressure again so I received a second injection. I stayed in bed and rested but my heart was full of deep emotions thinking about our future. Looking back over our past, my eyes filled with tears.

Apr. 21

At last the order was issued. An order for the evacuation was given formally by General DeWitt. The first move had limitations. Kazuo and others will leave here on the 28th as an advanced party.

Apr. 27

I went downtown because I still had some things to shop for.

Yoichi and Fumi came over and helped us do various things.

I felt very busy and became very tired. We spent all day in a rush. Finally I went for a final farewell at Hart's Drugstore. When I heard the kind words "please come back quickly and return to work," tears again overflowed.

At night we said goodbye to our neighbor Americans. Everybody cried for us. There should not be a difference in human hearts. Tears flowed. I pray from the bottom of my heart that peace will come as early as possible.

Apr. 28

Enter the Camp.

The rain cleared up since last night. At last the day has arrived. It is time to leave Seattle, the city where we have lived for such a long time. During the morning Tsuboi san borrowed an automobile to come to see us. Rikio also came by automobile to help. Yoichi and Fumi came. In this fashion it was a merry departure for our journey. Even though I tried not to cry, the tears flowed. Our group of 370 working people departed at 9:30 in a long string of cars and buses. We arrived in Puyallup at 11:30. We settled into our assigned place; A-2, Apt. 27. At 3 p.m. we received another physical examination and smallpox vaccinations. We all felt dissatisfied without army cots and cotton mattresses. Until late at night we heard a mixture of hammering and the crying voices of children. With some difficulty I finally fell asleep . . .

May 10

Rainy weather. Rained on and off.

It was an unusual lunch. Roast beef. This is the first time we had meat since we were interned in this camp.

At 2:30 p.m. there was Dr. Warren's sermon. I felt lonesome because there was no special gathering for Mother's Day. I shared "onigiri" [rice balls] with everyone. This was made by Fumi and entrusted to Reverend Thompson. After this I visited Ogishima san. I was treated with "oshiruko" [red bean sweet soup with rice cakes] and went to supper with them. After supper Ogishima visited our place. All of us talked together . . .

I asked Reverend Thompson for a bucket and two chairs.

May 11

Cloudy and cold.

I woke up early in the morning. Around 10 a.m. we received more internees from Seattle. When we greeted the buses the people looked like they were in "tomaru kago" [bamboo cage for transporting criminals] which were used in the old years. When I looked at the wire fences next to the buses my eyes filled with tears and my heart suffered. I prayed that I could believe in the wartime treaty and forget that I was captive and maintain my morale.

Today Matsuda's whole family was interned. They delivered the articles which I asked them to bring for me.

Sasaki and Obasawa san also were interned today. I heard that all of these people were staying in Area D. I will not be able to meet them. Kazuo and Michio supplied me with this news.

At night I wrote a letter to Tsuboi san and asked her to bring the articles that I left behind . . .

Jun. 29

Clear.

I did the laundry in the early morning . . .

I head that there was going to be a "Bon Odon" [Festival dance] practice today. I feel that these people are being insensitive to our current situation. They are, however, unbelieving friends and from that standpoint their actions are predictable.

June 30

Clear.

The heat is severe from the morning. I don't have the energy to do anything. I did finish the laundry during the morning. I spent the afternoon protecting myself from the heat. Even during coffee time nobody came over.

The heat made me drowsy and I could not get sleep.

Jul. 1

Clear.

The heat is severe and there is no breeze.

I heard that some rooms never got below 110° yesterday. It seems that today is hotter than yesterday. I did not have any appetite. At noon I ate an onigiri with Fumiko instead of lunch.

Also during the noon I stood under the grandstand to avoid the sun . . .

At night I went to bed exhausted.

I heard that the temperature in the sickbed rooms went up to 120°. This is certainly unbearable heat.

Jul. 2

Clear. The heat today is as hot as it was yesterday.

After lunch I stayed cool by sitting under the grandstand . . .

Aug. 15

The heat was severe. The temperature was 107°.

I was concerned over Ayako and Roger who left early this morning. The whole day was difficult to bear because of the heat.

I went to bed with a feeling of relief after we sent out our baggage. I was annoyed by the noise from the neighbors as well as all around. Dawn came without sleep because of this.

When I think that tonight is the last night I will be here I somewhat regret leaving this barrack which was home to us.

Aug. 16

We gathered at the gate at 7:30 a.m. with "obento" [boxed lunch] given to us from Tamura san and Kazuo. We left the area at 9:30 a.m.

We, the brethren of 500, departed to the hinterlands, locked in 16 old passenger train cars.

We arrived in Portland at 2:30 p.m. After a one hour break we departed at 3:30 and arrived at The Dalles at 5:50. After a three minute stop our train continued toward the Cascades.

It was difficult and hot for those two and a half hours before sunset! I felt more dead than alive. The nurses and soldiers checked on us hourly to see if we needed anything. Around 2:30 a.m. I fell into a doze after going crazy with suffering and fatigue.

Aug. 17

We arrived at Arlington, Idaho unnoticed, at 5:30 a.m. Everybody looked "deep black." They were no longer the same people as they were yesterday. After we had a chicken dinner for lunch, the heat increased. Half dead and half alive our bodies continued on. We arrived at Rock Mountain at 2:30. Finally, at 4 p.m., we arrived at the newly built camp after taking a bus journey, by bus, of 8 ri [ri = 2.44 miles].

Though it was unfinished we could see the grand scale of this city near the mountains. We were simply amazed. I was assigned to Block 5B. 6, Apt. A. After we roughly cleaned the dust from the room we went to bed. I fell into a deep sleep.

We had roast beef for our first supper in this camp . . .

Sep. 9

It was cloudy in the morning but the weather changed into the usual dusty conditions around noon. We could not open our eyes and mouth . . .

The speed of the wind increased and we were not able to see in front of us. I didn't want to mention this but I would like to offer a grudge word to the government. I heard that during the process of internment of the Portland people, a mother was seen crying, holding her child.

Sep. 10

It was a comfortable day; like the calm after the storm.

I finished laundering the sheets. I was a little tired. Surprisingly, Sasaki and Watanabe sans came.

We had a nice chat over tea. What a day! Even Beppu san came. She stayed and talked till around 8 p.m. Sato sans came and said that they came to this camp for business. They left with Beppu san. Kazuo and Roger came. They made a bench for us and we had a nice time together . . .

Nov. 17

It rained continuously.

I went to choir practice in the afternoon.

At night a memorial service was held at recreation hall number 34 for Shig Tanabe's mother who passed away last November 5th. I attended it taking advantage of the use of the hospital automobile. I returned at 9:30 and was tremendously fatigued and could not sleep.

The rain created puddles that rippled around the 21 and 34 area just like a small pond. I became concerned about the inconvenience of moving about.

Nov. 18

Rain and more rain.

We had received permission to go to Twin Falls so 6 of us, Hamamoto, Kazuo, Nomura and I, departed by auto at 9 a.m. in the rain. When we arrived on the road, Roger's expressions of joy moved me to tears. We arrived at city center at 9:30 and shopped. We rested at Reverend Thompson's home after lunch. We then walked around town again. We met Michio, had supper, then returned home. I was worn out . . .

Dec. 25

The muddy ground was completely covered by snow which fell last night. It was a beautiful cover of white cloth. It was a suitable sight for Christmas. Around noon it turned into a snow storm which lead to some extreme coldness.

The dinner treat for us in number 6 was a mess hall number 7 at 4:30. The waiters and cooks were all dressed in the beautifully decorated dining room. The radio emitted melodies of Christmas carols. For a moment I forgot where I was. We happily sat at our family table. A Christmas program was held at mess hall number 6 at 7 p.m. Nearly ten performances were shown with Kazuo acting as emcee. Our three person choir act was included. At 9 p.m. Santa Claus appeared and gave presents to all of us.

There was a severe storm outside and we were not able to walk with our heads up. But the gathering inside suited the day of the birth of the child of peace. It was a memorable Christmas day and we spent it joyfully.

Dec. 26

I was not feeling well probably due to mental fatigue.

I went to the placement office during the early morning to receive my unemployment allowance. It was postponed for two weeks because there was a shortage of workers.

I heard that Sister Sasaki was in bed with a cold. I made udon for her. Meals became increasingly worse because of rationing. We had sandwiches in the room.

(Reprinted with permission from Roger Shimomura)

III: Teaching Connections

Prologue: Layering as a Visual Framework

Historians frequently say that there are diverse perspectives on any historic event. Individuals perceive the world and their experience through unique lenses, depending on where they stood, what their interests were, whom they knew, and how they lived. Thus, historical events can only be understood through multiple perspectives and in the context of the multiple stories about an event. In short, you could say that the texture or feel of history is *layered*. This idea—that the past can be known only through a series of layered narratives—suggests that events and ideas gain meaning through the interactions and relationships between different perspectives, in different retellings, during different times. It also underscores that in order to understand the complexity of the past, we must proactively research, examine, compare and contrast, and analyze these various layers that represent the diversity of perspectives forming the complicated web of history.

Visual artists, likewise, use the technique of layering not only as a literal method of making art—in the form of collage, painting, or sculpture. This act of layering can also be enacted in a physical way, by constructing images and objects through an additive process that places materials on top of each other or by integrating different kinds of source materials into a single work. Layering can also be adopted as a metaphorical or symbolic strategy by presenting imagery that integrates multiple voices, perspectives, or vantage points.

The following subsection provides suggestions for using the idea of layering as a historical and artistic mechanism through which you might structure classroom investigations into the history of Japanese incarceration and notions of citizenship in the United States. The toolkit provides suggestions for a range of discussions and hands-on activities. These discussions and activities are premised on a thorough reading of all the primary documents and works of art included in the section. Before using the suggestions in the following toolkit, we encourage you to start with a broad-based discussion about the individual works of art in order to help students develop their own observational skills and connections to personal experience and opinion. Suggestions for how to facilitate a discussion about these works of art can be found in Chapter 6. Once you've had a chance to familiarize yourself with all the resources included in the section, you're ready to get started with the Teaching Toolkit. The Essential Questions, Key Ideas, and Instructional Goals in the toolkits do not represent a set of definitive facts, ideas, or questions but in and of themselves should be carefully analyzed and considered. This questioning should lead to additional questions, ideas, and pedagogical strategies. The "Observe, React, and Respond" discussion questions and "Constructing Visual Knowledge" activities have been compiled as a set of strategies to be adapted and interpreted for different classroom needs. These prompts do not offer a complete guide or lesson plan for teaching about Japanese Incarceration, but instead present a series of provocations to be combined with many other possible resources, questions, strategies, and outcomes.

Teaching Goals

Essential Questions

✧ What are the rights of an American citizen and how are those rights related to the idea of being an American, or of American identity?

✧ What are different definitions, experiences, and layers of American identity?

✧ What does the word *citizenship* mean? What does it mean to be an engaged citizen?

✧ Can art serve as social commentary?

Understandings/Key Ideas

Students will understand that:

✧ Artists have used the strategy of layering as a symbolic and functional method for creating art that integrates multiple voices, perspectives, and images to comment on the history of Japanese incarceration.

✧ Artists have used family history and autobiography to comment on and critique the history of Japanese incarceration and anti-immigrant policies in the U.S. during World War II.

✧ It is important to consider multiple perspectives about historical events such as the World War II–era incarceration of Japanese-Americans.

✧ Japanese incarceration during World War II had a lasting effect on Japanese-Americans and their families, as well as upon American law and society.

✧ Executive Order No. 9066, which was signed by Franklin D. Roosevelt in 1942, was one instance when the U.S. government restricted the rights of citizens during wartime.

Instructional Goals

Students will:

✧ Critically read and interpret a variety of visual and text-based sources including primary historical documents and works of contemporary art related to the incarceration of Japanese-Americans during World War II.

✧ Frame effective questions about the events of Japanese incarceration and the rights of United States citizens in times of war.

❖ Engage in debate about the meaning of citizenship and the responsibilities of governments during times of war.

❖ Construct visual arguments that reflect personal/individual understandings about the period of Japanese incarceration and contemporary interpretations of citizenship based on historical knowledge and primary documents.

Teaching Strategies

Use the following prompts either individually or together to explore these essential questions and understandings.

a. Ask students to look at all of the primary documents and works of art contained in this section. In order to help students explore the ideas contained in these texts and images, ask them to consider the following:

❖ Who is the author of each document or work of art?

❖ What is the argument or idea each author puts forth?

❖ Who might the intended audience be for each of the documents and artworks? That is, to whom, specifically, was each piece initially addressed?

❖ What was the purpose for which, or "occasion" upon which, the documents or artworks were created?

❖ What does each of these pieces suggest about the rights of American citizens during World War II? What do they suggest about the importance of civil liberties during wartime?

Choose one or more of the prompts below to extend the initial discussion based on a close reading of the primary documents and artworks.

b. Ask students to select one of the works of art and one of the primary documents presented here, and then to make a list of key ideas, images, and references that they observe in the text. Then ask each student to write down a question that they have about one of these ideas, images, or references. Invite them to select one of their questions and give it to a partner. Ask students to draft a response to their partner's question, explaining that it is fine if they don't know the answer; they should speculate, make an educated guess, or offer an opinion in this draft response. Next, give students time to research an answer to the question by providing access to the library

I. OBSERVE, REACT, AND RESPOND

and/or the Internet (with appropriate guidelines and suggestions). As a group, compile a list of all questions and related answers. Allow the group to contribute additional responses including educated guesses, opinions, and factual knowledge gleaned from their research. Using the toolkit provided below (or another model that you prefer), create a chart that visually reflects the variety of questions and answers, as well as the layers of information gathered for each question or category of question.

For Example . . .

Student Question: In the February 9 entry of her diary, Toku Shimomura talks about the Japanese American Citizen's League (JACL). What was the JACL? What did they do?

1 Response (answer based on speculation): Maybe it was a community group? Or a recreational club – like the Lions Club or the Italian-American club in my neighborhood? Did they just socialize? Did they do organizing for the local or national Japanese-American community – like petition lawmakers?

2 Response (answer based on research): Founded in 1929 (before World War II!); in California; fought for civil rights of Japanese-Americans.

3 Response (additional answers based on findings from the group): The JACL also supported Chinese-Americans and other groups that faced discrimination; fought against white supremacist organizations like The Grange and Native Sons of the Golden West; after World War II JACL petitioned for a formal government apology for Japanese Incarceration; led to the Civil Liberties Act of 1988.

Note: The group discussion should provide relevant information for many different questions and will create a web of related ideas and knowledge to be applied to specific questions.

c. Ask students to write a first-person narrative in the voice of one particular author from the texts or artworks presented in this section (an *author* could be President Franklin D. Roosevelt, the U.S. Army, Ben Sakoguchi, Roger Shimomura, or Toku Shimomura) explaining his or her ideas about the rights of U.S. citizens during World War II. What would this person say about the question of whether Japanese-Americans should have been registered, fingerprinted, and incarcerated during WWII and why?

a. Read the "Instructions to all persons of Japanese ancestry, May 3, 1942," and the diary of Toku Shimomura. Examine the works of art by Roger Shimomura and Ben Sakoguchi. Write down every location mentioned in these documents and works of art. What sections of the U.S. do the Evacuation Procedures stipulate for removal? What camps and cities do Roger Shimomura and Ben Sakoguchi refer to in their work? Where was Toku Shimomura living at the time she wrote her early diary entries? Research additional Assembly Centers, Relocation Centers, and Detention Centers where the U.S. government established internment camps to house Japanese-Americans from 1942 to 1945. Plot each of these locations to create an original map that displays as much information as possible about the different locations, activities, and participants in the removal of Japanese-Americans into internment camps. Create a key of symbols and colors to represent distinct locations, identities, and events included in the primary documents and works of art, as well as additional research conducted by students.

b. Brainstorm the different ways we might understand the meaning of citizenship. What associations do your students have with the words *citizen* and *citizenship*? Who can be an American citizen? What is the process for acquiring citizenship? What does "an American citizen" look like? Ask students to create a collection of portraits that reflects diverse ideas about citizenship. Students can use *found images* and *found text* from magazines, newspapers, the Internet, the library, or elsewhere. You may also consider using self-portraits or pictures of individuals from the school, community, neighborhood, city, or nation. Encourage students to *layer* images and text in order to create this "portrait" as a crowd or collection of portraits. As an extension of this idea, encourage students to interview members of their family, school and community to solicit their ideas about citizenship and use the text from these interviews as text elements that complement their visual "portrait" of citizenship.

c. Ask students to discuss their response to the following statements:

 ✧ In times of war the rights of citizens should be curtailed.
 ✧ Dissent during times of war is "disloyal."
 ✧ The demands of war justify the suppression of dissent.

Ask each student to design a two-sided T-shirt that represents their personal views about the rights of citizens during wartime. You can ask students to conduct

visual, historical, and other kinds of research into the history of civil liberties in wartime in the U.S. and elsewhere. Ask students to develop a short "tag line" or statement, and to choose a visual image that expresses their views on this subject. After printing or drawing their designs on the T-shirts, erect a clothesline outside of the school building to display for public exhibition.

Standards

National Council for the Social Studies Thematic Standards

III. People, Places, & Environments

The learner will…
b) create, interpret, use, and synthesize information from various representations of the earth, such as maps, globes, and photographs;

IV. Individual Development and Identity

The learner will…
h) work independently and cooperatively in groups and institutions to accomplish goals;

VI. Power, Authority and Governance

The learner will…
b) explain the purpose of government and analyze how its powers are acquired, used, and justified;
c) analyze and explain governmental mechanisms to meet needs and wants of citizens, regulate territory, manage conflict, establish order and security, and balance competing conceptions of a just society;

X. Civic Ideals and Practices

The learner will…
b) identify, analyze, interpret, and evaluate sources and examples of citizens' rights and responsibilities;
c) locate, access, analyze, organize, synthesize and apply information about selected public issues—identifying, describing, and evaluating multiple points of view;
d) practice forms of civic discussion and participation consistent with the ideals of citizens in a democratic republic;

h) evaluate the degree to which public policies and citizen behaviors reflect or foster the stated ideals of a democratic form of government;

i) evaluate the extent to which governments achieve their stated ideals and policies at home and abroad.

National Visual Arts Standards

Content Standard: 1: Understanding and applying media, techniques, and processes
Content Standard: 3: Choosing and evaluating a range of subject matter, symbols, and ideas
Content Standard: 4: Understanding the visual arts in relation to history and cultures
Content Standard: 5: Reflecting upon and assessing the characteristics and merits of their work and the work of others
Content Standard: 6: Making connections between visual arts and other disciplines

REFERENCES

Daniels, R. (1993). *Prisoners without trial: Japanese Americans in World War II*. New York: Hill and Wang.

Maira, S. (2004). Youth culture, citizenship, and gloabalization: South Asian muslim youth in the United States after September 11th. *Comparative Studies of South Asia, Africa, and the Middle East, 24*(1), 219–231.

Lowe, L. (1996). *Immigrant acts: On Asian American cultural politics*. Durham, NC: Duke University Press.

Marshall, T. H. (1973). *Citizenship and social class*. Westport, CT: Greenwood Press.

Ngai, M. (2004). *Impossible subjects: Illegal aliens and the making of modern America*. Princeton, NJ: Princeton University Press.

Roosevelt, F. D. (1942). Executive Order 9066. Accessed on February 22, 2009, from http://www.ourdocuments.gov/doc.php?flash=false&doc=74&page=transcript

Sakoguchi, B. (2008). [No title]. Retrieved on June 19, 2008, from http://www.flintridgefoundation.org/visualarts/recipients20052006_bensakoguchi.html

Shimomura, R. (2008). Artist statement. Retrieved June 10, 2008, from http://www.flomenhaftgallery.com/exhibitions/roger_shimomura_intro.htm

Wineburg, S. (2005). What does NCATE have to say to future history teachers? *Not much. Phi Delta Kappan, 86*(9), 658–665.

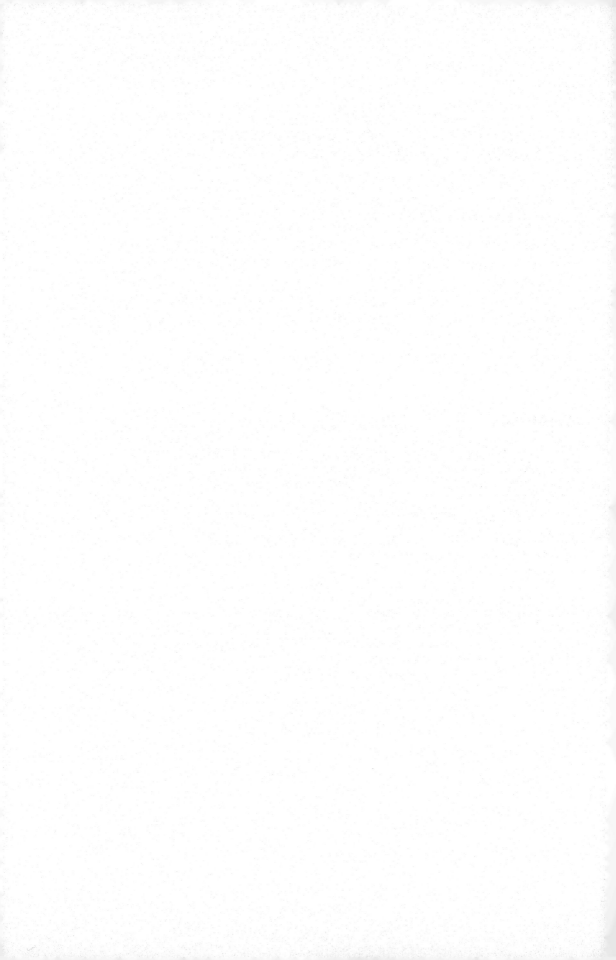

CHAPTER 8

Constructing Race

CHAPTER OVERVIEW

In this chapter, we take up questions about the histories of slavery and immigration in the U.S. Like the other historical subjects we have chosen to highlight in this book, the histories of slavery and immigration are topics that are central to both the public K–12 social studies curriculum, and to U.S. history and culture. Indeed, one could, hardly understand the story of U.S. history without close investigation into both topics. They have been among the most important features of the U.S. past; both have left deep marks on the legal, political, social, economic, and cultural foundations of the contemporary U.S.

Because these two topics are so foundational to the origins and culture of the U.S., there already exists—on the web, in books, in teaching manuals—a great number of models for teaching these subjects. In this chapter, we aim not simply to complement these extant resources, but, more pointedly, to offer resources that might push educators to use these topics to open up *thematic* questions about race, ideology, and U.S. history with their students. In specific, we focus on two central subjects: (1) the invention of racial categories, in legal and cultural contexts, over the past two hundred years; and (2) protest, especially the protest strategies that those who suffered the heavy hand of racial injustice mobilized in specific moments, to fight that injustice.

The idea of race as an ideology lies at the center of both of these concerns. "We tend to think of race as being indisputable, *real*," the historian Matthew Frye Jacobson (1999) has recently observed. "It frames our notions of kinship and descent"; it "influences our movements in the social world"; and "we see it plainly on one another's faces" (p. 1). It seems natural, timeless, biological. But, as Jacobson and others note, in the past several decades, a growing number of scholars have begun to argue that race is not in truth a biological fact. It is, to the contrary, a "product" of the historical and social imagination—a set of ideas that humans have invented over the past several centuries to explain their worlds and their actions. In fact, these scholars argue, our ideas about race are not only inventions, but also deeply illogical. Why is it, for instance, that "in

the United States, a white woman can have black children but a black woman cannot have white children?," Jacobson, for one, wonders. "Doesn't this bespeak a degree of arbitrariness in this business of affixing racial labels?" (1999, p. 2).

Counterintuitive and illogical as our ideas about race might be, the idea that race is a social invention with no basis in biology is still so jarring and so confusing that most of us have a hard time getting our heads around it at first. And to teach it in the secondary classroom? This is even harder to conceptualize. In this chapter, we introduce a modest set of resources that we hope might assist in this task. Although certainly not exhaustive or conclusive, the two sections of the chapter provides a set of resources— mini-archives, explanatory essays, and standards-aligned teaching suggestions—aimed at opening up a broader set of conversations about this idea within the specific contexts of the history of slavery and immigration. "Historians are fascinated by the social and cultural 'construction' of reality, the complex processes that produce the 'common- sense' categories of everyday life," the historians James Campbell and James Oakes have written (1993, p. 173). Can we take this kind of curiosity into the secondary history and art classroom?

REFERENCES

Campbell, J., & Oakes, J. (1993) In retrospect: The invention of race: Rereading *White over black*. *Reviews in American History, 21*, 172–183.
Jacobson, M. F. (1999). *Whiteness of a different color: European immigrants and the alchemy of race*. Boston: Harvard University Press.

SECTION 1: SLAVERY AND ABOLITION

I: Historical Introduction

In this section, we take up questions about the history of slavery and abolition in the U.S. Like the other historical subjects we have chosen to highlight in the Toolkit part of this book, the history of slavery is a topic that is central to the public K–12 social studies curriculum in the U.S. Indeed, one could hardly tell the story of U.S. history without including slavery—slavery was the institution that was most critical in creating the wealth of the new nation; it was the system that shaped Americans' enduring and distinctive ideas about racial difference; and it led to many of the most important moral, political, and constitutional questions that shaped the U.S. past (and that continue to shape the U.S. present).

We do not—in fact, we could not possibly—introduce, herein, a comprehensive guide to studying the history of slavery. Instead, we have organized this section around questions that emerge out of the work of two artists whose work addresses elements of the history of slavery and abolition: Kara Walker and Glenn Ligon. Although their work is in many ways dissimilar, the specific pieces we feature here contain some common elements, three of which are relevant to the historical investigation at the center of this Teaching Toolkit. First, both artists ask questions about how the memory of slavery continues to live in the contemporary moment. How, they ask, do images and ideas that developed during the slavery era continue to shape our lives, our culture, our politics? How do contemporary debates about the meaning of race and sex draw from ideas and language that developed during the years when slavery dominated U.S. economic, cultural, and political life? Second, both artists use the strategy of "visual quotation"— that is, both adopt, or borrow, a visual language from the antebellum (pre–Civil War) period of the nineteenth century. Walker uses the popular nineteenth-century portraiture style of silhouette cut-outs; Ligon adopts the visual style, and mimics the language, of antebellum abolitionist literatures. Third, both artists also take up the question of race and truth, and the relationship between the two.

Let's look first at the question of "borrowing." Any art historian will tell you that aesthetic borrowing is at the core of the creative process, and that artists have engaged in a range of borrowing practices for as long as we can remember. Indeed, one could hardly imagine either the Western or the non-Western artistic traditions without the interchange that happens when one artist draws from, or references, the work of another. The dictionary definitions of borrowing—"to take and use (something that belongs to someone else) with the intention of returning it" or "to take (a word, idea, or method) from another source and use it in one's own language or work"—suggest that to borrow is to act *without* malice, that it is an act that has few bad long-term effects. But as cultural historians and art critics have long noted, in the worlds of art and culture, creative "borrowing" can easily become creative "appropriation" ("the action of taking something for one's own use, typically without the owner's permission") or even outright "theft."

This is especially true when the subject at the center of the work of art is race, or culture. Historians of race and African America—and especially of African-American musics—have long noted, for instance, that creative borrowing and interchange was central to the development of a wide variety of American cultural forms. In the words

of the cultural critic Andrew Ross (1989), the "encounter" between black and white Americans has "governed" U.S. musical worlds "ever since the first minstrel shows" of the nineteenth century. But that encounter was not always a friendly, benevolent affair. It was, on the contrary, plagiaristic, commercial, exploitative, and always, Ross explains, "weighted to dominant white interests" (p. 68). So although black musicians created the musical conventions of jazz, it was a white man, Benny Goodman, who was virtually crowned the "King of Jazz" in the 1930s (Tate, 2003, p. 1). Likewise, rock 'n' roll evolved out of the work and traditions of working-class African-Americans, but it was only when Elvis adopted these styles that rock 'n' roll became a lucrative musical endeavor. That is to say that, in U.S. history, cross-cultural and cross-racial borrowing has often been a one-way affair. White artists have borrowed from the musical traditions of African-Americans, and used these borrowed forms to make enormous amounts of money for themselves—leaving their black mentors, who often remained financially destitute, behind. "Given such a history," Andrew Ross concludes, "it is no wonder that terms like 'imitation' are often read directly as 'theft' and 'appropriation' " in the world of U.S. art and culture (p. 68).

Certainly, creative borrowing is not always appropriative or harmful. However, when discussing race, borrowing, and aesthetics, it is important to keep in mind the long history of exploitative cross-racial borrowing in U.S. history. What then, do we make of the work of Ligon and Walker, two *black* artists who borrow aesthetic forms that are most closely associated with *white* artists and writers?

The work of both artists suggest that this kind of aesthetic borrowing can very powerfully comment on the ways that ideas about race influence not only what we say, but how we say it, whom we believe, and what we have forgotten. Ligon's work—which references and borrows the visual and textual style of a nineteenth-century literary convention—asks us to consider the relationship between race and credibility in U.S. pasts and presents. Adopting a range of the conventions that appeared within nineteenth-century slave narratives, Ligon's work raises a great number of historical, aesthetic, and political questions.

Many scholars consider slave narratives to have been critically important to both the nineteenth-century abolitionist movement and the development of the African-American literary tradition. Written, most frequently, by fugitives who had run away from their masters' plantations, slave narratives were part of the organized effort to abolish slavery in the U.S. Featuring frank descriptions of the brutality of white slave drivers and the delicate longings of enslaved African-Americans, they were distributed on the anti-slavery circuit in the U.S. and Europe. They were sold at local bookstores and made available at lectures featuring abolitionist speakers and personalities, including, often enough, lectures by the writers of slave narratives themselves. Lectures that featured formerly enslaved people speaking about their lives and their struggles had a powerful effect on popular consciousness and political ideologies—in part because they provided many white Northerners their first opportunity to see and hear the words of an African-American. The effect of seeing formerly enslaved people speak was, for many, "electrifying" (Africans in America, 1998). But even in the absence of a public appearance, the text of the narratives themselves did a great deal to make the abolitionist case against slavery. They contradicted the idea—popularly put forth by slave holders—that Southern U.S. slavery was benign; and they humanized African-Americans,

suggesting that they possessed a rich culture, a sharp intellect, and rich emotional lives—just like white people.

But the texts were also controversial. In the first place, a great many white Americans simply could not believe that members of a race that they had been taught were inferior and subhuman could write such lyrical and articulate tales. This disbelief was only reinforced when it was discovered that several "slave narratives" claiming to be authentic representations of life under Southern slavery were in fact "the fictional imaginings" of antislavery activists (Dorsey and Register, 2009, pp. 178–179). The truth was that most slave narratives were not fakes; they were the work of individuals who had suffered terribly in what many abolitionists called the "prison-house" of slavery. Nonetheless, because of popular disbelief, all slave narratives were subjected to intense scrutiny and some were falsely dismissed as lies.

In order to undermine pro-slavery advocates' accusations and disbelief, the writers of nineteenth-century slave narratives began to append, to their writings, a preface (or several prefaces) written by well-known and established white people. Formally called "Certificates of Character," these prefaces were meant to testify to the truthfulness of the slave narrative to which it was attached. These prefaces were meant to attest to the good character of the narrative's author, and to the veracity of their account. And they were always written by a white person. Most of the best-remembered slave narratives contain this sort of certificate: Harriet Jacobs' harrowing account of her life as a slave, *Incidents in the Life of a Slave Girl*, was prefaced by an enthusiastic testimonial written by the white feminist abolitionist Lydia Marie Child; and Frederick Douglass's well-known and powerful testimony featured a rousing testimonial by the renowned abolitionist publisher William Lloyd Garrison. "Mr. Douglass has very properly chosen to write his own Narrative, in his own style, and according to the best of his ability, rather than employ someone else," Garrison (1845) testified at the outset of the *Narrative of the Life of Frederick Douglass*. "I am confident that it is essentially true in all of its statements; that nothing has been . . . exaggerated, nothing drawn from the imagination; that it comes short of the reality, rather than overstates a single fact" (p. viii). These prefaces also often took the opportunity to advocate more generally for the abolition of slavery. "Reader!" Garrison's preface concludes. "Are you with the man-stealers in sympathy and purpose, or on the side of their down trodden victims? . . . If you are with the latter, what are you prepared to do and dare in their behalf?" (p. xii).

White Americans' unwillingness to believe that African-Americans could write so articulately and convey such complicated ideas and emotions—that is, the disbelief that made these prefatory testimonies necessary—derived from the invention of racial ideologies that can be tracked back to the seventeenth and eighteenth centuries and the American Revolution. These ideas, which were historically developed, and backed up by the full force of the law, were powerful determinants of the ideas, and the social worlds, of nineteenth-century Americans; so much so that even white *abolitionists* sometimes held the view that African-Americans, while deserving of freedom, had less intellectual capacity than Euro-Americans. It should come as no surprise, then, that slave holders and their apologists were unsparing in their deployment of the idea that African-Americans were intellectually inferior to whites. African-Americans, wrote one pro-slavery advocate in 1832, are "barbarous" creatures who have "but few and simple wants" (Kennedy, 1851, pp. 445–457).

These ideas reached far into the highest levels of U.S. government. In 1856 the Supreme Court (in *Dred Scott* v. *Sandford*) declared, famously, that black persons were "beings of an inferior order"—"so far inferior that they had no rights which the white man was bound to respect." "Numerous attempts have been made to establish the intellectual equality of the dark races with the white," another man, a white doctor from Mobile, Alabama, wrote, in 1854, "but they are nowhere to be found. Can anyone call the name of a full-blooded Negro who has ever written a page worthy of being remembered?" (Nott, 1854, pp. 49–61).

Imagine the effect, then, that a book such as the *Narrative of the Life of Frederick Douglass*—that is, a lyrical and intelligent book that was indeed written by a "Negro"—had when it was published in 1845. Graceful, well-crafted, and emotionally complex, Douglass's account cut through white supremacist ideas about the inferior "intellectual quality" of African-Americans, and their inability to write even one page "worthy of being remembered." In the first six months after its publication, Douglass's *Narrative* sold 4,500 copies; another 25,000 sold over the next twenty years (Painter, 1996, p. 103). Full of detailed descriptions of the horrors of slavery, Douglass's account, like many other slave narratives, told a story of the triumph of good over evil, stressing, in the words of one commentator, "how African Americans survived in slavery, making a way out of no way" and evoking "the national myth of the American individual's quest for freedom and for a society based on 'life, liberty, and the pursuit of happiness'" (Documenting the American South, 2004, para. 8). Written in the face of enormous opposition and doubt, slave narratives were astonishing and sophisticated works of literature. They testified to the horrors of the institution of slavery, to the unsupportability of the ideology of white supremacy, and the enormous strength of formerly enslaved Africans. And yet, these narratives were unacceptable without the imprimatur of a white person.

In a series of works that borrow the visual and textual conventions of these narratives and their appendices, Glenn Ligon investigates the ways in which ideas about race shaped just what, exactly, nineteenth-century white Americans believed, and how those ideas about race and truthfulness linger in the contemporary moment. In one of these works, for instance, Ligon adopts the visual style of a Certificate of Character. Therein, a nameless "White Person" testifies that Glenn Ligon is an upstanding citizen. Who, he asks, is believable? Who has the authority to speak about their experience? By borrowing the visual and textual style of a Certificate of Character, Ligon provokes consideration of the relationship between seemingly antiquated conventions and contemporary dilemmas.

In other pieces in this series, Ligon borrows other elements from slave narratives to tell stories about his life. By doing so, he suggests that perhaps nineteenth-century ideas about race and character continue to shape our contemporary lives and worlds.

Like Ligon, Kara Walker also references and borrows from the visual styles and historical events of the nineteenth century to comment on contemporary life. Walker's silhouette cut-outs resonate with a thousand meanings, and reference a dizzying array of racial and sexual ideologies. And, in ways that are at once similar and distinct from Ligon's, her work asks questions about the relationship between slavery and American ideas about whiteness and blackness. This is a connection that historians have also considered over the years. And for many scholars, inquiry into this connection has taken the shape of investigation into one specific historical question: did racism cause

slavery or did slavery cause racism in the U.S.? Although none of the most prominent scholars on this subject ever argued absolutely that one caused the other, the debates that this question has generated among historians over the past several decades reveal a great deal about the history—and the contemporary importance—of race and slavery. These debates also suggest exciting avenues for classroom-based historical inquiry (and, indeed, even for historical inquiry that is "standards-conscious").

In tackling this question, some historians have favored the idea that racial prejudice existed in British thought long before the creation of racial slavery in colonial North America, and that it was these ideas that led to the establishment of racial slavery in North America. Others have argued quite strenuously, to the contrary, that racism was the creation of slavery itself—that is, that in fact the British did not hold systematic ideas about the inferiority of Africans before the advent of slavery in the colonies.

Perhaps the best-known treatment of this question was put forth by Winthrop Jordan in his 1968 book *White over Black: American Attitudes toward the Negro, 1550–1812*. There, Jordan argued that although sixteenth-century Britishers had some vague notion of differences among nations and peoples, racism *per se* did not pre-date slavery, and it certainly did not cause slavery to exist. Slavery, he argued to the contrary, was created by the economic necessity of growing tobacco in the specific context of seventeenth-century Virginia—a task that required, in his words, labor that was "cheap but not temporary" (thus ruling out indentures), "mobile but not independent" (meaning not small farmers), and "tireless rather than skilled" (that is, not apprentices) (1968, p. 270). And as it happened, right at the time that Virginia planters developed a need for this sort of labor, Africans—who were already being enslaved by the Spanish and Portuguese—began to arrive in the British colonies (pp. 270–271). But in Jordan's view, it was not slavery alone that created racism. On the contrary it was the American Revolution, and its discourse about liberty and rights, that led to the creation of a systematic set of ideas about the inferiority of blacks. This might sound, at first glance, like a counter-intuitive, impossible contention. But Jordan (and other scholars after him) makes a strong case for this argument—one that repositions traditional ideas about the meaning and origins of American democracy, and lends itself to lively and productive classroom debate. His argument went like this: in the Revolutionary years, when treatises expounding the "naturalness" of human liberty seemed to appear around every corner, white Americans found themselves compelled to "account for those in their midst" who were not free (Campbell and Oakes, 1993, p. 179). The "account" they developed to explain this situation was one that declared African-descended people to be biologically inferior to European-descendants, and thus not entitled to the rights that Revolutionaries were coming to call "self-evident" and due "all men": that is, in order to justify the enslavement of Africans in Revolutionary America the Founders developed a systematic theory of racial difference and racial hierarchy.

Complex and elegantly written as it was, Jordan's work influenced, and helped shape the thinking of a generation of historians. But it has not escaped critique or revision. Perhaps most strikingly, in the early 1990s, Barbara Jeanne Fields, a professor at Columbia University, wrote a series of essays that both complemented and critiqued Jordan's work. There, Fields introduced a new concern into this decades-old discussion. Objecting not simply to Jordan's arguments but also to the way he framed his account, she argued that slavery and the Revolution did not simply create *racial prejudice*. It also,

and more importantly, created the very idea of *racial difference* in and of itself. That is to say: Fields argued that slavery and emancipation led to the invention of the very categories of whiteness and blackness that we—wrongly—continue to see as natural to this day. These categories, she argues, are neither natural nor biological. They are instead, historical and ideological: created by historical events and recreated every day through ideologies and commonplace rituals that reinforce the naturalness of these categories.

Fields' argument complements the work of a great number of scientists, anthropologists, and historians who claim that the entire framework of our beliefs about human difference is wrong. At the center of these conversations is a proposition that is so confusing that even the most subtle and well-read scholars have a hard time getting their head around it at first. That proposition is this: that the racial categories that we use to describe ourselves and other bodies and individuals are not biological, but rather ideological, and that racial categories such as "black," "white," and "Asian" are wholly invented categories: not facts but rather ideas that have gained meaning only through historical events, and through stories that we have told ourselves over the past two hundred years. The biological anthropologist Alan Goodman does a good job of summarizing this point in an essay entitled "Exposing race as an obsolete biological concept" (Pollock, 2008, pp. 4–8). When European scientists "first tried to explain human variation in the seventeenth and eighteenth centuries," he explains, they "divided humans into a discrete set of racial types." They did this, he observes, not because they were geniuses who, in their far-sightedness, could see the truth of the world, but rather because "ideologies about racial superiority and inferiority supported [their] policies of taking away land . . . and wealth . . . and rationalized the enslavement of Africans." In short, Goodman writes, racial categories reflect not "biological realities," but "social" and historical ones. Humans might be a diverse lot, but this "human diversity" is not, in fact cannot be, described in the biological terms upon which we have so long relied.

How might one teach such counter-intuitive and challenging ideas? One approach is to use primary historical documents to structure an investigation. If you look closely at primary source documents from seventeenth-century colonial North America, for instance, you can effectively watch as the early colonial elite began to falteringly develop U.S. legal and labor regulations, and through these, the racial ideologies that we have come to accept as natural. The text of legal statutes from seventeenth- and eighteenth-century colonies (selections of which are reproduced in the mini-archive that accompanies this essay) is particularly, acutely useful in this effort. These early laws bear witness to the ways in which the need for cheap, compliant labor in colonial North America shaped not just local legal structures, but also colonial American ideologies, and gave very direct rise to the concept of race as an organizer of human difference.

Even a quick overview of the trajectory of these laws subtly suggests this point: in 1619 African-descended slaves began to arrive in Virginia and Maryland. And for over forty years, Africans lived unspectacularly alongside other early Americans; it was not until 1661 that colonial statutes singled out "servants of African descent for special treatment" and began to officially establish their "condition of perpetual slavery." Indeed, as Barbara Fields (1990) notes, in the years between 1619 and 1661 even African *slaves* enjoyed rights that, "in the nineteenth century, not even free black people could claim" (p. 104). Perhaps most revealing, Virginia did not prohibit "interracial" liaisons until 1691. Beginning in 1661, and continuing for the next sixty-odd years, colonial

assemblies haltingly codified racial slavery and began to establish a systematic ideology of racial hierarchies and difference.

Meanwhile, the language they used in their articulation of these new codes reveals the plodding, one-thing-leading-to-the-other development of early American racial ideologies. To wit: at the outset, these laws spoke not of "black slaves" and "free whites" but rather of "heathens" and "Christians," "Englishmen," "Englishwomen," and "negroes." These terms reflected the social, economic, and ideological context of seventeenth- and eighteenth-century Europe and North America, and reflected the way that religion and nation stood far and away as the most important organizers of identity and politics. Thus African slaves were not remarkable, in these years, for being physically or intellectually different from the English. Rather they were remarkable for being non-Christian and non-English, and for their previous association with Spanish and Portuguese slave traders (hence the adoption not of the English word *black* but rather of the Spanish word *negro* as a referent to describe African slaves). "The historical experience of the English people in the 16th century had made for fusion of religion and nationality," Winthrop Jordan (1968) explained, which fused "the qualities of being English and Christian." Christians (and the English) were civilized; others were not (p. 286).

In short, as the historians Bruce Dorsey and Woody Register observe, slave masters "solidified their power over their enslaved laborers by their control of the state and by enacting laws that defined the meaning of freedom and slavery, and consequently the meaning of whiteness and blackness as well" (Dorsey and Register, 2008, p. 83). Or, as Barbara Fields puts it, these laws reveal "society in the act of inventing race" (Fields, 1990, p. 107).

In this section's mini-archive, we present selections from Kara Walker's and Glenn Ligon's work, and several primary source documents: selections from seventeenth- and eighteenth-century colonial slave codes and excerpts from two slave narratives from the nineteenth century. Together, these materials are meant to raise historical questions about the meaning and truth of race; to provoke discussion about the ways in which American racial ideologies were invented and consolidated through the conversations about U.S. slavery; and to invite investigation into the ideas of cultural borrowing and theft. At the center of both Ligon's and Walker's work is an idea that has long been debated among historians and other scholars, but which is in fact so jarring and so confusing at first, that even the most subtle and well-read among us have a hard time getting their head around it at first. That proposition is this: that the racial categories that we use to describe ourselves and other bodies and individuals are not *biological*, but rather *ideological*. That is to say that racial categories such as "black," "white," and "Asian" are wholly invented categories: not *facts* but rather *ideas* that have gained meaning only through stories that we have told ourselves over the past two hundred years. Counterintuitive as these ideas might be to Americans living in the twenty-first century, they merit attention—especially with young people.

II: Mini-Archive

Narratives by Glenn Ligon

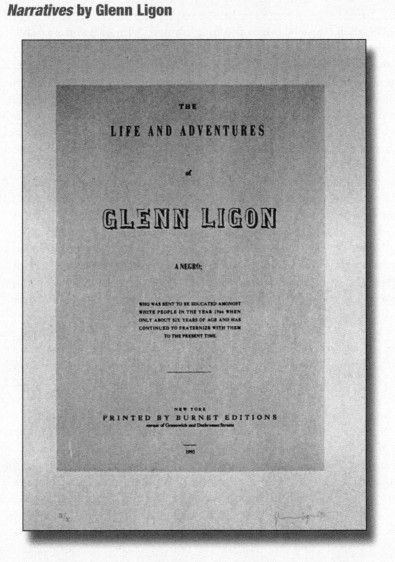

Figure 8.1 Glenn Ligon, *Narratives (The Life and Adventures of Glenn Ligon. . .)*, 1993.

Autobiography is the hook, the point of connection between the artist and the viewer, but it is always shown to be a departure point for a discussion of other issues.

(Glenn Ligon, 2005)

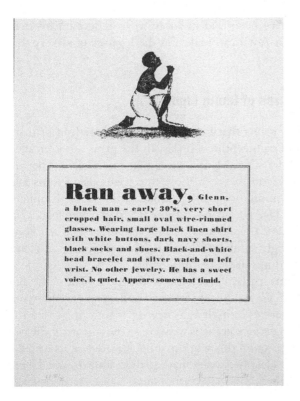

Figure 8.2 Glenn Ligon
*Runaways (Ran away, Glenn, a black
man – early 30's. . .)*, 1993.

In his prints, paintings, and sculptures, Glenn Ligon explores notions of African-American culture and identity including issues of race, sexuality, and representation. Ligon appropriates a wide range of historic and contemporary sources related to African-American experience including fugitive slave descriptions, civil rights era protest signs, and nineteenth-century slave narratives. Ligon borrows not only the visual form of these references, but also the power of the language they employ.

In 1993 Ligon presented the installation *To Disembark* at the Hirschhorn Museum and Sculpture Garden in Washington, DC. The title of the show refers to a book of poetry by Gwendolyn Brooks of the same name. In this installation, Ligon brought together a collection of objects and images exploring his identity as an African-American and larger notions of contemporary African-American experience, specifically in relation to the history of slavery in the United States. Upon entering the gallery, the viewer was confronted with a series of large packing crates positioned around the room. These wooden boxes resembled the crates typically used to ship works of art between galleries and exhibition spaces, with two exceptions. First, the sounds of heartbeats and music associated with African American culture—from spirituals to hip hop—emanated from inside as if trapped and bound for some unknown destination. Second, and less obvious, these crates were built to the specifications described in 1851 by the ex-slave Henry "Box" Brown in his *Narrative of the Life of Henry Box Brown, Written by Himself*, who escaped from slavery by traveling from "Richmond[,] Virginia, to Philadelphia in a box, three feet long, and two feet six inches deep". This reference is the first in a series of associations Ligon makes to the narratives of slaves and former slaves from the antebellum south. In each of the works from this exhibition, Ligon identifies with specific historic figures

and borrows the ways their stories have been told in an effort to reflect on his own experiences as a contemporary African-American male and the legacies of slavery that still pervade life in the twenty-first century.

Narratives (The Life and Adventures of Glenn Ligon . . .)

To Disembark also featured a series of prints that Ligon had created based on primary documents from the seventeenth and eighteenth centuries. In the print series entitled *Narratives*, Ligon recreates the look of a series of title pages that prefaced first-person narratives written by former slaves. Ligon recreates these title pages using fonts and compositional elements that closely mimic original examples from such prominent narratives as Frederick Douglass and Harriet Jacobs. Although Ligon's *Narratives (The Life and Adventures of Glenn Ligon. . .)*, 1993 (see Figure 8.1) and *Narratives (Folks and Places Abroad)*, 1993 (Figure 8.2) look strikingly similar to their original sources, upon closer inspection the viewer confronts something altogether different.

Most prominently featured in this particular image is the text "The Life and Adventures of Glenn Ligon, A Negro." We are quickly oriented to the fact that this work is about Glenn Ligon, and that he describes himself as a "negro." If we came to see the exhibition in 1993 and saw the work in person, perhaps we were already aware of the fact that Ligon is black. But if we stumbled upon this work in a book or out of its original context, this information might not be clear; we would have to dig a little deeper. Using the word "negro" is in and of itself a provocative statement. Negro is not a term typically

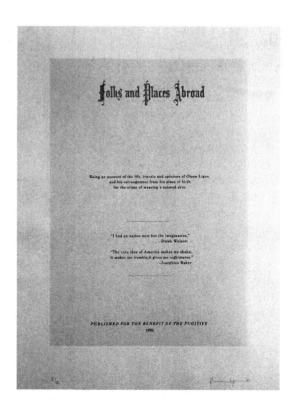

Figure 8.3 Glenn Ligon
Narratives (Folks and Places Abroad. . .), 1993.

used in twenty-first-century dialogue; it is an antiquated term used prior to the 1960s but now considered an archaic designation, often a racial slur. Designating his race in the way that Ligon has is also not a common means of introduction any more, or a necessary identifying factor when publishing. Ligon also includes a short description that the viewer must assume would be contained in the pages following such a title page, if there were such text to be read. This statement provocatively asserts that Ligon has fraternized with "white people" since the age of six years, the tone and context stipulating that this information is book worthy. The printer of this statement is kindly acknowledged at the bottom of the page, along with the cross streets (located in New York City) and the date, 1993. And that is the extent of the information we are given. There is no visual imagery, other then the selection of type and its placement on the page, and a faint signature at the bottom along with the print series information.

Without knowing anything about Glenn Ligon we might be inspired to ask the following questions: Are we looking at a primary historical document? Are we looking at a farce? Are we looking at a work of art? In a sense, we are looking at all three. Ligon has borrowed a seemingly antiquated form to present new questions about our present-day relationships to the history of race in this country. This new title page suggests several issues simultaneously: the significance of race as a means of locating the context and authority of author and viewer; connections between eighteenth-century and twenty-first-century tropes of race and racial difference; and borrowing from the past as a means to reframe the present. It is in the blatant references to negroes and whites and the assertion of a negro as author with confessional tales to tell of racial difference that Ligon most strongly connects his work to that of abolitionist publications intended to validate African-Americans and advocate for anti-slavery laws. This work of art suggests several entry points to explore both the history of this narrative form and its relationship to contemporary ideas about race, authenticity, and authority. What are the ways we know about the experiences of the antebellum South and the brutal inequality between blacks and whites that still permeate contemporary culture? How did narratives of slave experience contribute to public knowledge and opinion of race in America, then and now? In the historical record and in current events, who gets to speak for whom, and why?

Written narratives, such as the ones that Ligon has reconceived, were part of abolitionists' strategies intended to fight white supremacist ideas that African-Americans were subhuman. Pre–Civil War laws in many states stipulated that African-Americans were not permitted to learn to read or write. Although these laws no longer exist, their legacy still pervades ideas about race today. Ligon uses autobiography to present something that is both personal as well as universal, an ironic statement on who gets to speak and why–both historically and in the present day.

Slavery! Slavery! by Kara Walker

ABOUT THE ART

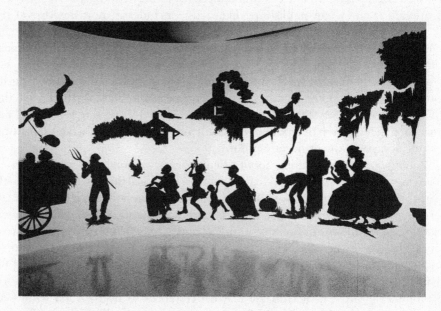

Figure 8.4 Kara Walker
Slavery! Slavery! Presenting a GRAND and LIFELIKE Panoramic Journey into Picturesque Southern Slavery or "Life at 'Ol' Virginny's Hole' (Sketches from Plantation Life)" See the Peculiar Institution as Never Before! All cut from black paper by the able hand of Kara Elizabeth Walker, an Emancipated Negress and leader in her Cause, 1997. Installation view at The Walker Art Center, Minneapolis, 2007. Photo by Dave Sweeney/The Walker Art Center. Courtesy of Sikkema Jenkins & Co.

One thing that got me interested in working this way, with the silhouettes, but then working on a large scale, had to do with two longings. One was to make a history painting in the grand tradition. I love history paintings. I didn't realize I loved them for a long time. I thought that they were ridiculous in their pompous gesture. But the more I started to examine my own relationship with history, my own attempts to position myself in my historical moment, the more love I had for this artistic, painterly conceit: which is to make a painting a stage and to think of your characters, your portraits or whomever, as characters on that stage. And to give them this moment. To freeze-frame a moment that is full of pain and blood and guts and drama and glory.

(Kara Walker, quoted in Sollins, 2003)

Kara Walker's prints, drawings, and silhouette images depict haunted landscapes populated by characters who act out melodramas inspired by the history of the American antebellum south. In her room-sized installations Walker uses the simple graphic style of eighteenth- and nineteenth-century silhouettes to present disarmingly beautiful, highly charged, and provocative images. Creating a theatrical space in which her unruly cut-paper characters interact Walker places these life-size silhouettes directly onto the walls of the exhibition space. These silhouette images depict unambiguous vignettes that take place in the American south at a brutal time when plantations were populated by slaves and their owners. Presented as scenes from the past, Walker's caricatures of blacks and whites embroiled in conflict require contemporary viewers to confront the ongoing tensions that pervade race relations in America today. Walker often uses overhead projectors to throw colored light onto the ceiling, walls, and floor of the exhibition space, forcing viewers to cast their own shadows into these dramas (Figure 8.5). As the shadows mingle with the silhouette dramas unfolding on the wall, Walker implicates all of us who look at the work in the historical fictions that she is portraying.

Moving to the town of Stone Mountain, Georgia, when she was thirteen, Walker was aware of the history of slavery, its pervasive legacies in the American South, and the not-so-subtle tensions between contemporary African-Americans and whites who carried that history with them. Stone Mountain once served as the headquarters of the Ku Klux Klan and proudly boasts a monument to the confederate soldiers on the same scale as Mount Rushmore. Walker recalls the dread she felt as an African-American girl poised between childhood and adulthood growing up in an environment where overt racial tensions informed daily life. Walker's father was an artist and encouraged her to draw at a young age. Originally a painter, Walker incorporated silhouette imagery into her paintings before she began to make the iconic silhouette images from cut black paper that she is best known for today. A meticulous researcher and a skilled draftsperson, Walker

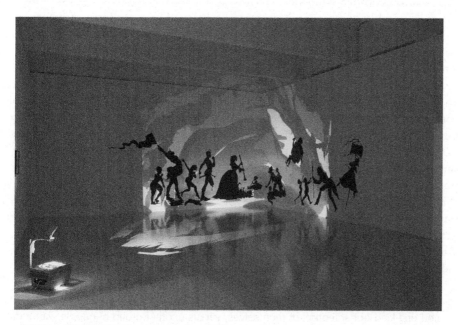

Figure 8.5 Kara Walker, *Darkytown Rebellion*, 2001.

combines in her work real stories borrowed from slave narratives as well as fictional elements derived from her own imagination and her alter ego as the Negress, a character often found in her writings and installations. Other influences such as the novel *Gone with the Wind* and popular images of Southern life and fashion contribute different visual styles and narrative voices to the epic scenes that Walker constructs. Without sound or text, her multi-character stories unfold through body gesture, landscape, and other visual clues that leave the viewer to complete the story as they see it. Walker's titles often mimic "old-timey" language and provide additional descriptive clues that self-consciously acknowledge her role as the artist as well as the historical events from which she derives her inspiration.

In the work *Slavery! Slavery! Presenting a GRAND and LIFELIKE Panoramic Journey into Picturesque Southern Slavery or "Life at 'Ol' Virginny's Hole' (Sketches from Plantation Life)" See the Peculiar Institution as Never Before! All cut from black paper by the able hand of Kara Elizabeth Walker, an Emancipated Negress and leader in her Cause* (1997) (Figure 8.4) Walker installed a collection of silhouettes in the round. Inspired by the cyclorama displays that became popular in the late nineteenth century, specifically the Atlanta Cyclorama that depicts the Battle of Atlanta during the American Civil War, *Slavery! Slavery!* is an eighty-five-foot long visual narrative that contradicts and questions the heroism and mythology presented in traditional visual forms from the past. *Slavery! Slavery!* immerses the viewer in various provocative dramas: a man and a woman dance to the beat of a drum with ragged clothes and cropped hair, bones in their hands; two figures peer out of a wagon filled with hay while a man with a pitchfork gestures to another figure seemingly falling from the sky with a rucksack. These images both defy and confirm the traditional folklore and stereotypes of Southern slavery: the uncivilized African, the prissy Southern belle. Walker uses particular visual clues to establish her scenes. Hanging vines and low-slung houses with porches cue us to a movie-set version of the rural South. Clothing, hairstyles, facial features, bare feet and shoes distinguish black figures from white figures. Each character is engaged in some form of power struggle or deceit. A chapter of American history is presented as a collection of intimate dramas taking place during a chaotic and violent time. The imagery resonates with racial stereotypes still perpetuated and questioned today. As we stand surrounded by these disturbing images, we are connected to a brutal moment in time, but we are forced to ask new questions about it. Walker has not only borrowed a traditional European form of representation—the silhouette—but a range of voices and sources to portray her fictional histories. Walker's use of the silhouette image refers to a format that captures accurate likenesses in profile—the only means available before the invention of photography. Her contemporary silhouettes capture antiquated likenesses but allow Walker, an African-American woman, to reclaim an art form that previously was limited to representing the white upper classes. Within this context, her imagery addresses the ways that history is re-presented, re-framed, re-told, and understood. Where do the lines between fact and fiction exist in historical narratives? How do the individual moments experienced by historical figures and their interpreters compress to become the historical record that we understand today? For Walker, her work confronts:

> The gross, brutal manhandling of one group of people, dominant with one kind of skin color and one kind of perception of themselves, versus another group of people with a different kind of skin color and a different social standing. And the assumption would be that, well,

times changed and we've moved on. But this is the underlying mythology, I think, of the American project. The history of America is built on this inequality, this foundation of a racial inequality and a social inequality.

(Walker in Art21, n.d)

What Walker presents is not an illustration of historical events. Instead, she is asking the viewer to consider their position in relation to this history and to take a hard look at the brutalities that are part of our collective memories, as well as our current consciousness.

Title page from Harriet Jacobs, *Incidents in the Life of a Slave Girl*, 1861

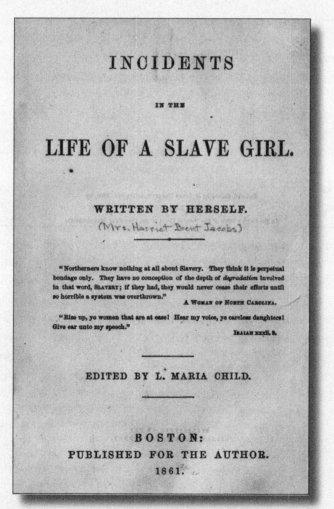

Figure 8.6 Title page from Harriet Jacobs, *Incidents in the Life of a Slave Girl*, 1861.

Excerpt from Harriet Jacobs, *Incidents in the Life of a Slave Girl*, Written by Herself, Boston 1861

READER, be assured this narrative is no fiction. I am aware that some of my adventures may seem incredible; but they are, nevertheless, strictly true. I have not exaggerated the wrongs inflicted by Slavery; on the contrary, my descriptions fall far short of the facts. I have concealed the names of places, and given persons fictitious names. I had no motive for secrecy on my own account, but I deemed it kind and considerate towards others to pursue this course.

I wish I were more competent to the task I have undertaken. But I trust my readers will excuse deficiencies in consideration of circumstances. I was born and reared in Slavery; and I remained in a Slave State twenty-seven years. Since I have been at the North, it has been necessary for me to work diligently for my own support, and the education of my children. This has not left me much leisure to make up for the loss of early opportunities to improve myself; and it has compelled me to write these pages at irregular intervals, whenever I could snatch an hour from household duties.

When I first arrived in Philadelphia, Bishop Paine advised me to publish a sketch of my life, but I told him I was altogether incompetent to such an undertaking. Though I have improved my mind somewhat since that time, I still remain of the same opinion; but I trust my motives will excuse what might otherwise seem presumptuous. I have not written my experiences in order to attract attention to myself; on the contrary, it would have been more pleasant to me to have been silent about my own history. Neither do I care to excite sympathy for my own sufferings. But I do earnestly desire to arouse the women of the North to a realizing sense of the condition of two millions of women at the South, still in bondage, suffering what I suffered, and most of them far worse. I want to add my testimony to that of abler pens to convince the people of the Free States what Slavery really is. Only by experience can any one realize how deep, and dark, and foul is that pit of abominations. May the blessing of God rest on this imperfect effort in behalf of my persecuted people!

(Documenting the American South, 2004,
available at http://docsouth.unc.edu/fpn/jacobs/jacobs.html)

Title page from Frederick Douglass, *Narrative of the Life of Frederick Douglass, An American Slave, Written by Himself*, 1845

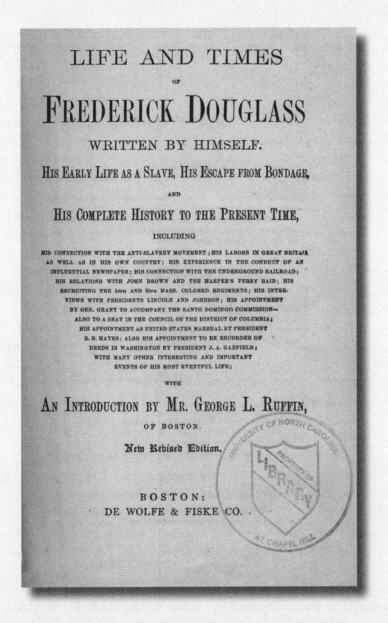

Figure 8.7 Title page from Frederick Douglass, *Narrative of the Life of Frederick Douglass, An American Slave, Written by Himself*, 1845.

William Lloyd Garrison, Preface to *The Narrative of the Life of Frederick Douglass, An American Slave, Written By Himself,* 1845

In the month of August, 1841, I attended an anti-slavery convention in Nantucket, at which it was my happiness to become acquainted with FREDERICK DOUGLASS, the writer of the following Narrative . . . I shall never forget his first speech at the convention—the extraordinary emotion it excited in my own mind—the powerful impression it created upon a crowded auditory, completely taken by surprise—the applause which followed from the beginning to the end of his felicitous remarks. I think I never hated slavery so intensely as at that moment; certainly, my perception of the enormous outrage which is inflicted by it, on the godlike nature of its victims, was rendered far more clear than ever . . . Capable of high attainments as an intellectual and moral being—needing nothing but a comparatively small amount of cultivation to make him an ornament to society and a blessing to his race—by the law of the land, by the voice of the people, by the terms of the slave code, he was only a piece of property, a beast of burden, a chattel personal, nevertheless!

. . . Mr. DOUGLASS has very properly chosen to write his own Narrative, in his own style, and according to the best of his ability . . . and, considering how long and dark was the career he had to run as a slave,—how few have been his opportunities to improve his mind since he broke his iron fetters,—it is, in my judgment, highly creditable to his head and heart. He who can peruse it without a tearful eye, a heaving breast, an afflicted spirit . . . must have a flinty heart.

. . . I am confident that it is essentially true in all its statements; that nothing has been set down in malice, nothing exaggerated, nothing drawn from the imagination; that it comes short of the reality, rather than overstates a single fact in regard to SLAVERY AS IT IS. The experience of FREDERICK DOUGLASS, as a slave, was not a peculiar one; his lot was not especially a hard one; his case may be regarded as a very fair specimen of the treatment of slaves in Maryland, in which State it is conceded that they are better fed and less cruelly treated than in Georgia, Alabama, or Louisiana. Many have suffered incomparably more, while very few on the plantations have suffered less, than himself. Yet how deplorable was his situation! what terrible chastisements were inflicted upon his person! what still more shocking outrages were perpetrated upon his mind! with all his noble powers and sublime aspirations, how like a brute was he treated, even by those professing to have the same mind in them that was in Christ Jesus!

. . . So profoundly ignorant of the nature of slavery are many persons, that

they are stubbornly incredulous whenever they read or listen to any recital of the cruelties which are daily inflicted on its victims. They do not deny that the slaves are held as property; but that terrible fact seems to convey to their minds no idea of injustice, exposure to outrage, or savage barbarity. Tell them of cruel scourgings, of mutilations and brandings, of scenes of pollution and blood, of the banishment of all light and knowledge, and they affect to be greatly indignant at such enormous exaggerations, such wholesale misstatements, such abominable libels on the character of the southern planters! . . .

. . . Reader! Are you with the man-stealers in sympathy and purpose, or on the side of their down-trodden victims? If with the former, then are you the foe of God and man. If with the latter, what are you prepared to do and dare in their behalf? Be faithful, be vigilant, be untiring in your efforts to break every yoke, and let the oppressed go free. Come what may—cost what it may—inscribe on the banner which you unfurl to the breeze, as your religious and political motto—"NO COMPROMISE WITH SLAVERY! NO UNION WITH SLAVEHOLDERS!"

WM. LLOYD GARRISON
BOSTON, May 1, 1845.

(Documenting the American South, 2004,
available at http://docsouth.unc.edu/neh/douglass/douglass.html)

Selected Timeline of Virginia Slave Codes, 1661–1705

1619

The first African laborers arrive in Virginia. They continue to "trickle in slowly for the next half century" (Jordan, 1968, p. 271).

1640

"Some Africans were in fact being treated as slaves"—that is, they were considered servants for life, as were their children. But this was the status of only some Africans, not all. The codification of racial slavery into law was still twenty years away (Jordan, 1968, p. 272).

1650

The colony of Virginia punished violators of the law equally whether they were English or African.

PRIMARY DOCUMENT

1661

Virginia law begins to "formally recognize the condition of perpetual slavery" and to systematically mark out servants of African descent for special treatment" in law (Fields, 1990, p. 104).

The early 1660s

"White men [begin] loudly protesting against being made 'slaves' in terms which strongly suggest that they considered slavery not as wrong but as inapplicable to themselves." ("White men were [now] more clearly free because Negroes had become so clearly slave.") (Jordan, 1968, p. 278.)

1660s

The "morbid arithmetic" of slavery and indenture in the Virginia colony begins to change. (Before this time, an "African slave for life cost twice as much as an English servant for a five-year term" but "stood a better-than-even chance of dying before five years could elapse.") (Fields, 1990, p. 104.)

Between 1661 and 1680

"A succession of acts in [Virginia and Maryland] defined with increasing precision what sorts of persons might be treated as slaves" (Jordan, 1968 p. 279).

1664

Maryland "established the legal status of a slave for life and experimented with assigning slave condition after the father"—but soon gave that up as paternity was very hard to determine (Fields, 1990, p. 107).

1670s

"The rulers of Virginia faced a . . . large class of young (white) freedmen, landless, single, discontented—and well armed" (Fields, 1990, p. 105).

1670s

Africans "began to flood into" Maryland and Virginia (Jordan, 1968, p. 272).

1676

Lawbreakers were treated differently depending on their race (Jordan, 1968, p. 276).

1680

"A new term appears [in the legal statutes of the colonies]—white" (Jordan, 1968, p. 287).

After 1690

"Slavery [begins] to assume its now familiar character as a complete deprivation of all rights" (Jordan, 1968, p. 279).

By 1700

"Racial slavery and the necessary police powers [that the act of enslaving humans into lifelong, hereditary bondage required] had been written into law" (Jordan, 1968, p. 279).

1705

"Virginia produced a codification of laws applying to slaves" (Jordan, 1968, p. 272).

III: Teaching Connections

Prologue: Borrowing as a Visual Framework

Both historians and artists borrow from various sources, including text-based or visual primary and secondary documents, in order to analyze and narrate stories of domination and resistance during each historical period. The act of borrowing allows historians and artists to look at traditional forms and accepted ideas in new ways. Borrowing the traditional format of a title page from a nineteenth-century book to make a contemporary work of art suggests a relationship between the past and the present. A traditional art form such as the silhouette portrait is often considered a nostalgic or "old-timey" practice. But when an artist uses the silhouette form to present new kinds of imagery that defy traditional expectations, she can insert new narratives and new ideas about the past, and the present, into our collective consciousness. How an artist or historian borrows and applies traditional forms or primary documents from the past is just as important as what is borrowed.

The period of slavery was a contentious and traumatic period in United States history. Waging their battle on moral as well as political and legal grounds, abolitionists campaigned throughout the antebellum (pre–Civil War) period to convince the white American public that African-Americans should possess the same rights as white Americans. Slavery and the ideas about racial difference that supported its perpetuation in the nineteenth century continue to shape contemporary U.S. society. Even the election of Barack Obama as president cannot hide the fact that race remains a powerful force in U.S. life, and the history and collective memory of slavery continues to shape politics and culture in the United States. This has prompted artists to explore the spaces where racial ideologies, and the distinctions between whiteness and blackness, have been most visible. The official certificates of character and validating prefaces to slave narratives by upstanding white citizens, the genteel practice of silhouette portraiture, and posters advertising runaway slaves are all sites that clearly display the content of these ideologies. They also provide visual tropes that contemporary artists have borrowed to comment on and critique these issues from a twenty-first-century perspective. This practice of

borrowing informs the suggested discussions and activities we present here to support student investigation of this particular time period and its continuing legacies.

The following subsection provides suggestions for a range of discussions and hands-on activities focused on a critical reading of the historic and contemporary narratives related to slavery and abolition in the United States. These discussions and activities are premised on a thorough reading of all the primary documents and works of art included in the section. Before using the suggestions in the following toolkit, we encourage you to start with a broad-based discussion about the individual works of art in order to help students develop their own observational skills and connections to personal experience and opinion. Suggestions for how to facilitate a discussion about these works of art can be found in Chapter 6. Once you've had a chance to familiarize yourself with all the documents included in the section, you're ready to get started with the Teaching Toolkit. The Essential Questions, Key Ideas, and Instructional Goals in the toolkits do not represent a set of definitive facts, ideas, or questions but in and of themselves should be carefully analyzed and considered. This questioning should lead to additional questions, ideas, and pedagogical strategies. The "Observe, React, and Respond" discussion questions and "Constructing Visual Knowledge" activities have been compiled as a set of strategies to be adapted and interpreted for different classroom needs. Again, these prompts are not exhaustive and do not offer a complete guide or lesson plan for teaching about the history of slavery and abolition in the United States, but instead provide a series of provocations to be combined with many other possible resources, strategies, questions, and outcomes.

Teaching Goals

Essential Questions

✧ What is the difference between respectful borrowing and injurious theft?
✧ What is the historical legacy of slavery in the United States?
✧ How do visual and text-based stories about American slavery and abolitionist strategies convey different ideas about the events and consequences of that time?
✧ How does creatively combining real and imagined events change our ability to understand and interpret the past?
✧ How does popular memory of slavery shape contemporary American cultural and political debates?

Key Ideas

Students will understand that:

✧ Artists borrow images, text, and historical documents to explore issues of race and their connection to history.
✧ Creative borrowing—in visual art, music, literature, and other places—can be, but is not always, a respectful act. It often reflects and amplifies differentials in power between individuals of different races, social classes, and genders.
✧ Ideologies of racial difference were socially constructed over the course of two and a half centuries, from the beginning of racial slavery in the U.S., in the early eighteenth century, through the American Revolution, and into the contemporary moment. They continue to develop, and to shape politics and culture in the United States.
✧ The writers of slave narratives often faced an incredulous audience. Many white people did not believe that African Americans could write such lyrical and literate accounts.

Instructional Goals

Students will:

✧ Critically read and interpret a variety of visual and text-based sources including primary historical documents and works of contemporary art related to slavery and abolition.
✧ Frame effective questions about the meanings of race in relation to the period of slavery and abolition in the United States.
✧ Engage in debate about the ways that race has been historically constructed and its relationship to ideas about race today.
✧ Construct visual arguments that reflect personal/individual understandings about slavery, the abolition movement, and race relations based on historical knowledge.

Teaching Strategies

Use the following activity prompts in sequence or individually to explore the essential questions and key ideas.

a. Ask students to look at all of the documents and works of art contained in this section. In order to help students explore the ideas contained in these texts and images, ask them to consider the following:

✧ Who is the author of each document or work of art?
✧ What is the argument or idea each author puts forth?
✧ Who might the intended audience be for each of the documents and artworks? That is, to whom, specifically, was each piece initially addressed?
✧ What was the purpose for which, or "occasion" upon which, the documents or artworks were created?
✧ What do each of these pieces suggest about the construction of race in the United States during the period of slavery and abolition?

Choose one or more of the prompts below to extend the initial discussion based on a close reading of the primary documents and artworks.

b. Have each student ask the student next to him/her if they can borrow something (a text, an object, or an image). Then ask them to reflect upon this exchange: What did they borrow? What was the unspoken agreement they entered into when they borrowed the item from their classmate? What are they allowed to do with the borrowed item while in possession of it? In what kind of condition does their classmate expect the item to be returned? Who decided the terms of the agreement? What does it mean to respectfully borrow something? Then, drawing from this discussion, ask students to reflect upon related questions: What might it mean to respectfully "borrow" an idea from another person? What might make that exchange injurious or disrespectful?

c. Divide the class into four groups. Ask one group to look at all the documents from the slave narratives by Harriet Jacobs and Frederick Douglass (Title Page from Harriet Jacobs, *Incidents in the Life of a Slave Girl*; Excerpt from Harriet Jacobs, *Incidents in the Life of a Slave Girl*; Title Page from Frederick Douglass, *Narrative of the Life of Frederick Douglass, An American Slave*; William Lloyd Garrison, Preface); ask another group to examine the Virginia Slave Codes; ask the third group to examine the artworks of Kara Walker; and ask the fourth group to look at the works by Glenn Ligon. Have each group discuss what their document(s) convey(s) about race and racial difference. Then ask each group to develop at least one provocative question that this document suggests. (Alternately, you might prepare a selection of questions for them to choose from, and distribute these questions among the groups. One question you might offer

to any of these groups, for instance, is: "Did slavery cause racism or did racism cause slavery?") Ask the group to swap their question(s) with another group and then attempt to construct an answer for this new question based on their original set of documents. As a class discuss the ways that all of the documents convey particular racial ideologies in relationship to slavery and/or abolition in the U.S.

d. Look carefully at Glenn Ligon's artwork *Narratives (The Life and Adventures of Glenn Ligon)* (1993) and the title page to Frederick Douglass's *The Narrative of the Life of Frederick Douglass* and accompanying Preface by William Lloyd Garrison. What are the similarities and differences between the primary documents and the work of art? Compare and contrast the language and content presented in these two forms of historical representation. What does each convey about issues of race and slavery at the time that they were created? What do these documents suggest about how race relations have changed over time?

a. Ask students to search out an interesting image or text that they find in their school or community, such as a flyer, poster, public signage, or graffiti. Then ask them to borrow and reimagine this image or text. Students might transform these found images by first photographing or redrawing them, and then creating a self-portrait of themselves that conveys something about their personal history, their life, values, or beliefs.

b. Make a list of the different ways that artists and historians "borrow" from the past—that is, through archival research, interviews, and visual research, and in the form of footnotes, citations, imitation, and quotation. Select a graphic format from the nineteenth century that combines text and image—a wanted poster, a theater playbill, a pamphlet, a newspaper—and create a twenty-first-century version that borrows specific elements or graphic references from the original format, but inserts contemporary language and imagery to comment on their personal ideas about a contemporary political question, such as how current ideas about race have been informed by the events of the past.

c. Ask students to create a visual biography of Frederick Douglass, Harriet Jacobs, William Lloyd Garrison, or one of the characters from a Kara Walker work. What is the character trait or emotion that best defines the life and qualities of this historical figure? Have students compile additional research in order to include relevant information about their selected person and the events of their lives, their ideas, and any other new information that would

II. CONSTRUCTING VISUAL KNOWLEDGE

contribute new ways of thinking about this person and their perspectives on race and slavery in the United States. Ask them to imagine what this person might be doing or talking about if they were alive today. What would they say about slavery and race in the United States from a contemporary perspective? Have students create a life-size representation of this figure (a simple contour or silhouette, stick figure, or collaged image compiled from existing representations/photographs/paintings), with visual clues that convey who this figure is (hair style, facial features, dress style, props they can hold in their hands, etc.). Install the figures and excerpts from student narratives in a way that presents these characters in a conversation with each other about issues of race. Consider creating an installation in a school hallway or utilize the four walls of a classroom space.

d. Ask students to write an original response to one of the following questions: (1) How does contemporary popular memory of slavery shape society today? or (2) Did slavery cause racism or did racism cause slavery? In each case, ask students to conduct a small research project that will inform their analysis of this question. Ask students investigating the first question (about popular memory) to ask a range of different people (family members, friends, local business owners, government officials, etc.) for their opinions and responses to this question. Ask students investigating the second question (about whether race caused slavery or vice versa) to conduct additional historical research into the history of early slave codes; the "Africans in America" website (http://www.pbs.org/wgbh/aia/home.html) contains a set of excellent resources for doing this kind of research. All students should record the results of their research in a notebook. Once students have completed their research, ask them to design and exchange a series of trading cards that represent each of the different answers to their question. Trading cards should include one side with primarily visual information, and the other with text-based information.

Standards

National Council for the Social Studies Thematic Standards

Standard I. Culture

The learner will…
b) predict how data and experiences may be interpreted by people from diverse cultural perspectives and frames of reference;

d) compare and analyze societal patterns for preserving and transmitting culture while adapting to environmental or societal change;

f) interpret patterns of behavior reflecting values and attitudes that contribute or pose obstacles to cross-cultural understanding.

Standard II. Time, Continuity, and Change

The learner will...

a) demonstrate that historical knowledge and the concept of time are socially influenced constructions that lead historians to be selective in the questions they seek to answer and the evidence they use;

d) systematically employ processes of critical historical inquiry to reconstruct and reinterpret the past, such as using a variety of sources and checking their credibility, validating and weighing evidence for claims, and searching for causality;

e) investigate, interpret, and analyze multiple historical and contemporary viewpoints within and across cultures related to important events, recurring dilemmas, and persistent issues, while employing empathy, skepticism, and critical judgment;

Standard III. People, Places, and Environments

The learner will...

i) describe and assess ways that historical events have been influenced by, and have influenced, physical and human geographic factors in local, regional, national, and global settings;

Standard IV. Individual Development and Identity

The learner will...

a) articulate personal connections to time, place, and social/cultural systems;

h) work independently and cooperatively in groups and institutions to accomplish goals;

Standard V. Individuals, Groups, and Institutions

The learner will...

b) analyze group and institutional influences on people, events, and elements of culture in both historical and contemporary settings;

c) describe and examine belief systems basic to specific traditions and laws in contemporary and historical movements;

Standard X: Civic Ideals and Practices

The learner will...

b) locate, access, analyze, organize, synthesize, evaluate, and apply information

about selected public issues—identifying, describing and evaluating multiple points of view;

d) practice forms of civic discussion and participation consistent with the ideals of citizens in a democratic republic

e) analyze and evaluate the influence of various forms of citizen action on public policy.

National Visual Arts Standards

Content Standard: 1: Understanding and applying media, techniques, and processes
Content Standard: 3: Choosing and evaluating a range of subject matter, symbols, and ideas
Content Standard: 4: Understanding the visual arts in relation to history and cultures
Content Standard: 6: Making connections between visual arts and other disciplines.

REFERENCES

Africans in America. (1998). Slave narratives and *Uncle Tom's Cabin*. Retrieved January 4, 2009, from http://www.pbs.org/wgbh/aia/part4/4p2958.html

Art21. (n.d.). The melodrama of *Gone with the Wind*. Interview with Kara Walker. Retrieved February 15, 2009, from http://www.pbs.org/art21/artists/walker/clip2.html

Brown, H. (1851). *Narrative of the life of Henry Box Brown, written by himself: electronic edition*. Retrieved December 27, 2008, from http://docsouth.unc.edu/neh/brownbox/brownbox.html

Campbell, J., & Oakes, J. (1993). In retrospect: The invention of race: Rereading *White over black*. *Reviews in American History, 21*, 172–183.

Documenting the American South. (2004). North American slave narratives: An introduction to the slave narrative. Retrieved January 4, 2009, from http://docsouth.unc.edu/neh/intro.html

Dorsey, B., & Register, W. (2009). *Crosscurrents in American culture: A reader in United States history: Vol. I. To 1877*. New York: Houghton Mifflin.

Fields, B. (1990). Slavery, race and ideology in the United States of America. *New Left Review, 181*(May/June), 95–118.

Garrison, W. L. (1845). Preface. In F. Douglass, *Narrative of the Life of Frederick Douglass, an American Slave, Written by Himself*. Boston: Anti-Slavery Office

Jordan, W. (1968). *White over black: American attitudes toward the negro, 1550–1812*. Chapel Hill: University of North Carolina Press.

Kennedy, J. P. (1851). *Swallow Barn or, A sojourn in the old dominion*. New York: Putnam.

Ligon, G. in Phillip, L. (2005). Glenn Ligon (interview). *C: International Contemporary Art*, September 22, 2005. Retrieved December 27, 2008, from http://www.accessmylibrary.com/coms2/summary_0286–17544025_ITM

Nott, J. C. (1854). *Types of mankind: Or, ethnological researches*. Alabama: Josiah Nott and George R. Gliddon.

Painter, N. I. (1996). *Sojourner Truth: A life, a symbol*. New York: W. W. Norton.

Pollock, M. (Ed.). (2008). *Everyday anti-racism: Getting real about race in school*. New York: New Press.

Ross, A. (1989). Hip and the long front of color. In *No Respect: Intellectuals and Popular Culture* (pp. 65–101). New York: Routledge.

Sollins, S. (2003). *Art21: Art in the twenty-first century 2*. New York: Harry N. Abrams, Inc.

Tate, G. (2003). *Everything but the burden: What white people are taking from black culture*. New York: Broadway Books.

SECTION 2: IMMIGRATION

I: Historical Introduction

It is a cliché to say that the U.S. is a nation of immigrants, or that, ever since its founding, the U.S. has welcomed immigrants to its shores. Many Americans can easily recite bits of the famous poem, written by Emma Lazarus, that is inscribed in the base of the Statue of Liberty. "Give me your tired, your hungry, your huddled masses, yearning to be free," the poem goes. "Send the homeless, tempest-tossed to me." Certainly the history and culture of the United States has indeed been deeply shaped by immigrants, and immigrant communities. But the history of immigration to the U.S. is a far more complicated tale, one that is filled also with federal and locally sanctioned exclusions, disenfranchisement, deportation, and exploitation; with protest; and with the labors of people wanting to make the promise of U.S. democracy real. This more complicated story might be somewhat harder to confront, and, at times, it has been politically controversial, but it is a historical story that has to be told, over and over again. And it is one that, in fact, holds far more in the way of provocative suggestions—about the promise and limitations of democracy, the interworkings of culture and politics, and the meaning of the past—than the simpler progress narrative we often resort to, of uniform uplift and refuge.

In this section, we feature the work of two artists whose work inquires into the relationship between immigration and democracy in the U.S., and a set of supplemental primary documents about exclusion, struggle, and resistance in the history of U.S. immigration. Much of our focus here is on the history of Asian-American immigrants. This is in part because one of the artworks we feature—Flo Oy Wong's *made in usa: Angel Island Shhh*—addresses the history of Chinese detainees held at Angel Island in the aftermath of the Chinese Exclusion Act of 1882. But there is another reason as well: the history of Asian-Americans and Asian immigrants in the U.S. provides an extremely useful lens through which we can clearly see the historical limitations on the U.S. ideals of liberty, freedom, and open borders, and the racial and geographical nature of these limitations. It is a story that has far-reaching implications; and it is a story about a population that has played a very important role in the history of the U.S. over the past 150 years. In short, the history of Asian immigration to the U.S. is a critical piece of U.S. history. But it is a story that remains largely overlooked in the secondary history curriculum.

Asians have been immigrating in large numbers to the U.S. since the mid-nineteenth century. In the words of Lisa Lowe (1996), "historically and materially, Chinese, Japanese, Korean, Asian Indian, and Filipino immigrants have played absolutely crucial roles in the building and sustaining of America" (p. 5). Nonetheless, throughout U.S. history, Asian immigrants have been subject to a great deal of discrimination. "The period from 1850 to World War II," Lowe writes, was "marked by legal exclusions, political disenfranchisement, labor exploitation and internment for Asian-origin groups" (p. 9). And it was not just immigrant or non-citizen Asians who suffered from discrimination, restriction, and outsider-like status. Even native-born, non-immigrant Asian-Americans have suffered from an anti-immigrant bias. In the U.S., as Lowe argues, "the Asian" has always been seen "as an immigrant, as the 'foreigner-within,' even when born in the United States and the descendent of generations born here before" (pp. 5–6).

The exclusion and exploitation of Asians reached a head in the late nineteenth and early twentieth centuries. In 1882, the U.S. passed a law that prohibited the immigration of individuals from China: commonly known as the Chinese Exclusion Act, this was the first law ever passed, in the U.S., that barred an entire group of people from entering the U.S. purely on the basis of racial or national origin. It would not, however, be the last law that did so. In 1917, for instance, Congress excluded all immigrants from India; in 1924, it barred Koreans and Japanese; in 1934, it barred Filipinos. Asians also suffered other sorts of legally binding discrimination: until World War II, the federal government barred most Asians not born in the U.S. from naturalizing; meanwhile, states such as California and Washington passed additional laws prohibiting Asians from, for instance, owning property.

Still, it would be a mistake to suggest that the story of Asian immigrants in the U.S. was simply a tale of marginalization and repression. To the contrary, the history of Asian immigrants in the U.S. contains elements of struggle and beauty. Always, they fought back against the harsh conditions they found in the U.S.: like their Jewish, Irish, and Latino brethren, Asian immigrants created community-based organizations; they used the courts and the legislative process to fight for equal rights; they made art and used creative expression to protest and maintain their dignity.

We have included, in the Teaching Toolkit that accompanies this essay, primary documents and works of art that testify, and pay homage, to the efforts of Asian immigrants to protest the discrimination that they faced in the U.S. Among these is a document (entitled "Appeal of the Chinese Equal Rights League to the People of the United States for Equality of Manhood") that details the efforts of one group of Chinese-Americans to protest a federal law passed in 1892. This law—"The Geary Act of 1892"—extended the Chinese Exclusion Act of 1882 and added several new provisions. Among other things, the law prohibited Chinese from testifying in court, and required all Chinese residents of the U.S. to carry an identification card with them at all times. Failure to carry, or wear, this card was punishable by deportation. The Chinese Equal Rights League was just one among many groups that gathered, in the aftermath of the passage of this law, to protest its provisions. Indeed, one historian has observed that Chinese immigrants' initial refusal to comply with the act amounted to what was "perhaps the largest organized act of civil disobedience in the United States" (Pfaelzer, 2007, p. 291).

The "Appeal of the Chinese Equal Rights League to the People of the United States for Equality of Manhood" suggests several of the strategies that Chinese Americans used in their efforts to protest, and overturn, the law: they created collective organizations, they held public fora, they wrote and published pamphlets, and they launched a series of legal and legislative campaigns. Although it does not contain extensive evidence of all of these efforts, the text of the "Appeal" is a rich source of historical information and argument. It also raises a range of questions. Why, for instance, did its writers seek, specifically, to gain "equal manhood?" That is, why did they use gendered language in their appeal? One reason might be because the vast majority of Chinese immigrants in the U.S. in these years were, indeed, men. But there might be other reasons, as well, including the fact that, because women did not have the right to vote in the U.S. in these years, "citizenship" was, generally speaking, a deeply gendered concept in and of itself. The document also raises questions about the hopes and dreams of Chinese-Americans in these years, and about the nature of their lives. It might seem remarkable to some readers, for instance, that this pamphlet was written in such effective English.

But the truth is that by 1892, many Chinese Americans had been born in the U.S. and learned English as their first language. Finally, the pamphlet suggests the very American nature of the group's strategies. Using the rights delineated in the First Amendment to the Constitution—freedom of speech, the right to assemble—they sought to gain full participation, and they sought only the protections that U.S. democracy promised. What, one wonders, does that suggest about the promise, and limitations, of American democracy?

Chinese-Americans and immigrants used other strategies to protest unjust conditions in these years, as well. Even those individuals who seemingly had no tools with which to fight did so. For instance, many Chinese would-be immigrants were detained, during these years, at the immigration station at Angel Island, in the San Francisco Bay. Having arrived, by boat, these migrants found themselves detained in barracks, sometimes for months on end, undergoing medical exams and personal interrogations, and waiting for word about their efforts to gain entry. Many of these migrants carved poems into the walls of their cells. One hundred and thirty five of these poems—all of which were written between 1910 and 1930—survive. Lost for many years (they were rediscovered in 1970, by a park ranger named Alexander Weiss), they survive to testify eloquently, and tragically, to the human suffering that followed on the heels of the Chinese Exclusion Act of 1882. "The floating clouds, the fog, darken the sky/The moon shines faintly as the insects chirp," reads one poem. "Grief and bitterness entwined are heaven sent/The sad person sits alone, leaning by a window" (Lai, Lim, and Yung, 1999, p. 52).

But as Flo Oy Wong suggests in *made in usa: Angel Island Shhh*, the poems were not simply cries of desperation. They were also utterances of hope and protest. "America has power, but not justice," one poet wrote. "In prison, we were victimized as if we were guilty." Although these poems remained unseen for a long time by anyone other than the detainees themselves, they memorialize a fierce struggle. And now, having long outlived the detention station itself, they remain to testify to this dark period in U.S. history. As historical documents, they do something very rare: they relate the story of a disenfranchised group of people in their own voices.

Some scholars have noted that these poems drew on a Chinese form of protest graffiti, known as "tibishi." Chinese tibishi artists were travelers who scribbled their observations upon the walls of the places in which they stayed. These writings offered counter-histories, stories that challenged the official government-sanctioned idea of truth. The Angel Island detainees' poems followed in this tradition—they contained lines that protested their treatment, that offered counter-histories, and that spoke directly to those individuals who would face similar treatment, in later days, at Angel Island (Race and Pedagogy Project, August 11, 2006, para. 3). In short, the poems were a kind of anguished resistance.

In the Teaching Toolkit that follows this essay, we feature excerpted translations of a few of these poems. We also present the aforementioned visual piece, by Flo Oy Wong, *made in usa: Angel Island Shhh*. Wong's work uses oral history and multi-media installation in an attempt to reconstruct a history of "paper people": those Chinese immigrants who, in order to gain entry to the U.S., had to lie about their familiar relations. Many of these "paper people" were detained at Angel Island for long stretches, and among the many texts that Wong weaves into her installations are excerpts from the poems from the walls of the detention center. What, if anything, do these poems suggest about the idea of the U.S. as a nation of immigrants, a refuge, a sweet land of liberty? What do they reveal

about the life histories, experiences, and personalities of those immigrants who were detained here? What kinds of information do these poems provide that other kinds of historical documents—newspapers, passport photos, political speeches—do not? What kind of protest are they?

The second work of art that we feature in this section is a piece that does not revolve around the history of Asian-Americans or Asian immigrants per se. Instead, Krzysztof Wodiczko's *Alien Staff* inquires into the immigrant experience in the U.S. more generally. But his work addresses questions that are deeply linked to the Angel Island poems and Wong's work. Wodiczko's *Alien Staff* is an interactive street performance that addresses questions about the limits of democracy, and the power of immigrants to tell their own stories in their own voices. At the heart of Wodiczko's *Alien Staff* is a concern that also shapes the work of many oral historians and historians of immigration—that is, Wodiczko is interested in providing a platform for ordinary people, immigrants to the U.S., to give voice to their experience and knowledge; to tell their stories, their histories, their ideas, and express their opinions in public.

Wodiczko has said that he makes his artwork in an effort to create space for immigrant voices in the public sphere in an effort to make real the promise of democracy. "Democracy as such does not exist," he says (in Chapter 5 of this volume); thus we must "play an active role . . . in the democratic process" by searching for, pursuing, and demanding it— by telling stories, in public, about "the 'Nameless' and the 'Vanquished'—the survivors, residents of our cities."

That, in large part, is what this section is about. Using the works of art and the primary documents we provide here, we hope you can spark a conversation with your students about the history of U.S. immigration; about the promise and limitations of U.S. democracy; and about the distinct kinds of stories that reveal themselves if you examine and remember the voices of the "vanquished": ordinary people who suffered, struggled, and did their best to protest the injustices that they faced.

II: Mini-Archive

ABOUT THE ART

made in usa: Angel Island Shhh series by Flo Oy Wong

Flo Oy Wong, *made in usa: Angel Island Shhh,* "Flag 8: Lee Suk Wan, 1930," 2000.

Flo Oy Wong, *made in usa: Angel Island Shhh,* "Flag 10: Wong Geung Ling, 1930," 2000.

SEE Plate 7 and Plate 8, in Insert

My art is symbolic of this country's multiple canons. My work is significant because it inserts little-known chronicles into the cultural landscape.
(Flo Oy Wong, artist's website, http://www.flo-oy-wongartist.com/)

Flo Oy Wong works across several mediums, moving from quilting and sewing, to installation and drawing, to painting and sculptural work. Inspired by the stories around her, Wong identifies historical and contemporary narratives and translates them into visual imagery.

> I make art that speaks of personal, family, community, cultural, and historical stories. To retrieve these narratives I interview people that I find heroic in order to explore disquieting matters that transform me and viewers to a place of healing, connecting, and understanding.
>
> (Wong, n.d. para 1)

The installation *made in usa: Angel Island Shhh* includes twenty-five hand-made flags, audio recordings of interviews Wong conducted with former detainees from Angel Island, and large mounds of red, blue, and white rice. Angel Island served as the primary detention center for Chinese immigrants trying to enter the United States from 1910 to 1940. Immigrants were detained sometimes for several weeks, months, or even years. Here, immigration officials assumed that the Chinese were entering with false papers and therefore presumed to be guilty unless proved otherwise. Each Chinese person entering the United States had to provide evidence that they were entering on legitimate grounds by giving consistent and detailed answers to repeated questions regarding their origin, identities, and destinations. Additional questioning often addressed their private lives, which was not only intimidating but also embarrassing for Chinese women. Interrogation typically lasted two to three days, but could continue indefinitely. This humiliating experience was, needless to say, traumatic.

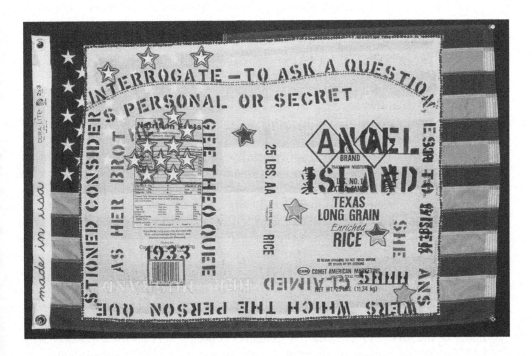

Figure 8.8 Flo Oy Wong, *made in usa: Angel Island Shhh,* "Flag 13: Gee Theo Quee," 2000.

First presented in the original barracks of the Angel Island Immigration Detention Center in the San Francisco Bay, *made in usa* is a visual testimony to what Wong calls a "currency of secrecy" that engulfed not only her own life growing up, but the lives of many Chinese-Americans who entered the United States during this time. The Chinese Exclusion Act of 1882 barred wives and the children of Chinese laborers living in the United States—some of whom were already U.S. citizens—from reuniting with their families. As a result, many Chinese immigrants were forced to hide their identities in order to enter the United States and an elaborate network of "paper people" using false identity documents was created. Each flag in Wong's installation *made in usa: Angel Island Shhhh* commemorates the immigration story of an actual "paper person." Wong created twenty-five flags for the installation (Figure 8.8), including one honoring her mother's story.

Wong's mother, Suey Ting Gee, came to the United States in 1933 with her three Chinese-born daughters and false documents that identified her as the sister of her husband, Seow Hong Gee. Upon arrival at Angel Island, these three daughters became the nieces of her father. After Wong's mother gave birth to Flo Oy, Gee arranged a false marriage with an acquaintance, Sheng Wong, so that their American born daughter would be legitimized. Similarly to many other Chinese-Americans, Wong grew up with not only the secret of her mother's real identity but her own false name and identity. She refers to herself as "a false paper girl" or *hoo gee nuey*. She has never met her "paper father." It was not until the 1960s, when amnesty was granted, that Wong's mother publicly acknowledged her "paper brother" as her husband and the confusing pieces of Wong's family history could be pieced together.

By installing *made in usa* in the now empty barracks of Angel Island (now a state park), Wong reanimates and reclaims a building filled with the stories of thousands of Chinese immigrants. Describing the barracks, Wong says, "the space is a musty and dark narrow room with poems carved on the walls" (2000, p. 23). Viewers who visited the installation confronted the cramped spaces where detainees were held while listening to interviews she conducted with former Angel Island captives presented in English and Chinese. The installation also included mounds of red, white, and blue rice placed on the floor underneath the flags presented on the walls. Before it was installed, Wong described her aspirations for the exhibition: "I want memories, questions, and history to float from my pieces, which feature secrets of 'paper people' revealed and concealed on my cloth rice sacks hand-stitched onto the American Flags. I want the silence of invisibility to break the 'paper people' narratives and eventually permeate the hearts and minds of those who will see the show" (2000, p. 23).

Wong's use of a standardized format and composition for each of the flags suggests the dehumanizing process of immigration experienced by Angel Island detainees. Each flag looks superficially the same—the composition includes a rice sack sewn on top of an American Flag with stenciled text, cloth stars, and sequins used to convey specific kinds of information. Much like the institutional forms used to solicit information from new immigrants, the text on each flag includes on the left side terse facts such as name, date, and port of entry. A definition of the word *interrogate* ("to ask a question, esp. to seek answers which the person questioned considers personal or secret") frames the outer contours of the sack. "Angel Island" is stenciled in bold letters on the right side, with "shhh" stenciled in small type below. Stars cut from an American flag are rimmed in red and scattered randomly across the surface of the rice sacks. Finally, Wong adds the "paper

person's" family secret that allowed them to enter through Angel Island. Each flag suggests the tension embedded in the idea of a unified American culture based on democratic principles. The American flag, symbolizing the freedoms and rights guaranteed by the United States Constitution has been combined with the contradictory experiences of segregation based on racist immigration laws that systematically kept Chinese families apart and denied citizenship to Asian immigrants. Each flag presents a mash-up of different forms of deeply personal and functionally bureaucratic information combined to present a new historical look at the individual lives of immigrants whose lives were irrevocably altered by the anti-immigrant policies of the United States government.

Alien Staff by Krzysztof Wodiczko

Krzysztof Wodiczko, *Alien Staff*, performance still, 1991–1993. Mixed media, each variant approx. 60 inches tall. Copyright Krzysztof Wodiczko. Courtesy of Galerie Lelong, New York.

SEE Plate 9 and Plate 10, in Insert

In the process of becoming a new person, an immigrant must imagine, examine, and question all identities—the past, present and future. Those who are ready to negotiate these psycho-political roles need this equipment, an artifice or prosthesis to begin this demanding process of fearless speech. I do not propose how all of this should be resolved. I only suggest that artists, who are situated between technology, discourses of democracy, and the lives of people, have unique opportunities to create practical artifacts that assist in this migratory and transitory world.

(Krzysztof Wodiczko, 2003)

ABOUT THE ART

Krzysztof Wodiczko was born in Poland in 1943 in the midst of World War II. Having emigrated twice—once from Poland to Canada and then from Canada to the United States—Wodiczko considers himself a nomad. By applying the term *nomad* to himself, Krzysztof suggests not someone without a home, but a person whose sense of place and home travels with him. Wodiczko's deeply political work explores complex issues of acclimation, displacement, communication, understanding, and cultural norms in a world increasingly shaped by global capitalism, nomadicism, and immigration. Combining sculptural and performative elements, Wodiczko's work often mirrors his ideas about democracy, requiring the participation and interaction of individuals and public audiences to conceptualize, create, and implement it. Wodiczko's work provides new opportunities for speech and exchange, most often for those who have been traditionally marginalized, unheard, or silenced.

Wodiczko is probably best known for his large-scale public projections presented on public monuments and buildings such as libraries, courthouses, and community centers. Wodizcko considers architectural facades and public monuments the bearers of living

histories and as sites to be reclaimed by living people. Addressing urgent local issues within communities across the United States and around the world—violence, war, homelessness, and poverty—Wodiczko utilizes video and digital technologies to create public events that allow individuals to project their experiences to the public through live audio, video and interactive media. (For more information about Wodiczko's public projections see Chapter 3.)

Alien Staff

In addition to these public works, Wodiczko has created a series of communicative devices designed specifically to address the situation of the immigrant. Aware of the sense of displacement that many immigrants experience, Wodiczko created a series of portable instruments to be used by those whose ability to participate in society and connect with other citizens was compromised by language barriers or cultural differences. One of these devices, *Alien Staff* (Figure 8.9), is a portable instrument, a digital walking stick that also serves as a means of public address. In form, *Alien Staff* is modeled after the walking sticks and staffs used in many cultures around the world both to aid in movement but also to convey a position of authority, power, or seniority. An object of curiosity, the staff presents the opportunity of dialogue to anyone interested enough to interact with the bearer. Combining video and audio technology, *Alien Staff* contains a high-tech mini-monitor and a small loudspeaker that allows the user to communicate using prerecorded and live messages. Subsequent versions of the staff utilized different kinds of materials and designs but also included new functions including small containers for artifacts or reliquaries where the user could keep important documents or objects such as a family photographs, a Green Card or Work Visa.

Alien Staff (1993) and a corresponding communicative work, *Mouthpiece* (1994; Figures 8.10 and 8.11) were exhibited together as part of the 1996 exhibition *Xenology: Immigrant Instruments 1992–1996*. *Mouthpiece* is another form of speech equipment designed for immigrants. Fitting over the mouth, this device becomes an extension of the immigrant's body that literally

Figure 8.9 Krzysztof Wodiczko, *Alien Staff*, 1991–1993.

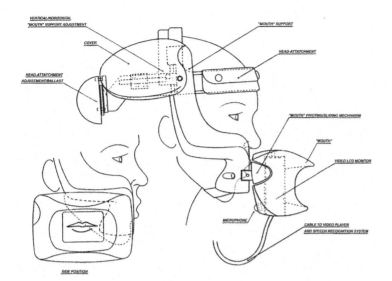

Figure 8.10 Krzysztof Wodiczko, *Mouthpiece (Porte-Parole)*, 1992–1996.

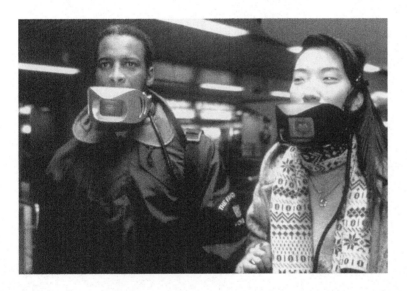

Figure 8.11 Krzysztof Wodiczko, *Mouthpiece (Porte-Parole)*, 1992–1996.

projects prerecorded words through a small screen and accompanying speakers. *Alien Staff* and *Mouthpiece* were both performed and exhibited around the world including in Spain, France, and Sweden. Conceptualized as functional tools for communication, both works were used by individuals Wodiczko met on the street and through colleagues. Documentation of their experiences was also included in the exhibit.

Each of Wodiczko's communicative devices provides a different way of storytelling and dialogue. By imagining the words in advance and playing them back, the user adopts the tools of a musician or editor who remixes existing sounds, words, and texts to create new music, images, and moving pictures. Collectively they offered the opportunity for immigrants to narrate their own stories, to describe the unique ways that they experience feelings of displacement and isolation, and to negotiate the ways they are

perceived as individuals and immigrants. "These speaking/walking sticks with their personal reliquaries, monitors, and recordings are a user's double. They can be used as therapeutic devices, as well as implements to participate in a democracy. The instruments provoke an exchange of opinions" (Wodiczko in Phillips, 2003, p. 37). Uniquely adapted by each participant (the immigrant and the audience), these tools generate new stories and interpretations with every use and interaction. Wodiczko's reference to the *Alien Staff* as a therapeutic device refers to his hope that each interaction with the *Staff* is an opportunity not just for the immigrant experience to be told and heard, but to begin to heal the divide between disconnected citizens, to address the isolation and dislocation of the "other" in our society and the pervasive fear of the stranger.

PRIMARY DOCUMENT

Poetry from Angel Island Immigration Station

In the quiet of night, I heard, faintly, the whistling of wind.
The forms and shadows saddened me; upon
seeing the landscape, I composed a poem.
The floating clouds, the fog, darken the sky.
The moon shines faintly as the insects chirp.
Grief and bitterness entwined are heaven sent.
The sad person sits alone, leaning by a window.

America has power, but not justice.
In prison, we were victimized as if we were guilty.
Given no opportunity to explain, it was really brutal.
I bow my head in reflection but there is
nothing I can do.

(Translations courtesy of Lai, Lim, and Yung, 1991.
Several more of these poems are available at
http://www.kqed.org/w/pacificlink/history/angelisland/poetry/)

Excerpt from The Geary Act (1892)

Be it enacted by the Senate and House of Representatives of the United States of America in Congress assembled, . . . [That] it shall be the duty of all Chinese laborers within the limits of the United States at the time of the passage of this act, and who are entitled to remain in the United States, to apply to the collector of internal revenue of their respective districts, within one year after the passage of this act, for a certificate of residence, and any Chinese laborer within the limits of the United States who shall neglect, fail, or refuse to comply with the provisions of this

PRIMARY DOCUMENT

act, or who, after one year from the passage hereof, shall be found within the jurisdiction of the United States without such certificate of residence, shall be deemed and adjudged to be unlawfully within the United States, and may be arrested . . . and taken before a United States judge, whose duty it shall be to order that he be deported from the United States, as herein before provided, unless he shall establish clearly to the satisfaction of said judge that by reason of accident, sickness or other unavoidable cause, he has been unable to procure his certificate, and to the satisfaction of the court, and by at least one credible WHITE witness, that he was a resident of the United States at the time of the passage of this act; and if upon the hearing it shall appear that he is so entitled to a certificate, it shall be granted upon his paying the cost.

. . .

Approved May 5, 1892.

> (Fifty-Second Congress. Sess. I. Chap. 60. 1892, available at http://www.uchastings.edu/racism-race/gearyact.html)

Appeal of the Chinese Equal Rights League to the People of the United States for Equality of Manhood, 1892

PRIMARY DOCUMENT

APPEAL
OF THE
Chinese Equal Rights League
TO THE
PEOPLE OF THE UNITED STATES
FOR
EQUALITY OF MANHOOD
[1892.]
PRICE, 10 CENTS.
PUBLISHED BY THE
CHINESE EQUAL RIGHTS LEAGUE,
42 Bible House, New York, N. Y.

The New and Monstrous Anti-Chinese Bill [the Geary Registration Act] . . . was read with astonishment by the majority of the people of the United States, and a thrill of indignation went through the hearts of many humanitarians, as cruel, unjust and exceedingly un-American. Upon the 1st of September, 1892, the leading English-speaking Chinese of the Eastern States called a meeting of its own citizens to assemble in New York to devise means to do what they could in the way

of pleading to the people of this great Republic to deliver their fellow countrymen from this outrageous persecution.

The Chinese Equal Rights League was then formed, with a membership of 150 English-speaking Chinese merchants and professional men, most of whom have lived in this country for more than ten years, while some ever since their childhood. Mr. Sam Ping Lee, a merchant of Philadelphia, was duly installed as president, and Wong Chin Foo, of New York, a journalist, was made secretary. A mass meeting at Cooper Union on the 22d day of September was then called, at which over a thousand prominent Americans and nearly two hundred Chinese merchants attended, the speakers including several prominent Americans, and Wong Chin Foo, the secretary of the Chinese Equal Rights League, and the following resolution was then unanimously adopted by the large audience assembled:

Whereas, The Congress of the United States, by an act approved May 5, 1892, unjustly and wickedly discriminating between foreign residents from different countries, has traversed and contravened the fundamental principles of common law and the Constitution of the United States, and has ignored the assertion of the Declaration of Independence—that all men are born with equal rights; and

Whereas, The provisions of this act of Congress, commonly known as the "Geary Bill," bestow unheard of powers on the Secretary of the Treasury, enabling him to fix illegal costs and expenses upon Chinese residents, thereby imposing "taxation without representation"; and

Whereas, The bill contains the outrageous proposition that any person who shall be arrested for its violations shall be adjudged guilty until he shall affirmatively prove his innocence; and

Whereas, The Chinese residents of the 'United States claim a common manhood with residents of other nationalities, and believe that they should have that manhood recognized according to the principles of American freedom;

Now, therefore,

We, the citizens of the United States, in mass meeting assembled, do hereby resolve and declare that the said bill is monstrous, inhuman and unconstitutional; and we hereby pledge ourselves to the support of that protest against the said bill which has been entered by the Chinese Equal Rights League of New York City.

(Courtesy of the Harvard University Library Open Collections Project, 2009, available at http://pds.lib.harvard.edu/pds/view/4581473)

Emma Lazarus, "The New Colossus" (1883)

Not like the brazen giant of Greek fame,
With conquering limbs astride from land to land;

PRIMARY DOCUMENT

Here at our sea-washed, sunset gates shall stand
A mighty woman with a torch, whose flame
Is the imprisoned lightning, and her name
Mother of Exiles. From her beacon-hand
Glows world-wide welcome; her mild eyes command
The air-bridged harbor that twin cities frame.
"Keep, ancient lands, your storied pomp!" cries she
With silent lips. "Give me your tired, your poor,
Your huddled masses yearning to breathe free,
The wretched refuse of your teeming shore.
Send these, the homeless, tempest-tost to me,
I lift my lamp beside the golden door!"

(Available at http://www.npr.org/templates/story/story.php?storyId=6359435)

III: Teaching Connections

Prologue: Mash-Up as a Visual Framework

The term *mash-ups* originally referred to the process of digitally combining music from one song with vocal material with another. Collaged together, these disparate tracks become one integrated track—and also a new musical form. But contemporary visual artists have also adopted the concept of mash-ups to combine and remix diverse sources in the interest of creating new relationships, new forms, and new ideas. Creative mash-ups emphasize the connections between and among sources and ideas from disparate disciplines, formats, and geographic locations. These amalgamations of ideas and forms of information confront an audience with new ways of thinking about and experiencing the work.

There are many ways of conveying the stories and the hardships of those individuals, whom we call immigrants, who have left their homelands and established new lives in a foreign country. And there are as many stories of immigrants leaving, acclimating, persevering, resisting, and negotiating the transition between one home and another as there are ways to hear, see, and understand those stories. New technologies offer new opportunities for telling and interpreting immigrants' stories, and present a wide range of ways to communicate and conversely to know the experiences of others. Artists who combine different multi-media sources and forms offer us the opportunity to reflect on the mashed-up character of our lives, and the diverse sources we turn to as we search for information. Thus, this hybrid form of knowledge that we call mash-ups points out and reflects the complex, collaged-together world we live in.

In this section we highlight particular stories of resistance to the unjustness of laws against immigrants. The following subsection provides suggestions for framing discussions and hands-on activities, and conducting, with young people, critical analyses of the experiences, specifically, of Chinese immigrants in the United States.

These discussions and activities are premised on a thorough reading of all the primary documents and works of art included in the section. Before using the suggestions in the following toolkit, we encourage you to start with a broad-based discussion about the individual works of art in order to help students develop their own observational skills and connections to personal experience and opinion. Suggestions for how to facilitate a discussion about these works of art can be found in Chapter 6. Once you've had a chance to familiarize yourself with all the documents included in the section, you're ready to get started with the Teaching Toolkit. The Essential Questions, Key Ideas, and Instructional Goals in the toolkits do not represent a set of definitive facts, ideas, or questions. They should be carefully analyzed and considered—and modified—at will. Our hope is that our initial questioning will lead to additional questions, ideas, and pedagogical strategies. Likewise, the "Observe, React, and Respond" discussion questions and "Constructing Visual Knowledge" activities have been compiled as a set of strategies to be adapted and interpreted for different classroom needs. Again, these prompts are not exhaustive and do not offer a complete guide or lesson plan for teaching about the history of immigration in the United States, but instead provide a series of provocations to be combined with many other possible resources, strategies, questions, and outcomes.

Teaching Goals

Essential Questions

✧ What strategies have immigrants used to resist anti-immigrant policies and fight anti-immigrant prejudice?
✧ Does the history of Chinese immigration to the United States, and the United States' efforts to restrict the rights of Chinese immigrants, refute the idea of the U.S. as a land of liberty, a refuge for the "huddled masses, yearning to be free?"
✧ What does the word *alien* connote in the context of immigration?
✧ How do artists utilize diverse communicative forms of visual, digital, and multi-media sources to construct new immigrant stories and ideas about immigration?

Key Ideas

Students will understand that:

✧ Protest can take a diversity of forms.
✧ In the late nineteenth and early twentieth century, the U.S. government passed a succession of laws aimed at restricting the rights of Chinese immigrants in the U.S.
✧ In the late nineteenth- and early twentieth-century U.S., organizations such as the Chinese Equal Rights League rose up to protest anti-Asian sentiment and the inequalities of U.S. immigration law.

✧ Artists combine different visual and performative strategies to narrate or convey personal stories and ideas, and as a form of resistance or critique.

Instructional Goals

Students will:

✧ Critically read and interpret a variety of visual and text sources, including historical documents and works of art, about the experiences of immigrants in the United States.
✧ Frame effective questions about the immigrant experience, exclusionary laws, democratic ideals, and cultural identity.
✧ Debate key ideas and issues about the history of immigration in the United States and its relationship to democratic ideals.
✧ Construct visual arguments that reflect personal/individual understandings about the experiences of immigrants and their efforts to protest anti-immigration laws.

Teaching Strategies

Use the following prompts, either individually or together, to initiate a series of discussions that explore the essential questions and key ideas.

a. Ask students to look at all of the documents and works of art contained in this section. In order to help students explore the ideas contained in these texts and images, ask them to consider the following:

✧ Who is the author of each document or work of art?
✧ What is the argument or idea each author puts forth?
✧ Who might the intended audience be for each of the documents and artworks? That is, to whom, specifically, was each piece initially addressed?
✧ What was the purpose for which, or "occasion" upon which, the documents or artworks were created?
✧ What do each of these pieces suggest about the history of Chinese

I. OBSERVE, REACT, AND RESPOND

immigrants in the U.S. and the various ways that immigrants have resisted and documented their experiences?

Choose one or more of the following prompts to extend the initial discussion based on a close reading of particular primary documents and works of art.

b. Choose either the flags from Flo Oy Wong's series *made in usa: Angel Island Shhhh* or Krzysztof Wodiczko's *Alien Staff* and *Mouthpiece*. Then select two of the following historical documents: the Geary Act, the Appeal of the Chinese Equal Rights League, a poem by an Angel Island detainee, or Emma Lazarus's "New Colossus" poem. Compare and contrast the text of the artwork with the text of the historical documents you have selected. What visual and textual sources does the work of art you have selected draw from—that is, what texts and images do they attempt to "mash up?" How does the information contained in the documents you have selected help you understand the work of art? Ask students to analyze the documents as a collective body of information about Chinese American experiences in the early twentieth century, and then create a single written narrative that combines all of these works into one analytical description.

c. In relation to the works by Krzysztof Wodiczko, discuss what the word *xenology* means. What are the origins of this word? How is it related to Wodiczko's work? Then discuss Wodiczko's use of the word *alien*. What are the implications of this word? Given the fact that the word *alien* has been used, historically, to cast certain kinds of immigrants—including Asian immigrants, and undocumented immigrants—as foreign and undesirable, why do you think Wodiczko chose to use the word *alien* in the title of a work of art that aims to make visible the personal stories of immigrants to the U.S.? Next look at the work of Flo Oy Wong. Discuss the language she uses to describe the immigrant community she is documenting. How do these words differ in meaning and implication from the word *alien*? How do these words relate to the visual imagery that she and Wodiczko create? What kinds of stories do these artists tell about immigrant communities?

d. Discuss student perceptions about immigrant communities in the United States and locally. Ask students to name different immigrant communities they are aware of, or part of. Ask students to write about what they know about this community. Use a timeline of United States history to chart and document student responses. To follow up, ask each student to select a local immigrant community (it could be their own community), and research its history: When

did this immigrant group first establish sizeable communities in your town? How big is the community now? What were the central obstacles members of this community faced at first? What kinds of community institutions did they build? What are the important cultural sites or places where community members meet each other? What obstacles do they face today? How has their portrayal in local newspapers changed over time? Then ask students to compare the results of their research with their initial written descriptions. Did they discover anything new or compelling about this immigrant group in their research? Give students a chance to share their writing with the group and use this discussion to facilitate follow-up conversations that can address potential misconceptions, stereotypes, and questions regarding various immigrant communities.

a. Search local historical societies, library collections, and the Internet for oral histories of your town and the immigrants who live there. Select excerpts from several of the oral histories, either in transcript or in recorded form. Ask your students to select one excerpt, and then create a visual history project based on the life and experiences of the person who tells their story in this text. If possible, connect this activity with activity I (d), above; that is, ask your students to choose oral histories of individuals from the local communities they researched earlier. Alternately, ask students to conduct their own oral histories with people that they know in the community. (Again, be sure that students do some research about the immigrant community from which their subject comes before conducting their oral history interviews.) Have students create a list of interview questions that will solicit additional information about the cultural history and lived experiences of this community. Ask students to take photographs (with the permission of the interviewees) of different objects, spaces, and symbols that their interviewees think reflect their community. Finally, mount an exhibition. Combine the voices and text from the interviews with photographic images to create a multi-media installation or presentation that reflects the information they have collected about this community. (For examples of multi-media installations see Chapter 4, Jackie Brookner's *Of Earth and Cotton*, 1994–1998).

b. Have students select and research an anti-immigrant policy from the recent or distant past, such as the Alien and Sedition Acts of 1798, the *U.S.* v. *Thind* Supreme Court decision of 1923, the Johnson–Reed Immigration Act of 1924, Operation Wetback of 1954, the Illegal Immigration Reform

II. CONSTRUCTING VISUAL KNOWLEDGE

and Immigrant Responsibility Act of 1996, or the Real ID Act of 2000. What communities were affected by that policy? How did members of that community resist or protest their treatment under this law? What different forms did the protest take? Ask students to make an effort to look specifically for creative and cultural forms of protest. Then ask students to compile their findings into a group timeline—one that all at once contains written and visual representations of events and actions. (Visual sources might include photographs, found images, newspaper or magazine articles, students' sketches, symbols or icons, historical documents, cartoons, or works of contemporary art.) Ask students to design a visually provocative pamphlet that informs people about the issues related to the anti-immigration act that they chose and suggestions for ways people can resist it. Then create a museum in your class. Install the timeline around the perimeter of the classroom, create a display of student-created brochures, and give tours to other classes.

Standards

National Council for the Social Studies Thematic Standards

Standard I. Culture

The learner will...
g) construct reasoned judgments about specific cultural responses to persistent human issues;

Standard II. Time, Continuity, and Change

The learner will...
b) apply key concepts such as time, chronology, causality, change, conflict, and complexity, to explain, analyze, and show connections among patterns of historical change and continuity;
d) systematically employ processes of critical historical inquiry to reconstruct and reinterpret the past, such as using a variety of sources and checking their credibility, validating and weighing evidence for claims, and searching for causality;

Standard IV. Individual Development and Identity

The learner will...
a) articulate personal connections to time, place, and social/cultural systems;
b) identify, describe and express appreciation for the influences of various historical contemporary cultures on an individual's daily life;
e) examine the interactions of ethnic, national, or cultural influences in specific situations or events;

Standard X: Civic Ideals and Practices

The learner will...
b) locate, access, analyze, organize, synthesize, evaluate, and apply information about selected public issues—identifying, describing and evaluating multiple points of view;
d) practice forms of civic discussion and participation consistent with the ideals of citizens in a democratic republic;
f) analyze a variety of public policies and issues from the perspective of formal and informal political actors;
h) evaluate the degree to which public policies and citizen behaviors reflect or foster the stated ideals of a democratic form of government.

National Visual Arts Standards

Content Standard: 1: Understanding and applying media, techniques, and processes
Content Standard: 2: Using knowledge of structures and functions
Content Standard: 3: Choosing and evaluating a range of subject matter, symbols, and ideas
Content Standard: 4: Understanding the visual arts in relation to history and cultures
Content Standard: 6: Making connections between visual arts and other disciplines

REFERENCES

Dempster, B. K. (2000). made in the USA: exhibition catalogue. San Fransisco, CA: Kerney Street Workshop.
Lai, H. M., Lim, G., & Yung, J. (1999). *Island: Poetry and history of Chinese immigrants at Angel Island, 1910–1940*. Seattle: University of Washington Press.
Lowe, L. (1996). *Immigrant acts: On Asian American cultural politics*. Durham, NC: Duke University Press.
Phillips, P. C. (2003). Creating Democracy: A Dialogue with Krzysztof Wodiczko. *Art Journal* 62(4), 32–47.
Race and Pedagogy Project at the University of California. (2006). Angel Island poems. Retrieved January 3, 2009, from http://rpp.english.ucsb.edu/classroom/ucsb-courses/english-104a/angel-island-poems
Wong, F. (n.d.). Artist website. Retrieved on December 20, 2008, from http://www.flo-oy-wongartist.com/

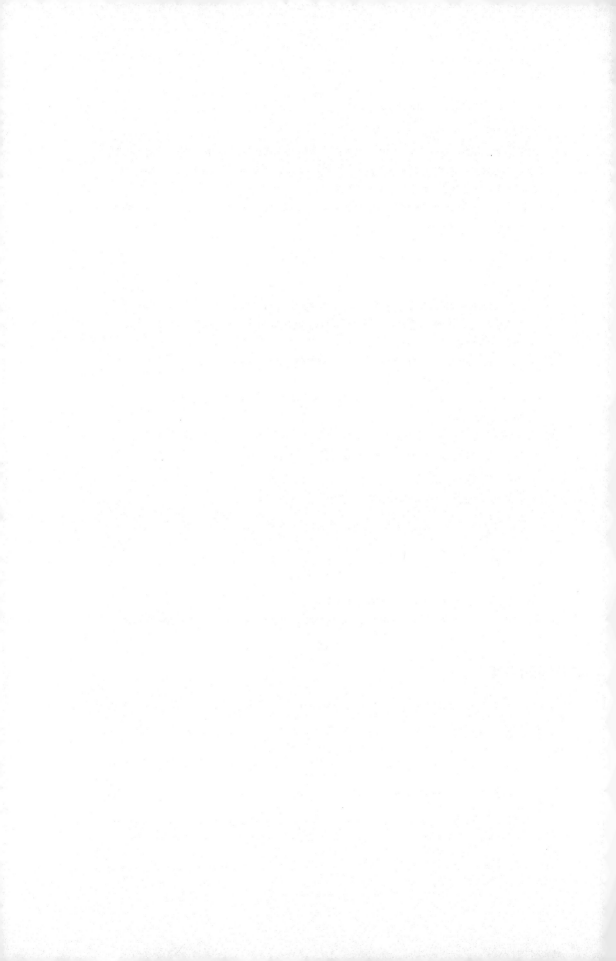

The United States and the World

CHAPTER OVERVIEW

There was a time when the only people who called the U.S. an "imperialist" power were anti-war protesters, and critics of the U.S.'s war making overseas. "One of the central themes of American historiography," the historian William Appleman Williams famously wrote in the middle of the twentieth century, "is that there is no American empire" (Williams, 1955, p. 379–395). When the U.S. appropriated Native American lands and Mexican territory in the nineteenth century, mainstream politicians called it "Manifest Destiny," or "civilizing the wilderness." Likewise, supporters of the U.S.'s undeclared war on the people of Vietnam in the mid-twentieth century called that conflict "containment," or Cold War pragmatism. But in the past few years, U.S. political discourse has seen a shift: in the era of the War on Terror, mainstream pundits and politicians have begun to use the term *imperialist*. Indeed, as the past-president of the American Studies Association, Amy Kaplan (2004), has noted, "today, across the political spectrum, policy makers, journalists, and academics" embrace the term *empire*.

> It's fashionable, in fact, to debate whether this is a new imperialism or business as usual, whether the United States should be properly called imperial or hegemonic, whether it is benevolent or self-interested, . . . whether this empire most closely resembles the British Empire or the Roman, and whether it is in its ascendancy or in decline.
>
> (Kaplan, 2004, p. 1)

Still, this new enthusiasm for the idea of an American empire has not settled the question of whether the U.S.'s actions abroad are just, or justified, or not. Likewise, questions about the motivations and effects of the U.S.'s historical encounters with people and territory outside of its borders remain unsettled. In this chapter, we invite investigation into the question of whether any moments in U.S. history might be considered "imperialist," and what it would mean if so. But we also look at the U.S.'s international encounters—within the specific context of Westward Expansion and the

U.S. war in Vietnam—through a range of other questions and concepts. What, we ask, should we make of the U.S. government's appropriation of Indian land? Might the U.S. owe a historical debt to the descendants of those Native Americans who were so deliberately and violently displaced? What, meanwhile, are the "lessons" of the U.S.'s war in Vietnam? How has this question helped shape public debate about war and U.S. foreign policy over the past three decades? How—and why—do conflicting memories of the Vietnam War continue to shape national debates?

The events detailed in these two sections are separated by a century, a continent, and a range of thematic concerns. But the histories of both Westward Expansion and the U.S. war in Vietnam invite consideration of the U.S.'s encounters with other nations and peoples, as well as the history of American ambitions for international power. Both events were also marked by violence, misunderstanding, and deep domestic political divisions. Our hope is that by presenting these two seemingly divergent histories next to each other, we might spark new ideas about both the history of U.S. foreign policy generally speaking, and about the kinds of questions we might ask about any given war or conflict more specifically. What lessons did Americans learn from the many wars they have fought? How has the U.S. been shaped by ideologies about land, territory, and property? And how useful is the idea of empire for describing U.S. pasts?

REFERENCES

Kaplan, A. (2004) Violent belongings and the question of empire today: Presidential address to the American Studies Association, October 17, 2003. *American Quarterly, 56*(1), 1–18.

Williams, W. A. (1955). The frontier thesis and American foreign policy. *Pacific Historical Review, 24*(4), 379–395.

SECTION 1: WESTWARD EXPANSION

I: Historical Introduction

Imagine, if you will, a map of the world. Imagine that this map does not indicate national political boundaries, that it does not divide nation from nation. Imagine instead, that this map is filled only with natural markers: the major bodies of water, the contours of floating land masses. Try, at least for a moment, to forget whatever standard political map—the Mercator, the Peters Projection, the upside-down world map—you have etched into your imagination. Try, at least for a moment, to recall that all the divisions that these maps contain—especially the divisions created by national borders—are not natural landmarks, not the work of nature, not inevitable.

This is a hard map to imagine; we do not tend to draw world maps without indicating major national and provincial borders. And, in fact, we do not tend to think of the national divisions that mark the world maps as inventions. And yet, the shape and contours of contemporary nations were not determined by tectonic shifts or volcanic eruptions. They were not, that is, set down by natural processes. To the contrary, they were created by historical events: wars, conquest, revolutions, violent contests for power.

This is true, also, about the contours of the United States. Like all political entities, the shape and reach of the United States of America was created by a series of historical events: wars, conquest, revolutions, violent contests for power. The U.S. did not always stretch all the way from the Atlantic to the Pacific oceans; it did not always look like a melting rectangle. And moreover, it was not "meant" to take the shape it currently takes. It is hard to recall that. Remember the thirteen original colonies? They certainly did not stretch across to the Pacific, or even down to Florida. How did thirteen colonies become fifty states?

In this section, we begin to inquire into this question. Addressing ourselves to the era of U.S. history that most textbooks call "Westward Expansion" we invite investigation into territory, land, property—and the historical processes that led the United States to take the shape that it currently holds. The framework that we offer for this inquiry revolves around a set of primary documents and works of art that address the displacement of Native Americans from land that would become part of the continental United States in the eighteenth and nineteenth centuries.

The story of how a nation that began as thirteen original colonies came to stretch from the Atlantic to Pacific oceans, and from the Great Lakes to the Gulf of Mexico, revolves around a few key moments when the U.S. "acquired" (to use far too neutral a term) new geographical territories. This story, as it is frequently told, is that the U.S. grew through a series of civilized financial transactions: Indians sold Manhattan to the U.S. government for $1; France sold a large chunk of land in the center of the continent to the U.S. for $15 million; and so on. But in fact, even these nominally legitimate and peaceful financial transactions featured acts of deception, misunderstanding, and theft. What right, for instance, did France have to the land it sold to the U.S. in the Louisiana Purchase? Very few French people lived on this land; instead, this territory was largely populated by members of several Indian nations. To quote the historian Colin Calloway, before the Louisiana Purchase:

the vast territory that lay roughly between the Mississippi and the Rocky Mountains . . . was Indian country. It was a world in which the presence of British, French, and Spanish traders and the aspirations of competing European nations had been felt for some time, but where Indian people and Indian power were still dominant.

(Calloway, 2004, p. 225)

Neither seller nor buyer consulted the Native residents of this territory before the transaction, and indeed, most Indians knew nothing about the sale until agents of the U.S. government began to force them off their land.

The completion of the financial transaction between France and the U.S., thus, did not secure this territory as "American." President Jefferson knew this, and so he sent the team of Meriwether Lewis and William Clark on their famous expedition (1804–1806) to collect information about, and to begin the difficult process of conquering, the land and the people who lived there. "Lewis and Clark's purpose," Calloway (2004) explains, "was to proclaim American sovereignty over the area, prepare the way for American commerce with the tribes, and gather as much information about this 'new land' and the many Indian peoples who inhabited it" (p. 225). The expedition did not entirely succeed—for Lewis and Clark cemented, among many Indian nations, bad feeling toward the United States, and also failed to sow as much division among the resident Indian nations as they had hoped to. But the explorers did gather a great deal of information about the social and political lives of the Indians that resided in this territory, information that the U.S. government would put to use later in developing policy and tactics for subduing the land and the people who lived on it.

Among the people who inhabited this territory were members of a number of Indian nations whose names we now know only as place names: the Omahas, the Missouris, the Cheyennes. There were also other nations living there, whose names most Americans do not know: the Otos, the Brulé, the Mandan, the Arikaras, the Hidatsa, the Arapahos, the Kiowas. These groups were a diverse lot. Some lived in societies that were primarily sedentary and agricultural; others had developed economies based on hunting and seasonal migrations. But whoever they were—whatever their economic structure, or their communal desires—after 1803, they were, to the U.S. government, a problem: they occupied land that the U.S. wanted to develop and settle for itself. And so, beginning with Jefferson's presidency, the official policy of the U.S. was removal. Jefferson, for one, developed a multi-pronged plan to "take Indian lands"—with "honor." First, he declared that the U.S. government would forcefully encourage Native people to adopt sedentary farming-oriented lives. As Indians became more dependent on farming for their livelihood, they would, in Jefferson's words, "perceive how useless to them are their extensive forests," and thus would be more "willing" to "exchange" their land for the goods they needed to farm and feed their families. Second, in their trade with Indian individuals, the U.S. would attempt to force them into debt. Or, in the words of the President: "We shall . . . be glad to see the good and influential individuals [among Indian nations] run into debt, because we observe that when these debts get beyond what the individuals can pay, they become willing to lop them off by a cession of lands" (quoted in Calloway, 2004, p. 210). Finally, Jefferson predicted (and accurately, as it turned out) that as American settlements began to develop on Indian homelands, Native people would either "incorporate with us as citizens of the United States," or, even better, "remove [themselves to land] beyond the Mississippi." Regardless, with Indians and white settlers living in such close proximity, Jefferson knew that conflict would

inevitably erupt—and when it did, the U.S. government could swoop in, "invade Indian country, suppress the uprising, and dictate treaties in which defeated Indians signed away land" (Calloway, 2004, p. 210). In short, as Calloway explains, "Jefferson showed little compunction in taking away [Indian] homelands," and ultimately, his strategy for acquiring Indian lands was effective. It resulted in the signing of at least thirty treaties with several Indian nations, and the cession by Native people of almost 200,000 square miles of territory to the U.S. government.

U.S. government efforts to appropriate Indian lands on both sides of the Mississippi gained another boost with the election of Andrew Jackson as president in 1828. Within two years, Jackson and Congress had passed the Indian Removal Act, which led to the removal of large numbers of Indian nations from areas east of the Mississippi, the brutal Trail of Tears, and a new era of conflict and strife among and between Indians and the U.S. But the trouble did not end there. As the nineteenth century progressed, the U.S. government developed new ways to appropriate Indian lands. Among the most effective of these efforts was the Dawes Allotment Act, passed by Congress in 1887.

The Dawes Act contained several linked provisions. First, it placed all decisions over Indian land in the hands of the federal U.S. government. Individual Indian families would, under the act, "receive" the rights to own an allotment of up to 160 acres of land. But there were several conditions that limited Native rights to this land. Arguing that Indian people did not understand the value of private property, the Dawes Act gave the U.S. government the authority to retain the title to all land allotted under the Act's provisions—for twenty-five years. At the end of this time, the nominal owners of this land would only get full rights to the land title if they had proven their ability to treat individual plots of land as "real estate"; that is, as valuable "property" according to the conventions of American capitalism. Other rights outlined in the Act, including the right to become a U.S. citizen, contained similar preconditions: Indians would only be eligible to U.S. citizenship if they proved that they had abandoned their "tribal" ways, and learned to treat land as property. "The main effect of this law," writes Colin Calloway, was not to settle the disputes over land that so plagued the people living in the western United States. On the contrary, the Act's central effect was to "strip Indian people of millions of acres of land" (Calloway, 2004, p. 341).

Thus, not only did the U.S. government ploddingly and violently steal the bulk of western North America from Native people; it did so in a way that radically clashed with the ideas about land, property, and ownership that governed many Native cultures and economies. Although there were great differences—social, cultural, economic, and other—among many of the nations who suffered the effects of appropriation, removal, and allotment, most of them did not view land and property in the same way that the U.S. federal government did. At least in that one respect, the Dawes Act accurately described the social world into which it intervened: many Native people did not, indeed, understand land to be "real estate," meant to be owned by individuals or to generate wealth at the expense of other people. "All of our teachings and beliefs were that land was not made to be owned in separate pieces by persons," a Cheyenne man named Wooden Leg later reflected. "It was not the Indian way of living" (quoted in Marquis, 1931, p. 155). This enforced privatization of land had a deep effect on Indian life. According to Ella C. Deloria, a Sioux who lived through the Dawes Act years, this policy created large groups of people who suffered "frightful loneliness" and intense financial troubles. "It wasn't easy to make the spiritual and social adjustment," she recalled. "The people were too used to living in large family groups, cooperatively and happily. Now here they were

in little father–mother–child units . . . often miles from their other relatives, trying to farm on arid land" (Deloria, 1979, pp. 62–63).

In the Toolkit that follows, we provide an entrée into the history of "Westward Expansion" through these themes of land and property. Featuring artwork by the Chicano artist David Avalos and Native American artist Jaune Quick-to-See Smith, as well as excerpts from several primary documents—including a few of those mentioned above—we hope to provoke lively inquiry into difficult questions. Taking our cue from the featured artwork we ask: What does it mean to "trade" or "sell" something? Who determines what is valuable? What does it mean to "own" land? How has U.S. popular culture erased the complexity of Native histories? What is the wilderness? What is civilization?

We also hope to provoke debate about the meaning of the U.S. government's approach to territory, property and expansion in the nineteenth century. Over the course of much of the past two centuries, the U.S. has liked to claim that unlike the great European powers, it has not engaged in widespread imperial adventures. In the words of a newspaper article published in 1848 (during the Mexican–American War), the U.S. "take[s] nothing by conquest . . . Thank God" (*The Whig Intelligencer*, quoted in Zinn, 1980/2003, p. 169). Or, in the words of the eminent historian William Appleman Williams, "One of the central themes of American historiography is that there is no American empire" (Williams, 1955, pp. 379–395) But the history of the Louisiana Purchase and the Lewis and Clark Expedition, Indian Removal, and the Dawes Act suggest that this might not be the full story. What, we encourage you to ask your students, can we make of the long history of the U.S. government's appropriation of Indian land? Can it be called "imperialism?" And how do we make sense of the various federal administrations—including Jefferson's and Jackson's—that presided over and drove these policies? Were these presidents simply making room for progress, civilization, and development? Or might the U.S. owe a historical debt to the descendants of those Native Americans who were so deliberately and violently displaced?

II: Mini-Archive

ABOUT THE ART

Trade (Gifts for Trading Land with White People) by Jaune Quick-to-See Smith

Jaune Quick-to-See Smith, *Trade (Gifts for Trading Land with White People)*, 1992. Oil and collage on canvas, with other materials, 60 170 inches. The Chrysler Museum of Art, Norfolk, VA, museum purchase. Copyright Jaune Quick-to-See Smith.

SEE Plate 11, in Insert

My stories are about my worldview from a Native perspective, but ultimately it's about the human condition. So I collage together this conglomeration of stuff because everything in the world is attached or connected.

(Jaune Quick-to-See Smith, n.d.)

An artist of Salish, French–Cree, and Shoshone heritage, Jaune Quick-to-See Smith seeks in her artwork to open a dialogue between her Native American heritage and Euro-American culture. Smith was born in Montana on the Flathead Reservation and is a member of the Salish Kootenai Nation. Identifying herself as a cultural worker, Smith creates images that layer symbols, stories, and myths passed down from her ancestors that speak to current issues faced by the Native American community. Integrating found images and text with painting and drawing, Quick-to-See Smith's images are filled with iconic references to Native American culture, identity, and history as they intersect with Euro-centric values and contemporary culture. Paintings, drawings, lithographs, and mixed media works carefully composed of abstract and representational imagery address pervasive Native American stereotypes, the intersections of capitalism and consumption, tribal politics, and environmental issues. Native versus Euro-centric notions of territory and ownership in particular are evident in much of her work. References to maps, flags, and landscape challenge twenty-first-century notions of ownership, property, and power. The size and scale of her work, some images as big as 14 feet wide and 5 feet tall, suggest a metaphorical relationship to landscape as well.

> I think of my work as an inhabited landscape, never static or empty. Euro-Americans see broad expanses of land as vast, empty spaces. Indian people see all land as a living entity. The wind ruffles; ants crawl; a rabbit burrows. I've been working with that idea for probably twenty years now.
>
> (Smith, n.d., para 1)

Trade (Gifts for Trading Land with White people)

As part of series of related artworks created during the quincentenary celebration of America, *Trade (Gifts for Trading Land with White People)* offers the viewer a chance to consider persistent stereotypes and myths about Native Americans that infiltrate daily life, beginning with the idea that Christopher Columbus "discovered" the New World in 1492. In contradiction to the Euro-centric and nationalistic pride inspired by this controversial historical moment, Smith has described the year 1492 as the "beginning of tourism." As a counterpoint to the traditional celebrations and tributes to the life and times of Christopher Columbus, Smith creates a contradictory statement that illustrates the radical divide stretching between that original discovery and present day.

Three square canvases compose the main body of the work. Each canvas is collaged with a combination of newspaper articles taken from contemporary Native American newspapers, photographs and early illustrations of animals and Native and colonial people, and contemporary advertisements. One section of the painting juxtaposes the headlines "Power Source" and "Notes from Indian Country" with an imposing portrait of a Native American man, most likely taken during the nineteenth century. These found images and texts are interspersed with sections of paint and bits of cloth. Red, yellow, and green have been brushed, splashed, and drizzled over the surface of the painting, obscuring some imagery below, highlighting other elements. The color red bookends the canvases and suggests symbolic associations ranging from the epithet "red man" to the spilled blood of persecuted ancestors. Placed on top of this background is a single outline of a large, hollow canoe. In light of the quincentenary, Smith has replaced

Columbus's *Niña*, *Pinta*, or *Santa Maria* with a boat that is most closely associated with Native American travel and trade. This image of a canoe begins to recede into the background in places but also seems poised to catch a series of objects that hang just above the paintings.

The suspended objects are a motley collection of contemporary stereotypes of Native Americans. Sports paraphernalia from the Washington Redskins, Atlanta Braves, and Cleveland Indians dangle with souvenirs and trinkets such as toy tomahawks, headdresses, beaded belts, and necklaces. Going back to the title of this work, Smith asks us to think specifically about trade as we look at this collection of images and objects. Trade or barter is commonly understood as an equal exchange; however, Native American history is filled with an inordinate number of very unequal and disenfranchising exchanges made with Europeans settlers and the United States government. Smith's use of trinkets and tourist items suggests the rumored but unofficially documented sale of the island of Manhattan by the Lenape Indians for what was then valued by the Dutch at 60 guilders. Although there is no official bill of sale to confirm this, the mythology of this trade has taught millions of school children that Manhattan was purchased for a paltry collection of glass beads, mirrors, shells, and furs by unsuspecting and naïve Indians in 1626. These stories of trade, however, are tainted by disparate ideas about the land and its value. Notions of property and ownership were foreign to Native tribes who did not believe that air, water, or land could be traded, purchased, or sold.

Smith is also pointing out the ways that antiquated stereotypes as represented in early documentary photographs of Native Americans have been traded for contemporary ones in the form of red-faced mascots and the children's game of "cowboys and Indians." *Trade (Gifts for Trading Land with White People)* highlights the continued use of racist imagery in advertising and consumer culture and the long history of mistreatment of Native Americans in the United States. Does Smith's ironic title suggest that contemporary trinkets should be offered for trade by the Native Americans in order to retrieve their lost lands? If Columbus's boats were the harbingers of a tourist economy that would decimate the lands, rights, and livelihoods of Native American populations, Smith's boat sits poised to offer a collection of racist trinkets of questionable value, perhaps to reclaim lands that have been lost, perhaps to expose the continuing legacy of Euro-centric exploitation of Native culture.

ABOUT THE ART

Wilderness by David Avalos

David Avalos, *Wilderness,* 2008. Digital collage (based on a 1989 installation).

SEE Plate 12, in Insert

This society is an oligarchy, yet it professes democratic ideals. I think public art is a real challenge to the oligarchy. It's also a challenge to everyday people and the democratic ideal.

(David Avalos, quoted in Simonds, 1994)

Born in San Diego, California, in 1947, David Avalos came of age during the Chicano Movement of the 1960s when student walkouts and other protest actions were raising national awareness about discriminatory practices and racist attitudes towards Chicanos. As an artist with community-based and activist interests, Avalos uses a wide range of media—including assemblage, installation, photography, billboards, murals, sculpture, and performance—to address social, economic, and cultural issues faced by local communities, including the division between private and public spaces, cultural identity, and Chicano and American history. Avalos, in an interview conducted by Margarita Nieto, says, "I think that one of the ways that my work helps contribute to making society is by insisting that we need to redefine U.S. culture" (1998, June 16–July 5, Archive of American Art, Smithsonian Institution).

As an artist engaged in social issues, Avalos has realized many of his projects in collaboration with other artists. These collaborations "were about having a voice beyond the ballot box. They were about a way of being citizens" (Avalos, 1998). Avalos is a co-founder of Border Art Workshop/Taller de Arte Fronterizo, an interdisciplinary artist group in San Diego that was devoted to socially and politically engaged art. Provoking local as well as national controversy, Border Workshop installations addressed the relationship between undocumented workers and the tourist industry in San Diego, the San Diego police force, and illegal immigration. In these projects—created in collaboration with Elizabeth Sisco and Louis Hock—Border Workshop hoped not only to draw attention to these issues, but to open a broader discourse about issues related to the Mexico–United States border. Their work as a collective reframed these social issues, forcing the audience to think about individual social responsibility and the ways that our daily lives are always connected to the lives of others who are undocumented, marginalized, and oppressed.

Wilderness

In 1989 Avalos created the work *Wilderness*, an 8-foot installation that comments on the myth of the western frontier. *Wilderness* presents ten photographs that represent the major tribes and regions of Native Americans taken by Edward S. Curtis (1868–1952). These images of the original inhabitants of the United States are juxtaposed with text that describes a collective mythology of the west as a wilderness. Avalos has closely cropped each photograph to focus on the facial features of each individual and selected only particular photographs that show the individual facing forward, staring directly into the lens of the camera and thus the eyes of the viewer. The ten images alternate between male and female portraits. One photograph shows a young Mohave woman, "Mosa," from 1903; another image presents the quintessential "Indian," Geronimo.

Curtis is considered a controversial figure in American history, or at least in the understanding of that history. Commissioned in 1904 by J. P. Morgan, Curtis set out to create a complete photographic record of all of the Native American tribes of North America. The images that he captured helped establish a pervasive stereotype of Native Americans as primitive and savage people with archaic rituals, beliefs, and traditions. Curtis's work culminated in the book *The North American Indian* (n.d), which received critical acclaim from the then U.S. president, Theodore Roosevelt. This interest in recording the lives of the "vanishing" Native peoples was conceived from a problematic

stance of anticipating the demise of an "inferior" race of people, essentially in the interest of qualifying the superiority of the dominant European culture. In the introduction of the book Curtis (1907–1930) writes:

> The task of recording the descriptive material embodied in these volumes, and of preparing the photographs which accompany them, had its inception in 1898. Since that time, during each year, months of arduous labor have been spent in accumulating the data necessary to form a comprehensive and permanent record of all the important tribes of the United States and Alaska that still retain to a considerable degree their primitive customs and traditions. The value of such a work, in great measure, will lie in the breadth of its treatment, in its wealth of illustration, and in the fact that it represents the result of personal study of a people who are rapidly losing the traces of their aboriginal character and who are destined ultimately to become assimilated with the "superior race."
>
> (Vol. 1, p. xiii)

Curtis's photographs follow closely on the heels of the Lewis and Clark expedition and are informed by the same national interest to catalogue and document Native American tribes and cultures from an anthropological standpoint. By documenting the "differences" between Native tribes and Europeans, the United States government was effectively empowered to develop policies that significantly decreased the legal rights of Native tribes including their ability to own and live on the land. Curtis's text written about the Mohave woman Mosa in Volume 2 (large plates) as published in *The North American Indian* reads:

> It would be difficult to conceive of a more aboriginal than this Mohave girl. Her eyes are those of the fawn of the forest, questioning the strange things of civilization upon which it gazes for the first time. She is such a type as Father Garces may have viewed on his journey through the Mohave country in 1776.
>
> (portfolio 2, p. 1)

Avalos pointedly acknowledges the racist assumptions that are embedded in the dominant narratives that shape our cultural and historical consciousness. Curtis's portraits are not neutral documents representing Native American populations. Instead, these images embody particular values, beliefs, and ideologies that frame our historical understanding of the West, territory, and citizenship.

Avalos has recontextualized these portraits by adding text and a dictionary definition of the word wilderness. It begins, "(1): a tract or region uncultivated and uninhabited by humans, (2): an area essentially undisturbed by human activity together with its naturally developed life community" and ends with "(3) a: a confusing multitude or mass: an indefinitely great number or quantity (I would not have given it for a ~ of monkeys—Shakespeare.) b: a bewildering situation (those moral ~es of civilized life—Norman Mailer)."

Wilderness emphasizes the irony and pervasiveness of the nineteenth-century assertion that the west was uninhabited—a wilderness that was free for the taking. Perceiving the native peoples as "other" and inferior allowed European pioneers in the nineteenth century to push westward and settle on land that was previously free from ownership. Dismissing the existence of native tribes is part of the myth of westward migration. Including a dictionary definition also suggests how dominant cultures establish and

reify these notions through "official" sources that overshadow counter-narratives or contradictory perspectives. Avalos's use of the word *wilderness* suggests the politics of definitions. How are definitions established, for whom, and for what purpose? These notions about the U.S. frontier, westward expansion, and the ongoing issue of U.S. borders continue to shape our cultural and national consciousness of the pioneering spirit of American culture. How do we understand the notion of the border today? What is the new frontier? How does the new frontier relate to the notion of frontier during the early nineteenth century?

An Excerpt from *Wooden Leg: A Warrior who fought Custer* (a Cheyenne Indian who fought General Custer in 1876)

After we had been driven from the Black Hills and that country was given to the white people my father would not stay on any reservation. He said it was no use trying to make farms as the white people did. In the first place, that was not the Indian way of living. All of our teachings and beliefs were that land was not made to be owned in separate pieces by persons and that the plowing up and destruction of vegetation placed by the Great Medicine and the planting of other vegetation according to the ideas of men was an interference with the plans of the Above. In the second place, it seems that if the white people could take away from us the Black Hills after that country had been given to us and accepted by us as ours forever, they might take away from us any other lands we should occupy whenever they might want these other lands. In the third place, the last great treaty has allowed us to use all of the country between the Black Hills and the Bighorn River and mountains as hunting grounds so long as we did not resist the traveling of white people through it on their way to or from their lands beyond their borders. My father decided to act upon this agreement to us. He decided we should spend all our time in the hunting region. We could do this, gaining our own living in this way, or we could be supported by rations given us at the agency. He chose to stay away from all white people. His family all agreed with him.

(Wooden Leg, in Marquis, 1931)

PRIMARY DOCUMENT

Excerpts from President Andrew Jackson's State of the Union Address, 1829

Actuated by this view of the subject, I informed the Indians inhabiting parts of Georgia and Alabama that their attempt to establish an independent government

would not be countenanced by the Executive of the United States, and advised them to emigrate beyond the Mississippi or submit to the laws of those States.

Our conduct toward [Indian] people is deeply interesting to our national character. Their present condition, contrasted with what they once were, makes a most powerful appeal to our sympathies. Our ancestors found them the uncontrolled possessors of these vast regions. By persuasion and force they have been made to retire from river to river and from mountain to mountain, until some of the tribes have become extinct and others have left but remnants to preserve for a while their once terrible names . . . The whites with their arts of civilization, [are] the resources of the savage [and] doom[ing] him to weakness and decay . . . It is too late to inquire whether it was just in the United States to include them and their territory within the bounds of new States, whose limits they could control. That step can not be retraced. A State can not be dismembered by Congress or restricted in the exercise of her constitutional power. But the people of those States and of every State, actuated by feelings of justice and a regard for our national honor, submit to you the interesting question whether something can not be done, consistently with the rights of the States, to preserve this much-injured race.

As a means of effecting this end I suggest for your consideration the propriety of setting apart an ample district west of the Mississippi, and without the limits of any State or Territory now formed, to be guaranteed to the Indian tribes as long as they shall occupy it, each tribe having a distinct control over the portion designated for its use. There they may be secured in the enjoyment of governments of their own choice, subject to no other control from the United States than such as may be necessary to preserve peace on the frontier and between the several tribes. There the benevolent may endeavor to teach them the arts of civilization, and, by promoting union and harmony among them, to raise up an interesting commonwealth, destined to perpetuate the race and to attest the humanity and justice of this Government.

This emigration should be voluntary, for it would be as cruel as unjust to compel the aborigines to abandon the graves of their fathers and seek a home in a distant land. But they should be distinctly informed that if they remain within the limits of the States they must be subject to their laws. In return for their obedience as individuals they will without doubt be protected in the enjoyment of those possessions which they have improved by their industry. But it seems to me visionary to suppose that in this state of things claims can be allowed on tracts of country on which they have neither dwelt nor made improvements, merely because they have seen them from the mountain or passed them in the chase. Submitting to the laws of the States, and receiving, like other citizens, protection in their persons and property, they will ere long become merged in the mass of our population.

(Jackson, 1829, available at http://www.presidentialrhetoric.com/
historicspeeches/jackson/stateoftheunion1829.html)

The Indian Removal Act of 1830

CHAP. CXLVIII.—An Act to provide for an exchange of lands with the Indians residing in any of the states or territories, and for their removal west of the river Mississippi.

Be it enacted by the Senate and House of Representatives of the United States of America, in Congress assembled, That it shall and may be lawful for the President of the United States to cause so much of any territory belonging to the United States, west of the river Mississippi, not included in any state or organized territory, and to which the Indian title has been extinguished, as he may judge necessary, to be divided into a suitable number of districts, for the reception of such tribes or nations of Indians as may choose to exchange the lands where they now reside, and remove there; and to cause each of said districts to be so described by natural or artificial marks, as to be easily distinguished from every other.

SEC. 2. And be it further enacted, That it shall and may be lawful for the President to exchange any or all of such districts, so to be laid off and described, with any tribe or nation within the limits of any of the states or territories, and with which the United States have existing treaties, for the whole or any part or portion of the territory claimed and occupied by such tribe or nation, within the bounds of any one or more of the states or territories, where the land claimed and occupied by the Indians, is owned by the United States, or the United States are bound to the state within which it lies to extinguish the Indian claim thereto.

SEC. 3. And be it further enacted, That in the making of any such exchange or exchanges, it shall and may be lawful for the President solemnly to assure the tribe or nation with which the exchange is made, that the United States will forever secure and guaranty to them, and their heirs or successors, the country so exchanged with them; and if they prefer it, that the United States will cause a patent or grant to be made and executed to them for the same: Provided always, That such lands shall revert to the United States, if the Indians become extinct, or abandon the same.

SEC. 4. And be it further enacted, That if, upon any of the lands now occupied by the Indians, and to be exchanged for, there should be such improvements as add value to the land claimed by any individual or individuals of such tribes or nations, it shall and may be lawful for the President to cause such value to be ascertained by appraisement or otherwise, and to cause such ascertained value to be paid to the person or persons rightfully claiming such improvements. And upon the payment of such valuation, the improvements so valued and paid for, shall pass to the United States, and possession shall not afterwards be permitted to any of the same tribe.

PRIMARY DOCUMENT

SEC. 5. And be it further enacted, That upon the making of any such exchange as is contemplated by this act, it shall and may be lawful for the President to cause such aid and assistance to be furnished to the emigrants as may be necessary and proper to enable them to remove to, and settle in, the country for which they may have exchanged; and also, to give them such aid and assistance as may be necessary for their support and subsistence for the first year after their removal.

SEC. 6. And be it further enacted, That it shall and may be lawful for the President to cause such tribe or nation to be protected, at their new residence, against all interruption or disturbance from any other tribe or nation of Indians, or from any other person or persons whatever.

SEC. 7. And be it further enacted, That it shall and may be lawful for the President to have the same superintendence and care over any tribe or nation in the country to which they may remove, as contemplated by this act, that he is now authorized to have over them at their present places of residence.

> (Indian Removal Act, 1830, available at http://memory.loc.gov/cgibin/
> ampage?collId=llsl&fileName=004/llsl004.db&recNum=458)

Excerpts from An Act to Provide for the Allotment of Lands in Severalty to Indians on the Various Reservations (The Dawes Allotment Act), 1887

PRIMARY DOCUMENT

Be it enacted by the Senate and House of Representatives of the United States of America in Congress assembled,

That . . . the President of the United States . . . hereby is, authorized, . . . to allot the lands in [Indian] reservation[s] to any Indian located thereon in quantities as follows:

To each head of a family, one-quarter of a section;

To each single person over eighteen years of age, one-eighth of a section;

To each orphan child under eighteen years of age, one-eighth of a section; and

To each other single person under eighteen years . . . one-sixteenth of a section.

[And] that upon the approval of the allotments provided for in this act by the Secretary of the Interior, he shall cause patents to issue therefore in the name of the allotees . . . and declare that the United States does and will hold the land thus allotted, for the period of twenty-five years, in trust for the sole use and benefit of the Indian to whom such allotment shall have been made, or, in case of his decease, of his heirs . . .

... *Provided*, That the President of the United States may in any case in his discretion extend the period . . .

And . . . that . . . if in the opinion of the President it shall be for the best interests of said tribe, it shall be lawful for the Secretary of the Interior to negotiate with such Indian tribe for the purchase . . . of such portions of its reservation not allotted.

. . . And if any religious society or other organization is now occupying any of the public lands to which this act is applicable, . . . the Secretary of the Interior is hereby authorized to confirm such occupation to such society or organization, in quantity not exceeding one hundred and sixty acres in any one tract, so long as the same shall be so occupied, on such terms as he shall deem just . . .

. . . [And] nothing in this act shall be so construed as to prevent the removal of the Southern Ute Indians from their present reservation in Southwestern Colorado to a new reservation by and with consent of a majority of the adult male members of said tribe.

<div align="right">(An act to provide for the allotment of lands in severalty to Indians on the various reservations, 1887, available at http://www.ourdocuments.gov/doc/php?doc=50&page=transcript)</div>

III: Teaching Connections

Prologue: The Interaction of Text and Image as a Visual Framework

Artists use text to convey ideas, arguments, and stories that might express a different sensibility or idea than if they were to use images alone. Since the time of illuminated manuscripts, artists have combined text and image to illustrate, decorate, complicate, emphasize, or challenge the meanings that either text or image might suggest independently. Artists have long relied on text to provide accompanying titles and captions that further describe their work but they have also integrated text into their work. Text often conveys a different sense of authority and specificity that often counters the more subjective sensibility of imagery. Although interchangeable in certain contexts, text and image offer different forms of language. Words and images can suggest symbolic associations but they can also be used to complement or describe each other; words and images can be juxtaposed to create new and unexpected meanings or can suggest stories and narratives; words and images can also be combined to create metaphors and construct provocative associations.

Writing about history not only requires research and analysis; it also requires consideration of how to represent the past through language. Thinking about the way contemporary artists use text and image can be useful for students-as-historians as it foregrounds questions about how we represent the past truthfully and the ways we receive information through visual imagery as well as written text. The history of the West has been represented in popular culture and popular imagery as much as in textbook narratives and academic papers. In light of these complementary modes of description, we have included two works of art in this section that utilize the strategy of combining text and image in order to investigate the rationales and laws that were used

to precipitate the United States government's expansion into Western territories and the populations that were effectively displaced because of it.

In this subsection, we offer a series of suggestions for using the idea of text and image as a lens through which you might structure classroom investigations on westward expansion in the United States. The resources that follow provide suggestions for a range of discussions and hands-on activities. These discussions and activities are premised on a thorough reading of all the primary documents and works of art included in the section. Before using the suggestions in the following toolkit, we encourage you to start with a broad-based discussion about the individual works of art in order to help students develop their own observational skills and connections to personal experience and opinion. Suggestions for how to facilitate a discussion about these works of art can be found in Chapter 6. Once you've had a chance to familiarize yourself with all the resources included in the section, you're ready to get started with the Teaching Toolkit. The Essential Questions, Key Ideas, and Instructional Goals in the toolkit do not represent a set of definitive facts, ideas, or questions but in and of themselves should be carefully analyzed and considered. This questioning should lead to additional questions, ideas, and pedagogical strategies. The "Observe, React, and Respond" discussion questions and "Constructing Visual Knowledge" activities have been compiled as a set of strategies to be adapted and interpreted for different classroom needs. These prompts do not offer a complete guide or lesson plan for teaching about westward expansion, but instead present a series of provocations to be combined with many other possible resources, questions, strategies, and outcomes.

Teaching Goals

Essential Questions

❖ What does it mean to "trade" or "sell" something? What does it mean to "own" land?

❖ How has U.S. popular culture erased the complexity of Native histories?

❖ Is the United States an empire? Does the United States have an imperialist history?

❖ How do text and image provide two distinct yet complementary languages for conveying information?

Key Ideas

Students will understand that:

❖ Many Native Americans had a different philosophy about the meaning of land than did white Americans in the early nineteenth century.

✧ The myth of the "uncivilized" Indian gave rise to U.S. policies sanctioning federal appropriation of Native lands and the removal of Native peoples from their lands.
✧ Artists use text in relation to images in order to convey ideas, present arguments, and tell stories.

Instructional Goals

Students will:

✧ Critically read and interpret a variety of visual and text-based sources including primary historical documents and works of contemporary art related to the theme of westward expansion.
✧ Frame effective questions about the differences between Native and European perceptions about the meaning and value of land in North America.
✧ Engage in debate about whether the United States government was involved in imperialist conquest during the period of Westward Expansion.
✧ Construct visual arguments that reflect personal/individual understandings about the period of Westward Expansion based on historical knowledge.

Teaching Strategies

Use the following prompts, either individually or together, to initiate discussions that explore the essential questions and key ideas.

a. Ask students to look at all of the documents and works of art contained in this section. In order to help students explore the ideas contained in these texts and images, ask them to consider the following:

✧ Who is the author of each document or work of art?
✧ What is the argument or idea each author puts forth?
✧ Who might the intended audience be for each of the documents and artworks? That is, to whom, specifically, was each piece initially addressed?
✧ What was the purpose for which, or "occasion" upon which, the documents or artworks were created?

I. OBSERVE, REACT, AND RESPOND

✧ What do each of these pieces suggest about the events of Westward Expansion in the United States?

Choose one or more of the following prompts to extend the initial discussion based on a close reading of particular primary documents and works of art.

b. Ask students to select one document and one work of art and look at them together. Compare and contrast the different ways the two sources provide information. Ask students to consider, for example, the artist's use of tone, color, composition, symbols, and language. How do they use adjectives, metaphors, and descriptive language in relation to the visual imagery? Then, ask students to imagine that, together, this document and this work of art make a "new" work of art. Ask students what new caption or title they might give to this combination of primary text document and visual work of art? What do they convey or suggest together, that they don't convey separately?

c. Brainstorm students' associations with the words *property* and *land*. In addition to personal ideas, ask students to identify different ideas about "property" and "land" represented in the historical documents and works of art included in this section. Discuss what each of the documents suggests about the relationship between humans and land. Have students construct individual responses, combining personal opinion and researched information found in the primary documents, that describe the differences and similarities between these ideas.

d. Look closely at the work *Trade (Gifts for Trading Land with White People)* by Jaune Quick-to-See Smith. First look at the imagery that is included on the three canvas panels, then the objects that are included above. How are words used in relation to the different images and objects included in this work? Ask students to take notes on what they see and use these notes to write a story about what they think is going on in the artwork. Each story should begin with the title of the work, *Trade* . . . Have each student read their story out loud to share different interpretations of one artwork, and the ideas it conveys about the idea of trade.

a. As a class, review the names of Native American nations that were displaced by U.S. policies in the nineteenth century (the Cherokee, of which Wooden Leg was a member, is one example). As a class decide on one of the nations to focus on. Research the experiences of that nation from the eighteenth century to the present time, including the sites and sizes of their population. Assign different

students or groups to research the information pertinent to the years 1760, 1800, 1860, 1900, 1960, and 2000. Bring together all of the information for different time periods into one map that reflects changes in population over time.

b. Ask students to investigate the history of property and land ownership in their own neighborhood, city block, or county. Research who the owners of nearby land were 200 years ago, 100 years ago, 50 years ago, 20 years ago, 10 years ago, etc. How and why did property change hands and how did changes in ownership change how the land was used or inhabited, and by whom? Create a series of postcards using text and image that document these changes over time, whether at a single address or location, or related to a larger community.

c. Ask each student to select one of the historical documents provided in this section. Create Xerox copies of these documents on which students can select and highlight what they consider to be the most important ideas, sentences, or phrases in the text. If a document has multiple pages, arrange each page in a grid formation so that you can see the entire document, and paste it on a single, large piece of paper or cardboard. Using white paint, eliminate all of the text not related to the highlighted material. Then ask students to create a visual symbol or image that can either complement the remaining text or juxtapose it with a counter-idea on a separate piece of paper. Finally ask students to transfer the symbol or image they have created onto the page with the highlighted text. Ask students to consider the size and placement of their symbol or image in relation to the text in order to convey their ideas most effectively.

II. CONSTRUCTING VISUAL KNOWLEDGE

Standards

National Council for the Social Studies Thematic Standards

Standard I. Culture

The learner will…
b. predict how data and experiences may be interpreted by people from diverse cultural perspectives ad frames of reference;

e. demonstrate the value of cultural diversity, as well as cohesion, within and across groups;

f. interpret patterns of behavior reflecting values and attitudes that contribute or pose obstacles to cross-cultural understanding;

Standard II. Time, Continuity, and Change

The learner will…

c. identify and describe significant historical periods and patterns of change within and across cultures such as the development of ancient cultures and civilizations, the rise of nation-states, and social, economic, and political revolutions;

Standard III. People, Places, and Environments

The learner will…

a. refine mental maps of locales, regions, and the world that demonstrate understanding of relative location, direction, size and shape;

b. create, interpret, use, and synthesize information from various representations of the early, such as maps, globes, and photographs;

h. examine, interpret, and analyze physical and cultural patterns and their interaction, such as land use, settlement patterns, cultural transmission of customs and ideas, and ecosystem changes;

i. describe and assess ways that historical events have been influenced by, and have influenced, physical and human geographic factors in local, regional, national and global settings;

Standard VI. Power, Authority, and Governance

The learner will…

a. analyze and explain governmental mechanisms to meet needs and wants of citizens, regulate territory, manage conflict, establish order and security and balance competing conceptions of a just society;

f. analyze and evaluate conditions, actions, and motivations that contribute to conflict and cooperation within and among nations;

i. evaluate the extent to which government achieve their stated ideals at home and abroad;

Standard VII. Production, Distribution, and Consumption

The learner will…

c. consider the costs and benefits to society of allocating goods and services through private and public sectors;

f. compare how values and beliefs influence economic processes;

Standard X. Civic Ideals and Practices

The learner will…

b. locate, access, analyze, organize, synthesize, evaluate, and apply information about selected public issues—identifying, describing and evaluating multiple points of view;

d. practice forms of civic discussion and participation consistent with the ideals of citizens in a democratic republic;

f. analyze a variety of public policies and issues from the perspective of formal and informal political actors;

h. evaluate the degree to which public policies and citizen behaviors reflect or foster the stated ideals of a democratic form of government.

National Visual Arts Standards

Content Standard: 1: Understanding and applying media, techniques, and processes

Content Standard: 2: Using knowledge of structures and functions

Content Standard: 3: Choosing and evaluating a range of subject matter, symbols, and ideas

Content Standard: 4: Understanding the visual arts in relation to history and cultures

Content Standard: 6: Making connections between visual arts and other disciplines

REFERENCES

Avalos, D. (1998). Oral history interview with David Avalos conducted by Margarita Nieto June 16–July 5, 1998, Smithsonian Archives of American Art website. Retrieved on June 18, 2008 from http://www.aaa.si.edu/collections/oralhistories/transcripts/avalos88.htm

Calloway, C. G. (2004) *First peoples: A documentary history of American Indian history*. Boston: Bedford/St. Martins.

Curtis, E. S. (1907–1930). *The North American Indian*. Retrieved on July 20, 2009 from http://curtis.libray.northwestern.edu/curtis/toc.cgi/

Deloria, E. (1979) *Speaking of Indians*. Vermillion, SD: Dakota Press.

Marquis, T. (1931) *Wooden Leg: A Warrior Who Fought Custer*. Lincoln: University of Nebraska Press.

Simonds, C. (1994). Public audit: an interview with Elizabeth Sisco, Louis Hock, and David Avalos. *Afterimage*, Summer.

Smith, J. (n.d.). Jaune Quick-to-See Smith (b. 1940): On creating impressions. Smithsonian American Art Museum website. Retrieved on January 10, 2009, from http://www.americanart.si.edu/collections/exhibits/kscope/smithexhframe.html

Williams, W. A. (1955). The frontier thesis and American foreign policy. *Pacific Historical Review, 24*(4), 379–395.

Zinn, H. (1980/2003) *A people's history of the United States: 1492–present*. New York: HarperCollins.

SECTION 2: THE U.S. WAR IN VIETNAM

I: Historical Introduction

In this section, we examine the history of the U.S. war in Vietnam. That war—which is known to Americans as the "Vietnam War," and to Vietnamese as the "American war"—was a very bloody and a very controversial one; and it was one from which the United States did not emerge victorious. It is perhaps for those reasons that it is also a war to which a great deal of retrospective attention has been paid. In the thirty-plus years since the U.S. officially left Vietnam, historians, journalists, military commanders, ex-soldiers, artists, and a great number of other people have debated the meaning of the U.S.'s efforts in Vietnam. "The specter of the Vietnam War so haunts American memory," notes the historian Christian Appy, "that there is no keeping it repressed, try as we might" (2007, p. 136).

The sheer quantity of writing about the war can make the task of teaching about its history seem overwhelming. Educators interested in teaching the Vietnam War face several additional challenges, as well. For one thing, the war lasted a very long time, and spanned several presidential administrations. For another, it generated a great number of heated historical and political debates. Where, an educator might wonder, should I begin? How can I choose which aspects of the war, which historical debates, which years, and which kinds of texts to focus my teaching around? How can anyone make sense of the great complexity of this conflict in the space of a few days, or even a few weeks?

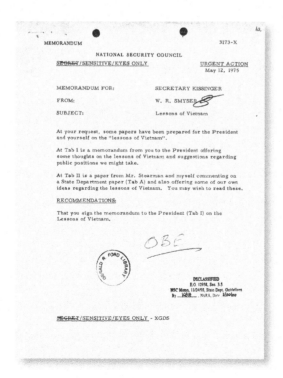

Figure 9.1 W. R. Smyser to Secretary Kissinger, "The Lessons of Vietnam." May 12, 1975.

One way to decide which information to include and which resources to make use of in your classroom is to organize your instruction around a provocative historical question or debate about the era. There are an infinite number of questions or debates from which to choose, but in this section, we offer—and present a set of resources related to—just one. That question is: What are the lessons of Vietnam? This is not a question that we invented on our own. A great many other commentators and historians have asked this question, in public and private, from the very moment the United States admitted defeat and left Southeast Asia. Perhaps the first person to ask this question was Secretary of State Henry Kissinger, who, in May 1975, directed members of his staff to write a confidential memo on the subject (Figure 9.1). (We supply the text of this document in the Teaching Toolkit that follows this essay.) But Kissinger was only the first in a long line of policymakers, historians, military commanders, journalists, anti-war activists, pro-war hawks, filmmakers, and others who attempted to derive some guiding "lessons" from that awful conflict. That the search for an answer to this continues today is evident in the many newspaper headlines that feature this formulation—"Historians Question Bush's Reading of Lessons of Vietnam War for Iraq," reads one, among many, recent headlines (Shanker, 2007).

In the Teaching Toolkit that we have compiled for this section, we offer a collection of primary source documents and works of art, each of which offers an entrée into an investigation of the meaning that we, in the twenty-first century, might make of the Vietnam war. Among the primary sources that we offer up for review here are several documents that you might call "memory-saturated" documents: oral histories, written testimonies, narrative and visual accounts based on the teller's own experience. This includes excerpts from an interview with former Secretary of Defense Robert McNamara (conducted by the documentarian Errol Morris).

Robert McNamara was the United States Secretary of Defense during both the Kennedy and the Johnson administrations. A former corporate executive with a penchant for maximizing the efficiency of bureaucracies, he would later be blamed, by many, for using his mathematical mind to intensify the war. "For many people," the filmmaker Errol Morris notes, McNamara was "the man who pressed Lyndon Johnson into escalating the war"—an "IBM machine with legs . . . devoid of ethical sensibilities, who escalated the war and then cried crocodile tears when it was too late" (quoted in Ryan, 2004, para. 54). Late in his life, McNamara authored a book, entitled *In Retrospect: The Tragedy and Lessons of Vietnam* (1996), in which he looked back at the war and offered a set of reflections on what the U.S. should learn from the mistakes he and other U.S. officials made during its duration. "With hindsight," McNamara asked in that book, "was the United States wise to intervene in Vietnam? What mistakes did we make? What lessons can be learned? And how can these lessons be applied to the present and future?" (xii–xiii). The book was criticized, as Morris suggests above, for being a literary form of crocodile tears—many observers thought that McNamara's remorse was disingenuous, or even obscene.

Nonetheless, McNamara's account caught the eye of the documentary filmmaker Errol Morris. Morris, who is known for making arresting documentary films about truth, lies, and memory, was intrigued by McNamara's story. He began to interview the former Secretary of Defense, and, in 2003 (shortly after the U.S. invaded Iraq), Morris released a film entitled *The Fog of War*, based largely on his one-on-one, on-camera interviews

with McNamara. Organized expressly, and entirely, around these oral history interviews, the film directly engages the idea, that McNamara, among others, holds, that the story of the U.S. intervention in Vietnam contains instructions for us in the present. "At my age, 85, I'm at age where I can look back and derive some conclusions about my actions," McNamara says at the outset of the film. "My rule has been . . . to try to understand what happened. Develop the lessons and pass them on." Indeed, the film explicitly counts down the "lessons" that McNamara's remembrances suggest. Some, such as "Lesson #1" ("Empathize with your enemy"), seem to indicate that if we do learn these lessons, we can save future generations from the terrors that befell so many during the Vietnam conflict. Others, such as "Lesson #2" ("Rationality will not save us") and "Lesson #9 ("In order to do good, you may have to engage in evil"), suggest that nothing we learn will ever change the human propensity for violence and killing.

McNamara takes the optimistic view. Warmakers must, he insists, keep in mind "proportionality"; they must try to understand their enemy, empathize with them, and resist inflicting undue harm on them. If they do, they will avoid the terror that U.S. troops rained down on the civilian population of Vietnam for more than a decade. Errol Morris, on the other hand, is far more pessimistic. "I think all historical situations are different," he said after the film's release. "There's only one thing that remains the same in history, and that's human idiocy": "our capacity for . . . for turning evidence into a form that's palatable to us, even if it means accepting untruth" (Morris, 2005, para. 95).

Other observers find an entirely distinct set of meanings in the Vietnam War. The eminent historian Marilyn Young (1991), for one, argues that any inquiry into the Vietnam war has to take into account the way that U.S.'s defeat in Southeast Asia transformed how the U.S. military prosecuted later wars. The military in fact, she argues, learned a great deal from Vietnam—not so much about how to *fight* a war as about how to *market* one. In the aftermath of Vietnam, she explains, the U.S. military spent a great deal more time selling their bellicose ambitions to the U.S. public: attempting to convince taxpayers that its cause for military action—in Iraq and elsewhere—was just; that the objective was accomplishable; and that the war would be fought "fast" and "hard," resulting in few U.S. casualties. Those marketing strategies, Young suggests, have been successfully deployed many times over—most effectively during the second invasion of Iraq in 2003.

The question of what the Vietnam War can and does mean in the contemporary moment remains the subject of debate. As a result, in addition to excerpts from McNamara's oral account, we also feature (in this section's Teaching Toolkit) the words of a soldier, Larry Colburn, who witnessed, in horror—and tried to interrupt—the now-notorious massacres of civilians in the village of My Lai. And we present the personal testimony of Vietnamese American Thi Bui, who was born in war-torn Vietnam and then migrated, with the rest of her family, to the U.S. A memory-saturated, eyewitness account, Bui's memories of her family's experience in Vietnam during the war—and afterward, as refugees—tells a noticeably different kind of tale from the one that Robert McNamara's or Larry Colburn's oral accounts do, and provides a distinct perspective on the war, one that Americans rarely consider when they consider the "lessons" of Vietnam.

Bui and her family were among the 950,000 Indochinese who came to the U.S. between 1975 and 1993 as post-war refugees and immigrants. Currently at work on a graphic novel based on her experiences, she is dedicated to attempt to "subvert the

American-centric perspectives that have dominated the way the Vietnam War has been portrayed." "I want Vietnamese people to be protagonists for a change, and not just faceless victims who die," she explains.

> I want to show them as complete human beings who eat, sleep, go to the bathroom, have sex, love, fear, betray—so that if they die, or get hurt, you mourn them as if you loved them, and not just as an abstract symbol of tragedy.
>
> (Bui, personal communication, August 14, 2007)

Bui's work and narrative suggests that in order to understand what the U.S. war in Vietnam can mean to us, now, in this moment, we need to understand individuals' stories. "History," she explains, "IS personal."

Bui's account also focuses our attention on the fact that wars have the power to change our relationships to each other and to the world. The "legacy of loss," for instance, "plays out in family relationships and through generations," creating rifts that affect how a person connects to other people and "behaves in the world" (personal communication, August 14, 2007). Perhaps, Bui suggests, the lesson of the Vietnam War is, very simply, that violence can change everything: where entire groups of people live, how they speak to one another, and what they believe is possible. "My birth four months before the fall of Saigon was the reason we stayed there," she remembers. "Two other babies never lived long enough to be part of history" (Bui, 2008).

"Remembering is itself a form of forgetting," the visual historian Marita Sturken has written (1997, p. 82). What are the lessons of Vietnam? We will never truly understand the meaning of the Vietnam War if we look at that event through only one perspective. Each of the memory-saturated personal testimonies we present here—Thi Bui's, Robert McNamara's, and Larry Colburn's—tells a distinct story, and offers a different set of answers to this question. Thus the question "What are the lessons of the Vietnam War?" has the potential to either frustrate or delight attentive students of U.S. history—depending on what they are looking for. Those students who long for easy answers and pat historical narratives will be frustrated by the breadth of the question and the deeply contentious nature of the answers that historians have attempted to provide for it. But these same characteristics hold the power to delight those students and history educators who seek lively debates and historical questions with clear relevance in the present moment. It is a question without one clear, indisputable answer. Probably the only succinct answer to the question would be "it depends on whom you ask." Ask a military commander and you'll get one set of responses; ask an anti-war protester, and you'll get an entirely different set of responses. Or, to use the more scholarly language deployed by the editors of the *Encyclopedia of American Foreign Policy*, "there is no nationwide consensus on the lessons of the Vietnam war" (Deconde *et al.*, 2002, p. 77). But if we are to understand the history of Vietnam, and perhaps more importantly, if we are to try to learn "the lessons" of that war, we will have to consider a range of accounts and perspectives, including the perspectives of individuals ranging from McNamara to Bui.

What, for your students, are the most compelling lessons of Vietnam? How has this question helped shape public debate about war and U.S. foreign policy over the past three decades? How—and why—do conflicting memories of the Vietnam War continue to shape national debates?

II: Mini-Archive

ABOUT THE ART

Việt Nam and *Small Wars* by An-My Lê

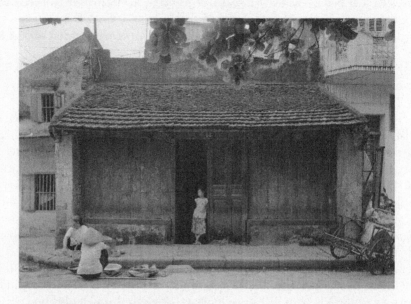

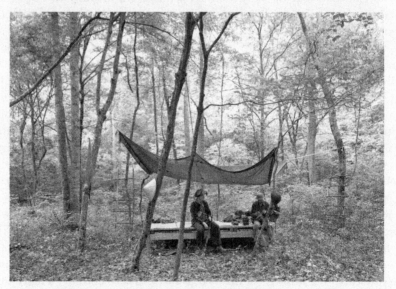

Figure 9.2 An-My Lê, *Untitled, Hanoi (girl in doorway)*, 1994.

Figure 9.3 An-My Lê, *Small Wars (Vietcong Camp)*, 1999–2002.

I've always tried to understand the meaning of war, how it has affected my life, and what it means to live through times of turbulence like that. A lot of those questions fuel my work. You approach different issues at different times of your life. When I first made the pictures in Vietnam, I was not ready to deal with war. Being able to go back to Vietnam was a way to reconnect with a homeland, or with the idea of what a homeland is and with the idea of going home.

One is always striving to suggest something beyond what is described. It's something I'm very aware of. Someone who doesn't know straight photography would have issues with this and maybe, would see my work as plain documentary. It does describe certain facts. But I think the strength of it comes from what I can suggest that was not in the photograph at first—what was not in what I saw, and not in the situation itself.

(An-My Lê, quoted in Sollins, 2007)

An-My Lê's photographs depict seemingly straightforward landscapes, but are embedded with rich historical and personal associations. Having lived through much of the Vietnam War in Saigon, Lê was evacuated with her family and relocated to the United States in 1975 when the war ended. As a political refugee Lê's memories of the Vietnam War are from her teenage years and they informed her early photographic work, as well as her ongoing interests as a photographic artist. Lê's work has continued to focus on sites of war including images of Vietnam after the war, photographing Vietnam War re-enactors in North Carolina, documenting Marines as they prepare for deployment to the Middle East in the California desert, and photographing the landscape as seen from a military aircraft carrier bound for Iraq.

Describing her memories of living in Vietnam during the war Lê says:

We lived in Vietnam through many of the offensives and coups. In 1968 after the Tet offensive the Viet Cong took over part of the city for a while . . . War was part of life for us. People ask, "Wasn't it frightening?" We were really too young to know it the way an adult would. As a child, its just part of your life and you deal with it when it happens.

(Lê, quoted in Sollins, 2007, p. 48)

After living in the United States for 20 years, Lê first returned to Vietnam in 1994 after the U.S. embargo was lifted and continued to visit several times to create her first series of photographs, *Việt Nam* (1994–1998).

Việt Nam (1994–1998)

In this series of photographs, Lê presents her perspective as a visitor to a homeland changed by war, yet in many ways timeless and ageless. Images of contemporary urban and agrarian landscapes suggest less about the emotional or physical scars from the war and instead represent the everyday lives of Vietnamese people. In the work *Untitled,*

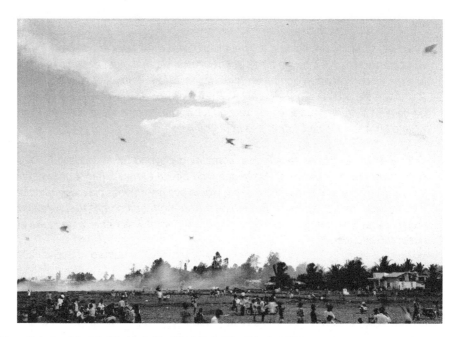

Figure 9.4 An-My Lê, *Untitled, Ho Chi Minh City (kites)*, 1998.

Hanoi (girl in doorway) (Figure 9.2), a young girl stands in a doorway of a traditional house, framed by a rickshaw and a pair of street vendors resting on the sidewalk. The image feels quiet—almost still—as we watch these three women at rest, framed by aging buildings and the overhang of a large tree. Apart from the title, only one prominent visual clue suggests that the image was taken in Vietnam. The *nón lá*, or traditional Vietnamese canonical hat, worn by one of the women in this image became familiar to Americans through photographs taken during the war.

In another image from this series, *Untitled, Ho Chi Minh City (kites)* (1998; Figure 9.4), a foreshortened view of a field is densely packed with groups of people and individuals, some gazing skywards, others talking in small groups. Above this field, the majority of the picture frame is devoted to an expanse of sky where clusters of kites float and hover. Although military airplanes once flew over Ho Chi Minh City, this image of Vietnam is not just peaceful, it is beautifully mundane. Apart from the date the photograph was taken, to unfamiliar American eyes there is little overt evidence about where and why these images were taken. The subtle beauty of the images captures a moment in time separate from the country's history yet symbolically linked in the American psyche with the events of a shameful war. The neutrality of the image shifts attention away from the idea of Vietnam as a site of conflict and instead presents a place where lives are lived and daily rituals enacted. Lê describes this visit to Vietnam, and the subsequent photographs she produced, as a journey that navigates between memories, stories, and reality.

Small Wars (1999–2002)

In her next series of photographs Lê was interested in exploring her relationship to the Vietnam War more directly. Locating a group of Vietnam War reenactors in North

Carolina, Lê participated in several reenactments as a condition of being able to photograph the proceedings. Many reenactment participants are avid collectors of Vietnam War paraphernalia and are required to wear authentic uniforms and use genuine artillery and equipment from the era. As an "authentic" Vietnamese person, Lê was enlisted to role-play as a North Vietnamese informant or Viet-Cong sniper and she is occasionally featured in the photographs from this series. As in her previous series, the photographs from *Small Wars* provide only subtle clues as to their origins and context. Instead the imagery focuses on the landscape and specific compositional elements that frame the actions taking place. In *Small Wars (Vietcong Camp)* (1999–2002; Figure 9.3), a makeshift shelter sits amid pine trees and evergreen forests, strangely unlike the Vietnamese landscapes presented in news coverage from the war. And yet, a *nón lá* is prominently positioned in the middle of the image, hanging from a tree while two soldiers dressed in camouflage rest underneath a low-slung tarp. Again we are reconnected with Vietnam but within a new contextual frame. Additional visual clues suggest that we are indeed looking at an image from the Vietnam war—period guns, the camouflage pattern, the style of the helmets—as well as perhaps far away from the realities of true combat—the tidiness of the uniforms, the well-placed leaves on the soldiers helmet, the deciduous forest. *Vietcong Camp* is a surprisingly placid image in the context of a very violent and messy war.

Another image, *Small Wars (Rescue)* (1999–2002; Figure 9.5) presents a more dramatic moment replete with smoke and airplanes. A fighter jet's nose is surrounded by soldiers who stand guard. A soldier falls out of the cockpit, apparently shot. Another soldier radios for help. Again, Lê has captured a moment that is both tense and tranquil simultaneously. There is a stillness to the airplane, almost entirely shrouded in smoke, and the soldiers do not carry the stress and fear of war on their faces, even as they anticipate an attack.

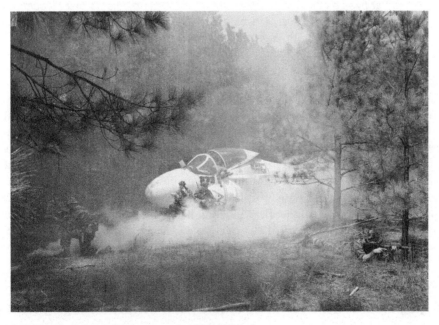

Figure 9.5 An-My Lê, *Small Wars (rescue)*, 1999–2002.

With these images, Lê is not telling us directly about specific events from the Vietnam War but she is offering a different kind of historical narrative, a personal journey that looks back on the Vietnam War as an event with both personal significance and a lasting mythology that we each carry with us. Vietnam is still a country haunted by its violent past. Wars are given fixed dates in history textbooks but their effects and impressions are ongoing, timeless. Lê's photographs serve as a kind of incomplete memory, or story that can be completed by the viewer as they bring their own knowledge of Vietnam, the experiences of Vietnamese people, and the events of the Vietnam War to an ongoing and infinitely evolving description.

ABOUT THE ART

Bringing the War Home: House Beautiful, 1967–72 by Martha Rosler

Martha Rosler, *Bringing the War Home: House Beautiful*, "Balloons," 1967–72.

Martha Rosler, *Bringing the War Home: House Beautiful, new series*, "Lounging Woman," 2004.

SEE Plate 13 and Plate 14, in Insert

The photograph is not mute, it speaks to people and people speak back to it, and all kinds of conversations can occur around it and the photomontage even more so because it speaks about a rupture or displacement, and that is really interesting to me.

I am at base a conceptual artist, and what I mean by that is that I would like to engage you in the arena perhaps of the visceral but also of the rational. I would like, perhaps, for you to leave the work with a question, and not just an answer.
(Martha Rosler, 2004 and 2008)

Martha Rosler is often described as a political or a socially engaged artist. In photographs, collages, videos, and performances, Rosler reshapes and recontextualizes seemingly mundane images into controversial and pointed political commentary. Focusing her artistic lens on issues such as homelessness, sexism and gender roles, consumer culture, urban gentrification, and the United States at war abroad, Rosler has created diverse bodies of work that challenge common stereotypes and defy expectations. An anti-war activist during the Vietnam War, Rosler has continued to support anti-war efforts through political and artistic work. Modeling her political proclivities, Rosler's visual work confronts the position of the viewer as a passive onlooker by presenting imagery designed to provoke outrage, and perhaps spur action.

Bringing the War Home: House Beautiful, 1967–72, "Balloons" and Bringing the War Home: House Beautiful, new series, "Lounging Woman"

In 1967 Rosler began to create a series of photomontages using found photographs of the events unfolding in Vietnam during the war, primarily from photojournalistic sources,

and imagery from contemporary American advertisements. In much the same way that serious and violent imagery presented in newspapers and movies is nonchalantly placed alongside spunky, irreverent advertisements for cosmetics or fashion, Rosler self-consciously juxtaposed seemingly disparate visual narratives unfolding in consumer culture and media coverage. In the work "Balloons" (see Plate 13, in Insert), an image of a serene, pristinely white living room is interrupted by a figure dressed in black carrying a child who has apparently been hurt or is perhaps already dead. The anxiety and fear apparent on the figure's face contrasts the serenity of the location. This living room captures an ideal of upper middle-class American life: clean, quiet, a place for sitting in overstuffed chairs. Our eyes shift mercilessly between a pile of colorful balloons that serve as the focal point of the image, directly in the middle of the composition, and the anxiety of the figures who approach the viewer. These figures seem to be coming up the stairs toward the viewer, imploring them for help. Whose responsibility is this child?

In another image from this series, "Red Stripe Kitchen" (Figure 9.6), the countertops in a well-ordered kitchen are laid out with all the necessary dishware for entertaining. Framed by two doorways, a pair of soldiers appear to be looking for something. Originally created for an American audience, this image not only implicates the viewer in the question of responsibility, it presents a scathing criticism of those whose lives are sheltered from violence while their government wages war in their name. In all of the images created for this series, Rosler viscerally merges the far away worlds of two nations at war: the Americans watching the violence unfold from their living rooms, and the Vietnamese suffering the violence directly. The images are an intended study in contradiction. While U.S. soldiers and Vietnamese citizens were dying abroad,

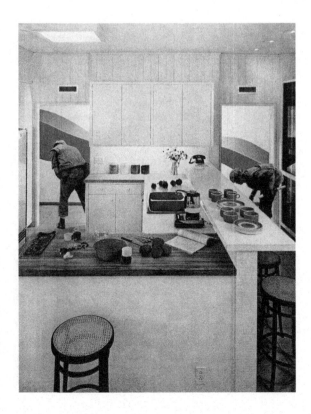

Figure 9.6 Martha Rosler
Bringing the War Home: House Beautiful, "Red Stripe Kitchen,"
1967–1972.

Americans continued to enjoy the relative safety and fulfillment of consumer culture, sheltered from the violence occurring in a country located on the other side of the world.

In a nod to the circular nature of history, forty years later Rosler created another series of photomontages, this time using images of the war in Iraq as her source material. In *Bringing the War Home: House Beautiful, new series* Rosler again juxtaposes images of clean interiors and stylish, friendly models, with the atrocities of the Iraq war. In "The Gray Drape" (2008; Figure 9.7) an elegant woman in full-length satin gown is eager to show us her billowing drapes. Outside her window the street is on fire, a grieving woman wearing a burqa holds an infant, and American soldiers patrol in the distance. In "Lounging Woman" (Plate 14) a model literally spills out of an overstuffed chair while soldiers climb among the rubble of a bombed building behind her. Although the model's pose almost mimics the look of a casualty of war, her head rests contentedly on a perfectly white rug, a stack of magazines casually spayed out on a table next to her. These updated images bring the same visual juxtaposition to a war that has often been compared to the Vietnam War. Rosler seems to be suggesting that the issues have not changed, that we have learned nothing from the past.

Combining images from advertising with documentary photography presents not just a jarring combination of photographic styles, but also the uncomfortable feeling of being implicated by these images. The Vietnam War was the first major war to be seen on television. In media coverage the war literally did come into people's living rooms via their television screens. The escapist quality to most advertisements is undermined by the horrible imagery of innocent people involved in war. Increasingly, media coverage has made access to images and information about wars happening beyond our borders

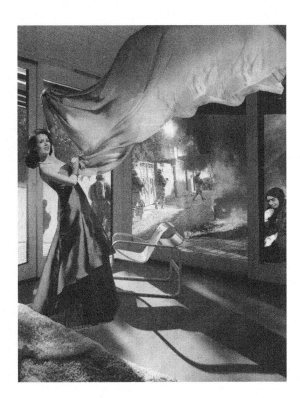

Figure 9.7 Martha Rosler, *Bringing the War Home: House Beautiful, new series*, "The Gray Drape," 2008.

both more available and at the same time less dramatic. We are inured to the violence by its very accessibility. Rosler calls into question what exactly we learn from the images that reach us through television, newspapers and the Internet. How does visual imagery contribute to our perceptions and opinions about the events of the Vietnam War and more recently the Iraq War, and in what ways can imagery sway public sentiment and convey lessons for future wars?

Excerpts from the Remembrances of Former Secretary of Defense Robert S. McNamara

Any military commander who is honest with himself, or with those he's speaking to, will admit that he has made mistakes in the application of military power. He's killed people unnecessarily—his own troops or other troops—through mistakes, through errors of judgment. A hundred, or thousands, or tens of thousands, maybe even a hundred thousand. But, he hasn't destroyed nations. And the conventional wisdom is don't make the same mistake twice, learn from your mistakes. And we all do. Maybe we make the same mistake three times, but hopefully not four or five. They'll be no learning period with nuclear weapons. You make one mistake and you're going to destroy nations.

In my life, I've been part of wars. Three years in the U.S. Army during World War II. Seven years as Secretary of Defense during the Vietnam War. 13 years at the World Bank across the world. At my age, 85, I'm at an age where I can look back and derive some conclusions about my actions. My rule has been try to learn, try to understand what happened. Develop the lessons and pass them on . . . In the case of Vietnam, we didn't know them well enough to empathize. And there was total misunderstanding as a result. They [the North Vietnamese] believed that we had simply replaced the French as a colonial power, and we were seeking to subject South and North Vietnam to our colonial interests, which was absolutely absurd. And we, we saw Vietnam as an element of the Cold War. Not what they saw it as: a civil war.

. . . What is morally appropriate in a wartime environment? Let me give you an illustration. While I was Secretary, we used what's called "Agent Orange" in Vietnam. A chemical that strips leaves off of trees. After the war, it is claimed that that was a toxic chemical and it killed many individuals—soldiers and civilians—exposed to it. Were those who issued the approval to use Agent Orange criminals? Were they committing a crime against humanity? Let's look at the law. Now what kind of law do we have that says these chemicals are acceptable for use in war and

these chemicals are not. We don't have clear definitions of that kind. I never in the world would have authorized an illegal action. I'm not really sure I authorized Agent Orange—I don't remember it—but it certainly occurred, the use of it occurred while I was Secretary.

(McNamara, in Morris, 2003. Full transcript available at http://www.errolmorris. com/film/fow_transcript.html)

Primary Document: Excerpt from an Interview with Former U.S. Army Specialist Larry Colburn, January 2006

PRIMARY DOCUMENT

It started out [early in the morning] as a routine air support and reconnaissance mission, but as the day progressed, we noticed obviously that we weren't receiving any fire. Our job was to fly low level and try to entice people into giving up their positions by firing on us. And that wasn't happening.

We saw people leaving the village. It was a Saturday morning, so it wasn't uncommon for the people to go to market on Saturday morning. So we thought it was good that these women and children and elderly people were leaving the area. And as we progressed around the perimeter of the area that the troops were being inserted into, we found nothing, as far as resistance. At some point we had to go refuel. And it was so quiet that morning that we didn't even call a backup team to cover us while we were refueling.

And then when we came back from refueling, we started finding the same people that were leaving the area on the road out of the village were now dead on the road and in the ditches. And [we] tried to piece together different scenarios . . . Finally, after marking a few bodies with smoke for medical assistance, we witnessed [one American soldier] approach a wounded woman and walk up to her and kick her with his foot, step back and blow her away. Then we realized what was going on and exactly who was doing the killing.

[So the pilot of my aircraft,] Mr. Thompson, landed by the ditch, where there were probably 150, 200 people dead or dying. There was an American soldier standing there. We actually landed the aircraft, because the communication was so bad. He physically got out of the aircraft, went over and spoke to the soldier and explained to him these were obviously civilians. There were no weapons captured. There were no draft age males. These were civilians. We need to help them out. And the soldier agreed and said he'd help them out, and as we lifted off again, we heard automatic weapons fire, and he was firing into the ditch again.

So at that point, [we] spotted an earthen-type bunker with some faces peering out of it. And there was an approaching squad of Americans. And . . . we all decided

that if we didn't do something within the next 30 seconds, these people would die. So [Thompson] landed the aircraft in between the advancing American troops and the people in the bunker, went over and spoke to a lieutenant and told him—or asked him how we could get these people out of the bunker. They were obviously civilians. And the lieutenant replied he'd get them out with hand grenades.

Mr. Thompson, who was outranked by this lieutenant, actually gave the lieutenant an order, told him to keep his people in place. He had a better idea, and I think he told him, "If you fire on these people when I'm getting them out of the bunker, my people will fire on you." So he went over to the bunker himself and coaxed the villagers out. And we thought there were two or three. There were nine or ten, and we were in a small three-place helicopter, and all three seats were occupied. So we had to call down a gunship and use it as a medevac to remove these people from the area, take them down the road and then the gunship came back on station.

After that, we went back to the ditch. [We] spotted movement in the ditch. Mr. Thompson landed again. [Another soldier] and I got out of the aircraft, went to the ditch. By the time I got there, [the other solider] was already in the ditch. He retrieved a small child and handed the child up to me, and we carried the child to a hospital orphanage a few miles away. And Mr. Thompson left the child with a nun and let her know that his family was probably all gone, so take care of him.

(Colburn, on *Democracy Now!*, 2006. Full transcript available at http://www.democracynow.org/2006/1/18/hugh_thompsons_crewmember_remembers_helping_to)

Excerpts from the Remembrances of the Vietnamese Artist and Educator Thi Bui, 2008

New York Methodist Hospital, 2005. I'm in labor. The baby's head is crowning and there are too many people gathered around to watch. "What is Ma doing?" I want to know. In my periphery I see her go from the bathroom to a chair and back again.

Trevor tells me she is throwing up. She flew to New York to hold my hand through this, but during it she can barely look at me. She shrinks into the corner, helpless, held hostage by her empathy.

I am her own flesh and blood; in this moment, lying with my legs wide open, I am she and she is dying.

I want to be a fighter, a yeller, but in truth I just want to lie still in this cold room and close my eyes with dignity, and most of all not speak. I look for signs of progress in the faces around me because this is what it has come to—the birth is no longer all mine; the experts tell me what to do, what is happening. In my surrender I want to retreat inward, to go all the way back,

PRIMARY DOCUMENT

to be the baby and not the mother. But there is only moving forward, and Trevor, sensing my fear, holds my hand and talks to me softly.

. . . Ma did this six times. How did she have the courage to do this six times? You forget how painful it is, she tells me, as I gaze down at a perfect sleeping baby in his hospital bassinette. In the first seconds I held my son, I touched a truth as old as life. He had announced his independence already in the womb, kicking me and stretching against the confines of my body. Here he is now both separate and desperately reliant on me, between us a cord stretching to keep us together as time and gravity and consciousness move us apart. With a rush it dawns on me that *family* is now something I have created, and not just something I was born into. The responsibility is immense. A wave of empathy for my mother washes over me.

1. *Giang Quyên*/Giang Quyen (zaang kwea-en)
2. *Anh Thu*/Anh Thu (ayng tu)
3. *Thùy*/Thuy (twee)
4. *Thao*/Thao (tao)
5. *Thi*/Thi (tee)
6. *Nhât*/Nhatty (natty)

Backwards. We can retrace our steps over the ocean, through the war, by naming our births. Nhatty is the youngest, born in Malaysia, two hours walking through sand outside a U.N. refugee camp for boat people. I am the next to youngest, and my birth four months before the fall of Saigon was the reason we stayed there, and the beginning of hard times and midnight schemes to escape the country. Thuy was born two weeks before the Tet Offensive, when the northern Communists ramped up their mission to liberate South Vietnam from American imperialism and the Vietnamese capitalists who went along with it. Anh Thu came early, the result of a bumpy trip on the back of a Lambretta, over roads strewn with landmines, from the deep Mekong Delta to the safety of a hospital in the capital. Two other babies never lived long enough to be part of history; they are reminders, I suppose, of a third-world closeness to death, a certain commonness of human suffering and sense of life as a gamble that characterizes that place, those times.

These are dark and difficult moments for me to illustrate. There were no cameras there to capture the magic of our first cries. There are only stories whose grisly details add a grimness and ferocity to our voices, as though they carried the anguish of our mother's heart and of the times in which we were born.

I hold my baby close and write with confidence that some things, like childbirth, are good to forget, and some things, like history, should not be forgotten. I collect my family's stories not because we are special or different, but because they are necessary for me to piece together, to remember, the circumstances that send a family to the other side of the world; to weigh the opportunities gained with the

knowledge of self lost, and to consider the price we all paid for war, as individuals, as a family, and as pieces of a broken up country.

My memories are housed in a burnt orange apartment on Utah Street in North Park, San Diego. This is where I heard the stories a thousand times, and where I navigated the minefields that are growing up with a legacy of loss. Lives were lived; things ugly and beautiful happened; I learned to accept this, and to close my eyes and turn away from what I could not control. If I go back to a time before I learned this trick, this secret to my happiness, it is not to harm or blame but to understand, as if by laying out all the pieces of a puzzle, how one's hurt connects to another's.

(Bui, 2008)

Excerpts from Congressional Hearings on the Indochina Migration and Refugee Assistance Act, 1975

HEARINGS BEFORE THE SUBCOMMITTEE ON IMMIGRATION, CITIZENSHIP, AND INTERNATIONAL LAW OF THE COMMITTEE ON THE JUDICIARY, HOUSE OF REPRESENTATIVES ON INDOCHINA REFUGEES, MAY 5, 1975

Mr. EILBERG [chairman of the subcommittee]: The subcommittee will come to order. In the past 10 days, the United States has conducted what may well be the greatest mass movement of refugees, over the longest distance, that we have ever witnessed. The President has authorized the parole into the United States of over 130,000 Vietnamese and Cambodian refugees. These refugees come into the U.S. territory seeking, first, asylum, and in most instances, permanent resettlement as well. In fact, this is only the second time in the history of the United States that this country has become a country of first asylum. Less than 10 years ago, the United States offered asylum to those Cubans who wanted to leave the Castro regime, and over 600,000 Cubans came to the United States for resettlement. The primary issues confronting us at this time are not whether the evacuation was proper and legal, nor whether the President has exceeded his authority in admitting refugees, but rather, what efforts should be made to resettle these refugees and what funds must be made available to meet this problem.

We must try to solve this problem at a time when the United States faces the highest rate of unemployment in 30 years. We are also faced with a shortage of housing, a high cost of living, and a growing apprehension about foreign aid. The Congress is faced with a great dilemma: should the United States abandon its

PRIMARY DOCUMENT

traditional role of offering asylum to the needy and to the persecuted? Can the United States ignore the convention and protocol on the status of refugees to which we are a signatory? It has been suggested that the events of last week constituted the final chapter of the Vietnam conflict. In my mind, however, this final chapter can only be written after we have decided what actions are to be taken for the unfortunate victims of that war, particularly for those who reach our shores and seek refuge here. We cannot under-estimate the capacity of this country to respond to this serious problem. At the same time, we must strive to insure that the presence of large numbers of refugees does not disadvantage the American people. In anticipation of this difficult dilemma, I took the floor of the House on April 16th and stated:

It is imperative that the President immediately present the Congress with detailed, long-range plans to resettle any Vietnamese who are able to depart from South Vietnam. At my direction, members of the committee staff visited Camp Pendleton, Calif., over this past weekend to review and study the Vietnamese refugee situation there and observe processing procedures which have, been established. Through the efficiency of the Marine Corps, particularly the base commander at Camp Pendleton, Gen. Paul Graham, facilities have been set up to accommodate some 18,000 refugees. Notwithstanding the thoroughness of the Marine Corps, the staff report points out the urgent need to resettle the refugees rapidly. Although the health of the refugees appears to be good at this time, any protracted stay in this different climate and overcrowded conditions in reception centers could result in disaster.

Greater participation by the voluntary agencies in finding resettlement opportunities is also necessary. We must turn to the obvious questions. What is the responsibility of the United States to provide resettlement facilities and financial assistance? Has the State Department succeeded in seeking the agreement of the international community in offering resettlement opportunities? These, and other important questions, have been presented to the officials of the executive branch during the course of three hearings, and numerous consultations with the committee. Unfortunately, the committee was unable to receive any comprehensive answers.

(Congressional Hearings on the Indochina Migration and
Refugee Assistance Act, 1975)

"Lessons of Vietnam" memo requested by Secretary of State Henry Kissinger, ca. May 12, 1975 (draft – never submitted to the President)

Memorandum
National Security Council
Sensitive/Eyes Only
Memorandum For: Secretary Kissinger
From W.R. Smyser
Subject: Lessons of Vietnam

At your request, some papers have been prepared for the President and yourself on the "lessons of Vietnam." . . .

It is remarkable, considering how long the war lasted and how intensely it was reported and commented that there are really not very many lessons from our experience in Vietnam that can be usefully applied elsewhere despite the obvious temptation to try. Vietnam represented a unique situation, geographically, ethnically, politically, militarily, and diplomatically. We should probably be grateful for that and should recognize it for what it is, instead of trying to apply the "lessons of Vietnam" as universally as we once tried to apply the "lessons of Munich."

. . . A frequent temptation of many commentators has been to draw conclusions regarding the tenacity of the American people and the ultimate failure of our will. But I question whether we can accept that conclusion. It was the longest war in American history, the most distant, the least obviously relevant to our nation's immediate concerns, and yet the American people supported our involvement and its general objectives until the very end. The people made enormous sacrifices. I am convinced that, even at the end, they would have been prepared to support a policy that would have saved South Vietnam if such an option had been available to use.

. . . If one could offer any guidelines for the future about the lessons to be drawn regarding domestic support for foreign policy, it would be that American political groups will not long remain comfortable in positions that go against their traditional attitudes. The liberal Democrats could not long support a war against a revolutionary movement, no matter how reactionary the domestic tactics of that movement.

. . . Another lesson would be the absolute importance of focusing our own remarks and the public debate on essentials—even if those essentials are not clearly visible every night on the television screen. The Vietnam debate often turned into a fascination with issues that were, at best peripheral . . . The Mylai incident [for instance] tarnished the image of an American Army that had generally—though not

always—been compassionate in dealing with the civilian population . . .

In terms of military tactics, we cannot help draw the conclusion that our armed forces are not suited to this kind of war . . . it was both a revolutionary war fought at knife-point . . . within the villages. It was also a main force war in which technology could make a genuine difference. Both sides had trouble devising tactics that would be suitable for each type of warfare. But we and the south Vietnamese had more difficulty with this than the other side.

. . . In the end, we must ask ourselves whether it was all worth it, or at least what benefits we did gain. I believe the benefits were many . . .

(Smyser to Kissinger, 1975, available at http://www.ford.utexas.edu/library/exhibits/vietnam/750512a/htm)

III: Teaching Connections

Prologue: Juxtaposition as a Visual Framework

Juxtaposition is intended to be shocking. Visual artists often use the strategy of juxtaposing two or more very different images to present something unexpected, to engender new knowledge or ideas, or to reframe the way we understand the visual imagery that permeates both daily life and the assumptions we make about the past. Some artists have also used this strategy as a means of questioning traditional symbolic associations, or the expectations that they imagine the viewer will bring to these symbols.

In this subsection we deploy the idea of juxtaposition as a lens through which to view narratives about the U.S. war in Vietnam. Perhaps most notably, we juxtapose, here, the memories of Vietnamese refugees—those who were displaced by the war—with the accounts of Americans who both shaped and witnessed the most brutal of the U.S.'s attacks on the Vietnamese people. Then, we juxtapose these personal narratives with the political and legal language that structured official U.S. government documents from the same time period. By doing this, we hope to raise questions about the ways in which we, in the contemporary moment, translate and understand the events of the Vietnam War. We use the strategy of juxtaposition in this Teaching Toolkit in an attempt to present a diverse collection of voices and narrative methods, in an effort to frame pedagogically engaging conversations about the lessons of the Vietnam War.

The following Teaching Connections provide suggestions for a range of discussions and hands-on activities focused on a critical reading of the U.S. war in Vietnam. These discussions and activities are premised on a thorough reading of all the primary documents and works of art included in the section. Before using the suggestions in the following toolkit, we encourage you to start with a broad-based discussion about the individual works of art in order to help students develop their own observational skills and connections to personal experience and opinion. Suggestions for how to facilitate a discussion about these works of art can be found in Chapter 6. Once you've had a chance to familiarize yourself with all the documents included in the section, you're ready to get started with the Teaching Toolkit. The Essential Questions, Key Ideas, and Instructional

Goals in the toolkits do not represent a set of definitive facts, ideas, or questions but in and of themselves should be carefully analyzed and considered. This questioning should lead to additional questions, ideas, and pedagogical strategies. The "Observe, React, and Respond" discussion questions and "Constructing Visual Knowledge" activities have been compiled as a set of strategies to be adapted and interpreted for different classroom needs. Again, these prompts are not exhaustive and do not offer a complete guide or lesson plan for teaching about the history of the U.S. war in Vietnam, but instead provide a series of provocations to be combined with many other possible resources, strategies, questions, and outcomes.

Teaching Goals

Essential Questions

✧ What are the lessons of the U.S. war in Vietnam? How has this question helped shape public debate about war and U.S. foreign policy over the past three decades? How—and why—do conflicting memories of the Vietnam War continue to shape national debates?

✧ How did U.S. policies affect the experiences of Vietnamese citizens and shape the Vietnamese community in the U.S.?

✧ How does the strategy of juxtaposition present different ways of understanding and debating the United States war in Vietnam?

Key Ideas

Students will understand that:

✧ Artists have represented personal experiences about the Vietnam War through oral history, visual testimonies, and original works of art that combine different representational strategies.

✧ Americans continue to debate the meaning of the Vietnam War. Even though the war has been officially over for forty years, these debates remain very heated.

✧ To understand the history of the war in Vietnam we have to consider a range of perspectives, including the perspectives of Vietnamese and Vietnamese-Americans.

✧ Our knowledge of the war in Vietnam has been mediated through different lenses and platforms: television, newspapers, oral histories, diaries, visual art, and movies.

Instructional Goals

Students will:

✧ Critically read and interpret a variety of visual and text-based sources including primary historical documents and works of contemporary art related to the United States war in Vietnam.
✧ Frame effective questions about the effects of war on the groups of different people who were directly and indirectly affected by the events of the war in Vietnam.
✧ Engage in debate about the lessons of the United States war in Vietnam.
✧ Construct visual arguments that reflect personal/individual understandings about U.S. involvement in wars both past and present based on historical knowledge.

Teaching Strategies

I. OBSERVE, REACT, AND RESPOND

Use the following prompts, either individually or together, to initiate a series of discussions that explore the essential questions and key ideas.

a. Ask students to look at all of the documents and works of art contained in this section. In order to help students explore the ideas contained in these texts and images, ask them to consider the following:

✧ Who is the author of each document or work of art?
✧ What is the argument or idea each author puts forth?
✧ Who might the intended audience be for each of the documents and artworks? That is, to whom, specifically, was each piece initially addressed?
✧ What was the purpose for which, or "occasion" upon which, the documents or artworks were created?
✧ What do each of these pieces suggest are the most important "lessons" of the United States war in Vietnam?

Choose one or more of the following prompts to extend the initial discussion based on a close reading of particular primary documents and works of art.

b. Ask students to read the excerpted first-person accounts by Robert McNamara and Larry Colburn. Then, ask them to discuss, in pairs what visual images each

account suggests, and to list as many of these images as they can in their notebooks. Next ask students to look at the two visual series presented in this section, An-My Lê's photographs from *Small Wars* and *Viêt Nam*, and Martha Rosler's *Bringing the War Home: House Beautiful,* 1967–72 and *Bringing the War Home: House Beautiful, new series*, 2004. Ask students to compare the imagery they see in these works of art with those they encountered in the narratives of Robert McNamara and Larry Coburn. What are the similarities and differences in these images? Ask students to select three images from their observations of both the personal testimonies and the visual artworks that they find most striking. Then ask them to write an essay, using descriptions of each of these images, explaining what they think are the most important lessons of Vietnam.

c. Pick one historical document and one work of art and look at them together. Compare the kinds of information they present, and how they present that information. That is, how does the creator of each use tone, or voice? Color? Composition (that is, how different elements of the document are placed in relation to others)? When was each image made? Then ask students to write an analysis that describes the process of "juxtaposing" a historical document and a work of contemporary art. What do these documents convey together, that they do not convey separately?

a. Ask students to identify a family member, a friend, a school employee, or a person from their community who was alive during the war in Vietnam. Ask them to interview this person about their recollections of this time. What does this person think are the lessons they learned from living through this period? Ask students to look for images from popular sources such as films, political cartoons, photographs of war, and war propaganda, and then juxtapose these images with excerpts from their interviews. Students might also create a silhouette of the head of the person they interviewed, and then collage the images they found in popular sources, or draw images based on the list they created in the activity presented in I(b), above, within or outside of this silhouette. Then, reproduce an excerpt from their interview on acetate paper, place the acetate over the image-filled silhouette, and glue it down. Finally, collect all student artworks and put them together (with a title page) to create a collective book of ordinary citizens' recollections of the Vietnam War era.

II. CONSTRUCTING VISUAL KNOWLEDGE

b. Curate an exhibition that juxtaposes different kinds of historical and visual documents to tell a new story about the war in Vietnam. Ask students to draw pictures of the images they discussed in I(b), above. Then, using these images, invite them to make a visual argument that indicates what they think are the most important "lessons of Vietnam." Encourage your students to use the strategy of juxtaposition as they create their visual arguments; they could, for instance, place two distinct images next to each other. Finally, facilitate a classroom gallery walk. Ask students to discuss how their classmates have combined different sorts of images to make their arguments. How does the use of juxtaposition change the meaning of the images presented?

Standards

National Council for the Social Studies Thematic Standards

Standard II. Time, Continuity, and Change

The learner will…
a. demonstrate that historical knowledge and the concept of time are socially influenced constructions that lead historians to be selective in the questions they seek to answer and the evidence they use;
d. systematically employ processes of critical historical inquiry to reconstruct and reinterpret the past, such as using a variety of sources and checking their credibility, validating and weighing evidence for claims, and searching for causality;
e. investigate, interpret, and analyze multiple historical and contemporary viewpoints within and across cultures related to important events, recurring dilemmas, and persistent issues, while employing empathy, skepticism, and critical judgment;

Standard IV. Individual Development and Identity

The learner will…
h. work independently and cooperatively in groups and institutions to accomplish goals;

Standard VI. Power, Authority, and Governance

The learner will…

g. evaluate the role of technology in communications, transportation, information-

processing, weapons development, and other areas as it contributes to or helps resolve conflicts;

Standard IX. Global Connections

The learner will…
h. illustrate how individual behaviors and decisions connect with global systems;

Standard X. Civic Ideals and Practices

The learner will…
c. locate, access, analyze, organize, synthesize and apply information about selected public issues—identifying, describing, and evaluating multiple points of view;
d. practice forms of civic discussion and participation consistent with the ideals of citizens in a democratic republic;
f. analyze a variety of public policies and issues from the perspective of formal and informal political actors.

National Visual Arts Standards

Content Standard: 1: Understanding and applying media, techniques, and processes
Content Standard: 2: Using knowledge of structures and functions
Content Standard: 3: Choosing and evaluating a range of subject matter, symbols, and ideas
Content Standard: 4: Understanding the visual arts in relation to history and cultures
Content Standard: 6: Making connections between visual arts and other disciplines

REFERENCES

Appy, C. G. (2007). Class wars. In L. Gardner & M. Young (Eds.), *Iraq and the lessons of Vietnam: Or, how not to learn from the past* (pp. 136–149). New York: The New Press.
Bui, T. (2008). *Backwards*. Unpublished graphic novel.
Colburn, L. (2006). Interview with Amy Goodman on *Democracy Now!* January 18.
Deconde, A., Burns, R. D., Logevall, F., & Ketz, L. B. (Eds.). (2002). *Encyclopedia of American foreign policy*. New York: Charles Scribner's Sons.
McNamara, R. S. (1996). *In retrospect: The tragedy and lessons of Vietnam*. New York: Vintage.
Morris, E. (Dir.). (2003). *The fog of war: Eleven lessons from the life of Robert S. McNamara*. United States: Sony Pictures Classic.
Morris, E. (2005). The anti-post-modern post-modernist: A lecture by Errol Morris. Retrieved January 7, 2009, from http://www.errolmorris.com/content/lecture/theantipost.html
Rosler, M., & Blazwick, I. (2008). Taking responsibility. *Art Monthly, 314*(March), 1–7.

Rosler, M., & Herrshaft, F. (2004). Interview with Martha Rosler. *Fehe.org*. Retrieved on January 28, 2009, from http://www.fehe.org/index.php?id=571

Ryan, T. (2004). Making history: Errol Morris, Robert McNamara and *The Fog of War. Sense of Cinema*. Retrieved January 10, 2009, from http://www.sensesofcinema.com/contents/04/31/errol_morris_interview.html

Shanker, T. (2007). Historians question Bush's reading of lessons of Vietnam War for Iraq. *New York Times*, August 23.

Smyser, W. R. (1975). Lessons of Vietnam: memo to Henry Kissinger. Gerald R. Ford Library, Folder "Vietnam (23)", National Security Adviser. Presidential Country Files for East Asia and the Pacific. Retrieved November 12, 2008, from http://www.ford.utexas.edu/library/exhibits/vietnam/750512a.htm

Sollins, S. (2007). Interview with An-My Lê. In *Art:21—Art in the twenty-first century 4*. New York: Harry N. Abrams.

Sturken, M. (1997). *Tangled memories: The Vietnam War, the AIDS epidemic, and the politics of remembering*. Berkeley: University of California Press.

Young, M. (1991). This is not Vietnam, this is not a pipe. *Middle East Report, 171*(July–August), 21–24.

Resources

ARTIST AND EXHIBITION CATALOGUES

Anon. (2001). *Oyvind Falstrom: Another space for painting*. Barcelona: Museu d'Art Contemporani de Barcelona.

Attie, S. (1998). *Sites unseen: Shimon Attie European projects: Installations and photographs*. Burlington, VT: Verve.

Attie, S. & Beaver, C. (2000). *Between dreams and history: The making of Shimon Attie's public art projects* (videorecording). Ben Lomond, CA: distributed by The Video Project.

Attie, S., Egan, N., & Stille, A. (2004). *The history of another*. Santa Fe, NM: Twin Palms.

Fusco, C. & Wallis, B. (2003) (Eds.) *Only skin deep: Changing visions of the American self*. New York: Harry N. Abrams.

Group Material. (1987). *Constitution*. Philadelphia, PA: Temple Gallery

Sims, L. S., Hulser, K., & Copeland S. (2007). *Legacies: Contemporary artists reflect on slavery*. New York: New York Historical Society.

Schaffner, I. & Winzen, M. (Eds.). (1998). *Deep storage: Collecting, storage, and archiving in art*. Munich: Prestel-Verlag.

Lippard, L. (1990). *A different war: Vietnam in art*. Seattle: Real Comet Press.

Thompson, N. (2006). *Ahistoric occasion: Artists making history*. North Adams, MA: Massachusetts Museum of Contemporary Art.

Wallis, B. (1990). *Democracy: A project by Group Material*. Seattle: Bay Press.

Weems, C. M. (2008). *Carrie Mae Weems—Constructing history: A requiem to mark the moment*. Savannah, GA: Savannah College of Art and Design.

Zinn, H., Konopacki, M., & Buhle, P. (2008). *The people's history of American empire: A graphic adaptation*. New York: Metropolitan Books.

CONTEMPORARY ART JOURNALS

Art in America: http://www.artinamericamagazine.com/

Fine arts journal covers creative art movements internationally for artists, dealers and collectors. Articles cover styles from the contemporary to the classical, in media such as painting, sculpture, and photography.

ArtForum: http://www.artforum.com/

Magazine emphasizing contemporary art, focusing on contemporary painting and sculpture, including critical and historical essays and reviews.

Art Journal (College Art Association): http://www.collegeart.org/artjournal/

The mission of *Art Journal*, founded in 1941, is to provide a forum for scholarship and visual exploration in the visual arts; to be a unique voice in the field as a peer-reviewed, professionally mediated forum for the arts; to operate in the spaces between commercial publishing, academic presses, and artist presses.

New Art Examiner: **Chicago-based art magazine.**

Founded in October 1973 by Derek Guthrie and Jane Addams Allen, its final issue was dated May–June 2002.

CONTEMPORARY ART ONLINE

Art21: http://www.pbs.org/art21/

Art21 creates a variety of curricular resources in conjunction with each season of the series. Art21 Educators' Guides provide background information on featured artists, suggested discussion questions and hands-on activities, and additional resources on contemporary art and artists. Toolkits and the Art21 Online Lesson Library provide further suggestions for using Art21 materials in educational contexts. Art21's interdisciplinary materials provide connections to many subject areas, including the Performing Arts, Language Arts, and Social Studies.

The Museum of Modern Art (MoMA): http://www.moma.org/

Founded in 1929 as an educational institution, The Museum of Modern Art is dedicated to being the foremost museum of modern art in the world.

The Whitney Museum: http://whitney.org/

The Whitney Museum houses one of the world's foremost collections of twentieth-century American art. The Permanent Collection of some 12,000 works encompasses paintings, sculptures, multimedia installations, drawings, prints, and photographs, and is still growing. The museum was founded in 1931.

RESOURCES FOR TEACHING

Cahan, S. & Kocur, Z. (1996). *Contemporary art and multicultural education*. New York: Routledge.

For more information about creating a class zine visit the following web sites:

Aulik, D. (2006). *Zines, literacy, and the adolescent.* http://www.ala.org/ala/mgrps/divs/aasl/aaslpubsandjournals/kqweb/kqarchives/volume35/351aulik.cfm
http://www.undergroundpress.org/zine-resources/
http://www.voices.axspace.com/support/student_guide.htm
http://www.zinebook.com/resource/zineguide.pdf

Comic books:

McCloud, S. (1993). *Understanding comics: The invisible art*. New York: Harper Perennial.
McCloud, S. (2000). *Reinventing comics: How imagination and technology are revolutionizing an art form*. New York: Harper Perennial.

Conducting oral history interviews:

http://www.doingoralhistory.org/in_classroom/THT_article.htm

Oral history links and resources:

http://www.learnnc.org/lp/pages/767

Video art for the classroom:

Szekely, G. & Szekely, I. (Eds.). (2005). *Video art for the classroom*. Reston, VA: National Art Education
 Association.
Educational video center. http://www.evc.org

About the Authors

Dipti Desai is an Associate Professor and director of the graduate program in art education at New York University. Prior to coming to NYU, she taught art education at SUNY New Paltz. Her teaching career includes two years in New Zealand, where she taught courses in Education at Victoria University in Wellington, and extensive experience teaching students from diverse cultural and ethnic backgrounds at the elementary and middle school level in the United States, India, and New Zealand. Her work has been published in several journals and books, including *Studies in Art Education*, *Multicultural Perspectives*, *Democracy and Education*, and the forthcoming issue of *Journal of Curriculum and Pedagogy*. She serves on the editorial board of several journals in art education and the advisory board for non-profit organizations in New York City and is the current Senior Editor for the Journal of Cultural Research in Art Education.

Jessica Hamlin is the Director of Education and Public Programs for the non-profit organization Art21, Inc. She has spent the past twelve years talking, thinking, teaching, and writing about contemporary art and its potential as a pedagogical resource. As an art educator, Jessica has spent time in museums, galleries, non-profit arts organizations, and schools, connecting the art of our time to students, teachers, and public audiences. Previously, she led education programs at the non-profit gallery Art In General and the community-based Saturday Art School at Pratt Institute, and participated in a comprehensive planning and assessment process with the Boston Mayor's Office of Cultural Affairs, examining school and community-based arts programs in the Boston Public Schools.

Rachel Mattson is a historian, a teacher educator, and an Assistant Professor at SUNY New Paltz. She earned a PhD in U.S. History from New York University in 2004, and then served for several years as the Historian-in-Residence in NYU's Department of Teaching and Learning. Her work has appeared, among other places, in the *Radical History Review*, *Notable American Women*, the *Village Voice*, and *WNYC*, as well as in a forthcoming issue of *Rethinking History*. An active public historian, Mattson has been involved in a range of NYC-based arts and activist organizations for over fourteen years, and currently sits on the advisory board for the group Circus Amok. You can read her blog, *How History Feels*, at http://www.howhistoryfeels.blogspot.com/.

Figure Credits and Permissions

Integrated Black and White

All image files are digital unless otherwise marked

Figure 1.1 Fred Wilson, "Metalwork 1793–1880," *Mining the Museum*, 1992
Selections from the Maryland Historical Society
Silver vessels in Baltimore Repousse style, 1830–1880, maker unknown
Slave shackles, c. 1793–1872, maker unknown (probably Baltimore)
(Photograph: Jeff Goldman, The Museum of Contemporary Arts and Maryland Historical Society, Baltimore, MD)

Figure 1.2 Barbara Kruger
Untitled (Your Fictions Become History), 1983
Gelatin silver print
76¼ 39½ inches
Milwaukee Art Museum, gift of Contemporary Art Society

Figure 1.3 "Ending Discrimination in Public Housing: Williamsburg Fair Housing v. NYCHA," a temporary street sign researched and designed by Marina Gutierrez about fair housing in her Brooklyn neighborhood of Crown Heights for *REPOhistory*'s *Civil Disturbances: Battles for Justice in New York City*, 1998–1999. Courtesy of Tom Klein.

Figure 1.4 Kara Walker
The End of Uncle Tom and the Grand Allegorical Tableau of Eva in Heaven, 1995
Cut paper and adhesive on wall
13 × 35 feet
Installation view at The Walker Art Center, Minneapolis, 2007
Photo by Gene Pittman/The Walker Art Center
Courtesy of Sikkema Jenkins & Co.

Figure 1.5 Glenn Ligon
Runaways (Ran away, Glenn. Medium height, 5'8", male...), 1993.
1 from a series of 10 lithographs
16 × 12 inches
Courtesy Regen Projects, Los Angeles, CA
© Glenn Ligon

Figure 1.6 Peggy Diggs
Here & Then, 2006
Public Art Project
Courtesy the Artist

Figure 2.2	Joshua Brown, "Great Moments in Labor History II, In Which a Group of Early 21st Century Historians Goes Back in Time to Witness…The Completion of the Transcontinental Railroad." Originally published in LABOR 1(1) (Spring 2004).
Figure 2.3	Joshua Brown, "Make Your Own History." Originally published in the *Radical History Review* 1981, 25 (1)
Figure 2.4	Jacob Lawrence (1917–2000), "The Migration of the Negro, Panel No. 14: Among the social conditions that existed which was partly the cause of the migration was the injustice done to the Negroes in the court." (1941) © 2009 The Jacob and Gwendolyn Lawrence Foundation, Seattle/Artists Rights Society (ARS), New York. Photo Credit : Digital Image © The Museum of Modern Art/Licensed by SCALA / Art Resource, NY
Figure 3.1	Comics as Oral History Project Student artwork Courtesy Thi Bui. Permission granted by student. This is a page of a graphic novel by Ephraim Hafftka
Figure 3.2	Comics as Oral History Project Student artwork Courtesy Thi Bui. Permission granted by student. These are pages of a graphic novel by Sarah Rooney
Figure 3.3	Comics as Oral History Project Student artwork Courtesy Thi Bui. Permission granted by student. These are pages of a graphic novel by Sarah Rooney
Figure 3.4	Comics as Oral History Project Student artwork Courtesy Thi Bui. Permission granted by student. These are pages of a graphic novel by Sarah Rooney
Figure 3.5	Thi Bui *Backwards*, 2008 Pages of graphic novel Courtesy of Artist
Figure 3.6	Thi Bui *Backwards*, 2008 Pages of graphic novel Courtesy of Artist
Figure 3.7	Thi Bui *Backwards*, 2008 Pages of graphic novel Courtesy of Artist
Figure 4.1	Jenny Holzer *Hand Yellow White* (detail, Panel 8 and Panel 9), 2006 Oil on linen; eight panels, 33 × 204 inches Jenny Holzer, member Artists Rights Society (ARS), New York

Figure 4.2 Shimon Attie
 Detail, *An Unusually Bad Lot*, 1999–2000
 Courtesy of Jack Shainman Gallery

Figure 4.3 Walid Raad,
 Hostage: The Bachar Tapes, 2000, video still
 © Walid Raad
 Image courtesy of the Video Data Bank (www.vdb.org)

Figure 4.4 Melinda Hunt
 Adult Mass Burial with pages from Hart Island Burial Record Books,1997
 Dimensions 42 × 48 inches
 Courtesy of Artist, of the Hart Island Project ©1991–2008 Melinda Hunt
 Photograph by Joel Sternfeld

Figure 4.5 Greta Pratt
 Nineteen Lincolns, 2005
 Photographs
 Dimensions 30 × 30 inches
 Courtesy of Artist

Figure 4.6 An-My Lê
 29 Palms: Combat Support Service Operations I, 2003–2004
 Gelatin silver print
 26½ × 38 inches
 Courtesy of Murray Guy, New York

Figure 4.7 Tomie Arai
 Memory-in-Progress: A Mother–Daughter Oral History Project
 An Immigrant's Story, 1989
 Silkscreen Print, 22 × 30 inches
 Courtesy of Artist

Figure 4.8 Tomie Arai
 Double Happiness, 1998
 Mixed media installation with sound
 Dimensions variable
 Courtesy of Artist

Figure 4.9 Jackie Brookner
 Of Earth and Cotton, 1994–1998
 Installation
 Courtesy of Artist
 ©Jackie Brookner

Figure 4.10 Roger Shimomura
 American Diary: December 12, 1941
 Acrylic 11 × 14 inches, 1997
 Collection of: Steven B. Mendes, Chicago, Illinois

Figure 4.11 Kara Walker
 Negress Notes (Brown Follies), 1996–1997
 Watercolor on paper
 9 6 inches
 Courtesy of Sikkema Jenkins & Co.

Figure 5.1 Krzysztof Wodiczko
 Soldiers and Sailors, Brooklyn Projection, 1985
 Public slide projection at Soldiers and Sailors Memorial Arch, Grand Army
 Plaza, Brooklyn, NY
 © Krzysztof Wodiczko
 Courtesy of Galerie Lelong, New York

Figure 5.2 Krzysztof Wodiczko
 Bunker Hill Monument Projection, 1998
 Public video projection at Bunker Hill Monument, Boston, Massachusetts
 © Krzysztof Wodiczko
 Courtesy of Galerie Lelong, New York

Figure 5.3 Krzysztof Wodiczko
 Nelson's Column Projection, 1985, Detail
 Public slide projection at Nelson's Column, Trafalgar Square, London, England
 © Krzysztof Wodiczko
 Courtesy of Galerie Lelong, New York

Figure 5.4 *Leisler's Rebellion*, a temporary street sign researched and designed by Stephen
 Duncombe for *REPOhistory*'s *Lower Manhattan Sign Project* (LMSP),
 NYC, 1992. Photograph Courtesy of Greg Sholette.

Figure 5.5 *Marshia P. Jonson*, a temporary memorial about the transgendered street activist
 that was researched, designed and installed in the Meatpacking District
 of Manhattan by *REPOhistory* for the project *Queer Spaces*: nine street signs
 commemorating gay and lesbian activism in NYC, 1994. (Each sign in this
 project was photosilkscreened text on a triangular piece of press-board painted
 pink.) Courtesy Jim Costanzo.

Figure 5.6 "The Great Negro Plot of 1741 New Amsterdam," a temporary street sign
 researched and designed by Mark O'Brian and Willie Birch for *REPOhistory*'s
 LMSP, 1992. Photograph courtesy Tom Klein.

Figure 7.1 Erika Rothenberg, John Malpede, Laurie Hawkinson
 Freedom of Expression National Monument
 August 17–November 13, 2004
 Foley Square, New York, NY
 Courtesy of the Artists

Figure 7.2 Erika Rothenberg, John Malpede, Laurie Hawkinson
 Freedom of Expression National Monument
 August 17–November 13, 2004
 Foley Square, New York, NY
 Courtesy of the Artists

Figure 7.3 Jenny Holzer
 Wish List Black (detail, panel 10), 2006
 Oil on linen; 16 panels, 33 × 102 inches
 Jenny Holzer, member Artist Rights Society (ARS), New York

Figure 7. 4 Jenny Holzer
 Colin Powell Green White (detail, Panel 3 and Panel 4), 2006
 Oil on linen; four panels, 33 × 102 inches
 Jenny Holzer, Member Artists Rights Society, (ARS), New York

Figure 7.5 Jenny Holzer
 For the City, 2005
 Light Projections of Poetry and Declassified Documents
 Rockefeller Center Sept 29–Oct 2
 NYU Bobst Library Oct 3–5
 NY Public Library Oct 6–9
 Artists Rights Society (ARS), New York

Figure 7.6 "The USA PATRIOT ACT and Government Actions that Threaten Our Civil
 Liberties." Flyer created by the American Civil Liberties Union, 2001–2002,
 available at www.aclu.org.

Figure 7.7 Roger Shimomura
 American Diary: April 28, 1942, 1997
 Acrylic 11 × 14 inches
 Collection of: Gaylord Neeley, Washington, D.C.

Figure 7.8 Ben Sakoguchi
 "To Hell with Habeas Corpus" from the series *Postcards from Camp*, 1999–2001
 Acrylic on canvas, 11 × 16 inches
 Courtesy of the Artist

Figure 7.9 Ben Sakoguchi
 Shikata ganai from the series *Postcards from Camp,* 1999–2001
 Acrylic on canvas, 11 × 16 inches
 Courtesy of the Artist

Figure 8.1 Glenn Ligon
 Narratives (The Life and Adventures of Glenn Ligon…), 1993
 Photoetching on chine collé
 27⅞ × 21 inches
 Courtesy Regen Projects, Los Angeles
 © Glenn Ligon

Figure 8.2 Glenn Ligon
 Runaways (Ran away, Glenn, a black man – early 30's...), 1993
 1 from a series of 10 lithographs
 16 × 12 inches
 Courtesy Regen Projects, Los Angeles, CA
 © Glenn Ligon

Figure 8.3 Glenn Ligon
 Narratives (Folks and Places Abroad...), 1993
 1 from a series of nine etchings with chine colle
 28 × 21 inches
 Courtesy Regen Projects, Los Angeles, CA
 © Glenn Ligon

Figure 8.4 Kara Walker
*Slavery! Slavery! Presenting a GRAND and LIFELIKE Panoramic Journey into
Picturesque Southern Slavery or "Life at 'Ol' Virginny's Hole' (Sketches from Plantation
Life)" See the Peculiar Institution as Never Before! All cut from black paper by the able
hand of Kara Elizabeth Walker, an Emancipated Negress and leader in her Cause*, 1997.
Cut paper and adhesive on wall, 12 × 85 feet.
Installation view at The Walker Art Center, Minneapolis, 2007
Photo by Dave Sweeney/The Walker Art Center
Courtesy of Sikkema Jenkins & Co.

Figure 8.5 Kara Walker
Darkytown Rebellion, 2001
Cut paper and projection on wall
15 × 33 feet
Photo by Dave Sweeney/The Walker Art Center
Courtesy of Sikkema Jenkins & Co.

Figure 8.6 Title page from *Incidents in the Life of a Slave Girl by Harriet Jacobs*, 1861. Used
with permission of Documenting the American South, The University of
North Carolina at Chapel Hill Libraries.

Figure 8.7 Title page from *The Life and Times of Fredrick Douglass, A Slave Narrative*, 1845.
Used with permission of Documenting the American South, The University
of North Carolina at Chapel Hill Libraries.

Figure 8.8 Flo Oy Wong
made in usa: Angel Island Shhh
Flag 13: Gee Theo Quee
Mixed media, 24 × 36 inches
Courtesy of Artist

Figure 8.9 Krzysztof Wodiczko
Alien Staff, 1991–1993
Mixed media
Each variant: approx. 60 inches tall
© Krzysztof Wodiczko
Courtesy of Galerie Lelong, New York

Figure 8.10 Krzysztof Wodiczko
Mouthpiece (Porte-Parole), 1992–1996
Mixed media
© Krzysztof Wodiczko
Courtesy of Galerie Lelong, New York

Figure 8.11 Krzysztof Wodiczko
Mouthpiece (Porte-Parole), 1992–1996
Mixed media
© Krzysztof Wodiczko
Courtesy of Galerie Lelong, New York

Figure 9.1 W. R. Smyser to Secretary Kissinger, "The Lessons of Vietnam."
May 12, 1975, Cover Memo. Folder "Vietnam (23)", National Security
Adviser. Presidential Country Files for East Asia and the Pacific, Gerald R.
Ford Library. Courtesy Gerald R. Ford Library.

Figure 9.2	An-My Lê *Untitled, Hanoi (girl in doorway)*, 1994 Gelatin silver print 20 × 24 inches Courtesy of Murray Guy, New York
Figure 9.3	An-My Lê *Small Wars (Vietcong Camp)*, 1999–2002 Gelatin silver print 26½ × 38 inches Courtesy of Murray Guy, New York
Figure 9.4	An-My Lê *Untitled, Ho Chi Minh City (kites)*, 1998 Gelatin silver print 20 × 24 inches Courtesy of Murray Guy, New York
Figure 9.5	An-My Lê *Small Wars (rescue)*, 1999–2002 Gelatin silver print 26 ½ × 38 inches Courtesy of Murray Guy, New York
Figure 9.6	Martha Rosler *Bringing the War Home: House Beautiful,* "Red Stripe Kitchen," 1967–72 Photomontage, 24 × 20 inches Courtesy of Martha Rosler
Figure 9.7	Martha Rosler "The Gray Drape", 2008 Photomontage, 40 × 30 inches Courtesy of Martha Rosler

Full Page Inserts

Plate 1	Erika Rothenberg, John Malpede, Laurie Hawkinson *Freedom of Expression National Monument* August 17–November 13, 2004 Foley Square, New York, NY Courtesy of the Artists
Plate 2	Erika Rothenberg, John Malpede, Laurie Hawkinson *Freedom of Expression National Monument* August 17–November 13, 2004 Foley Square, New York, NY Courtesy of the Artists
Plate 3	Roger Shimomura *American Diary: February 3, 1942*, 1997 Acrylic 11 × 14 inches Collection of: Doug Hill, Norman, Oklahoma
Plate 4	Roger Shimomura *American Diary: April 21, 1942*, 1997 Acrylic 11 × 14 inches Collection of: Esther Weissman, Shaker Heights, Ohio

Plate 5	Ben Sakoguchi
	"Rohwer, Arkansas" from the series *Postcards from Camp,* 1999–2001
	Acrylic on canvas, 11 × 16 inches
Plate 6	Ben Sakoguchi
	"Heart Mountain, Wyoming" from the series *Postcards from Camp,* 1999–2001
	Acrylic on canvas, 11 × 16 inches
	Courtesy of the Artist
Plate 7	Flo Oy Wong
	made in usa: Angel Island Shhh
	"Flag 8: Lee Suk Wan, 1930"
	Mixed media, 24 × 36 inches
	Courtesy of Artist
Plate 8	Flo Oy Wong
	made in usa: Angel Island Shhh
	"Flag 10: Wong Geung Ling, 1930"
	Mixed media, 24 × 36 inches
	Courtesy of Artist
Plate 9	Krzysztof Wodiczko
	Alien Staff, performance still, 1991–1993
	Mixed media
	Each variant: approx. 60 inches tall
	Copyright Krzysztof Wodiczko
	Courtesy of Galerie Lelong, New York
Plate 10	Krzysztof Wodiczko
	Alien Staff, performance still, 1991–1993
	Mixed media
	Each variant: approx 60 inches tall
	Copyright Krzysztof Wodiczko
	Courtesy of Galerie Lelong, New York
Plate 11	Jaune Quick-to-See Smith
	Trade (Gifts for Trading Land with White People), 1992
	Oil and collage on canvas, with other materials, 60 × 170 inches
	The Chrysler Museum of Art, Norfolk, VA, Museum Purchase
	Copyright Jaune Quick-to-See Smith
Plate 12	David Avalos
	Wilderness, 2008
	2008 Digital Collage (Based on a 1989 Installation)
	Courtesy of Artist
Plate 13	Martha Rosler
	Bringing the War Home: House Beautiful,
	"Balloons," 1967–72
	Photomontage, 24 × 20 inches
	Courtesy of Martha Rosler
Plate 14	Martha Rosler
	Bringing the War Home: House Beautiful, new series,
	"Lounging Woman," 2004
	Photomontage, 24 × 20 inches
	Courtesy of Martha Rosler

Index

Page numbers followed by an f denote pages with figures; Plates can be found in the insert between pages 80 and 81.

Made in the USA
Las Vegas, NV
21 February 2022